BODY MATTERS

MANCHESTER
UNIVERSITY PRESS

body matters

FEMINISM
TEXTUALITY
CORPOREALITY

edited by
AVRIL HORNER
and ANGELA KEANE

**Manchester
University Press**

Manchester and New York

*distributed exclusively
in the USA by St. Martin's Press*

Published by Manchester University Press
Oxford Road, Manchester M13 9NR, UK
and Room 400, 175 Fifth Avenue, New York, NY 10010, USA
http://www.man.ac.uk/mup

Distributed exclusively in the USA by
St. Martin's Press, Inc., 175 Fifth Avenue, New York, NY 10010, USA

Distributed exclusively in Canada by
UBC Press, University of British Columbia, 6344 Memorial Road, Vancouver, BC, Canada V6T 1Z2.

British Library Cataloguing-in-Publication Data
A catalogue record for this book is available from the British Library.

Library of Congress Cataloging-in-Publication Data applied for

ISBN 0 7190 5468 0 *hardback*
　　 0 7190 5469 9 *paperback*

First published 2000

06 05 04 03 02 01 00 10 9 8 7 6 5 4 3 2 1

Typeset by
Northern Phototypesetting Co. Ltd., Bolton
Printed in Great Britain by
Bell & Bain Ltd, Glasgow

CONTENTS

v

CONTENTS

vi

ACKNOWLEDGEMENTS

The idea for *Body Matters: Feminism, Textuality, Corporeality* emerged from a conference entitled 'Identifying Feminisms' held at the University of Salford in September 1996. We would like to thank all those who attended and who made the day such an interesting event; we would also like to express our gratitude to the European Studies Research Institute at the University of Salford for funding and facilitating the conference. Matthew Frost, of Manchester University Press, has been a source of good advice, wise editorial guidance and urbane wit throughout the book's progress. Our thanks also go to Lauren McAllister, of Manchester University Press, for her friendly efficiency and to Howard Horner, who sorted out several word-processing problems with patience and good humour.

NOTES ON THE CONTRIBUTORS

Sara Ahmed is a lecturer, and Director of Masters Studies, in the Institute for Women's Studies at Lancaster University, where she teaches courses on gender, race and colonialism. Her first book, *Difference that Matter: Feminist Theory and Postmodernism*, was published by Cambridge University Press in 1998. She has also published articles on feminist theory, and on postcolonial theory, in journals including *Social and Legal Studies, Australian Feminist Studies, Hypatia, Oxford Literary Review, New Formations, European Journal of Cultural Studies and Theory* and *Culture and Society*. She is currently working on a new book provisionally entitled *Strange Encounters: Embodied Others in Post-Coloniality* (Routledge, forthcoming).

Elisabeth Bronfen is Professor of English and American Studies at the University of Zurich. She has been a guest professor at Columbia University, Princeton University, Sheffield Hallam University, the University of Copenhagen and the University of Aarhus. A specialist in nineteenth- and twentieth-century literature, she has also written articles in the areas of gender studies, psychoanalysis, film, cultural theory and art. Book publications include *Over Her Dead Body: Death, Femininity and the Aesthetic* (Manchester University Press, 1992) and a collection of essays, *Death and Representation*, co-edited with Sarah W. Goodwin (Johns Hopkins University Press, 1993). She has edited a four-volume German edition of Anne Sexton's poetry and letters. Her most recent books are *The Knotted Subject: Hysteria and its Discontents* (Princeton University Press, 1998) and a monograph on Sylvia Plath in the British Council series 'Writers and their Work' (Northcote Press, 1998). A book version of her doctoral dissertation has appeared in English, under the title *Dorothy Richardson's Art of Memory: Space, Identity, Text* (Manchester University Press). A book on the notion of home in Hollywood films is about to appear in German, entitled *Heimweh*. Current research projects include a cultural history of the night and a cultural studies reconsideration of the fifties.

Sue Chaplin is engaged in doctoral research at the University of Salford where she teaches English on a part-time basis; she also teaches law part-time at Manchester Metropolitan University. She obtained her first degree in law from the University of Nottingham in 1988, qualified as a solicitor in 1991 and received an MA in English from the University of Salford in 1997. Her research, which seeks to locate the sublime at the interface between poetics and politics, uses Irigarayan theory to explore the relation between the sublime, the law and the body of the 'improper' female subject in mid-to-late eighteenth-century fiction.

Her most recent publication is an article entitled 'Terror, Transcendence and Control in Charlotte Dacre's *Zofloya, or The Moor'*, included in *Spectres of Romanticism*, edited by Sharon Ruston and published by Edwin Mellen Press (1999).

Rachel Connor is currently a lecturer in English at the North East Wales Institute of Higher Education in Wrexham. She previously taught in the English Department at the University of Liverpool, where she is registered as a Ph.D. candidate and is in the final stages of writing up her doctorate. Her thesis, entitled 'Visible Worlds: The Process of the Image in the Work of H.D.', focuses on H.D.'s film writings and fictional prose and is underpinned by a theoretical framework of contemporary debates on the notions of gender, identity, subjectivity and corporeality. Her most recent publications include various book reviews and an essay on H.D. for the journal *Manuscript* and several entries on contemporary women writers for *The Cambridge Guide to Women's Writing in English*.

Charmaine Eddy is an Associate Professor in the Department of English at Trent University in Peterborough, Ontario, Canada, where she teaches American fiction, literary and critical theory, and the work of African-American women writers. Her most recent and forthcoming publications and papers include 'The Black and White of Race' (a critique of white feminist positionality discourse), 'The Policing and Proliferation of Desire in William Faulkner's *Sanctuary'*, 'The Discursive Symptomatic in Freud and Irigaray' and 'Contested Spaces: Disease and Diasporic Identities in Jamaica Kincaid's *My Brother'* (an examination of the diasporic subject through the body with AIDS). She is currently working on *Grey Matters: The Paradox of the Body in William Faulkner's Fiction*. She has also co-edited a special issue of the *Journal of Canadian Studies*, 'Perspectives on Timothy Findley'.

Regenia Gagnier was formerly Professor of English and Director of the Programme in Modern Thought and Literature at Stanford University; she is now Professor of English at the University of Exeter, where she teaches Victorian studies, especially the *fin de siècle*, social theory, feminist theory and interdisciplinary studies. Her books include *Idylls of the Marketplace: Oscar Wilde and the Victorian Public* (Stanford University Press, 1986), *Subjectivities: A History of Self-Representation in Britain, 1832–1920* (Oxford University Press, 1991) and an edited collection, *Critical Essays on Oscar Wilde* (Macmillan, 1992). She is currently completing a book-length study of the histories of economics and aesthetics in market society.

Amanda Gilroy is Director of the Master's Programme in English Studies at the University of Groningen, where she teaches eighteenth- and nineteenth-century British literature and feminist theory. She has edited a collection of essays on travel writing, entitled *Romantic Geographies: Discourses of Travel, 1775–1844* (Manchester University Press, 1999). She is the co-editor, with W.M. Verhoeven, of *The Emigrants* by Gilbert Imlay (Penguin, 1998) and of *Dangerous Liaisons: Letters, History, Culture* (University Press of Virginia, 1999); with Keith Hanley, she has edited *Joanna Baillie: A Selection of Poems and Plays* (Pickering and Chatto, 2000).

NOTES ON THE CONTRIBUTORS

Val Gough is lecturer in English and Director of the MA in Science Fiction Studies at the University of Liverpool. She has published on women writers of the inter-war period, feminist science fiction, and language and gender. She has co-edited, with Gill Rudd, *A Very Different Story: Studies in the Fiction of Charlotte Perkins Gilman* (Liverpool University Press, 1999) and *Optimist Reformer: Charlotte Perkins Gilman* (Iowa University Press, 1999).

Clare Hanson is Professor of English in the Department of English and Drama, Loughborough University. She has written numerous essays on twentieth-century women writers, including Angela Carter and Michèle Roberts, and is editor of *The Critical Writings of Katherine Mansfield* (Macmillan, 1987) and *Re-reading the Short Story* (Macmillan, 1994); she is also a regular reviewer of feminist criticism. Book publications include *Katherine Mansfield* (Macmillan, 1981), *Short Stories and Short Fictions, 1880–1980* (Macmillan, 1985) and *Virginia Woolf* (Macmillan, 1994). She has recently completed a study of the 'woman's novel' in the twentieth century, to be published by Macmillan in 2000.

Avril Horner is Professor of English and Director of the European Studies Research Institute at the University of Salford. Her research interests and publications focus on twentieth-century literature and in particular on modern poetry, women's writing and the Gothic. She is the co-author, with Sue Zlosnik, of *Landscapes of Desire: Metaphors in Modern Women's Fiction* (Harvester Wheatsheaf, 1990) and *Daphne du Maurier: Writing, Identity and the Gothic Imagination* (Macmillan,1998). She is currently working, with Sue Zlosnik, on *Dead Funny: Gothic and the Comic Turn*, forthcoming from Macmillan.

Vivien Jones is a senior lecturer in the School of English and a Co-Director of the Centre for Interdisciplinary Gender Studies at the University of Leeds. She has published books on Henry James and Jane Austen and numerous articles on gender and writing in the eighteenth century. She is the editor of *Women in the Eighteenth Century: Constructions of Femininity* (Routledge, 1990), of Jane Austen's *Pride and Prejudice* for Penguin Classics (1996) and of *Women and Literature in Britain, 1700–1800* (Cambridge University Press, 2000). She is currently completing a book on the cultural significance of the seduction narrative from 1740 to 1800, which includes extensive analysis of shifting representations of prostitutes and prostitution in the period.

Angela Keane is a lecturer in English at Salford University. Her primary research interests relate to British women's writing of the Romantic period. She has published articles on Ann Radcliffe, Helen Maria Williams, Hannah More and Edmund Burke, and is author of a forthcoming book: *Women Writers and the English Nation in the 1790s: Romantic Belongings* (Cambridge University Press, 2000). She is currently researching women's relationship to anti-consumerist movements in Britain between 1780 and 1832.

Scott McCracken is Senior Lecturer in English at the University of Salford. He is author of *Pulp: Reading Popular Fiction* (Manchester University Press, 1998),

co-author of *Introducing Cultural Studies* (Prentice Hall, 1999) and co-editor, with Sally Ledger, of *Cultural Politics at the Fin de Siècle* (Cambridge University Press, 1995). He has published articles on George Gissing, Olive Schreiner, Joseph Conrad and cyborg fictions and is currently writing a book on masculinity and the modernist novel, forthcoming from Manchester University Press.

You-me Park is Assistant Professor of English at the George Washington University, Washington DC. Her work on gender, nation and postcoloniality has appeared in *Positions: East Asia Cultures Critique, Dangerous Women, In Pursuit of East Asian Culture, Restoration* and *American Literature*. She is currently preparing her book manuscript, *States of Emergency: Women and the Discourse of Expendability*, for publication.

Rajeswari Sunder Rajan is a Fellow at the Nehru Memorial Museum and Library, New Delhi, and Visiting Professor at the George Washington University, Washington DC. Her publications include *Real and Imagined Women: Gender, Culture and Postcolonialism* (Routledge, 1993) and two edited collections, *The Lie of the Land: English Literary Studies in India* (Oxford University Press, 1992) and *Signposts: Gender Issues in Post-Independence India* (Kali for Women, 1999). She has also published articles in *Signs, Oxford Literary Review, Yale Journal of Criticism* and *Critical Inquiry*. Her forthcoming book, *In India: Women, Law, Citizenship and the Postcolonial State*, will be published by Oxford University Press. She is on the editorial board of *Interventions: International Journal of Postcolonial Studies* and is currently working on the Indian novel in English 'after Rushdie'.

Susan Rowland is Senior Lecturer in English at the School of Humanities, University of Greenwich. Her principal research is into Jung and modern literary theory and she is the author of *C.G. Jung and Literary Theory: The Challenge from Fiction* (Macmillan, 1999). Working with a particular emphasis on women writers and feminist theory, she aims to reinvent Jung in a postmodern and feminist context. She is currently working on a book on women's crime fiction which will include psychoanalytic studies, to be called *Six Queens of Crime*.

Susan Spearey is an Associate Professor of English Literature at Brock University, Canada. Her research interests include postmodern Gothic, spatiality and geographic consciousness in diaspora writing, historiography and ethics in postcolonial and postmodern literatures, Victorian poetry, prose and novels, and literature of the British Empire. She has published in *Canadian Literature, Journal of Commonwealth Literature* and a number of edited collections of essays. She is currently working on literary responses to the Truth and Reconciliation Commission's hearings and amnesty proceedings as part of a larger, book-length study of displacement and dispossession in terms of geographical location, narrative subject position and human rights.

Ursula Tidd is a lecturer in French in the Department of Modern Languages at the University of Salford. Her principal research interests are Simone de Beau-

voir's literary and philosophical writing, twentieth-century French life writing and gender studies. She is the author of *Simone de Beauvoir, Gender and Testimony* (Cambridge University Press, 1999) and of essays on Beauvoir's autobiography and philosophy forthcoming in *Hypatia: A Journal of Feminist Philosophy* and *Marginal Forms, Marginal Voices: Diaries in European Literature*, eds Russell West and Rachael Langford. She has also published articles on Beauvoir's writing in *Women in French Studies*, *New Readings* and *Simone de Beauvoir Studies*. She is currently preparing an edited book, *Women in Contemporary France*, with Abigail Gregory.

Sue Zlosnik is Associate Dean of Arts and Head of English at Liverpool Hope University College. Together with Avril Horner she has published *Landscapes of Desire: Metaphors in Modern Women's Fiction* (Harvester Wheatsheaf, 1990) and *Daphne du Maurier: Writing, Identity and the Gothic Imagination* (Macmillan, 1998). They are now working on *Dead Funny: Gothic and the Comic Turn*, to be published by Macmillan. In addition to a number of other publications co-authored with Avril Horner she has also written essays and articles on the fiction of George Meredith, on whom she wrote her doctoral thesis.

INTRODUCTION

That bodies matter is axiomatic in current feminist debate. In feminist literary and cultural criticism, 'the body' crops up with such regularity that the overprivileged 'mind' seems to have had its day. However, apart from the near universal rejection of Cartesian mind–body dualism, there is no critical consensus about how and why bodies matter. Indeed, many of the contributors to this collection of essays draw attention to the dangers of reifying an undifferentiated body as a foundation for political identity. Equally, there is some resistance to the dematerialisation of the body, which is symptomatic of the play of differences in postmodern discourse.

The title of this book, *Body Matters: Feminism, Textuality, Corporeality*, immediately signals its engagement with the work of Judith Butler, in particular her *Bodies that Matter: On the Discursive Limits of 'Sex'* (1993). Butler's writings on the links between sexual identity, discursive practice, desire and gender performance as reiterated ritual have been extremely influential since the late 1980s or so. In challenging a common feminist assumption that gender is intricately related to the sexed body, Butler argued in *Gender Trouble: Feminism and the Subversion of Identity* (1990) that gender does not necessarily proceed from biological sex:

> The presumption of a binary gender system implicitly retains the belief in a mimetic relation of gender to sex whereby gender mirrors sex or is otherwise restricted by it. When the constructed status of gender is theorized as radically independent of sex, gender itself becomes a free-floating artifice, with the consequence that *man* and *masculine* might just as easily signify a female body as a male one, and *woman* and *feminine* a male body as easily as a female one. (Butler 1990: 6)

Butler's contribution to the debate on the body is part of a broader attempt to dissolve the gender/culture and nature/sex binary divisions which, as Donna Haraway has demonstrated, were the structuring paradigms of 'a broad liberal reformulation of life and

1

social sciences in the post-Second World War, Western, professional and governing elites' divestment of pre-war renditions of biological racism' (Haraway 1991: 134). Although second-wave feminism critiqued the nature/culture pair on the grounds of its implications for women (who were aligned with nature, while men were identified with the processes of cultural transformation), the sex and gender distinction remained unhistoricised. According to Haraway, by aligning sex with biology, feminists fatally bypassed the cultural history of the body, or misguidedly invoked the female body and nature against the patriarchal 'dominations of history':

> feminists have argued against 'biological determinism' and for 'social constructionism' and in the process have been less powerful in deconstructing how bodies, including sexualized and racialized bodies, appear as objects of knowledge and sites of intervention in 'biology'. Alternatively, feminists have sometimes affirmed the categories of nature and the body as sites of resistance to the dominations of history ... Rather than marking a categorically determined pole, 'nature' or 'woman's body' too easily then means the saving core of reality distinguishable from the social impositions of patriarchy, imperialism, capitalism, racism, history, language. (Haraway 1991: 134–5)

Against these positions, Butler and others argue that since culture is the means by which we name and understand 'sex', then 'sex' itself 'is just as much a cultural construction as gender is presumed to be' (Bristow 1997: 212). In adopting this stance, Butler shows her allegiance to Michel Foucault, whose *History of Sexuality: An Introduction* ([1976] 1990) provocatively situated the body as a socially inscribed surface, a contingent relation in the modern 'incitement to discourse' on sexuality. Like Foucault, Butler moves beyond those social constructionists who see meaning as something simply imposed on the inert body, concurring with his designation of 'materiality', including the materiality of the body, as 'a certain effect of power' (Butler 1993: 34). However, Butler, like other feminist critics, has drawn attention to the limits for feminism of Foucault's conception of the body. In *Bodies that Matter*, for instance, she raises questions about the means by which certain bodies come to matter in Foucault's model of discursive power:

> Insofar as Foucault traces the process of materialization as an investiture of discourse and power, he focuses on that dimension of power that is productive and formative. But we need to ask what constrains the

2

domain of what is materializable, and whether there are modalities of materialization ... To what extent is materialization governed by principles of intelligibility that require and institute a domain of radical unintelligibility that resists materialization altogether or that remains radically dematerialized? Does Foucault's effort to work notions of discourse and materiality through one another fail to account for not only what is excluded from the economies of discursive intelligibility that he describes, but what has to be excluded for those economies to function as self-sustaining systems? (1993: 35)

Following Luce Irigarary, Butler points out that what has to be excluded from 'the economies of discursive intelligibility' is 'the feminine ... the unspeakable condition of figuration, ... that which, in fact, can never be figured within the terms of philosophy proper, but whose exclusion from that propriety is its enabling condition' (37). In Foucault's model of materialisation, the female body is unintelligible.

Elizabeth Grosz puts a different gloss on the problem of Foucault and the female body when, in *Volatile Bodies: Toward a Corporeal Feminism* (1994a), she contests his enigmatic suggestion that 'bodies and pleasures' are not only 'the raw materials on which power works' but 'the sites for possible resistance to the particular form power takes' (1994a: 155). Citing his utopian claim that: 'The rallying point for the counterattack against the deployment of sexuality ought not to be sex-desire, but bodies and pleasures' (Foucault [1976] 1990: 157) she asks:

is it that bodies and pleasures are somehow outside the deployment of sexuality? Or are they neuralgic points within the deployment of sexuality that may be strategically useful in any challenge to the current nexus of desire-knowledge-power? Why are bodies and pleasures a source of subversion in a way that sex and desire are not? Perhaps more important, whose bodies and whose pleasures are to be such a 'rallying-point'? Foucault's implicit answer seems clear, seeing that he rarely discusses female bodies and pleasures, let alone women's sex and desires: in lieu of any specification, one must presume, along with the rest of patriarchal culture, that the neutral body can only be unambiguously filled in by the male body and men's pleasures (1994: 155–6).

A number of essays in this collection share the reservations about Foucault's potential for feminist approaches to the body that Butler and Grosz map out here. Foucault's work remains, however, crucial to our understanding of the discursive production of 'bodies' and 'matter', in particular, the production and proliferation of outlawed sexualities through the mechanisms of juridical prohibition.

Foucault's importance to queer theory, and of queer theory's significance in our understanding of sexuality, is registered by Butler in *Bodies that Matter*. In the context of drawing attention to 'the materiality of the signifier itself' and to the fact that the language we use to analyse sexuality is always historically contingent, she argues that the recent emergence of queer theory – to which her own work is an important contribution – is not as an 'answer' to the question of sexual identity, but a stage in the debate that will, inevitably, be overtaken as discourse itself shifts its ground. Such self-reflexiveness is not to be seen as cynicism or nihilism; rather it should help (in Dianne Chisholm's words) 'to supplement and de-centre the dominant and reductive Hegelian opposition of masculine/feminine, hetero/homo' (Wright 1992: 219). Furthermore, it should open up possibilities for change:

> To problematize the matter of bodies may entail an initial loss of epistemological certainty, but a loss of certainty is not the same as political nihilism. On the contrary, such a loss may well indicate a significant and promising shift in political thinking. This unsettling of 'matter' can be understood as initiating new possibilities, new ways for bodies to matter.
> (Butler 1993: 30)

Bodies that Matter thus sets out to investigate materiality itself and to explore the 'genealogy of its formulation' (Butler 1993: 32); in so doing, it engages critically with the work of Marx, Freud, Foucault, Lacan and Irigaray, amongst others. Butler's work has provoked its own critics, like Seyla Benhabib and Nancy Fraser, who have respectively questioned the implications of her Nietzschean debunking of 'selfhood, agency and autonomy' (Nicholson 1995: 21) in *Gender Trouble* and the grounds of her interrogation of matter in later work.[1] Nevertheless, Butler's arguments have stimulated a much-needed dialogue between Marxists and feminists, humanists and postmodernists, structuralists and poststructuralists, historicists and deconstructionists, and provided a synthesis of debates which situate the body on the boundaries of the physical and the psychoanalytic, the linguistic and the material. The 'body' for Butler is the product of both language and materiality: 'language and materiality are not opposed, for language both is and refers to that which is material, and what is material never fully escapes from the process by which it is signified' (Butler 1993: 68). Butler has thus been a crucial contributor to the debate which has effected a significant paradigmatic shift in our

understanding of the relationship between meaning and matter. The result, as Deborah Lynn Steinberg has pointed out, has been a reconfiguration of the body as 'both matrix and matter of culture' (Steinberg 1996: 226).

In dialogue with critics such as Butler, Elizabeth Grosz has developed her own arguments in an attempt to understand what she describes as 'embodied subjectivity … psychical corporeality' (Grosz 1994: 22). Like Butler, she claims that the material body is inseparable from its various cultural and historical representations and she asserts that such representations and cultural inscriptions 'quite literally constitute bodies and help to produce them as such' (Grosz 1994: x). In exploring the ability of bodies 'to extend the frameworks which attempt to contain them' (Grosz 1994: xi), she focuses on the specificities of the female body and engages with the work of philosophers such as Spinoza, Merleau-Ponty and Deleuze and Guattari. Grosz's essay 'Sexual Signatures: Feminism After the Death of the Author' is particularly pertinent for this volume since, in exploring the link between feminism, corporeality and the nature of textuality, its agenda is similar to that adopted by many of the contributors to this collection. In this essay, Grosz teases out possible answers to the question 'what enables us to describe a text as feminist or feminine?' She notes that feminist literature generally provides four answers to this question: (1) the sex of the author; (2) the content of the text; (3) the sex of the reader; and (4) the style of the text. Noting that these 'answers' are all, in their different ways, problematic, she concludes that:

> There is nonetheless a way of proposing a femininity for texts that takes some elements from each position but also deals with what each leaves out, with what I would call 'discursive positioning', a complex relation between the corporeality of the author, that is, the author's textual residues or traces, the text's materiality, and its effects in marking the bodies of the author and readers, and the corporeality and productivity of readers … The sex of the author has, I would contend, no direct bearing on the political position of the text, just as other facts about the author's private or professional life do not explain the text. Nevertheless, there are ways in which the sexuality and corporeality of the subject leave their traces or marks on the texts produced, just as we in turn must recognise that the processes of textual production also leave their trace or residue on the body of the writer (and readers). This indeed seems the point of Judith Butler's understanding of the 'discursive limits of sex'. (Grosz 1995: 18)

This is precisely the focus of this volume, which, in its analysis of such 'discursive positioning', addresses the relationship between feminism, textuality and corporeality.

The distinctive feature of *Body Matters: Feminism, Textuality, Corporeality*, then, is that it combines attention to, and intervention in, current theoretical debates about the body with sustained analysis of literary texts and other kinds of textual representation of 'the body'. It therefore works at the intersection of theoretically based literary criticism and cultural studies. Each essay and part carries a particular emphasis and focus; the volume as a whole explores the implications of the recent turn to the body as a site of difference in representation and interrogates categories such as the racial body; the sexed body; the gendered body; the consuming body; the productive body; the commodified body. With a valuable degree of methodological self-consciousness, these essays look at representations of the female body in and through a broadly 'post-Enlightenment' historical period (from the late eighteenth century to the present), reading bodies both as contingent, discursive signs and as material sites of ethical responsibility.

By focusing on the last two centuries, we are not suggesting that the body prior to the late eighteenth century has not been a site of enquiry; the current wealth of work on the body in earlier periods, inspired predominantly by Bakhtin and Foucault, demonstrates that this is not the case.[2] However, the eighteenth century has come to be understood – again, largely under the aegis of Michel Foucault – as the period in which the body was first subjected to 'modern' forms of analysis, with the emergence of a number of 'disciplines' and categories of social and cultural description which granted the body discursive centrality whilst making it newly problematic. For instance, nascent theories of political economy initiated the bifurcated concept of the productive/non-productive bodies of capitalism; developments in the study of human physiology explained an infinite range of ills (individual and social) as the symptoms of sympathetic arrangement of the body (Mullan 1988), whilst aesthetic enquiry explained the body's pleasures in similar terms, granting cultural authority to the body which was most sympathetic in its response to aesthetic stimuli (Eagleton 1990). Arguably, the culture of sensibility, which informs each of these categories of explanation, prepared the conceptual ground for marking categories of difference on the body through scientific investigation and simultaneously subjecting those

differences to moral scrutiny. For instance, the 'two-sex' model of the body which emerged from developments in the study of anatomy (Laqueur 1990), and the racial body, which came to be understood as a biological, genetic category under the aegis of physical anthropology, were both eighteenth-century scientific 'discoveries', to which moral characteristics were rapidly attributed in other contexts (Ellis 1996). The predictable consequences for women and people of colour of the rapprochement between scientific and moral classification provoked immediate reactions from late eighteenth- and early nineteenth-century liberal reformers. Reformers' objections to the biological arguments for civic exclusion were grounded on the very claims to identity – class, race and gender – and to common humanity which are the subject of much current feminist and postcolonial critique, as illustrated by essays in this collection by Sara Ahmed, Charmaine Eddy and Rajeswari Sunder Rajan.

This volume, then, examines ways in which textual representations of female bodies can afford a locus for feminist identities and concerns. At the same time, it offers a particular historical and textual focus and a certain self-reflexiveness concerning the narratives carried by both theory and 'history'. Overall the collection points to theoretical concerns that have been crucial for the gender debate in the 1990s, especially in relation to representations of the body. Several essays take issue, in a creative sense, with the work of some of the prominent theorists of 'the body' and illustrate the questions such writings have raised about the way the body is constructed within given discursive formations by applying their insights in the form of concrete textual analysis.

The essays in the collection are arranged to reflect the way in which their authors conceptualise the 'matter' of the body; that is, they are organised in parts which emphasise the primary methodological and political concerns, rather than the textual subject of the essay. There are continuities and debates across as well as within the parts, as contributors engage with the work of a common core of theorists to raise a range of questions about critical practice. The essays in the first part – 'Consumption, production and reproduction' – share an interest in bodies in and as social relations. To this extent, they implicitly contest what might be called Butler's 'formalist materialism': a concept of matter which is rooted in psychoanalytic discourse, rather than the historical and economic apprehension of the material as it is understood in the orthodox Marxist tradition. Rege-

nia Gagnier's essay provides a helpful context in which to understand the often unwritten tensions in approaches to 'the material' in corporeal feminism, when she historicises the shift in emphasis in cultural and literary scholarship, predominantly in the United States, from an 'aesthetics of production' to an 'aesthetics of consumption'. As Gagnier suggests, this shift was initially conceived as a political critique of a masculinist and heterosexist Marxism which valued the labouring body at the expense of the desiring body. That critique, she argues, has become concomitant of consumer society itself: a purely formal understanding of the body which occludes the actual social relations in which people are 'producers and consumers, workers and wanters, sociable and self-interested' (p. 45). Turning from the history of the present, Gagnier's essay goes on to provide an historical epistemology of aesthetic values, focusing on the transition in the 1870s from consumerist to productivist aesthetics. Scott McCracken similarly dispenses with the production/consumption binary which has divided approaches to the social relations of the body. McCracken's reading of Dorothy Richardson's novel *Pilgrimage* focuses on its representation of the worlds of office work and the café as sites for a New Woman's identity: sites where the body expends and replenishes itself. McCracken finds in these spaces in *Pilgrimage* a means to locate an embodied subjectivity which is historicised, material and gendered but which depends neither on the orthodox Marxist category of 'labour' nor the feminist-consumerist attention to sexual desire. Angela Keane and Amanda Gilroy both focus on the 'reproductive' body as it is constituted in contradictory discourses of maternity in the 1790s. While Keane considers the 'matriphobic' content of the decade's debate on population – a debate that provides a context for Mary Wollstonecraft's approach to maternity – Gilroy looks at the premium that was placed on the maternal body in other discourse. Wollstonecraft, Keane argues, adumbrates aspects of the nineteenth-century critique of the alienating effects of capitalism (some of which are rehearsed by Gagnier): while Wollstonecraft 'Romantically' conceives of herself both as a desiring subject and as a (re)productive subject, she recognises the ubiquitous division of the (re)productive body from the desiring body under capitalism. In social practice, the mother is simply a machine. In a related context, Gilroy demonstrates how domestic devotion was recognised as a national, political problem throughout the eighteenth century, and analyses the mechanisms through which women's reproductive

and nurturing powers were harnessed for the British nation and empire.

The essays in the second part – 'Matters of difference: misrecognition and dissymmetries'- follow more closely Butler's approach to materiality. Charmaine Eddy frames her reading of Alice Walker's *The Color Purple* with a critique of identity politics' tacit acceptance of 'the anatomical as the foundation for cultural difference' (p. 97) and its invocation of prediscursive biological markers: 'already sexed and raced bodies' (p. 98). Eddy traces the implications of this reduction of sex or race to sexuate or racial characteristics, and the consequences of the separation of gender from race in critical discourse. Eddy's critique turns on the psychoanalytic concept of misrecognition, in which the body is the screen upon which subjects project and play out their misidentifications. Misrecognition, Eddy argues, reminds us that the body is already "*marked as*" something other in our representational economies' (p. 100). Thus 'marking as' signifies the space between the 'materiality of the body and the materialising of cultural difference' (p. 100): the biological characteristics and the history that makes us see them. Sara Ahmed similarly critiques the tendency of some theorists of the body to invoke race simply as a signifier of difference. Focusing on the social production of 'strangers', Ahmed asks us to recognise 'the function of difference in establishing not only bodily matter, but also which bodies come to matter' (p. 88). Following Butler's definition of 'materialisation' as the production of an 'effect of boundary, fixity and surface' (Butler 1993: 9), Ahmed asks how bodies come to take certain shapes over others and how, in social space, some surfaces provoke different effects from others. In an essay which focuses on the vexed role the body plays in western culture, Elisabeth Bronfen looks at the way in which the 'murky interface between the cultural articulation of an absent human corporeality and the real insistence of bodily presence has proven to be one of the most persistent phantasms of our image repertoire' (p. 109). Like Eddy and Ahmed, Bronfen argues that we need to attempt to 'preserve and explore the difference between the various positions which the body has come to assume in our image repertoire and in our critical discourse, so as to ask ourselves continually why this difference matters' (p. 113). Moreover, in an essay which again critiques the masculinism of Foucault's approach to the discourse of heterosexuality, Ursula Tidd follows Butler in questioning Foucault's romantic reading of *Herculine Barbin, Being the Recently Discovered Memoirs of a Nine-*

teenth-Century French Hermaphrodite. She contests that Foucault, and other male commentators who read the text as a subversion of enforced heterosexuality, miss the condemnation Barbin suffered both as a lesbian and as 'having been a Don Juan in drag' (p. 81). Tidd thus advocates critical attention to the dissymmetry of both Barbin's sexual identity and her/his autobiographical narrative.

Part III – 'Memory and mourning: narratives of violation' – again brings together essays that explore historically and culturally diverse representations of the body. These essays share an interest in the social practices that violate women's bodies and the ethics of forms of representation and critical analysis, which risk repeating that violation. In an essay that considers fictional and non-fictional prostitution narratives, Vivien Jones explores the ethical and political gap between the prostitute as a discursive sign and the prostitute as 'suffering individual'. In an analysis of both the contemporary feminist debate on prostitution and eighteenth-century 'histories' of sex workers, Jones explores the 'possibilities for a self-conscious double vision which negotiates eighteenth-century evidence in terms of current feminist preoccupations' in order to avoid the production of the 'prostitute' as a monolithic and marginalised category in feminist debate (p. 130). Rajeswari Sunder Rajan raises similar problems for postcolonial criticism, in an essay which considers the resonance in contemporary India of the story of Drapaudi's disrobing (an episode of the ancient Sanskrit epic of the *Mahabharatha*). Rajan takes two approaches to the text to show how the 'uses of tradition' in postcolonial societies may be understood: first, she reads the story in the context of the ubiquitous phenomenon of 'eve-teasing' in contemporary Indian metropolitan society; secondly, she subjects appropriations of Draupadi as a proto-feminist cultural heroine to 'materialist' critique ('material' here signifying the institutional violations against women in Indian society). You-me Park wishes 'to honour the memories' of picture brides: women who 'crossed oceans to become brides to fulfil promises that their pictures gave away to unknown men' (p. 159) – and who continue to do so. Park shares Jones's and Rajan's interest in the 'yearnings and desires' of objectified women, implied in the ways these women are remembered and in the 'narratives elided, remoulded, and silenced' in our act of retelling (p. 160). The process of 'ethical' memory, of acknowledging 'that which has been excluded or repressed from the here-and-now in the process of rendering the present both comprehensible and habitable' (p. 171) is the subtext of

Susan Spearey's reading of Toni Morrison's *Beloved*. Following Butler and Derrida on the relationship between the corporeal and the spectral, Spearey provides a conceptual framework in which to understand Morrison's attempt to move beyond contesting the history of slavery to 'new strategies for understanding identity, history and agency' (p. 173): strategies which include a spectral apprehension of the body in history.

The fourth part – 'Re-viewing bodies in fiction' – focuses explicitly on the significance of corporeal feminism for literary debate and for the re-evaluation of women's writing. The essays in this part reassess the work of three twentieth-century women writers and contest prevailing critical discourses on their respective subjects: H.D., whose work has been read primarily in the light of Ezra Pound's definition of the *Imagiste*; Daphne du Maurier, or more particularly du Maurier's Rebecca, who for some time has been represented in the framework of class-based criticism; and Elizabeth Bowen, whose popularity and literary reputation went into decline after her death in 1973, and whose work has been dismissed on the basis of its formal contrivance. Each of these essays 're-evaluates' the significance of the writer by focusing on her work in relation to theoretical debates about corporeality in the construction of female subjectivity. Rachel Connor foregrounds 'the contemporaneity of H.D.'s thinking about gender difference' and reconfigures the visual aspect of her work in the light of Irigaray's notion of the '"specul(aris)ation" of western theoretical discourse' (pp. 199–200). Avril Horner and Sue Zlosnik retrieve the textual Gothic ancestry of Daphne du Maurier's *Rebecca* and of du Maurier's authorial status, in order to realign the current critical emphasis on the class dynamics of the text and the author's life. In a reading that uncovers Rebecca's 'uneasy status' as fleshly vamp and uncanny vampire, Horner and Zlosnik lay bare a 'cultural ambivalence towards the sexually expressive and autonomous woman' (p. 220). Clare Hanson unlocks new aspects of Elizabeth Bowen's fiction by drawing on Deleuze and Guattari's concept of the 'Body without Organs', a body which exceeds its 'assigned (Oedipal) subjectivity' (pp. 185–6) . Hanson reassesses Bowen's fictions as explorations of 'the potential of the body on the plane of immanence', or in Deleuze and Guattari's terms, the 'relations of movement and rest between molecules or particles, capacities to affect and be affected' (Deleuze and Guattari [1980] 1988: 261).

The final part – 'Spirits, mystics and transcendents' – continues

the collection's critique of Cartesian mind–body dualism by considering texts which conceptualise its collapse: in the 'sensible transendence' of Charlotte Brontë's *Villette*; in the 'imaginal bodies' of Margaret Atwood's *Alias Grace*; and in the 'a/theology' of Hélène Cixous's *Le Livre de Promethea*. Sue Chaplin's reading of *Villette* foregrounds 'the operation of female spiritual forces' in Brontë's novel. This operation approximates Luce Irigaray's notion of 'sensible transcendence' (p. 225): a conceptualisation of an embodied symbolic order that embraces flesh and spirit, mystery and matter, femininity and masculinity. Chaplin reads *Villette* as an attempt 'to free the masculinist conception of materiality "from its metaphysical lodgings" (Butler 1993:30)' (p. 232). The text as Chaplin reads it thus anticipates and is illuminated by contemporary feminist critique of western philosophy. Similarly, Susan Rowland draws attention to the self-conscious collapse of cultural and theoretical categories in Margaret Atwood's *Alias Grace*, a novel which investigates 'bodily dislocation and spectralisation sedimenting around the genesis of Jungian theory' (p. 244), in particular nineteenth-century spiritualism. Rowland's essay, first, incorporates an explication of poststructuralist critique of Jungian theory, drawing attention to the implications of the concepts of 'imaginal bodies' and the 'anima' for contemporary approaches to feminine corporeality; and, secondly, reads Atwood's novel as a deconstruction of binary systems which 'pinion and (mis)represent the feminine' (p. 244). Val Gough's essay foregrounds the turn to mystical or spiritual discourse in postmodernism's search for new ways of thinking about alterity, a new discourse which 'takes account of the radical deconstruction of the subject, yet remains insistent upon the bodily dimension' (p. 234). Gough finds in Hélène Cixous's novel *Le Livre de Promethea* a successful deployment of one such discourse: the medieval female mystic's desire for Christ's body, reworked by Cixous to convey the power of lesbian desire. Gough claims that the novel collapses distinctions between textuality and the body and argues – *contra* Lacan – for the knowability of the subversive bodily experience. These essays, like many others in the collection, argue for a continuum between the fictional texts and the theoretical texts that inform the readings.

In contemporary feminist theory, at least, women's bodies are no longer the degraded half of Cartesian dualism. Attention to the history and to the cultural processes (particularly here the textual processes) that constitute corporeality allows us to critique, re-evaluate and

transform women's relations to their own and others' bodies. But reconceptualising the body is only part of the process of transformation. Without the context of institutional practice, the reconceived body remains an ideal phenomenon. When they are confined to the formal realm of textual practice, bodies may matter but they exert no material force. The challenge for 'corporeal feminism' is not simply to reconceptualise matter, but to transform the social relations of lived bodies.

<div style="text-align: right">

Avril Horner and Angela Keane
Salford, 1998

</div>

Notes

1 See Benhabib 1995 and Fraser 1998, who asks for a closer alliance on the left between what she sees as the ahistoricism of Butler's 'politics of recognition' and the orthodox Marxist 'politics of redistribution' (149).
2 See for instance: Bahktin 1968, Beckwith 1993, Bynum 1992, Kay and Rubin 1994, Laqueur 1990, Sawday 1995, Stallybrass and White 1986.

References

Bakhtin, M. (1968) *Rabelais and His World*, trans. Helene Iswolsky, Cambridge, Mass., MIT Press.

Beckwith, S. (1993) *Christ's Body: Identity, Culture and Society in Late Medieval Writings*, London, Routledge.

Benhabib, S. (1995) 'Feminism and Postmodernism', in L. Nicholson (ed.), *Feminist Contentions: A Philosophical Exchange*, London and New York, Routledge.

Bristow, J. (1997) *Sexuality*, London and New York, Routledge.

Butler, J. (1990) *Gender Trouble: Feminism and the Subversion of Identity*, London and New York, Routledge.

—— (1993) *Bodies that Matter: On the Discursive Limits of 'Sex'*, London and New York, Routledge.

Bynum, C.W. (1992) *Fragmentation and Redemption: Essays on Gender and the Human Body*, New York, Zone Books.

Deleuze, G. and F. Guattari ([1980] 1988) *A Thousand Plateaus: Capitalism and Schizophrenia, Vol. 2*, trans. Brian Massumi, London, Athlone Press.

Eagleton, T. (1990) *The Ideology of the Aesthetic*, Oxford, Blackwell.

Ellis, M. (1996) *The Politics of Sensibility: Race, Gender and Commerce in the Sentimental Novel*, Cambridge, Cambridge University Press.

Foucault, M. ([1976] 1990), *The History of Sexuality. Vol. 1. An Introduction*, trans. Robert Hurley, Harmondsworth, Penguin.

Fraser, N. (1998), 'Heterosexism, Misrecognition and Capitalism: A Response to Judith Butler', *New Left Review*, 228, 140–9.

Grosz, E. (1994) *Volatile Bodies: Toward a Corporeal Feminism*, Bloomington and Indianapolis, Indiana University Press.

—— (1995) *Space, Time, and Perversion: Essays on the Politics of Bodies*, London and New York, Routledge.

Haraway, D.J. (1991) '"Gender" for a Marxist Dictionary', in *Simians, Cyborgs, and Women: The Reinvention of Nature*, London and New York, Routledge.

Kay, S. and M. Rubin (eds) (1994) *Framing Medieval Bodies*, Manchester, Manchester University Press.

Laqueur, T. (1990) *Making Sex: Body and Gender from the Greeks to Freud*, Cambridge, Mass., Harvard University Press.

Mullan, J. (1988) *Sentiment and Sociability: The Language of Feeling in the Eighteenth Century*, Oxford, Clarendon Press.

Nicholson, L. (ed.) (1995) *Feminist Contentions: A Philosophical Exchange*, London and New York, Routledge.

Sawday, J. (1995) *The Body Emblazoned: Dissection and the Human Body in Renaissance Culture*, London and New York, Routledge.

Stallybrass, P. and A. White (1986) *The Poetics and Politics of Transgression*, London, Methuen.

Steinberg, D.L. (1996) 'Cultural Regimes of the Body: An Introduction', *Women: A Cultural Review*, 7 (3), 225–8.

Wright, E. (ed.) (1992) *Feminism and Psychoanalysis: A Critical Dictionary*, Oxford, Blackwell.

part one

CONSUMPTION, PRODUCTION AND REPRODUCTION

1

'CANDID ADVICE TO THE FAIR SEX':
or, the politics of maternity
in late eighteenth-century Britain

AMANDA GILROY

During the later 1790s conservative commentators like the Rev. T.J. Mathias and the Rev. Richard Polwhele were turned wild by 'unsex'd females' – Mary Wollstonecraft and her followers – who indulged in 'Gallic freaks' and despised 'NATURE'S law'.[1] Though she advocates the rights of women in claiming female authority over childbirth at a time when this was fast becoming a masculinised domain,[2] midwife Martha Mears's antenatal advice book, *The Pupil of Nature; or, Candid Advice to the Fair Sex* (1797), aligns her with those conservative models of femininity paradigmatically represented by Hannah More in Polwhele's poem 'The Unsex'd Females'. Speaking only as a mother to other mothers in the transparent language of the heart (2–3), Mears disclaims any interest in the unfeminine topic of public politics (a 'subject … quite out of my sphere' (157)). However, as feminists of the 1970s loudly proclaimed, the personal *is* political, and Mears contributes to the late eighteenth-century concern with 'the proper management' of mothers and children on which depended, as William Buchan puts it, 'the safety and prosperity of the state' ([1769] 1800: 36). In this essay, I will examine Mears's moralised project of body management and suggest that it accrues particular patriotic resonances in the context of the political anxieties and vulnerabilities of post-French-Revolutionary Britain. Finally, I will relate her work to some novelistic renderings of the disciplining of maternal agency.

If Mears's antenatal advice functions as a historically specific technology of gender, the maternal body nevertheless always bears the weight of inherited cultural baggage, and a brief consideration of recent work on the cultural discourses of eighteenth-century mater-

nity is in order. Toni Bowers's important book *The Politics of Motherhood* (1996) demonstrates that the late eighteenth-century ideal of the private, nurturing, domestic mother was engendered by earlier struggles over maternal agency and authority. Bowers traces the increasing distance between maternal and public authority to the reign of Queen Anne, arguing that Anne's literal maternity, and its conspicuous failure (her five children were dead by the time she was thirty-five, and she suffered at least thirteen miscarriages or stillbirths (Bowers 1996: 48)), frustrated her attempts to claim the symbolic maternal authority wielded by Queen Elizabeth. Moreover, Anne's reign was dominated by Britain's involvement in the War of the Spanish Succession and the ailing queen was always at a distance from this important arena of political events. Thus, Anne was 'unintentially complicit' in the construction of a plot of maternal failure that helped to control maternity's threat to patrilineal inheritance structures. Similarly, representations of 'unnatural' maternal behaviour, such as abandonment and infanticide in Defoe's *Moll Flanders* and *Roxana*, helped to codify a particular version of 'natural' middle-class motherhood by which the virtuous Augustan mother was sequestered from the public world.

Ruth Perry argues that eighteenth-century English 'motherhood was a colonial form – the domestic, familial counterpart to land enclosure at home and imperialism abroad' (1992: 185). Female fertility was conceived of as a national resource, and around mid-century women became the objects of an extensive print culture: maternal devotion was celebrated in poetry and prose, while medical men and moralists guided women in how to act, how to feel, and how to care for their children. Directed mostly to the women themselves, this literature differs from earlier advice produced for medical practitioners, including midwives. In a backlash against wet-nursing, maternal breast-feeding became the symbol of maternal virtue, domestic economy and national responsibility, so that 'By the end of the eighteenth century this bodily service came to be constructed as part of all women's unpaid reproductive labor' (Perry 1992: 197). Like Perry, Felicity Nussbaum examines the ways in which reproductive politics was informed by the political and economic demands of imperialism. Women's reproductive labour was regulated and harnessed to the task of providing bodies for trade and colonisation, and women's maternal function was validated by scientific discourse: 'representations of wombs in medical texts of the period become bigger and

those of heads become smaller as the reproductive capacity of woman overshadows her ability to do intellectual labour' (Nussbaum 1995: 48). The 'ideologies of maternal affection' purveyed in mid-century pediatric manuals helped to recruit women 'to a domesticity associated with the national destiny' (Nussbaum 1995: 24). 'Perverse' mothers, again, paradigmatically, Defoe's Roxana, threaten this cultural edifice, and 'The crisis of authority over England's mothers is sometimes deflected onto … the territories outside the mother country' (Nussbaum 1995: 48), and frequently onto the figure of the exotic, 'other' woman, so that ideologies of imperialism alienate women from each other in racial as well as in class terms (the middle-class mother is pitted against the lower-class prostitute, for example). What Nussbaum notes again and again is the imbrication of the exotic and the domestic – for example, in Samuel Richardson's novel *Pamela* (1740), Mr B's threats of philandering, or 'polygamy', in order to prevent Pamela's breast-feeding, expose the power prerogatives of patriarchy and colonialism, both of which take place over female bodies.

As Nussbaum and Bowers demonstrate, discourses of the natural and the unnatural help to produce and police the boundaries of bourgeois motherhood, and Mears continues to privilege motherhood in essentially middle-class, male terms. Indeed, Mears's treatise represents a post-revolutionary extension, or distension, of that eighteenth-century failure of maternal authority so illuminatingly discussed by Bowers. In ways that Mathias and Polwhele would no doubt have found quite reassuring, Mears counters anxieties about 'unsex'd females', that is, gender-transgressive women, masculine or licentious, given over to the excesses of all things French, with her extended picture of what one might call 'sexed females', properly feminine women, pregnant not political, who will consume advice designated for 'the chaste eye[s]' (7) of her 'fair countrywomen' (2). Thus, maternity, which is explicitly de-eroticised, brings woman 'nearer to the perfection of her being' (4). Mears's maternal pupils are instructed simply to follow nature, for Nature will teach 'her darling object, woman' (5) 'to do what is right and avoid what is dangerous or improper' (1). In advocating this guide, Mears follows not only Rousseauvian thought (and her Popean epigraph)[3] but also the contemporary medical valorisations of women's 'nature' as maternal and domestic: in his influential *Essay on Nursing*, which was adopted as the medical guidelines of the London Foundling Hospital and which went through at least eleven editions in English and French in the fifty

years after its first publication in 1748 (Perry 1992: 198), William Cadogan claims that 'If we follow Nature instead of leading or driving it, we cannot err' (1748: 3). Importantly, in Mears's text, social propriety is equated with corporeal safety, while any disregard for nature's law has dangerous bodily effects: social impropriety is written on the maternal body.

Mears presents herself as 'the humble handmaid of nature' (2), her advice necessary because an acute state of femininity needs proper restraints. The pregnant woman appears as a figure of 'exquisite sensibility', subject to the 'feverish effects' of her 'awakened' nerves (15). Mears devotes a chapter to outlining 'rules for the management of the temper and passions' (41) that will 'enable them [pregnant women] to acquire a habit of serenity' (33). The most dangerous emotion is anger, which rends the delicate female nervous system and imperils the life of mother and child. It is figured in terms of hysterical 'symptoms': 'The mouth is covered with foam … the voice is choked, or emitted in hoarse and thundering bursts … the features are writhed in convulsive agony' (30; see also 15). Such behaviour is castigated as 'unnatural' to women, who are defined as such by their 'sweet manners, and mild address' (31). Moreover, asserts Mears, 'Let beauty also know, that the ravages of the small pox are far less destructive than those of anger' (31). The bodily self-discipline that Mears promotes would have been familiar to readers of women's novels of the period: in Sarah Scott's *The History of Sir George Ellison* (1766), the second Mrs Ellison, Scott's model of virtuous motherhood, rejoices when her daughter's unruly body/spirit is disciplined by smallpox; in Burney's almost contemporaneous *Camilla* (1796), Eugenia learns self-discipline through disfigurement. Mears's readers can avoid such disfigurement if they only 'yield … to the soft controul of tenderness and reason' exercised by their husband or father (32). Women are advised that 'the best state of mind they can be in at the time of labour' – and at all other times, the book implies – 'is that of submission to the necessities of their situation' (124).

Earlier midwifery literature had similarly prescribed the correct conduct for pregnant women, especially the suppression of emotions that might deprave or deform the infant. Though Mears retains this concern, she shifts the emphasis from the unborn infant to the management of the female body. This management takes place within the parameters of the new-style sentimental family, that is, it is rational, tender, non-coercive, but perhaps thereby even more compelling than

older-style patriarchal prerogatives. As in the many conduct books of the period, women are educated so that they become self-regulating. In order to induce female 'serenity', Mears produces a whole set of practical 'rules concerning diet, air, exercise, and the passions' which structure the experience of time, space and embodiment for her readers. Bodily 'composure' (92) is attained through unremitting attention to diet: Mears recommends that women indulge in their 'natural relish for vegetables, fruit, and every thing cooling' (50), as well as jellies and broths. She prohibits 'hot, stimulating liquids', and says that pregnant women should avoid animal food (134). During pregnancy and after delivery, 'a low regimen' will be the 'best preservative' (134) of health, guarding against fevers and inflammations. The feminine 'restraint' Mears advocates is always construed as natural: 'the chief restraint we wish to impose is that prescribed by nature – the restraint of temperance and sobriety' (51). Should this dietary regime fail to prevent the body from becoming 'disordered' (76), because of its 'natural disposition to fulness' (70), Mears documents a supplementary programme of emetics and 'gentle palliatives' designed to secure and control bodily evacuations. In addition, pregnant women should follow a programme of 'agreeable exercise' (walking or riding in an open carriage (71)), and avoid the enervating effects of 'luxury' and 'indolence' (70), following rather the 'simple nature' that regulates the (idealised) life of rural labouring women. The rest of their time is devoted to other aspects of domestic economy, especially the pursuit of cleanliness (see 42–3), which was regarded during the 1790s as something of a female 'patriotic' duty, which Mary Wollstonecraft, for example, thought regrettably neglected by French women ([1792] 1994: 66).[4]

Mears also offers sartorial advice for the health and comfort of pregnant women: like other writers of the period, she inveighs against stays, and hopes that 'no pregnant lady will ever again be mad enough to put on … that gothic coat of mail, to cramp and torture nature, when her operations should be most easy and unconfined' (17). A woman who follows the dictates of 'common sense' and rationality will not be tempted 'to put herself and her child into a whalebone press or to totter about on stilts [that is, high-heeled shoes], at the risk of the most alarming injuries' (71). This combination of rationality and bodily liberation would make Mears sound like a disciple of Wollstonecraft, were it not for the fact that while the literal corsets are cast off, the mind-forged manacles remain. Her whole

programme is designed to corset women. Indeed, as Mears would have known, tight lacing was blamed for damaging women's nipples and causing problems in breast-feeding, a subject to which William Moss gives much attention in his *Essay on the Management, Nursing, and Diseases of Children* ([1781] 1794), so that she is implicitly preparing her reader for maternal breast-feeding and underlining the 'naturalness' of a domestic arrangement that restricts the mother's scope of activity to the care of her child. Moreover, her soft maternal bodies fit the non-corseted, Greco-Roman dress-style adopted in the last years of the century, a look which emphasised female vulnerability.

Mears situates maternal breast-feeding, in her penultimate chapter, as the culmination of her regimen and the supreme sign of maternal commitment, as, of course, do many other writers of the period. While she gives some practical guidance on breast care, including information on breast pumps for mothers with nursing difficulties (141–2), her comments are characteristically sentimental and moralistic. Mears declares that 'nature' makes the mother's 'health and happiness, and very often her life dependent on the discharge of this most sacred of all duties' (139): only anger (30) and abortion (111) can send a woman as precipitously to the grave as an unnatural refusal to nurse her own child. William Buchan in his influential *Advice to Mothers* similarly asserts 'that a mother, who is not prevented by any particular weakness or disease from discharging that duty, cannot neglect it without material injury to her constitution' (Buchan 1803: 99). Maternal health is thus dependent on the performance of a particular activity, but as the rhetoric of 'duty' in both Buchan and Mears makes clear, what is really at stake is a commitment to a specific form of domesticity. Even if a wetnurse has to be employed, she, too, must 'be induced to make some little sacrifices for the well-being of the infant' (154). The benefits of breast-feeding are almost unlimited, moral as much as physical: 'nothing else can so effectually promote her recovery from childbed, the future establishment of good health, the exquisite sense of wedded joys, the capacity of bearing more children, and the certainty of receiving from them the most endearing returns of affection' (140).[5] Mears offers a final, clinching, colonial 'persuasive' (140) if health, reproductive capacity and domestic bliss should prove insufficient inducements to maternal nursing:

The wives of American savages extend this mark of solicitude even to infants who die upon the breast. After having bestowed upon them the

rights of sepulture, they come once a day, for several weeks, and press from the nipple a few drops of milk upon the grave of the departed suckling! (140–1)

According to this narrative, breast-feeding is the essentialist bedrock of maternal identity; even the least 'civilised' women recognise their maternal duty. This story, Mears claims, will make an 'impression on the feeling heart' (140), while, by implication, those unfeeling mothers who fail to nurse appear unnatural, uncivilised, and perversely un-English in comparison with the savage mother.

The desired result of the gentle coercion that is directed throughout the book to the processes of bodily activity is the production of what Foucault calls 'docile bodies' (1979: 138). Thus, Mears's programme offers to deliver the happiness promised by Sarah Pennington, for example, in maternal advice to her daughters, to women of 'docile tempers' ([1761] 1995: 64). Similarly, Hannah More in her *Strictures on the Modern System of Female Education* (1799) argues that 'An early habitual restraint is peculiarly important to the future character and happiness of women', for 'A girl who has docility will seldom be found to want understanding sufficient for all the purposes of a useful, a happy, and a pious life' (More 1996: 162, 163). The woman's mind and body are rendered submissive to domestic ideology through the colonisation of domestic space. As Mears puts it, the mother who 'suckles her child', the paradigmatic maternal activity, 'will listen to me with docility' (154). *The Pupil of Nature* is thus a good example of 'the physiological colonization of women's bodies' which corresponds 'to the psychological colonization of women's subjectivity in both companionate marriage and motherhood' (Perry 1992: 194). Though Mears's explicit agenda is female health, her preoccupation with middle-class female sensibility produces a perversely debilitated figure of languishing, attentuated maternity. In contrast to her own vision of the productive post-partum days of rural labouring women, Mears confines her middle-class patient 'to the horizontal posture for at least four or five days' after delivery, 'however hearty she may appear, or think herself'; for the following two weeks, 'she should always be placed in a reclining attitude on a sofa'; by the end of the month she may be able to venture so far as to stroll in the garden (132).

Mears's concern with the production of docile maternal bodies correlates with broader social anxieties in the later 1790s. William St

Clair has documented the relation between national/economic anxieties and anxieties about gender by graphing the fluctuations in the price of government stocks along with the publication figures for advice books for women. His graph shows how after the early 1790s 'the advice book curve rises as the gilts curve falls' (St Clair 1989: 509), with particularly high and low points in the years 1795–1800, which would seem to correlate with the anti-Jacobin panic during these years. Published in 1797, Mears's book appeared in the year in which England twice mobilised its troops against a possible French invasion, and in which the *Anti-Jacobin Review* was founded. Since conservative commentators thought that the indelicate, unfeminine behaviour of French women contributed to the French Revolution, they were acutely concerned during these years to place suitable restraints on British femininity in terms of female conduct, and more broadly to limit women's role in the cultural life of the nation. The conservative moralist Hannah More, for instance, writes of the dangers of cultivating female imagination rather than reason, and she uses imagery which suggests a horror of prolific motherhood to critique the proliferation of women's novels which threaten to overrun and destroy society. By implication, the 'fecundity' (More 1996: 170) of the female body and imagination must be kept in check. Indeed, William Buchan in his phenomenally popular *Domestic Medicine* (1769, into its seventeenth edition by 1800) deemed the 'force' of the maternal 'imagination' to be 'epidemical' (Buchan [1769] 1800: 114). If childbearing women were a national and natural resource, they had to be rationally managed in the interests of productivity, and of a domestic ideology that kept women in the home. What Mears calls 'a moral intention in nature' further serves national interests by 'preserv[ing] an equilibrium in the population of nations' (105), through a transglobal gestation period ('which would have been deranged, had the pregnancy of women [like that of animals] been of shorter duration in hot countries than in cold' (105)), and by the production of more men in northern countries and more women in the south. Mears thus assuages contemporary anxieties about the excesses of the female body and imagination and about overpopulation: nature, medicine and masculinity operate together to check possible 'derang[ements]'.

Writing in a revolutionary era, Mears occludes any sense of the contemporary political scene (apart from a stray reference to Thomas Paine's *Age of Reason*, which she has seen advertised but has not read

(157)); instead, she adheres to the politics of counter-revolution, what moralist John Bennett called 'a revolution in the sentiments and conduct of [the female] sex', the product of which was a new 'maternal culture' (Bennett 1787: 95–6). Bennett presents maternity as a controlled domestic spectacle, for the domestic woman appears to best advantage in the nursery, where her husband and the reader find her simultaneously 'holding forth the moral page for the instruction of one [infant], and pouring out the milk of health to invigorate the frame and constitution of another' (Bennett 1787: 95–6). Mears is no longer dependent on paternal surveillance,[6] for her women readers internalise the tenets of domestic ideology, and simply follow (their) nature. While Polwhele's 'unsex'd females' 'Sport, in full view, the meretricious [clearly unmaternal] breast' (Jones 1990: 187), Mears's ladies are breast-feeding in the nursery.

Mears's advice functions within a broader trend whereby the potentially revolutionary energy of the female body is disciplined in the interest of national consensus in the aftermath of the French Revolution.[7] Her work is continuous with other conservative writings on maternity in the 1790s, especially conduct books and novels. As Jane Spencer has shown, 'the revolutionary potential for maternal authority which Mary Wollstonecraft had outlined [in *The Wrongs of Woman*]' was quickly 'submerged' (1992: 210). Wollstonecraft's Maria advises her absent daughter to think and act for herself; she does not offer moral, maternal advice but presents her story as an example of patriarchal oppression in order to help her daughter avoid similar victimisation. Importantly, she 'dare[s] to break through all restraint to provide for your [her daughter's] happiness' (Wollstonecraft [1798] 1976: 124). While novels by Charlotte Smith (*The Young Philosopher*, 1798) and Mary Hays (*The Victim of Prejudice*, 1799) explore Wollstonecraft's radical model of maternal authority, many other novels promote restraint of various sorts, as they negotiate with the perceived risks of women's reading habits, especially their reading of novels. Like Mears, who asks 'her own sex … [to] grant a candid hearing to one who is herself a mother' (2), Jane West emphasised her maternal role in addressing 'the inexperienced part of her own sex' (quoted in Spencer 1992: 203). The heroine of *The Advantages of Education* (1793) learns to curb her natural desires, her 'impetuosity', by following her mother's prudent advice: 'That philosophy which I wish my readers to possess', claims West's narrator, 'is constantly occupied in assimulating [*sic*] our desires to our situations' (quoted in Spencer

1992: 204). The dangers of progressive parenting are represented in Amelia Opie's *Adeline Mowbray: The Mother and Daughter* (1804), in which Adeline's mother neglects her childrearing duties because her attention is absorbed by the American Revolution; as a result, she fails to suppress the disastrous influence of Glenmurray's radical philosophising on her daughter, especially her rejection of the institution of marriage. Just as Mears turns away from politics, so does Opie show how politics impedes proper maternal authority. My final example of the conservative impulse to regulate maternal authority is Maria Edgeworth's *Belinda* (1801): against the maternal, domestic ideal offered by Lady Anne Percival, Lady Delacour is represented as an 'unnatural' mother. Following the dictates of fashionable sentiment, Lady Delacour nurses her second child herself, but because she 'became heartily sick of the business' (Edgeworth [1801] 1994: 42) her child dies. Her failure to *feel* appropriately maternal, rather than only affectedly so, is marked in the disfigurement of her body, in the festering wound to her unnourishing breast. This mutilation is miraculously cured when she accedes to male medical control and is recuperated into domesticity, the restored breast symbolising her acceptance of sentimental maternity. Through the experience of bodily disfigurement Lady Delacour learns to submit to a conservative regime of maternal behaviour, which entails a further disciplining of the body as she must repress all the gender-transgressing desires exhibited in her energetic adventures with Harriot Freke.

Martha Mears's *Pupil of Nature*, like Edgeworth's *Belinda*, functions as a technology of motherhood: in disciplining the maternal body and behaviour it actually depletes maternal agency. In the wake of widespread anxieties about gender in revolution and counter-revolution, Mears reproduces the soft female body of sensibility which requires an education in sentimental medicine, the type of education castigated by Mary Wollstonecraft whereby the mind ultimately shapes itself to the body. Thus, Mears's political anatomy of the maternal body represents not just female bodies in need of restraint but minds oppressed. However, in detailing the regimen of maternal behaviour, Mears also clearly exposes the apparatus of domestic ideology. Given the continuing preoccupation with the significance of motherhood in western culture, it is worth remembering that maternal 'instincts' were made, not born.

Notes

1 Mathias claimed that 'Our *unsexed* female writers now instruct, or confuse, us and themselves in the labyrinth of politicks, or turn us wild with Gallic frenzy' (Mathias 1798: 238); Polwhele, 'The Unsex'd Females: A Poem' (1798), quotations from 1.20 and 1.12 (Jones 1990: 186).
2 For a detailed discussion of obstetric practices in the 1790s, see Jones (1997).
3 Mears's epigraph to the book is 'Take Nature's Path, and mad Opinions leave' (*Essay On Man*, 'Epistle IV, 1.29').
4 Contemporary medical advice generally advocated 'a proper regimen' of diet and conduct, etc. in the treatment of diseases (Buchan [1769] 1800: x) – Mears makes such advice gender specific.
5 Mears's acknowledgement that 'the act itself is attended with a sweet thrilling, and delightful sensations' (140) might be seen as a momentary return of the repressed, a reference to the 'pleasured', maternal body that Angela Keane, in her essay in this collection, argues is absent from Foucault's account of sexuality.
6 On paternal surveillance, see also Cadogan (1748: 25).
7 See Nicola Watson's (1994) account of the gradual disciplining of first-person epistolary forms (associated with the feminine and the insurgent) by third-person historical narratives which ratified the patriarchal authority of family and state at the end of the eighteenth century.

References

Bennett, J. (1787) *Strictures on Female Education: Chiefly as it Relates to the Culture of the Heart, in Four Essays*, London, Printed for the Author and sold by T. Cadell, etc.

Bowers, T. (1996) *The Politics of Motherhood: British Writing and Culture, 1680-1760*, Cambridge, Cambridge University Press.

Buchan, W. ([1769] 1800) *Domestic Medicine: or, A Treatise on the Prevention and Cure of Diseases by Regimen and Simple Medicines*, 17th edn, London, A. Strahan.

—— (1803) *Advice to Mothers, on the Subject of Their Own Health, and on the Means of Promoting the Health, Strength, and Beauty, of Their Offspring*, London.

Cadogan, W. (1748) *An Essay Upon Nursing, and the Management of Children, from Their Birth to Three Years of Age*, London.

Edgeworth, M. ([1801] 1994) *Belinda*, ed. Kathryn J. Kirkpatrick, Oxford and New York, Oxford University Press.

Foucault, M. (1979) *Discipline and Punish: The Birth of the Prison*, trans. A. Sheridan, New York, Vintage Books.

Jones, V. (1990) *Women in the Eighteenth Century: Constructions of Femininity*, London and New York, Routledge.

—— (1997) 'The Death of Mary Wollstonecraft', *British Journal for Eighteenth-Century Studies*, 20, 187–205.

Mathias, T.J. (1798) *The Pursuits of Literature. A Satirical Poem. In Four Dialogues. With Notes*, 7th edn, rev., London, T. Becket.

Mears, M. (1797) *The Pupil of Nature; or, Candid Advice to the Fair Sex*, Printed for the

Authoress, and sold at her house, no. 12, Red Lion Square, and by Faulder, New Bond-Street, and Murray and Highly, Fleet-Street.

More, H. (1996) *Selected Writings of Hannah More*, ed. Robert Hole, London, Pickering and Chatto.

Moss, W. ([1781] 1794) *An Essay on the Management, Nursing, and Diseases of Children*, London, W.N. Longman.

Nussbaum, F. (1995) *Torrid Zones: Maternity, Sexuality, and Empire in Eighteenth-Century English Narratives*, Baltimore and London, Johns Hopkins University Press.

Pennington, S. ([1761] 1995) *An Unfortunate Mother's Advice to Her Absent Daughters*, in *The Young Lady's Pocket Library, or Parental Monitor* [1790], intro. V. Jones, Bristol, Thoemmes Press.

Perry, R. (1992) 'Colonizing the Breast: Sexuality and Maternity in Eighteenth-Century England', *Eighteenth-Century Life*, 16, 185–213.

St Clair, W. (1989) *The Godwins and the Shelleys*, London and Boston, Faber and Faber.

Spencer, J. (1992) '"Of Use to Her Daughter": Maternal Authority and Early Women Novelists', in D. Spender (ed.), *Living by the Pen: Early British Women Writers*, New York and London, Teachers College Press, Columbia University.

Watson, N.J. (1994) *Revolution and the Form of the English Novel, 1790–1825*, Oxford, Clarendon Press.

Wollstonecraft, M. ([1792] 1994) *A Vindication of the Rights of Woman*, in J. Todd (ed.), *Political Writings*, Oxford, Oxford University Press.

—— ([1798] 1976) *The Wrongs of Woman*, ed. Gary Kelly, Oxford, Oxford University Press.

2

MARY WOLLSTONECRAFT'S IMPERIOUS SYMPATHIES:
population, maternity and Romantic individualism

ANGELA KEANE

> Through the political economy of population there was formed a whole grid of observations regarding sex. There emerged the analysis of the modes of sexual conduct, their determinations and their effects, at the boundary line of the biological and economic domains. There also appeared those systematic campaigns which, going beyond the traditional means – moral and religious exhortations, fiscal measures – tried to transform the sexual conduct of couples into a concerted economic and political behavior. (Foucault [1976] 1990: 25)

Michel Foucault's familiar account of the series of 'interventions and regulatory controls' which constituted the emergence of a 'biopolitics of the population' in the eighteenth century exemplifies both the power and the limits of the Foucauldian approach to the matter of bodies. Foucault cogently conceptualises the deployment of sexuality for the production of docile, disciplined bodies, a deployment which he argues, enigmatically, can be countered by pleasured bodies. Feminists such as Judith Butler (1993) and Elizabeth Grosz (1994) have drawn attention to the way in which the disciplined and pleasured bodies of Foucault's account are oddly neuter, a neutrality which 'can only be unambiguously filled in by the male body and men's pleasures' (Grosz 1994: 156). As Judith Butler suggests, the general exclusion of femininity in Foucault's account is inevitable, for he inherits, even as he resists, a philosophical tradition in which the feminine is the 'constitutive outside' of body and soul, matter and meaning. The feminine, the female body, is no more than the 'specular effect' which confirms phallogocentric autogenesis (Butler 1993: 35–6).

This essay takes its cue from Foucault and his feminist critics, and seeks to recover a body that is missing from this account of population discourse: the body of the mother. This body is absent from Foucault's analysis because she is assumed to be part of the monogamous, heterosexual couple which constitutes the norm of biopolitical production, escapes its most vigilant surveillance and consequently falls outside of Foucault's political interest. Foucault thus oddly repeats the logic of population discourse itself, in so far as the maternal body is excluded from the domain of its power, constituting power's object not its subject. I want to demonstrate the force of this exclusion by focusing on the work of a woman who two centuries ago tried and failed to resist the objectification of the maternal body in contemporary political economy: Mary Wollstonecraft.

Wollstonecraft was an early critic of modern 'biopolitics', as she recognised and contested the means by which capitalism alienated men from women and women's minds from their bodies, and valued those bodies as machines or as property, reproducer or commodity. However, like other early criticism of capitalism, including those of contemporary radicals such as Godwin and Romantics like Wordsworth, Wollstonecraft's critique was based on a mind–body dualism. This foundation meant that she could only reproduce the logic of the system which she sought to eradicate. Her liberal philosophical inheritance, and her Christianity, meant that she conceptualised the body as separate from and subordinate to reason (that which in the Lockean tradition constitutes the subject as a right-bearing individual) and to the imagination (which in the emerging Romantic tradition was the sign of divine intelligence made human). In this order of things, maternal *re*production is a low form of creation, the simple production of matter. The social value of that matter depends not on its relation to the mother-machine who bears it, but on its cultural inscription (the child is a *tabula rasa*) or its realisation of divine gifts (creative genius). With this matrix as her philosophical foundation, Wollstonecraft could only ask for women to be recognised as reasonable beings with the potential for higher genius and that they be endowed with the rights of subjects despite, not because of, their reproductive capacity.

As well as providing a fuller account of this idealising tendency in Wollstonecraft's work, and its implicit legacy for later generations of feminists who are still struggling with the politics of reproduction, this essay seeks to revise a prevailing critical myth about her attitude

towards the maternal body. Recent feminists who, like Foucault, have been attentive to the subject of sexual pleasure, but have focused on the pleasures of the female body, have indicted Wollstonecraft for privileging the 'bourgeois mother' as the model of femininity. Cora Kaplan (1986), for instance, arrived at this conclusion in her powerful analysis of Wollstonecraft's denial of the pleasured body, in particular the sexual body of the lower-class woman, in her essay 'Wild Nights: Pleasure/Sexuality/Feminism'. A more recent approach by Rajani Sudan (1996) comes to a similar conclusion via a different route, citing Wollstonecraft's investment in a patriotic discourse of maternal productivity as evidence of her implicit imperialism. Although these essays provide valuable insights into the complicity of liberal feminism with discourses of class and racial oppression, they miss the ambivalence in Wollstonecraft's attitude towards the maternal body, not least her own maternal body. It is to that ambivalence, and its grounding in population discourse of the 1790s, that I want to turn.

In the 1790s, social and political theorists in Britain and France turned with particularly anxious attention to the apparently growing and mobile populations of European nations. The theories which sought to give meaning to this numerical expansion and social and geographic movement of bodies bear out Foucault's account of the regulative effect of population discourse. The renowned 'exchange' between Condorcet, Godwin and Malthus in particular was inflected by fantasies of restrained and profligate sexual practice, by disciplined and desiring bodies. Condorcet's *Sketch for a Historical Picture of the Progress of the Human Mind* and Godwin's *Enquiry Concerning Political Justice* both outline rational schemes for social improvement, and envisage the triumph of will over the body; a triumph which would, in a utopian future, make humanity's desires commensurate with their rational needs, and eradicate the present causes of human suffering, including the most recalcitrant reminders of the body's presence: disease and death. Malthus's *Essay on Population*, which was published in 1798 and famously reversed the long-standing association between population increase and national well-being, characterises a more intransigent body. He labelled Godwin and Condorcet's utopian visions as little more than displaced religion:

> Both these gentlemen have rejected the light of human religion, which to the ablest intellects in all ages, has indicated the future existence of the

> soul. Yet so congenial is the idea of immortality to the mind of man that
> they cannot consent entirely to throw it out of their systems. (Malthus
> 1986: 1, 86)

Mortality and disease, along with moral imperatives like marriage, are the natural check to population growth, balancing resources with the numbers of those to be resourced. Both of these 'systems' assume a mind–body duality, as the rationalists claim the triumph of the will over the body, and Malthus asserts the dominant force of sexual passion and appetite. And in both, the reproductive body of the woman is figured as an object always in need of vigilance, to be checked naturally by famine, socially by marriage, or by the force of reason which renders sexual passion and its fruits unnecessary (Gallagher 1987; Jacobus 1995). The interests served by these essays are those of bodies and minds which are implicitly male.

Wollstonecraft's writings of the 1790s consistently pursue the agenda which she initiated in 1792 with *A Vindication of the Rights of Woman* (Wollstonecraft 1989: 5): to write women into the class-based account of social inequalities which was being mapped out by her fellow radicals, including Godwin. Her method of social analysis was to measure the degree of civilisation in society by its treatment of women, and to this extent she was following the example of stadial social and economic theory. In much of Wollstonecraft's commentary on the effects of social inequality she finds that women, the most abused, are the first to reach the level of the brute, the first to lose their powers of reflection, the most alienated from their labours and from their bodies. She finds that dependence is the root of corruption, and that consequently women of all classes are the most corrupt.

Wollstonecraft measured her theoretical insights against empirical evidence, when, during journeys to France and Scandanavia in the 1790s, she observed the national differences in women's social status. Wollstonecraft travelled first to France, going there at the end of 1792, in flight from a failed affair with Henry Fuseli. She was, of course, following her political conscience too. With the support of her publisher Johnson, she would write *An Historical and Moral View of the Origins and Progress of the French Revolution*, first published in 1794 (Wollstonecraft 1989: 6).

In this somewhat digressive narrative, Wollstonecraft sought to situate the revolution in a broad historical trajectory, and hence write off its failures as the symptoms of deterministic laws of social

progress. She brought various laws to bear as she struggled to absolve the revolutionary agents from blame for violence, and to project an optimistic long-term outcome. Thus, she invokes a rationalist belief in human perfectibility, resisting arguments for the necessity of inequality, and argues that the progress of reason will gradually improve social relations; almost simultaneously, she evokes a primitivist indictment of the depraved trajectory of civilisation. The unwieldy nature of these dialectical explanations meant that Wollstonecraft would not get much beyond the origins, or at least the events of the early months, of the revolution. However, a significant part of her diagnosis of the revolution's failure is her indictment of commercial culture, which she often describes using analogies of sexual degradation and in terms of its impact on the status of women. Referring frequently to the debased tastes of the French court, she also implicates the bourgeoisie, for whom trade in female bodies – be it prostitution or marriage – is just another kind of business: business demands a trade in female bodies. This critique is haunted by a proto-Malthusian pessimism about the potential of reason to transform social relations. The barbarity of commercial culture, and the violent turn of the revolution, she suggests, are a sign of humanity's 'biological' intransigence, and, as though citing some new-found rule of nature, Wollstonecraft punctuates her narrative with the maxim that reason progresses more slowly than passion: 'the strongest conviction of reason cannot quickly change a habit of body; much less the manners that have been gradually produced by certain modes of thinking and acting' (Wollstonecraft 1989: 6, 53).

Wollstonecraft is alert to the drives of appetite and passion which exceed a rational regime, and to the intractable power of the body, which, for women, more often leads to destruction than to glory. It is this conviction which underpins some of Wollstonecraft's most repressive statements about sensual pleasures, such as the attacks on promiscuity, physical inertia, 'luxury', over-refined or excessive eating, which so trouble later generations living with the legacy of early feminist puritanism. In her *Vindication of the Rights of Woman*, for instance, she used a commonplace association between luxury and female infertility:

> Luxury has often introduced a refinement in eating, that destroys the constitution ... The depravity of the appetite which brings the sexes together, has had a still more fatal effect. Nature must ever be the standard of taste, the gauge of appetite – yet how grossly is nature insulted by the volup-

tuary … Women becoming … weaker, in mind and body, than they ought to be, were one of the grand ends of their being taken into the account, that of bearing and nursing children, have not sufficient strength to discharge the first duty of a mother. (Wollstonecraft 1989: 5, 207–8)

Wollstonecraft is certainly unable or unwilling to countenance non-productive sexual pleasure as a form of satisfaction (and certainly not as sustenance) for women. Here is the censorious voice noted by Kaplan and which seems to make the case for bourgeois domesticity and maternity: but it comes in the context of an attack on a culture which consumes more than it reproduces, and weakens the social body in the process. However, the disciplined body which is the corollary of these attacks is not the neatly reproductive maternal body, fulfilling its duty as the woman-machine of capitalism, for Wollstonecraft indicts that body too. The barely disguised contempt for 'child-begetters', part of the 'common herd of eaters and drinkers' of whom she wrote several years later in a letter to Gilbert Imlay, suffuses her work (Wollstonecraft 1989: 6, 41). Unpalatable as it is, this contempt is to be understood not simply as an attack on female pleasure, but as part of a gendered contribution to nascent political economy, and as a proto-Romantic response to the tyranny of matter: a tyranny which is particularly imprisoning for women.

The critique of Wollstonecraft as an advocate of the restriction of female sexuality to productive maternity, then, tells only a partial story. Frequently, bourgeois motherhood is figured as a fly-trap, the inevitable but fatal destiny for women like Wollstonecraft. At one point in the *Vindication*, Wollstonecraft acknowledges her inability to think outside of the discourse of marital if not maternal female subjectivity. In what could be read as either a pious plea for women to be prepared for an afterlife, or a demand for the single woman's right to survive in this one, she complains: 'How are women to exist in a state where there is to be neither marrying nor giving in marriage, we are not told' (Wollstonecraft 1989: 5, 102). As a woman undoubtedly struggling to register her own consciousness and that of other women, to seek out happiness as well as survival, she is alert to the fragile border between plenitude and deprivation, delight and abjection: a border marked most strongly in the maternal body itself, that productive object of the power of sex.

This is a case she makes most vociferously in her later writing from Scandinavia: a perspective which may be overdetermined by her own predicament during her time there. Having fled to France to

escape Fuseli, Wollstonecraft met Gilbert Imlay, an American entrepreneur. In the course of their relationship she became pregnant and when he left France on business she found herself abandoned. Despite their estrangement, or because of it, she agreed to act as his agent for a business deal in Scandanavia. There are two sets of published letters from this period: *Letters Written During a Short Residence in Sweden, Denmark and Norway* (abbreviated here to the *Scandinavian Letters*) and her private *Letters to Imlay* (Wollstonecraft 1989: 6). The former amount to both a reprimand to her erstwhile lover Imlay for involving himself in business to the detriment of their relationship, and a gendered critique of Smithian free enterprise, as she extends her criticism to the opportunistic traders who thrive on the wartime black market and to the commercial men of Scandanavia who neglect their domestic responsibilities in favour of the pursuit of business. Characteristically, she notes in these letters how the women in Denmark with whom she is forced to socialise have been degraded by their subservient status. They are, she writes 'simply notable housewives, without accomplishments, or any of the charms that adorn more advanced social life' (Wollstonecraft 1989: 6, 321). If the status – and consequently the behaviour – of a nation's women is an index of its state of civilisation, then commercial society in Denmark is yielding retrograde effects. Danish bourgeois women may be reasonable domestic economists (able to 'save something in their kitchens') but they are rendered by maternity the 'slaves of infants, enfeebling both body and mind' (Wollstonecraft 1989: 6, 321). In her letters to Imlay, she figures herself at times like the Scandinavian bourgeois mother, enslaved to the tyrant child. When she asks for him to take part in her upbringing she uses language she expects him to understand: 'My little one … wants you to bear your part in the nursing business, for I am fatigued with dancing with her, and yet she is not satisfied' (Wollstonecraft 1989: 6, 394). Her playful conflation of private and public business, metaphors of debt and satisfaction, turns to bitter invective as Imlay proves impervious to her persuasions. In one of many letters which claims (probably unnecessarily) to put an end to their relationship, she argues for the right of possession of their child. Hers, she writes, have been the greater labours, hers the higher, more committed investment:

> Considering the care and anxiety a woman must have about her child before it comes into the world, it seems to me, by a natural right, to

belong to her. When men get immersed in the world, they seem to lose all sensations, excepting those necessary to continue or produce life! – Are these the privileges of reason? Amongst the feathered race, whilst the hen keeps the young warm, her mate stays by to cheer her; but it is sufficient for man to condescend to get a child, in order to claim it. (Wollstonecraft 1989: 6, 377)

Throughout these letters, she threatens to make herself independent, to divest herself of 'want', to pursue her 'own project' and to give up the hope of 'being necessary' to him (Wollstonecraft 1989: 5, 395). Again, these threats are evidently superfluous, as Imlay does not appear to contest them.

In these letters, the Malthusian strain overwhelms the Godwinian optimism. However, whilst she anticipates Malthus in his inducements to sexual and reproductive restraint, she directs her arguments away from the line which he was to take in favour of women's sexual and economic dependence. Wollstonecraft argues instead for women's access to a life of the mind; a life which can only be achieved when they are liberated from their bodies. It is capitalism, she suggests, which keeps them tethered, a point which she reiterates in sketches of women impoverished by excessive sexual and economic spending, producing too many children with too little to support them. She attacks a society in which men are encouraged to 'spend' more than they can afford, where women are not equipped to control their sexual and financial economies but are frequently left to pick up the bill of caring for children inside and outside marriage. In Scandanavia, for instance, she is moved by the sight of a young woman whose predicament struck a chord with her own. Working as a wet-nurse, the woman earned twelve dollars a year, and paid out ten 'for the nursing of her own child; the father had run away to get clear of the expence [sic]'. This 'most painful state of widowhood' demonstrates 'the instability of the most flattering plans of happiness', none more flattering nor unstable than domestic security (Wollstonecraft 1989: 6, 283).

What often appear, then, to be morally conservative calls for the regulation of domestic and national economies through the control of female sexuality and social miscibility, inducements to companionate, adequately resourced domesticity, are also portraits of women already made miserable through marriage or motherhood, and for whom middle-class domesticity yields as much risk as profit. For instance, in her *Vindication*, she counters Rousseau's portrait of

woman 'formed to please and be subjected to man' by imagining this woman widowed and responsible for a large family: 'encumbered with children, how is she to obtain another protector – a husband to supply the place of reason? ... She either falls an easy prey to some mean fortune-hunter, who defrauds her children of their parental inheritance, and renders her miserable; or becomes the victim of dis-content and blind indulgence' (Wollstonecraft 1989: 5, 117). Sketched in defence of a rational education and economic independence for women, this portrait of the 'mother ... lost in the coquette' tells of the downward mobility of the maternal body, and anticipates the destiny of those 'pretty creatures', childless young women circulating in the marriage market. Valued most for their reproductive potential, they are lost to fortune the moment they embrace motherhood, or mother-hood embraces them.

Descriptions of the infertile rich, of the idle, fertile, 'voluptuous' women unfit for maternal duty, the degraded state of the abandoned or widowed mother and of unsustainable children, are cumulative evidence against a culture which has devalued the maternal body, fears its power of reproduction and is unable to reconcile women's needs with the resources provided by men, be they material, emo-tional or psychic. In this respect Wollstonecraft reproduces the matri-phobic content of contemporary population discourse, its dreadful fantasy of woman's prolific reproductive potential, which is barely containable by companionate marriage. In a single passage in the *Scandanavian Letters*, for instance, her perfectibilist optimism ('The increasing population of the earth must necessarily tend to its improvement') gives way to anxiety for a world in which increase of supplies is outstripped by the geometrical increase of bodies; a popu-lation which has not been 'checked' by the Godwinian will of reason:

> I anticipated the future improvement of the world, and observed how much man had still to do, to obtain of the earth all it could yield. I even carried my speculations so far as to advance a million or two years to the moment when the earth would perhaps be so perfectly cultivated, and so completely peopled, as to render it necessary to inhabit every spot; yes, these bleak shores. Imagination went still further, and pictured the state of man when the earth could no longer support him. Where was he to fly to from universal famine? ... I really became distressed for these fellow creatures, yet unborn. The images fastened on me, and the world appeared a vast prison. (Wollstonecraft 1989: 6, 294–5)

Wollstonecraft's distress for 'these fellow creatures, yet unborn' is

underscored perhaps by the more immediate spectre of children abandoned by fathers, and mothers imprisoned by insufficient resources. However, another reproductive economy controls this passage too: the economy of Wollstonecraft's productive imagination and its powers of generation. Like the maternal body, this is figured here pathologically, beyond the control of reason. She is unable to stop her speculations, to stem her fantasies of reproduction, and thus peoples the earth beyond its capacity to provide; her imaginary children 'fasten' on and overwhelm her, and she mourns them before they are born. This over-fertile imagination is perhaps the Gothic, feminine underside of a masculine model of Romantic creativity: a model to which Wollstonecraft undoubtedly aspires in her pursuit of independence from her body and from other bodies, but which she can never quite achieve, or at least conceptualise. As she notes in a letter which describes the fatigue and melancholy she experiences on her travels: 'My imagination has never yet severed me from my griefs – and my mind has seldom been so free as to allow my body to be delicate' (Wollstonecraft 1989: 6, 310). By 'delicacy' here, Wollstonecraft implies lightness not fragility: her present frame of mind weighs down her body.

The imaginative transcendence which eludes Wollstonecraft is underpinned by the sublime aesthetic which, for her Romantic contemporaries, provided a fantasy of autogenesis, which not only negates the need for other people (minds and bodies) but demands their elimination from the imagined scene, until matter becomes a figment of the mind's eye. Its operations are epitomised in Wordsworth's solitary contemplations of the scene of nature in 'Tintern Abbey', in which the poet's imagination empties out the land, eventually eliminating all matter. As Frances Ferguson has argued so cogently, this Romantic dematerialisation is a fantasy retreat from the pressure of other bodies and other minds, symptomatic both of the perception of population growth and urban crowding and of demands in the 1790s for political franchise from those who had not previously 'counted' (1992).

Wollstonecraft certainly seems to desire this state of transcendence, but never records Wordsworthian moments of epiphany. The closest she comes to idealistic release from the body is to a state of solitude: that is, a release from the demands of other bodies. She records such a moment in a letter from Scandinavia, when, recalling a night spent looking out on to the sea and the rocks of the shoreline,

she writes 'I was alone'. However, solitude lasts for only one clause of a sentence: 'I was alone till some involuntary sympathetic emotion, like the attraction of adhesion, made me feel that I was still a part of a mighty whole, from which I could not sever myself' (Wollstonecraft 1989: 6, 249). Wollstonecraft's attachment to the mighty whole is figured here less as a choice than as a corporeal compulsion. It is a discursive compulsion, symptomatic of the fact that Wollstonecraft's conception of the imagination is still grounded in eighteenth-century sentimentalism. In sentimental discourse, the imagination functions as an extension of the body, closely related to the concept of sympathy. Its operation is always figured therefore as a material relation: a relation to the vibrations of the body, responding to other things, other bodies exerting the pressure of other wills. It is precisely this sense of interrelation which overwhelms Wollstonecraft and leaves her feeling body-bound. In the scene to which I have just referred it is significantly the sight of her sleeping child which prompts the train of thought which follows and which takes her from solitude to connection: from the 'rosy cheek I had just kissed' to 'the idea of home', to 'the state of society'. As she sheds a tear on her daughter's face she is lost for an explanation of this pull towards community and asks 'What are these imperious sympathies?' (Wollstonecraft 1989: 6, 249).

That Wollstonecraft's sympathies produce tears is a sign of the abjection which she associates with her body, a body which is here explicitly maternal. If at times Wollstonecraft exhibits no more than a rational indifference to the demands of her body (especially, as Vivien Jones (1997) has noted, the demands of her pregnant body), at other moments she rails at the power it exerts over her, a power which she identifies as sympathy. Imagination and sympathy were of course central to Adam Smith's explanation, and vindication, of the mechanisms of the market-place; far from engaging in the cut-throat competition which dominated Hobbesian versions of the social world, Smith's commercial world, he argued, is regulated by the benign operations of sympathy, a correspondence of like minds. The aspirational, upwardly mobile entrepreneur is driven by a desire to emulate the successes of his 'correspondents' and the sign of true sympathetic connection, of the operation of imagination, is social and economic success.

For Wollstonecraft, imagination in the service of capitalism is degraded and libidinous, bound to the body. As she writes in her 1793 *Letter on the Present Character of the French Nation*, imagination is an

artful coquette 'who lures us forward, and makes us run over a rough road, pushing aside every obstacle merely to catch a disappointment'. To disrupt the cycle of commercial economy, imagination should be subdued by reason, for the 'wants of reason are very few' and, 'were we to consider dispassionately the real value of things, we should probably rest satisfied with the simple gratification of our physical necessities, and be content with negative goodness' (Wollstonecraft 1989: 6, 444).

Wollstonecraft's fantasy of a pared-down economy, a world where we consider 'the real value of things' ungilded by imagination, is apparently attainable in the northern reaches of Scandinavia, where, she is told, there are communities which are untouched by the debauch of commerce. Descriptions of these places carry her back to 'the fables of the golden age: independence and virtue; affluence without vice; cultivation of mind, without depravity of heart'. Oddly she stops herself from journeying to these utopian spaces on the grounds that she is 'hurrie[d] … forward to seek an asylum in such a retreat' by that wanton 'imagination': a guide which she cannot trust. She feels herself obliged to follow reason, figured as a kind of reality principle, as it 'drags [her] back, whispering that the world is still the world, and man the same compound of weakness and folly, who must occasionally excite love and disgust, admiration and contempt' (Wollstonecraft 1989: 6, 308–9). Her own need to live by reason is subordinate, then, to the responsibility she feels to live in an unreasonable world.

The world soon shows its Janus face to Wollstonecraft when she is forced to make an unplanned stop at an inn in Quistram. There she meets a concourse of people from a neighbourhood fair, a group who excite disgust and contempt more than love and admiration. Amidst 'clouds of tobacco', fumes of brandy, 'a rude tumult of the sense', she fails to find a bed, or 'even a quiet corner … – all was lost in noise, riot, confusion' (Wollstonecraft 1989: 6, 313). Like Wordsworth in Bartholomew Fair, she fails to see signs of her own humanity in these 'stupid, obstina[te] … half alive beings, who seem to have been made by Prometheus, when the fire he stole from Heaven was so exhausted, that he could only spare a spark to give life, not animation, to the inert clay' (Wollstonecraft 1989: 6, 314). Here is the Romantic Wollstonecraft, figuring herself as the index of full humanity, able to distinguish herself from mere sensual beings. She possesses that genius which, she wrote to Imlay, is 'the foundation of taste, and of that

exquisite relish for the beauties of nature, of which the common herd of eaters and drinkers and child-begetters, certainly have no idea' (Wollstonecraft 1989: 6, 41).

Like other Romantics, Wollstonecraft is desiring and unsatisfied, wishing to empty the world through the power of imagination, and longing to live according to the wants of reason. That she fails to do so is a symptom of an imagination which is grounded in the body, a body which is an object of a materialistic culture. Wollstonecraft doubles the 'exclusion' of the feminine in population discourse when she retreats to metaphysics, and what we now call Romantic individualism, in order to bypass the unintelligible condition of the maternal body in capitalist culture. Her perspective on other mothers is marked by her inability to reconcile fallen female sexuality and wasted reproduction with her Enlightenment vision of a rational species. She can make her own maternal body intelligible not as matter but as an outward, if lesser, sign of her higher consciousness. In her happiest moments, she describes her reproductive capacity as an extension of her Promethean creativity, evidenced in numerous references to her first child Fanny as a small, dancing child, a matterless 'sprite'. In more conventionally Christian terms, she suggests that the body is no more than a case for her soul: 'I feel a conviction that we have some perfectible principle in our present vestment, which will not be destroyed just as we begin to be sensible of improvement; and I care not what habit it next puts on, sure that it will be wisely formed to suit a higher state of existence' (Wollstonecraft 1989: 6, 279).

Undoubtedly, Wollstonecraft's nascent feminism is stymied by the mind–body binarism which is the subject of much contemporary feminist critique. However, she offers a powerful cultural critique of the material effects of capitalism on women, which could be paraphrased as the rejoinder she issues to Imlay: 'You would render mothers unnatural and there would be no such thing as a father' (Wollstonecraft 1989: 6, 435). When she tries to resist the distorted premium commerce places on the wants of the body, and indeed the demands of love which is 'a want of the heart', she resorts to idealism, or at least, gropes towards it, bound as she is by the 'imperious sympathies' of her own maternal body. Freedom from that melancholy weight is achieved only at the expense of the body itself, as Wollstonecraft repeats the matriphobia of her male contemporaries, figuring the body as abject and alienated.

Wollstonecraft's matriphobic legacy may be undergoing revision

under the aegis of postmodern 'corporeal' feminism, and its drive to collapse mind–body dualism, to grant subjectivity to matter. Still, while the philosophical ground is being prepared, the redistribution of resources which would mean that women can afford maternity, and can experience the pleasures, and pains, of the maternal body continuously with other forms of subject performance, is a slow and uneven process. If Wollstonecraft's melancholy reflections have any historical value, it is surely that her descendants should continue to attend to both the material and ideal constituents of women's subjectivity, so that our social sympathies are less 'imperious' than radically transformative.

References

Butler, J. (1993) *Bodies That Matter: On the Discursive Limits of 'Sex'*, London, Routledge.

Ferguson, F. (1992) *Solitude and the Sublime: Romanticism and the Aesthetics of Individuation*, London, Routledge.

Foucault, M. ([1976] 1990) *The History of Sexuality. Vol. 1: An Introduction*, Harmondsworth, Penguin.

Gallagher, C. (1987) 'The Body Versus the Social Body in the Works of Thomas Malthus and Henry Mayhew', in C. Gallagher and T. Laqueur (eds), *The Making of the Modern Body: Sexuality and Society in the Nineteenth Century*, Berkeley, University of California Press.

Grosz, E. (1994) *Volatile Bodies: Toward a Corporeal Feminism*, Bloomington, Indiana University Press.

Jacobus, M. (1995) *First Things: The Maternal Imaginary in Literature, Art, and Psychoanalysis*, London, Routledge.

Jones, V. (1997) 'The Death of Mary Wollstonecraft,' *British Journal for Eighteenth-Century Studies*, 20 (2), 187–205.

Kaplan, C. (1986) *Sea Changes: Culture and Feminism*, London, Verso.

Malthus, T.R. (1986) *The Works of Thomas Robert Malthus. Vol. 1. An Essay on the Principle of Population, as it Affects the Future Improvement of Society. With Remarks on the Speculations of Mr. Godwin, M. Condorcet, and Other Writers*, eds E. A. Wrigley and D. Souden, Pickering Masters Series, 8 vols, London, Pickering.

Sudan, R. (1996) 'Mothering and National Identity in the Works of Mary Wollstonecraft', in Alan Richardson and Sonia Hopkosh (eds), *Romanticism, Race, and Imperial Culture, 1780–1834*, Bloomington, Indiana University Press.

Wollstonecraft, M. (1989) *The Works of Mary Wollstonecraft*, eds J. Todd and M. Butler, 7 vols, London, Pickering.

3

PRODUCTIVE, REPRODUCTIVE AND CONSUMING BODIES

in Victorian aesthetic models

REGENIA GAGNIER

In a recent article entitled 'The Economies of Taste' the British Wilde scholar and cultural theorist Ian Small labelled a school of critics distinctively 'American' (Small 1996). In contradistinction to the British tendency to emphasise production and producers, these critics had brought to the fore the institutions of the market-place, the commodification of culture and artists, consumerism, and the psychology of desire for the goods and services of modernity. Small used my *Idylls of the Marketplace* (Gagnier 1986) and my more recent work on the histories of economics and aesthetics (Gagnier 1993, 1995), but he might have used any number of recent studies of commodification, largely but not exclusively from the US: Andrew Miller's book *Novels Behind Glass* (1995); Anne McClintock's work on commodity racism (1995); Rita Felski's on feminine modernity as the erotics and aesthetics of the commodity (1995); Kathy Psomiades's work on how the duality of femininity permitted Aestheticism both to acknowledge and to repress art's status as commodity (1997); and Laurel Brake's work on the periodicals market (1994). Writing on Wilde, Richard Dellamora has recently used Bataille to talk about 'nonproductive expenditure' (1995). In *The Ruling Passion* (1995) Christopher Lane has focused on exchange as a motive for empire, which would be nothing new except that he means exchange of sexual desire among men rather than goods. Talia Schaffer has shown how the respective commodifications of 'interior design' versus 'home decoration' in the *fin de siècle* were gendered (1995). And so forth.

Now it is not surprising that this emphasis on markets, commodification and consumption is more prominent in US scholarship

43

than in British. As early as the 1840s John Stuart Mill, Marx and other observers of the spirit of capitalism anticipated that the United States would go further than Europe in the unrestrained pursuit of markets, and it is a commonplace of political economy that US consumer capitalism had advanced on British industrial capitalism by the end of the nineteenth century. And Small is right to point out that there has been a shift in emphasis in US scholarship away from an aesthetics of production to an aesthetics of consumption. This shift is evidently reconfiguring Victorian studies as a whole, once dominated by figures of industrial revolution and increasingly dominated by figures of speculation, finance, circulation, exchange and desire in all its modern forms. This drift has entailed a new focus on the late Victorian period. If gender, sexuality and postcolonial studies have revitalised the whole field of Victorian studies, they have arguably shone most brilliantly as they have converged with commodity theory on the *fin de siècle*.

One of the developments of the 1980s that is continuing through the 1990s was what might be called neoliberal scholarship – scholarship that takes for granted that society is about individuals maximising their self-interest and scholarship that is in itself individualist, sensational or pleasure-seeking, and expressly commodified. The political critique driving this scholarship identified productivism with masculinist Marxism or heterosexism, charging that male leftists had blamed a decline in working-class consciousness on a feminine desire to consume and imitate the decadent leisure class, which betrayal led to universal commodification and massification (Steedman 1987; Fox 1994; Felski 1995). The feminist, gay, and multicultural response to this masculine leftism was in defence of desire, especially the desire of the forgotten peoples of modernity for the goods and services of the world (including sexual goods and services). In my view this defence of desire is as justified as the earlier Marxist defence of the value of labour. Yet some of the more sensational recent work on what Guy Debord called the society of the spectacle suggests to me that the emphasis on desire has become less a criticism of the limits of productivism (as in early Baudrillard) or reproduction than the concomitant of neoliberal, or consumer, society itself.

Theoretically, the gender implications of the shift from production to consumption are unstable and potentially volatile. It may be that Marxism and other productivist analytics valued labour at the expense of desire; but inseparable from the centrality of labour was

the centrality of the labouring body in social relations. Even if we were to grant a positive role to women-as-consumers rather than reproducers in the liberation of desire, late Victorian consumerism in the form of the economics of desire – theorised in marginal utility theory – is precisely known for its formalism and abstraction, qualities that have historically been associated with masculine, abstract, individualism. This means that no gender absolutes can be derived from the shift from production to consumption. It is because neoliberalism, or consumer-driven market policy, is purely formal that it has been able to crow about growth and efficiency while occluding actual social relations. Arguments like Lawrence Birken's (1988), that whereas the labour theory of value made work and property necessary to citizenship, modern mass consumption liberates all alike, are what I mean by neoliberal criticism.

Now surely a criticism that occludes human labour and creativity is as reductive as that which sees people as mere producers and reproducers. Surely people are *both* producers and consumers, workers and wanters, sociable and self-interested, vulnerable to pain but desirous of pleasure, longing for security but also taking pleasure in competition. If we add to these continuums the fact that people may also be idle, apathetic and unconscious of their motivations, we approach something like the grid of possibilities in modern market society. That is, people do not only identify themselves by what they consume, what they do in their leisure, what constitutes their pleasure, or conversely, what they do not do, or do not have, in relation to others. They also identify themselves by whether they make nails, automobiles, books, contracts, breakfast, hotel beds, music, babies or speeches. We are born of labour and desire.

The so-called Decadents themselves expressed this range of emotions evoked by modern market society. As early as 1863, Baudelaire had reacted, via his figure of the dandy, against a bourgeois ethos of productivity and domestic reproduction, rejecting masculine virility itself: 'the more a man cultivates the arts, the less often he gets an erection' (Baudelaire 1966: 28–9). Attacking the socialist-feminist George Sand, he wrote 'Only the brute gets really good erections. Fucking is the lyricism of the masses' (Baudelaire 1986: 175–210, 213). He himself went on to explore the more voyeuristic (consumptive) pleasures of the *flâneur*. The dandy Barbey formulated the choices to Huysmans between renunciation of worldly goods or total, self-destructive consumption: after *A Rebours* he could only choose between 'the foot of

the cross or the muzzle of a pistol'. *A Rebours* itself proclaimed a weariness of production – Des Esseintes gave himself 'a funeral banquet in memory of [his own] virility' – and set himself to consuming the exotica of the world (Huysmans 1982: 27). George Moore's hero, Mike Fletcher, in the novel of that name treated women like cigarettes, consuming and disposing of them in an insatiable search for stimulation:

> More than ever did he seek women, urged by a nervous erithism which he could not explain or control. Married women and young girls came to him from drawing-rooms, actresses from theatres, shopgirls from the streets, and though seemingly all were as unimportant and accidental as the cigarettes he smoked, each was a drop in the ocean of the immense ennui accumulating in his soul. (Moore 1977: 261)

Oscar Wilde's description of a cigarette also described the perfect commodity: cigarettes, Wilde said, were the perfect type of the perfect pleasure, because they left one unsatisfied (Wilde 1978: 228). The *fin de siècle's* basic stances toward the economy – boredom with production but love of comfort, insatiable desire for new sensation, and fear of falling behind the competition – culminated in Max Beerbohm's publication of his *Complete Works* at the age of 24. 'I shall write no more,' he wrote in the Preface of 1896, 'Already I feel myself to be a trifle outmoded. I belong to the Beardsley period. Younger men, with months of activity before them ... have pressed forward since then. *Cedo junioribus*' (1896: n.p.). Beerbohm satirised the duality of aestheticising/commodifying one's life in *Zuleika Dobson* (1911), in the double images of dandy and female superstar. Real women, like Mrs (Mary Eliza) Haweis in her *Beautiful Houses* (1881), on the other hand, were packaging the world in moments of taste and connoisseurship and commodifying them for suburban effects. Indeed in political economy it is the comfort of the suburban home, comfort increasingly – or illusorily – accessible to common folks, that won for consumption its status as the essence of modernity (Taylor 1996).

I could easily multiply examples of late Victorian self-awareness of a shift from production to consumption. But now I want to situate these basic stances toward the economy – boredom with production but love of comfort, fear of falling behind the competition, insatiable desire for new sensation, and so forth – in relation to moments in the history of aesthetics and cultural critique. The remainder of this essay will be concerned with some aesthetic epistemologies that we find in

nineteenth-century Britain in relation to production and consumption and their correspondingly imagined bodies. The approach will be pragmatic, to see what these aesthetics *did*. Ethical aesthetics arose with industrialism and was concerned with the creation of self-regulating subjects and autonomous works; aesthetics of production were concerned with producers or creators of work; aesthetics of taste or consumption, often with a physiological base, became dominant by the *fin de siècle*; and aesthetics of evaluation, best evoked today under the name of Matthew Arnold, were historically linked with the idea of national cultures. These aesthetics had a number of points of contact or overlap, but they were often promoted with very different motivations. Mill, like Kant before him, was concerned with the moral good and the creation of the liberal, ethical individual who could be relied on to subjugate individual desires to the social good. Marx, Ruskin and Morris wanted to provide the conditions for producers whose work would be emotionally, intellectually, and sensuously fulfilling, and whose societies would be judged by their success in cultivating creators and creativity. Aesthetics of taste, deriving from Hume and Burke, distinguished between objects of beauty and then distinguished between those who could and could not distinguish, often claiming that such capacities correlated to physiological or social stages of development. Finally there were aesthetics of evaluation, like Arnold's, in which the point was to measure one object against another by standards of 'truth' or 'seriousness'; but the 'tact' that was thus demonstrated in one's ability to discriminate was less a matter of physiology than of status, for Arnoldian evaluation was in the service of locating individuals in relation to class, class in relation to nation, and nation in relation to globe, 'civilization' or 'race' (Young 1995).

Thus some aesthetics were concerned with humans as ethical individuals and others with humans as creators fulfilling their role as producers of the world. Some aesthetics were concerned with the object produced or created; and others with the consumers of objects. Another way to put this is that some were concerned with productive bodies, whose labour could be creative or alienated, while others were concerned with pleasured bodies, whose tastes established their identities. Granting overlap among these groups, much confusion has none the less resulted from reifying something called 'the Aesthetic' and something monolithic called 'value', which reifications have only recently begun to be rectified primarily through feminist, gay, and

postcolonialist analytics (Eagleton 1990; Connor 1992; Woodmansee 1994). In proposing an historical epistemology of aesthetic values, I want to clarify our possibilities for aesthetics, value, and the contested development of these in market society, being sensitive to the tensions or struggles between competing aesthetic models and even within one model alone. Here I shall focus on the transition around the 1870s, from productivist to consumerist aesthetics. Elsewhere I have related this transition to the transition in economics from political economy to marginal utility theory (Gagnier 1993, 1995).

Although in our contemporary ecocriticism John Ruskin is rightly seen as one of the early proponents of 'moral consumption', the movement that Ruskin called the political economy of art focused less on the spectator or consumer than on the producer of the work and conditions of production. This was also William Morris's aesthetic after him, and, of course, that of Marx and generations of Marxists (although Marxist aesthetics has typically included a critique of ideology with its critique of production). Contrary to an aesthetics located in the object (Plato's) or in the perceiver (Kant's or Burke's), the political economists of art (in Ruskin's phrase) began with the very body of the artist and ended with a theory of creative production (Ruskin 1932). Thomas Hardy's character Jude Fawley in *Jude the Obscure* reads the buildings at Christminster (i.e., Oxford) as Ruskin 'reads' (his own term) the cathedrals at San Marcos or Amiens (Ruskin 1985, 1987): 'less as an artist-critic of their forms than as an artizan and comrade of the dead handicraftsmen whose muscles had actually executed those forms' (Hardy 1974: 103). These muscles, of course, have been aestheticised and eroticised, along with their feminine counterpart the reproductive woman, as part of a productivist ethics for a century and a half; if the model was broadly gendered it was also rooted in the body as firmly as Kant's or Mill's ethico-aesthetic was rooted in the mind.

We should pause here, in an age of consumer demand, to remark how seriously the nineteenth century from a wide range of perspectives took the labour theory of value, from Ricardo to Marx, Mill, Ruskin and Hardy. The theory said that the cost of a commodity was the value of the labour power it took to produce it, plus the value of the labourer's wear and tear in production, plus the value of the labourer's family's subsistence, or, as Marx said, the value of labour power was 'the necessaries by means of which the muscles, nerves, bones, and brains of existing labourers are reproduced and new

labourers are begotten' (Marx 1967: 572). Much of the outrage in novels like *Jude the Obscure*, written well after the theory had been discredited as a theory of price, is against a society that literally undervalues its producers. And Hardy's terms are, like 'labour', those of political economy: production, reproduction, and the body whose labour was its defining feature. They are also specifically Malthusian in the body's reproductive capacity. From the beginning Jude is conscious of himself, of his 'unnecesary life' (36), as part of Malthus's 'surplus population', and his children die 'because we are too menny' (356). Correspondingly, Sue's gendered, reproductive labours are what she seeks, hopelessly, to avoid in pursuit of a (bodiless) aesthetic partnership.

The impulse to historicise art, to read in art the history of social relations, of course, goes back to Hegel, a student of political economy. There is some question as to whether Kant ever actually saw a work of art (Schaper 1992: 386–7), and in any case his examples in the third *Critique* of the Sublime and Beautiful are drawn from nature, e.g., sublime cataracts and mountains or the beautiful song of a bird. Hegel, on the other hand, made representation central, deriving the aesthetic impulse from the fact that it was human nature, as he said, to represent ourselves to ourselves. Thus art is an index of its time, its producers, and their conditions of production (Hegel 1975). At the end of the nineteenth century, in his magisterial *History of Aesthetic*, Bernard Bosanquet saw the culmination of this tradition of philosophical aesthetics in the materialism of Ruskin and Morris. In so far as workers were free in their producing activity, so far would they produce the work of free humanity. In England, Bosanquet concluded, aesthetic insight had had a remarkable influence on economic theory (Bosanquet 1892: 441–71). The dissolution of Romantic art into excessive internality and subjectivity predicted by Hegel would presage the birth of Morris's unalienated worker, whose 'art [was] the expression of pleasure in labour'. Unlike the monumentally abstract eighteenth-century science of aesthetics, for the Victorians aesthetics was the realm of daily life and its vicissitudes. Bosanquet, for example, was particularly interested in Morris's production in the domestic arts of furniture making, tapestries, textiles and carpets.

In contrast there was biological or physiological aesthetics, as in Grant Allen's *Physiological Aesthetics* (1877), which, through its position of authority in the academy, rapidly gained dominance over the applied aesthetics of Ruskin and Morris, and in which the cultivation

of a distinctive 'taste' in the consumption of art replaced concern for its producers. The roots went back to Hume and Burke, who had analysed the psychological bases of taste. According to Hume, the structure of the mind made some objects naturally inclined to give pleasure or to inspire fear (Hume 1963). In William Knight's *fin-de-siècle Philosophy of the Beautiful* (1895) Knight estimated that Burke's influential essay of 1756 had reduced aesthetics to the lowest empirical level, identifying the beautiful with the source of pleasant sensations. In Burkean sensationism, the experience of an elite group of Anglo-Irish takes on the appearance of universalism; the irrational feelings associated with the sublime are given equal place with the sociable feelings associated with the beautiful; and enlightenment or reason is subordinated to mechanism. Burke's very constrained subject – increasingly the subject of political conservatism – is chained to physiology and driven by self-preservation and, to a lesser extent, benevolence. 'We submit to what we admire, but we love what submits to us', Burke famously said of our respective reactions to the sublime and the beautiful (Burke 1986: 113). We respond naturally to the beautiful in the form of the small, the smooth, the curvilinear, the delicate and the bright. We admire the sublime in the form of the vast, the rugged, the jagged, the solid and massive, and the dark. Erasmus Darwin perceived the associational basis of the beautiful when he named it a characteristic of beauty to be an object of love. We love the smooth, the soft and the warm because we were once nourished thence. His grandson Charles later theorised the sense of beauty in relation to sexual selection. Many have remarked on the gender implications of Burke's theory (De Bolla 1989; Eagleton 1992; Gelpi 1993; Poovey 1994). Here I shall explore physiological aesthetics in relation to pleasure and consumption.

Since Hume, biological aesthetics had included custom with physiology in conditioning our response to the beautiful (Hume 1963). In the course of the nineteenth century biological aesthetics merged with established associationist psychology, which gained legitimacy as an academic discipline under Herbert Spencer and Alexander Bain in the century's second half. As it came to dominate psychology, economics and sociology, it also came to dominate aesthetics, shifting the study from its German roots in ethics or reason and Victorian roots in production to that of reception, consumption or individual pleasure. Indeed, for our purposes, the empiricist tradition in aesthetics of Hume and Burke, which is typically opposed to Kant-

ian reason, is significant for its grounding precisely in sense, in the pleasures of consumption. Bain banished everything but pleasure from aesthetics. Following Bain, in *Physiological Aesthetics* Allen defined the beautiful as that which afforded the maximum of stimulation with the minimum of fatigue or waste, in processes not directly connected with life-serving functions.

Allen wrote, 'The aesthetic pleasure is the subjective concomitant of the normal amount of activity, not directly connected with life-serving functions, in the peripheral end-organs of the cerebro-spinal nervous system' (Allen 1877: 34). Although taste had its source in the brain's hardware, whole societies could cultivate it with Lamarckian consequences. Conditions of leisure give rise to two classes of impulse, play and aesthetic pleasure. In play we exercise our limbs and muscles; in aesthetic pleasure we exercise our eyes and ears – the organs of higher sense as opposed to the more functional senses of taste and smell. In this aesthetic, whose proponents included Spencer as well as Bain, the highest quality or quantity of human pleasure was to be derived from art (Spencer [1852] 1883; Bain 1888).

Contrary to the expressed goals of social justice and egalitarianism among the political economists of art, the experiencers of this pleasure fall into predictable hierarchies, and here is where aesthetics most heavily draws upon a lexicon of civilisation and barbarism, or stages of development. With painstaking discussions of the physical origins of aesthetic feelings, Allen ultimately argued that existing likes and dislikes in aesthetic matters were the result of natural selection. From thence it was but a short step to distinguish between stages of aesthetic development, and Aesthetic Man, like Economic Man, was distinguished from others lower in the scale of civilisation (whom Allen, following Spencer, Bain and other associationists, interprets, after Burke, as 'children' or 'savages'). 'Bad taste', writes Allen, 'is the concomitant of a coarse and indiscriminate nervous organisation, an untrained attention, a low emotional nature, and an imperfect intelligence; while good taste is the progressive product of progressing fineness and discrimination in the nerves, educated attention, high and noble emotional constitution, and increasing intellectual faculties' (1877: 48). 'The common mind', as he put it, 'translated the outward impression too rapidly into the reality which it symbolized, interpreting the sensations instead of observing them' (1877: 51). Rather than immediately translating the impression into its 'real' analogue, on the other hand, the aesthetic mind 'dwelled rather upon the

actual impression received in all the minuteness of its slightest detail' (1877: 51). This, of course, meant that persons of taste dwelt upon the representation and their subjective response to it, rather than upon any referent it might have in the external world. (The aesthete Walter Pater, as I have argued elsewhere, emphasised this subjective and formalist response in his aesthetic (Gagnier 1993, 1995).) Today, institutionalists like Pierre Bourdieu have shown how the tendencies to 'dwell in the referent' or the representation have functioned as distinctive marks of social class (Bourdieu 1988; Gagnier 1991).

In Allen's influential article 'The New Hedonism' (1894), the author of *Physiological Aesthetics* and by then publicist of the New Woman specifically opposed the New Hedonism, or the philosophy of pleasure and pain, to the Old Asceticism, which he associated with the work ethic and self-restraint, specifically targeting the productivist tradition represented by Carlyle. 'Self-development', he proclaimed, 'is greater than self-sacrifice' (Allen 1894: 382). Yet although Allen's interest is in pleasure, feeling and sensation, these are inextricably linked with sexual reproduction, and the document is specifically an argument in favour of sex : 'Now there is one test case which marks the difference between the hedonistic and ascetic conception of life better than any other. I am not going to shirk it … From beginning to end, there is no feeling of our nature against which asceticism has made so dead a set as the sexual instinct' (1894: 383–4). In lists comparable to those of *Physiological Aesthetics*, Allen argues that from the beautiful song of the bird to the pleasing physical properties of animals, flowers and fruits, 'every lovely object in organic nature owes its loveliness direct to sexual selection' (1894: 385). He goes on to attribute all our 'higher emotions' – 'our sense of duty, parental responsibility, paternal and maternal love, domestic affections … pathos and fidelity, in one word, the soul itself in embryo' (1894: 387) – to 'the instinct of sex'. Thus the reproductive body returns at the *fin de siècle* to haunt the consuming or pleasured body, in direct evolutionary descent. Throughout the 1890s Allen's heterosexual aesthetic, with its beautiful body of sexual selection, was in cultural dialectic, both implicit and explicit, with other, perverse aesthetics. In some cases, as I wrote some years ago, art for art's sake was allied with a defence of sex for sex's sake, or non-reproductive sex (Gagnier 1986). In other cases, the aesthetic was not beautiful at all, but sublime and terrible, and its body was often abject, repulsive. We have come to call this Other body the 'Gothic' body (Hurley 1996).

Physiological aesthetics – aesthetics that calculated immediate pleasure – was pervasive in the *fin de siècle*; not just in Pater's *Renaissance*, in which he wrote that our object was 'to get as many pulsations as possible into the given time' (Pater 1974: 17), but also in Vernon Lee's 'psychological aesthetics'. ('Physiological' and 'psychological' were used interchangeably.) On the basis of her reading of Allen, Lee experimented on the sensitive body of her lesbian lover, Clementina Anstruther-Thomson, which aesthetic experiments compromised the ethical aesthetics Lee had inherited from Ruskin and the missionary aesthetics the aristocratic Anstruther-Thomson had inherited from a tradition of women's philanthropy (Maltz 1999).

In fiction, we could choose from many examples, but I will stay with Hardy's *Jude the Obscure*, exquisitely divided between two incompatible aesthetics, one productivist, deriving from Ruskinian principles of work and creativity, and one physiological, discriminatory, an aesthetics of taste. The first espouses a labour theory of value, as in Jude's esteem for his craft and his belief that his educational labours will result in class mobility, and the other espouses a standard of taste, best illustrated in the contrast between Arabella and Sue. The example of *Jude the Obscure* takes us full circle, for of course the novel is about desire: the desire to be free of one's class, one's gender, one's marriage and reproductive function. It is about the desire to live aesthetically the life of rich and varied sensations that Jude associates with the mental life and material beauty of Oxford. But unlike Jude, Hardy is not an idealist (a 'dreamer of dreams') but a realist, and his novel is ultimately an anti-aesthetic, showing how social institutions oppose the aesthetic life.

Yet the desire for the good things of the world persists and is exacerbated in our own time. When political theorists say, as they are wont to do today, that economic liberalism is the total subordination of the economy and politics to 'culture', they are defining 'culture' for our time as the desires, needs and tastes of individuals: the end of history in consumer culture. Economists today have a principle that 'tastes are exogenous'. This means that the construction of taste is external to their models, that they no longer ask why people buy what they buy or do not buy what they do not. The principle is often extended further, to an aesthetic *laissez-faire*, claiming that it is of no concern what others like, that it is an intrusion on people's liberty to speculate on the rightness – or even the origins – of their tastes. Revealed Preference Theory ensured that the only 'preferences'

revealed were those revealed by consumption patterns, whether or not such so-called preferences were determined by financial constraint or even coercion. Yet as economists have abandoned enquiry into the complexity of choice and preference, cultural critics have become more sophisticated at analysing precisely that. The levelling of high and low culture in the broader conception of culture that characterises most literature and culture departments has resulted in superb research on why people have the tastes they have. And at no time in history has the construction of taste been more significant.

The sociologist J. Urry describes contemporary global culture as images, language and information flowing through 'scapes' of geographically dispersed agents and technologies (Urry 1996). This cultural flow gives rise to a cosmopolitan civil society that 'precipitates new modes of personal and collective self-fashioning as individualization and cultural formations are ... combined and recombined'. Urry insists that it is important to see how heavily *culturalised* the flows are, how much global *cultures* have to do with global constructions of preferences of taste: 'Increasingly economies are economies of signs ... [T]his has implications for the occupations structure and hence for the increasingly culturally constructed preferences of taste'. It is precisely this cultural construction of taste that is the province of critics of culture.

But as we study what statistical price lists and micro-economics cannot tell us, that is, as we study the construction of taste, we must remember that people are not only consumers. We are both workers and wanters, with bodies born of labouring bodies and desiring bodies. Although there has been a shift in emphasis from production to consumption, and the dominant tendency today is to think more of individuals than of social groups and more of desire than of scarcity, there is more to be said about the dialectical relationship between production and consumption in both economics and aesthetics. An aesthetics and economics of pleasure became salient in ideological terms at the *fin de siècle*, having competed with ethical, political economic and evaluative models. It was doubtless Anglo-American society in the 1980s, with its construction of society as individuals maximising their self-interest and pursuing happiness, which sensitised us to this development and which leads to our emphasis on consumption and excess rather than production or self-regulation. Yet the record of alternative models is worth keeping if we want less reductive accounts of market society.

References

Allen, G. (1877) *Physiological Aesthetics*, London, Henry S. King.
—— (1894) 'The New Hedonism', *Fortnightly Review*, March, 377–92.
Bain, A. (1888) *The Emotions and the Will*, New York, Appleton.
Baudelaire, C. (1966) *The Painter of Modern Life and Other Essays*, London, Phaidon.
—— (1986), *My Heart Laid Bare and Other Prose Writings*, trans. Norman Cameron, London, Soho.
Beerbohm, M. (1896) *Complete Works*, London, John Lane.
Birken, L. (1988) *Consuming Desires: Sexual Science and the Emergence of a Culture of Abundance 1871–1914*, Ithaca, Cornell.
Bosanquet, B. (1892) *History of Aesthetic*, London, George Allen and Unwin.
Bourdieu, P. (1988) *Distinction: A Critique of the Judgment of Taste*, Cambridge, Harvard University Press.
Brake, L. (1994) *Subjugated Knowledges: Journalism, Gender, and Literature in the Nineteenth Century*, London, Macmillan.
Burke, E. (1986) *A Philosophical Enquiry into the Origin of our Ideas of the Sublime and the Beautiful*, ed. James T. Boulton, Notre Dame, University of Notre Dame Press.
Connor, S. (1992) *Theory and Cultural Value*, Oxford, Blackwell.
De Bolla, P. (1989) *The Discourse of the Sublime: Readings in History, Aesthetics, and the Subject*, Oxford, Blackwell.
Dellamora, R. (1995) 'Wildean Economics', paper presented at CUNY Graduate Center, May.
Eagleton, T. (1990) *The Ideology of the Aesthetic*, Oxford, Blackwell.
—— (1992) 'Aesthetics and Politics in Edmund Burke', in Michael Keneally (ed.), *Irish Literature and Culture*, Gerards Cross, Colin Smythe.
Felski, R. (1995) *The Gender of Modernity*, Cambridge, Mass., Harvard University Press.
Fox, P. (1994) *Class Fictions: Shame and Resistance in the British Working-Class Novel, 1890–1945*, Durham, Duke University Press.
Gagnier, R. (1986) *Idylls of the Marketplace: Oscar Wilde and the Victorian Public*, Stanford, Stanford University Press.
—— (1991) *Subjectivities: A History of Self-Representation in Britain 1832–1920*, Oxford, Oxford University Press.
—— (1993) 'On the Insatiability of Human Wants: Economic and Aesthetic Man', *Victorian Studies*, 36 (2), 125–54.
—— (1995) 'Is Market Society the Fin of History?', in Sally Ledger and Scott McCracken (eds), *Cultural Politics at the fin de siècle*, Cambridge, Cambridge University Press.
Gelpi, B. (1993) '"Verses with a Good Deal about Sucking": Percy Bysshe Shelley and Christina Rossetti', in G. Kim Blank and Margot K. Louis (eds), *Influence and Resistance in Nineteenth-Century English Poetry*, New York, St Martin's Press.
Hardy, T. (1974) *Jude the Obscure*, London, Macmillan.
Hegel, G.W.F. (1975) *Hegel's Aesthetics: Lectures on Fine Art*, trans. T.M. Knox, Oxford, Oxford University Press.

Hume, D. (1963) 'Of the Standard of Taste', in *Essays Moral, Political and Literary*, ed. Eugene F. Miller, Indianapolis, Liberty.

Hurley, K. (1996) *The Gothic Body: Sexuality, Materialism, and Degeneration at the Fin De Siècle*, Cambridge, Cambridge University Press.

Huysmans, J.K. (1982) *Against Nature*, Harmondsworth, Penguin.

Kant, I. (1987) *Critique of Judgment*, Indianapolis, Hackett.

Knight, W. (1895) *Philosophy of the Beautiful*, London, Murray.

Lane, C. (1995) *The Ruling Passion: British Colonial Allegory and the Paradox of Homosexual Desire*, Durham, Duke University Press.

Maltz, D. (1999) 'Engaging "Delicate Brains": Vernon Lee, Kit Anstruther-Thomson and Psychological Aesthetics', in Talia Schaffer and Kathy Alexis Psomiades (eds), *Women and British Aestheticism, 1860–1934*, Charlottesville, University Press of Virginia.

McClintock, A. (1995) *Imperial Leather: Race, Gender, and Sexuality in the Colonial Contest*, New York, Routledge.

Marx, K. (1967) *Capital*, New York, International Publishers.

Miller, A.H. (1995) *Novels Behind Glass: Commodity Culture and Victorian Narrative*, Cambridge, Cambridge University Press.

Moore, G. (1977) *Mike Fletcher*, New York, Garland.

Pater, W. (1974) *Selected Writings*, ed. Harold Bloom, New York, Signet.

Poovey, Mary (1994) 'Aesthetics and Political Economy in the Eighteenth Century: The Place of Gender in the Social Constitution of Knowledge', in G. Levine (ed.), *Aesthetics and Ideology*, New Brunswick, Rutgers, 79–105.

Psomiades, K.A. (1997) *Beauty's Body: Femininity and Representation in British Aesthetics*, Stanford, Stanford University Press.

Ruskin, J. (1932) *The Political Economy of Art*, in *Unto This Last and Other Essays*, London, Dent.

—— (1985) 'The Nature of Gothic', in *Unto This Last and Other Writings*, ed. Clive Wilmer, London, Penguin.

—— (1987) *The Bible of Amiens*, in *On Reading Ruskin*, trans. and ed. Jean Autret *et al.*, New Haven, Yale University Press.

Schaffer, T. (1995) 'The Women's World of British Aestheticism', esp. Ch. 1 'The Home is the Proper Sphere for the Man: Inventing Interior Design, 1870–1910', Ph.D. Dissertation, Cornell University.

Schaper, E. (1992) 'Taste, Sublimity, and Genius: The Aesthetics of Nature and Art', in *The Cambridge Companion to Kant*, Cambridge, Cambridge University Press.

Small, I. (1996) 'The Economies of Taste: Literary Markets and Literary Value in the Late Nineteenth Century', *ELT*, 39 (1), 7–18.

Spencer, H. ([1852] 1883) 'Use and Beauty', in *Essays: Scientific, Political, and Speculative. Vol. I*, London, Williams and Norgate.

Steedman, C.K. (1987) *Landscape for a Good Woman*, New Brunswick, Rutgers.

Taylor, P.J. (1996) 'What's Modern About the Modern World-System? Introducing Ordinary Modernity Through World Hegemony,' *Review of International Political Economy*, 3 (2), 260–86.

Urry, J. (1996) 'Is the Global a New Space of Analysis?', *Environment and Planning, A* 28 (11), 1977–82.

Wilde, O. (1978), *The Picture of Dorian Gray*, in *The Portable Oscar Wilde*, ed. Richard Aldington, Harmondsworth, Penguin.

Woodmansee, M. (1994) *The Author, Art, and the Market*, New York, Columbia University Press.

Young, R. (1995) *Colonial Desire: Hybridity in Theory, Culture and Race*, London, Routledge.

4

EMBODYING THE NEW WOMAN:
Dorothy Richardson, work and the London café

SCOTT McCRACKEN

The door opened and closed with its familiar heavy wooden firmness, neatly, with a little rattle of its chain. Her day scrolled up behind her. She halted, trusted and responsible, for a long second, in the light flooding the steps from behind the door.

The pavement was under her feet and the sparsely lamplit night all around her. She restrained her eager steps to a walk. The dark houses and the blackness between the lamps were elastic about her. (Richardson 1979: 2, 74)[1]

At the end of Chapter 3 of *The Tunnel* [1919], the fourth volume in Dorothy Richardson's long novel, *Pilgrimage*, her urban heroine, Miriam Henderson begins a walk destined to remain lost in the depths of her unconscious. The absence is intriguing, provoking several avenues of enquiry. Her passage from Wimpole Street to The Strand, where she re-emerges at the beginning of Chapter 4, is a good example of the kind of female *flâneurie* that has provoked intense speculation in recent cultural criticism (Wolff 1985; Pollock 1988; Wilson 1991). The apparent detachment of mind from body that occurs during the walk – 'she wondered what she had been thinking since she left Wimpole Street, and whether she had come across Trafalgar Square without seeing it or round by some other way' (2, 75) – might be taken as an example of the mind–body split that is the target of feminist philosophers such as Judith Butler and Elizabeth Grosz (Butler 1993; Grosz 1994). But the gap between the chapters also marks the almost unbridgeable divide between the two identi-

ties: the worker and the consumer. The forty-three pages of Chapter 3 are devoted entirely to an account of Miriam's day at work as a dental receptionist. In Chapter 4 she reawakes – 'she came to herself' (2, 75) – transformed from New Woman employee to New Woman about town. In this new guise, she searches out an ABC, one of the café chains that catered for single women in late nineteenth-century London.

The hiatus between the chapters marks a moment of narrative difficulty in Richardson's project: the problem of siting the performance of a New Woman identity in relation to the new, gendered division of labour in late Victorian London. As Nancy Fraser has pointed out in her critique of Habermas's distinction between material and symbolic reproduction, the division between worker and consumer has always been gendered (Fraser 1989: 124). Conventionally, male workers are understood to exist in the real world of capitalist production; female consumers buy the goods produced by men either for the family or to adorn themselves as part of the same world of commodities (Bowlby 1985: 23–30). The journey Miriam takes between chapters marks a transgression of these conventional boundaries; and, in addition, each chapter represents a form of troubled embodiment that goes beyond the constraints of Victorian femininity. But, if Miriam's missing moments signal a difficulty in the narrative, they also create a problem for a cultural criticism that would seek to site the performance of new identities in a history of material practices. As I suggest at the end of this essay, poststructuralist theories of the body have paid insufficient attention to the alienating effects of work under capitalism, preferring to dwell on consumption as the key site for the constitution of identity.[2] On the one hand, Miriam's lost, transitional passage from worker to consumer demonstrates the difficulty of achieving a coherent account of what Elizabeth Grosz calls 'an embodied subjectivity or a psychical corporeality' (1994: 22). On the other, the contradictions that emerge between the world of work and that of consumption demonstrate the social complexity of what Judith Butler calls the 'gendered matrix of relations' that produce the subject (1993: 7).

Taking my lead from *Pilgrimage* itself, I will defer the (now) conventional focus on the sexed body and begin with the eating body as a point at which work and consumption meet. Cultural critics have usually left the masticating, digesting and excreting body to the anthropologists. As Terry Eagleton has commented: 'there has been

strikingly little concern with the physical stuff of which bodies are composed, as opposed to an excited interest in their genitalia'. Eagleton does little to disabuse those who argue that Marxism sees gender as insignificant: 'There has been much critical interest in the famished body of the Western anorexic, but rather little attention to the malnutrition of the Third World' (Eagleton 1998: 207). But it can be plausibly argued that food is as central to social organisation as sexuality; and indeed food and sex are rarely unrelated. As Mary Douglas and Claude Lévi-Strauss have pointed out, the moment of eating is one of both material and symbolic embodiment:

> For Douglas, in western as well as non-western cultures, the consumption of food is a ritual activity. She argues that food categories constitute a social boundary system; the predictable structure of each meal creates order out of potential disorder. The meal is thus a microcosm of wider social structures and boundary definitions. (Lupton 1996: 9)

Pilgrimage abounds in descriptions of eating and drinking and many of the key scenes are staged in cafés and restaurants. More importantly, however, the rituals of eating make the link between identities made by work and identities made through consumption. Dorothy Richardson was acutely aware of the social significance of food. Like her heroine, she worked at the sharp end of the eating body, as a receptionist in a dental practice. Between 1912 and 1922 she wrote regular columns for the *Dental Record* (including one called 'Diet and Teeth') and she also translated three books on diet. In her fiction, dentistry and the culture of the Wimpole Street practice become exemplary metaphors for the interpenetration of material and symbolic reproduction. The workplace is recognised as a key site for the production of a New Woman identity, but it also has a dialectical relationship to women's consumption. For Miriam, as for thousands of other women who entered London's labour force in the period (Vicinus 1985: 25–30), work is both an economic necessity and an opportunity to enter London's public sphere. She earns £1 a week, the wage that was to become the subject of a famous Fabian pamphlet. *Round about a Pound a Week* described the survival of whole working-class families on between 18 and 30 shillings, but even as a single woman the margin her wage gives to Miriam is tiny (Reeves 1913). She often chooses between books and eating. None the less, her limited ability to make choices is significant. In his history of eating in England and France, Stephen Mennell argues that political security and economic

surplus are prerequisites for 'the cultural syndrome of bourgeois rationality as a whole' (Mennell 1985: 34). Miriam's pound a week provides her, alone in the city, with the minimal material conditions for an identity beyond the Victorian, middle-class family. Thus, if the opportunities for performing a New Woman identity appear most clearly in the forms of consumption permitted by that small surplus, it is work that produces what Judith Butler would call the 'regulatory norms' of a new kind of femininity (1993: 15).[3]

Miriam's employment provides her with a basic wage and the possibility of a marginal existence in the city, but the practice in Wimpole Street is also a symbolic site in which social identities are produced. Many of the rituals associated with food are designed to distance the eater from the physical processes involved (Lupton 1996: 22). The culture of dentistry as a medical practice concerned with the consequences of eating has to perform a double distancing from food and bodily decay. In Chapter 3, dental instruments – as the cold, clinical consequence of indulgence – symbolise Miriam's alienation from her work. One of her last tasks before she leaves the practice is to cover the tools of the trade: 'Leaving the dried instruments in a heap with a wash-leather flung over them she gathered up the books, switched the room into darkness, felt its promise of welcome, and trotted downstairs through the quiet house' (2, 74). Work alienates Miriam from her own appetites. Keeper of order of the practice's instruments and finances, she is also in charge of their intellectual consumption. Her literary capital outweighs her actual capital and she is put in charge of ordering the practice's library books; but her position within the firm relies on self-deprecation and denial. Meals at work dramatise the regulation of social boundaries. The ritual of the practice's lunch is described in detail and is punctuated by Miriam's refusal of food: 'Have some pâté, Miss Hens' – No? despise pâté?' (2, 56). Scared of 'contemptible self-indulgence' (2, 56) Miriam constructs a disciplined feminine self through abstinence (Orbach 1988). The meal as social event underlines her own subordination. Her attempts to make relationships on the basis of equality are constrained by the rigid boundaries constructed by position and gender:

'Have a biscuit and butter Miss Hens'n.'
Miriam refused and excused herself.
On her way upstairs she strolled into Mr Leyton's room. He greeted her
 with a smile – polishing instruments busily.
'Mr Hancock busy?' he asked briskly.

'M'm.'

'You busy? I say, if I have Buck in will you finish up these things?'

'All right, if you like,' said Miriam, regretting her sociable impulse. (2, 58)

In this encounter the intimate relationship between food and sex is revealed, as the reader becomes aware that the ironically named Mr Buck is suffering from syphilis. He is another victim of the over-consumption and self-indulgence from which dental masculinity 'protects' the young Miriam. Her identity as a female worker is produced against and between the horror of Buck's unregulated body and the hygienic Mr Leyton's professional power and knowledge:

'I boil every blessed thing after he's been ... if that's any indication to you.'

'*Boil* them!' said Miriam vaguely distressed and pondering over Mr Leyton standing active and aseptic between her and some horror ... something infectious ... it must be that awful mysterious thing ... how awful for Mr Leyton to have to stop his teeth.

'Boil 'em,' he chuckled knowingly.

'Why on earth?' she asked.

'Well – there you are,' said Mr Leyton – 'that's all I can tell you. I boil 'em.'

'Crikey,' said Miriam, half in response and half in comment on his falsetto laugh, as she made for the door. (2, 59)

Women's exclusion from medical knowledge about venereal disease was a campaigning focus for feminists in the period (Walkowitz 1980). A few pages later, subversive revenge is wreaked on Mr Leyton when Miriam observes his grotesque form failing to achieve dignity through the more delicate ritual of tea:

His shirt and the long straight narrow ends of his tie made a bulging curve above his low-cut waistcoat. The collar of his coat stood away from his bent neck and its tails were bunched up round his hips. His trousers were so hitched up that his bent knees strained against the harsh crude Rope Brothers cloth. The ends of his trousers peaked up in front, displaying loose rolls of black sock and the whole of his anatomical walking shoes. Miriam heard his masticating jaws and dreaded his operation with his tea-cup. A wavering hand came out and found the cup and clasped it by the rim, holding it at the edge of the lifted newspaper. She busied herself with cutting stout little wedges of cake. Mr Leyton sipped, gasping after each loud quilting gulp; a gasp, and the sound of a moustache being sucked. (2, 69)

Comic retribution for masculine pretension is one of the key strands of *Pilgrimage*. However, it does not obscure the fact that Miriam's femininity is produced in relation to a division of labour that would allow her to wash the instruments used on Mr Buck and add up his bills, but which excludes her from a fully embodied subjectivity. None the less, her identity is not just that of office skivvy. Work puts her, geographically at least, at the centre of things. Her job and her lodgings in Bloomsbury are an escape from the 'backwater' that lies beyond Euston Road: 'by day and by night, her unsleeping guardian, the rim of the world beyond which lay the northern suburbs, banished' (2, 15). Paid employment is an entry ticket to *fin-de-siècle* London, and the 'elastic' darkness of the city just outside the office allows multiple stages on which new identities can be rehearsed.

Her lost journey takes Miriam through the major shopping, restaurant and theatre districts of the West End. A reconstruction of her route suggests that she might have walked through Soho with its many French and Italian cafés and restaurants; but Miriam does not frequent Soho restaurants until much later. At this early stage in her odysseys, her destination is one of the teashops run by the Aerated Bread Company, an ABC. The ABCs were one of the new chains of cheap, but respectable, cafés and restaurants that sprang up to service London's new consumers, catering for shoppers, theatre-goers and workers in central London (Service 1979; Thorne 1980; Weightman, 1992). In a city well known for its unsanitary and poor-quality food and the masculine culture of its pubs and eating houses, the new teashops were designed to appeal to unaccompanied women.[4] Miriam's path through the city figures the dialectical relationship between the labouring and the consuming body. The complexity of late nineteenth-century consumer capitalism means that the connections are indeed obscure, but they are, none the less, two sides of the same coin. The presence of New Women workers, like Miriam, creates the conditions for new forms of consumption; but, at the same time, the new forms permit new kinds of embodied subjectivity to emerge. As spaces of consumption in which new social boundaries could be explored, ABCs, J. Lyons coffeehouses and later Soho cafés and restaurants figure as key sites for the performance of new gendered identities.

Tracing the genealogy of the ABC in *Pilgrimage* reveals a legacy of childhood pleasures and adult independence. The chain is first mentioned in the first volume, *Pointed Roofs* [1915], as one of the childhood treats she will miss when she leaves England to take up her first teach-

ing post in Germany: 'No more all day *bézique* … No more days in the West End … No more matinées … No more ABC teas' (1, 18). However, when Miriam gets to Germany her relationship with cafés changes. While a visit to the German café, Kreipe's, is regarded by her pupils as a much-anticipated treat, for Miriam it also a transition from childhood and the possibility of a new, assertive form of adult femininity:

> There were only women there – wonderful German women in twos and threes – ladies out shopping, Miriam supposed. She managed intermittently to watch three or four of them and wondered what kind of conversation made them so emphatic – whether it was because they held themselves so well and 'spoke out' that everything they said seemed so important. She had never seen women with so much decision in their bearing. She found herself drawing herself up. (1, 89)

Miriam is able to imagine the possibility of subjecthood through her perception of the café as a space in which an independent femininity might be performed. Her childhood pleasure in food as a treat persists and is even surpassed:

> Three cups of thick-looking chocolate, each supporting a little hillock of solid cream arrived at her table. Clara ordered cakes.
> At the first sip, taken with lips that slid helplessly on the surprisingly thick rim of her cup, Miriam renounced all the beverages she had ever known as unworthy. (1, 89)

However, her supposition that subjecthood can be attained through consumption is undercut by the constraints of paid employment. Her moment of indulgence becomes an instance of overindulgence. Later at dinner her employer, Fräulein Pfaff, 'went round the table with questions as to what had been consumed at Kreipe's' (1, 89), requiring each cake to be described. An ascetic biscuit receives a smile, but Miriam, who chose the 'familiar-looking *éclair*', is almost alone in her 'excesses'. In what can be taken as a lesson in how to behave as an employee, the excessive moment of consumption is used to fix Miriam into an economy in which she is the weaker party.

It is, then, significant that the next appearance of an ABC, in the subsequent volume, *Backwater* [1916], is when Miriam takes her mother out to tea rather than the other way round. Miriam's forced cheerfulness is ostensibly an attempt to recreate the atmosphere of the family treat, but its real purpose is to show off her new-found independence and knowledge of the city:

'You'll see our ABC soon. You know. The one we go to after the Saturday pops. You've been to it. You came to it the day we came to Madame Schumann's farewell. It's just round here in Piccadilly. Here it is. Glorious. I must make the others come up once more before I die. I always have a scone. I don't like the aryated bread. We go along the Burlington Arcade too. I don't believe you've ever been along there. It's simply perfect. Glove shops and fans and a smell of the most exquisite scent everywhere.'

'Dear me. It must be very captivating.'

'Now we shall pass the parks. Oh, isn't the sun AI copper bottom!'

Mrs Henderson laughed wistfully. (1, 199)

The inviting mention of an Arcade opens up the debate about Miriam as female *flâneuse*; but it is enough here to point to the way in which the ABC is located within what David Lynch in *The Image of the City* calls a path, one of the routes through which the city space is mapped by its inhabitants (1960). Miriam, significantly, is the one who maps, who knows the city's slang, its attractions and dangers. The excess of goods – gloves, fans and scents – with their associations of a dangerously public femininity makes her mother nervous; but if in the workplace Miriam's subordinate position as employee is clear, on the streets as a consumer, she is able to define herself against her mother's more timid relationship to the city. The consumption of the scone, not the 'ayrated' bread, misspelt perhaps to emphasise the point, marks her distinctive and authoritative taste and it is this new-found 'elastic' space into which Miriam walks at the end of a day's work.

Reached without conscious thought, The Strand, in keeping with its name, is represented as a liminal space. A nexus of commerce, theatre and the restaurant trade, it marks (at least in the middle-class Miriam's opinion) the end of the respectable West End. This diversity of contradictory urban spaces provides the conditions for what Butler calls a 'proliferative catachresis', permitting the production of new gendered identities (1993: 83, 89):

Most of the shops were still open. The traffic was still in full tide. The jeweller's window repelled her. It was very yellow with gold, all the objects close together and each one bearing a tiny label with the price. There was a sort of commonness about The Strand, not like the cheerful commonness of Oxford Street, more like the City with its many sudden restaurants. She walked on. But there were theatres also, linking it up with the West End and streets leading off it where people like Bob Greville had

chambers. It was the tailing off of the West End and the beginning of a deep dark richness that began about Holywell. Mysterious important churches crowded in amongst little brown lanes ... the little dark brown lane ... She wondered what she had been thinking since she left Wimpole Street, and whether she had come across Trafalgar Square without seeing it or round by some other way. (2, 75)

On the edge of the West End, Miriam is between what Franco Moretti, in his recent study of literary geography, calls two 'half Londons, that do not add up to a whole' (Moretti 1998: 86). In Richardson's complex rewriting of London she draws on the representation of the East End established by realist writers such as George Gissing and Arthur Morrison. Their imagery of penetration and contamination, Gissing's 'corners and lurking-holes' ([1886] 1982: 26), is reproduced here in the 'little brown lanes ... the dark little brown lane'. Yet characteristically Richardson's text enjoys imagining the city's otherness, the 'deep dark richness that began about Holywell', the centre of the Victorian pornography industry. The urban imaginary opens up the possibility of new identities of which Miriam is not yet conscious. Certainly, her awakening brings a repulsion for bourgeois marriage as represented by the jeweller's window, 'yellow with gold'.

Her experience of the streets is far from utopian. The constraints on her movement are brought home by her immediate encounter with male violence: 'They were fighting; sending out misery and suffocation into the surrounding air ... she stopped close to the upright balanced threatening bodies, almost touching them. The men looked at her. "Don't" she said imploringly and hurried on trembling' (2, 75). And this threat underlines the importance of the ABC, which appears at the moment of crisis, 'suddenly at her side'. While, 'nearly full of men' and 'not one of her own ABCs' (the ABC closest to her lodgings becomes 'her ABC' (2, 329), a first port of call before she ventures out into less hospitable parts of the city), the teashop signals a safe, homely space: 'its panes misty in the cold air'. In this more distant hostelry, the interior creates a strange hybrid of public and private. The 'City men' who occupy it make for an atmosphere of masculine work with their 'uncongenial scraps of talk that now and again penetrated her thoughts'; but the restaurant has its own domestic hearth:

> The shop turned at a right angle showing a large open fire with a fire-guard, and a cat sitting on the hearth-rug in front it. She chose a chair at a small table in front of the fire. The velvet settees at the sides of the room were more comfortable. But it was for such a little while tonight. (2, 76)

Amongst the City men, Miriam chooses a feminised space, but her performance of femininity on the stage of the ABC is not, cannot be, the domestic role of Victorian ideology. In earlier volumes of *Pilgrimage*, Miriam has felt her way towards a new kind of gendered identity. In *Honeycomb* [1917], the volume that precedes *The Tunnel*, the Wilde Trial exerts a powerful effect on her, pulling her towards the city and its possibilities: 'Her sympathies veered vaguely out towards the patch of disgrace in London' (1, 429). In her entrance into the teashop – 'She walked confidently down the centre, her plaid-lined golf-cape thrown back' – she achieves something akin to what Judith Halberstam calls 'female masculinity'; a gendered identity that is neither masculine nor feminine according to Victorian conventions (Halberstam 1998). Again, however, work is a necessary precondition for her performance as well as a crucial element in its staging. Transgressing sexed boundaries, Miriam also transgresses the gendered roles of worker and consumer. The dialectic between work and consumption finds its image, once again, in what she eats and drinks. Miriam's boiled egg, roll and butter and small coffee represent the cheapest available meal that allows her to eat out. This is not the treat of the childhood tea, the indulgence of the German *éclair*, nor the daring idiosyncrasy of the scone in the home of aerated bread. It is the meal of the white-collar worker on round about a pound a week.

Later in *Pilgrimage* the small egg, roll and butter become a kind of currency against which other commodities are measured (2, 150). At one point she compares it with home cooking; 'the lovely little loaf and the wholesome solid fish would cost less' (2, 259), but Miriam's preference for mass catering over miraculous loaves and fishes cannot just be put down to her lack of culinary skills. Her wage and situation give her access to a public life and the ABC provides the stage upon which she can perform her new identity. Later, as she gains confidence, she starts to frequent a late-night Soho café and to meet her lovers in more expensive restaurants. But her ability to see them on equal terms is only ensured by her earlier colonisation of the ABCs, each of which, to a greater or lesser extent, she makes her own. The role of the London café in Richardson's text makes it possible to suggest that the new chains like the ABCs and J. Lyons coffeehouses did provide the kinds of public space in which a new gendered identity could be performed. Equally though, in the figure of the small egg, roll and butter, Richardson was concerned to show the material constraints which defined the embodiment of that identity. Miriam's

spartan meal cannot be divorced from the circulation of commodities in which her labour plays a small, but crucial part.

In contrast to Richardson's modernist text, the labouring body has been given very little attention in poststructuralist theories. Marxism, including Marxist feminism, is usually lumped together with forms of social constructivism that see nature 'as a passive surface, outside the social' (Butler 1993: 4) and have 'a biologically determined, fixed, and ahistorical notion of the body' (Grosz 1994: 16–17). There has been surprisingly little dialogue between Butler's theory of performativity, Grosz's corporeal feminism and the work of cultural materialists like Judith Walkowitz and Jonathan Dollimore, who are more concerned with the historical formation of sexuality (Dollimore 1991; Walkowitz 1992). Yet, despite the fact that Freud is a more common reference point than Marx, historical materialism remains to a greater or lesser extent the dialogic (if often rebuffed) partner of much poststructuralist writing on the body. Derrida's belated acknowledgement of Marx's ghostly presence is well known (1994). Butler's engagement with Marxist discussions surfaced as a concern in a recent debate with Nancy Fraser in the pages of *New Left Review* (Butler 1998; Fraser 1998). At issue was the role of heterosexism in the development of capitalist relations. However, in Butler's main works she often manages to pull her conception of matter deftly out of the history of social formations.

Butler's direct engagement with Marx in *Bodies That Matter* is confined to one footnote (1993: 250, n. 5). Yet nowhere in her work is the spectre of Marxism a more haunting presence than in this text. Butler argues that she is seeking to displace radical constructivism with 'a poststructuralist rewriting of discursive performativity as it operates in the materialization of sex' (1993: 12). However, if Marx*ists* are to be deconstructed, then Marx himself is credited with a view of matter understood not as a 'blank surface or slate awaiting an external signification', but as 'a principle of *transformation*, presuming and inducing a future' (1993: 31). The reference is to the 'Theses on Feuerbach', which Marx jotted down in his notebooks in 1845:

> The chief defect of all previous materialism (including Feuerbach's) is that the object, actuality, sensuousness is conceived only in the form of the *object or perception (Anschauung)*, but not *as sensuous human activity, practice (Praxis)*, not subjectively. (Marx 1967: 400)[5]

In this Butler finds a point of departure for her own materialist theory:

according to this new kind of materialism that Marx proposes, the object is not only transformed, but in some significant sense, the object is transformative activity itself and, further, its materiality is established through this temporal movement from a prior to a latter state. (1993: 250, n. 5)

However, if not a misreading, this is at least a tendentious interpretation of Marx, giving a certain weight to one side of his dialectic. While it is true that 'in some significant sense' Marx describes the materialisation of the object as 'transformative activity itself', his concern is to show that human activity is also real and objective: 'Feuerbach wants sensuous objects, really distinct from the thought objects, but he does not conceive human activity itself as *objective* activity' (Marx 1975: 421). Where Marx wishes to emphasise the material nature of thought, Butler is more interested in the conceptual nature of matter.

The footnote curtails the dialogue with Marx, leaving the reader with two directions in which to go: first to Ernst Bloch's *The Principle of Hope* and second to Jean-François Lyotard's *The Inhuman: Reflections on Time*. That the second reference refers specifically to one chapter of Lyotard's poststructuralist work, while no indication is given where to look in Bloch's work of unorthodox Marxism (consisting of three volumes and 1,376 pages), is perhaps another sign of an unfinished dialogue. Lyotard's essay is an extended meditation on the mind–body relationship consistent with Butler's theories (1991). Where Bloch discusses the 'Theses on Feuerbach', he makes it clear that by 'sensuous human activity' Marx means work:

Within the province of normal human environment, independence of being from consciousness is by no means the same as independence of being from human work. The independence of this external world from consciousness, its Objectivity, is instead so far from being cancelled by the mediation of work with the external world that it is in fact ultimately formulated by it. (Bloch 1986: 1, 259)

This is very close to Butler's formulation, 'the object *is* transformative activity itself', except that labour does not feature as a term in *Bodies that Matter*. When the proletariat does poke its head above the machine, it belongs to a body rather like that of Charlie Chaplin in *Modern Times*, one that has itself become mechanical:

any attempt to circumscribe an identity in terms of relations of production, and solely within those terms, performs an exclusion and hence, produces a constitutive outside, understood on the model of the Der-

ridean 'supplément,' that denies the claim to positivity and comprehensiveness implied by that prior objectivation. (Butler 1993: 194)

Few, and only the most vulgar, Marxists would suggest that the relations of production are the last word on the identity of the worker. It is part of the invidious nature of capitalism that it reduces identity to those relations alone. This is the importance of Miriam's walk, which figures not just as the lost supplement that forms her identity in excess of the relations of work, but also as the difficult mediation between the social and historical conditions that constrain identity and the possibility of new and pleasurable performances. As I have put it elsewhere, we need to be aware of the stage on which the performance takes place (McCracken 1996). For a fully historical and materialist analysis, the totality of all the conditions that make up Marx's 'sensuous human activity' need to be addressed, including the working, the consuming and the eating body, even if that totality cannot, ultimately, be fully represented and many of its routes, paths and passages are destined to remain lost to conscious thought.

Notes

1 Original publication dates of the individual novels that make up *Pilgrimage* are shown in square brackets in the text.
2 See Chapter 3 in this collection.
3 'The agency denoted by the performativity of "sex will be directly counter to any notion of a voluntarist subject who exists quite apart from the regulatory norms which she/he opposes' (Butler 1993: 15).
4 Although in J. Lyons establishments a 'written code stipulated that "strange ladies", whether alone or in pairs, were not to be admitted, or if by some oversight they had been let in, they were to be secluded by screens from the public gaze' (Richardson 1976: 166).
5 Quoted in Butler (1993: 250, n. 5).

References

Bloch, E. (1986) *The Principle of Hope*, trans. N. Plaice, S. Plaice and P. Knight, Oxford, Blackwell.
Bowlby, R. (1985) *Just Looking: Consumer Culture in Dreiser, Gissing and Zola*, London, Methuen.
Butler, J. (1993) *Bodies that Matter: On the Discursive Limits of 'Sex'*, London and New York, Routledge.
—— (1998) 'Merely Cultural', *New Left Review*, 227, 33–44.
Derrida, J. (1994) *Spectres of Marx*, London, Routledge.
Dollimore, J. (1991) *Sexual Dissidence: Augustine to Wilde, Freud to Foucault*, Oxford,

Oxford University Press.

Eagleton T. (1998) 'Edible écriture', in S. Griffiths and J. Wallace (eds), *Consuming Passions: Food in the Age of Anxiety*, Manchester, Mandolin.

Fraser, N. (1989) *Unruly Practices: Power, Discourse and Gender in Contemporary Social Theory*, Cambridge, Polity Press.

—— (1998) 'Heterosexism, Misrecognition and Capitalism: A Response to Judith Butler', *New Left Review*, 227, 140–9.

Gissing, G. ([1886] 1982) *Demos: A Story of English Socialism*, Brighton, Harvester.

Grosz, E. (1994) *Volatile Bodies: Towards a Corporeal Feminism*, Bloomington and Indianapolis, Indiana University Press.

Halberstam, J. (1998) *Female Masculinity*, Durham, Duke University Press.

Lupton, D. (1996) *Food, the Body and the Self*, London, Sage.

Lynch, D. (1960) *The Image of the City*, Cambridge, Mass., MIT Press.

Lyotard, J.F. (1991) *The Inhuman: Reflections on Time*, Cambridge, Polity Press.

Marx, K. (967) 'Theses on Feuerbach', in *Writings of the Young Marx on Philosophy and Society*, New York, Doubleday.

—— (1975) 'Theses on Feuerbach', in *Karl Marx: Early Writings*, Harmondsworth, Penguin.

McCracken, S. (1996) 'Stages of Sand and Blood: The Performance of Gendered Subjectivity in Olive Schreiner's Colonial Allegories', *Women's Writing*, 3 (3), 231–42.

Mennell, S. (1985) *All Manners of Food: Eating and Taste in England and France from the Middle Ages to the Present*, Oxford, Blackwell.

Moretti, M. (1998) *Atlas of the European Novel 1800–1900*, London, Verso.

Orbach, S. (1988) *Fat is a Feminist Issue*, London, Arrow.

Pollock, G. (1988) 'Modernity and the Spaces of Femininity', in *Vision and Difference: Femininity, Feminism and the Histories of Art*, London, Routledge.

Reeves, M.S. (1913) *Round about a Pound a Week*, London, G. Bell and Sons.

Richardson, D. (1979) *Pilgrimage*, 4 vols, London, Virago.

Richardson, D.J. (1976) 'J. Lyons & Co. Ltd.: Caterers & Food Manufacturers, 1894 to 1939', in D. Oddy and D. Miller (eds), *The Making of the Modern British Diet*, London, Croom Helm.

Service, A. (1979) *London 1900*, St Albans and London, Granada.

Thorne, R. (1980) 'Places of Refreshment in the Nineteenth-Century City', in A. King (ed.), *Essays in the Social Development of the Built Environment*, London, Routledge.

Vicinus, M. (1985) *Independent Women: Work and Community for Single Women, 1850–1920*, London, Virago.

Walkowitz, J. (1980) *Prostitution and Victorian Society: Women, Class and the State*, Cambridge, Cambridge University Press.

—— (1992) *City of Dreadful Delight: Narratives of Sexual Danger in Late-Victorian London*, London, Virago.

Weightman, G. (1992) *Bright Lights, Big City: London Entertained 1830–1950*, London, Collins and Brown.

Wilson, E. (1991) 'The Invisible Flâneur', *New Left Review*, 191, 90–110.

Wolff, J. (1985) 'The Invisible Flâneuse: Women and the Literature of Modernity', *Theory, Culture and Society*, special issue, 'The Fate of Modernity', 2 (3), 37–46.

part two

MATTERS OF DIFFERENCE:
MISRECOGNITION
AND DISSYMMETRIES

5

BODILY DISSYMMETRIES
AND MASCULINE ANXIETY:
Herculine has the last laugh

URSULA TIDD

The memoirs of Herculine Barbin, a nineteenth-century hermaphrodite, have become one of the best-known case studies and first-hand testimonies of intersexuality. The text was initially published in 1872 by Dr Auguste Tardieu, a forensic specialist, who received the manuscript from a Dr Régnier who reported Barbin's suicide in 1868. Just over a century later, in 1978, her/his story was published by Gallimard in 'Les Vies parallèles', a new series edited by Michel Foucault. In 1980, an English translation appeared accompanied by an important introduction by Foucault, a dossier of documents relating to Herculine's case and a story by Oscar Panizza, *A Scandal at the Convent*, based on the Barbin story.[1] Then in the mid-1980s, a film was made by René Féret, entitled *Mystère Alexina*, starring Philippe Vuillemin. Most recently, gender theorists, such as Judith Butler, have focused once more on Barbin's story, engaging simultaneously with Foucault's reading of her/his situation as exposing and exploding the regulative categories of sex.

Positioned as an object of knowledge at the literal interstices of medical, legal, political and philosophical discourses concerning subjectivity, the hermaphrodite has regularly presented new causes for anxiety according to prevailing notions of sex, gender and subjecthood. As Lorraine Daston and Katharine Park (1995) have shown, although accounts of hermaphrodism in early modern France are marked by their heterogeneity, from the sixteenth century there was a new and sustained medical interest in hermaphrodites, accompanied by urgent moral and social concern. Daston and Park argue nevertheless that notions about hermaphrodism were rooted in an estab-

lished tradition of ancient and medieval reflection on generation and sexual difference. From this tradition, two conflicting models of hermaphrodism emerged which would have significant implications for succeeding formulations of intersexuality. The first model was associated with the Hippocratic theoretical tradition and conceptualised hermaphrodites as being absolutely sexually intermediate on a sexual spectrum along which unambiguous male, intersexual and female bodies were produced according to the distribution of maternal and paternal seed and the position of the foetus in the womb.[2] The second model, rooted in Aristotelian notions of sexual difference, viewed the hermaphrodite as possessing a body with doubled genitalia, the result of an inadequate resolution between male and female principles. However, unlike the Hippocratic model, this genital doubling had no significance for the sex of the body as a whole, for this was determined, according to Aristotle, by the heat of the heart and, regardless of corporeal morphology, was always decisively determined as male or female. According to Daston and Parks, these two models had quite different effects on prevailing notions of sex and gender, for the Hippocratic model permitted a spectrum of sexual bodies and behaviour, thereby posing a major threat to the social order based on the heterosexual matrix, whereas the Aristotelian model offered merely an explanation of hermaphrodism as a local disorder of bodily morphology which left existing binary notions of sex intact. In Foucault's and Butler's discussions of intersexuality, to which I will refer below, elements of the Hippocratic model of hermaphrodism predominate and they thereby challenge the Aristotelian discourse of the existence of an always-already 'true sex'.

As Barbin's story demonstrates, the hermaphrodite poses a variety of dilemmas for the political regime of heterosexuality at the level of the production of heterosexed bodies, sexual orientation, lifestyle and citizenship which are played out through the discursive web of the autobiographical text and its accompanying dossier. As a testimonial autobiography of an hermaphrodite, Barbin's text dramatises her/his precarious subjecthood and explodes habitual metaphors of truth as correspondence and coherence through which sex and subjectivity are represented and understood. Presented as a death-bed confession by Barbin and discovered by Dr Régnier, who performed the post-mortem on Barbin's body, the text adopts certain tropes of modern autobiography which will be considered in this discussion of Barbin's text as intersexual autobiography.

Following Jean-Jacques Rousseau's *Confessions* – with which Barbin would almost certainly have been acquainted, for s/he was well-read in both Classical and French literature – the narrator proclaims her/his sincerity and attempts to communicate a sentimental truth from a position of exile and (justified) paranoia. On several occasions, like most autobiographers, Barbin reflects anxiously on the autobiographical task, acknowledging her/his lack of literary ability compared to the 'masters' of mid-nineteenth-century French serialised fiction, such as Dumas and Féval. Her/his literary anxiety acts as a metaphor for her/his anxiety over sexual identity and potency, as literary form mimes the autobiographical subject's ambiguous corporeal morphology, thereby observing the common autobiographical trope of conflating textual body with authorial self.[3] Barbin's inability to wield her/his pen skilfully and assume a place amid the literary 'greats' echoes her/his inability to assume a place in the regime of 'true sex' and marry Sara, the object of her/his desire. Reminding her/his reader, however, that s/he is composing a 'personal story'(35), Barbin is nevertheless aware that once her/his subject matter is apparent to the reader, s/he may lose her/his autobiographical authority in so far as s/he proclaims that her/his story is completely unrepresentative of anyone else's life.[4] The singularity of the autobiographer's life related is also famously vaunted by Rousseau in the *Confessions* in a declaration which unwittingly, yet strikingly, anticipates Barbin's autobiographical situation:

> I have resolved on an enterprise which has no precedent, and which, once complete, will have no imitator … I am made unlike any one I have ever met; I will even venture to say that I am like no one in the whole world. I may be no better, but at least I am different. Whether Nature did well or ill in breaking the mould in which she formed me, is a question which can only be resolved after the reading of my book. (17)

Published almost a century later than Rousseau's *Confessions*, Barbin's own confessions inadvertently provide an ironic critique of Rousseau's defence of sexual difference and nature.

In her/his memoirs, Barbin relates how, fatherless, s/he was given up by her/his mother at the age of seven to be brought up in a hospital and then various convent schools. S/he subsequently trained as a teacher and taught at a convent school, where s/he began a sexual relationship with another teacher, Sara, having previously been emotionally and sexually attracted to other women. S/he is

unable to conceal the relationship from her confessor and confesses both to him and, later, to an unknown monk. Meanwhile, the relationship between Barbin and Sara attracts increasing homophobic disapproval, for at this stage, people are unaware that their relationship is between an hermaphrodite and a woman. Meanwhile, the unexplained pregnancy of a former student at the school causes Barbin to worry about the possible consequences of her/his relationship with Sara. Experiencing increasing and unexplained pain, Barbin is examined successively by several doctors and her/his intermediate sexual status is revealed. With the support of a senior churchman, an authorisation is obtained for a change in her/his civil status. However, gossip and public derision force Barbin – now known as Abel Barbin – into a precarious existence in Paris until s/he decides to leave to work on a steamship as a form of self-imposed exile. Here, Barbin's text breaks off and Foucault's editorial note explains that s/he committed suicide in February 1868 'by means of a charcoal stove' (117).

As a confessional document, Barbin's text flouts autobiographical conventions pertaining to the production of a consistent and complete truth in confession by a self-knowing subject. Significantly, the sensationalist title of the English translation – *Herculine Barbin, Being the Recently Discovered Memoirs of a Nineteenth-Century French Hermaphrodite* – differs from the original French title of 'Mes souvenirs'. The title of the English translation does not therefore reflect the text which it precedes for, as Judith Butler notes in her reading of the text in *Gender Trouble*, the emotional and sexual attachments formed by Barbin are related in a highly elliptical manner (Butler 1990: 97). It is effectively a story *by* an hermaphrodite (following the English title) but not *of* an hermaphrodite, for it is only in the accompanying medical reports that the reader learns of the specific corporeal morphology at issue. These relate that Barbin had no breasts or womb and had consequently never menstruated, possessing an enlarged clitoris or small penis capable of some ejaculation and a vagina ending in a 'cul-de-sac'. Moreover, the death-bed written confession is inconsistent with the oral confessions delivered to a series of priests and doctors which are recorded throughout the narrative so that there is an assymmetrical 'doubling' of confessional narratives which mimes the assymmetrical genital doubling of the intersexual body. The persistent use of ellipsis in the written confession additionally obliges the reader to supply the 'missing part' of the textual body in a further

miming of what Barbin alludes to as the deficiencies of her/his inter-sexed body.[5]

Yet the confessional form to which Barbin has repeated recourse – as if to construct a self to be absolved – is imbricated in a social ritual of truth production, as Foucault argues in the first volume of *The History of Sexuality*, but does not acknowledge in his introduction to Barbin's story. Sex is a privileged theme of confession, which further serves to modify s/he who confesses:

> The confession is a ritual of discourse in which the speaking subject is also the subject of the statement; it is also a ritual that unfolds within a power relationship, for one does not confess without the presence (or virtual presence) of a partner who is not simply the interlocutor but the authority who requires the confession, prescribes it and appreciates it, and intervenes in order to judge, punish, forgive, console, and reconcile; a ritual in which the truth is corroborated by the obstacles and resistances it has had to surmount in order to be formulated; and finally, a ritual in which the expression alone, independently of its external consequences, produces intrinsic modifications in the person who articulates it: it exonerates, redeems, and purifies him; it unburdens him of his wrongs, liberates him, and promises him salvation. For centuries, the truth of sex was, at least for the most part, caught up in this discursive form. (Foucault 1990: 61–2)

For Barbin, however, the production of oral and written confessions concerning her/his intersexuality serves only to facilitate society's disciplinary gaze, which decrees the parameters of acceptable bodily morphology, thereby tightening its discursive grip on Barbin and eventually driving her/him to bodily annihilation in suicide.

Michel Foucault's interest in the Barbin case is related to his broader project evident in works such as *The Archaeology of Knowledge*, *Discipline and Punish* and the *History of Sexuality*, which explores how sex and sexual difference are constituted in discourse as 'true' features of bodily identity and subjectivity. Moreover, the topics of hermaphrodism and women were to be the focus for projected volumes of *The History of Sexuality* which were never completed. Hermaphrodism also featured in Foucault's series of lectures at the Collège de France in 1974–5 on 'Les Anormaux', whom he characterised as having been discursively constituted into three groups: the human monster (which included hermaphrodites), the disciplinary individual and the masturbator (Foucault 1989: 73–81). Foucault describes these 'human monsters' as being deemed monstrous not only because

of their exceptional physicality but also because they jam up the juridical machinery which regulates social institutions such as marriage laws, the baptismal canon and laws of succession and inheritance. The 'human monster', according to Foucault, combines the impossible and the unutterable.

Foucault's commentary on Barbin's text was initially delivered in a slightly different format to France's oldest gay organisation, Arcadie, in 1979. This was a very male-dominated, conservative 'homophile' organisation which had existed since 1954. Foucault's 'hommo-sexual' audience is significant, for it may partially explain why he is uniquely concerned with the regulatory matrix of 'true sex', disregarding the lesbian specificity of Barbin's relationship with Sara (as it is initially perceived by the convent community and the society in question) and the ensuing homophobia to which s/he is subjected.[6] In his commentary, Foucault briefly surveys the treatment of hermaphrodites and signals the period of 1860–70 as a particularly intense period of investigation into sexual identity, when not only were hermaphrodites, such as Barbin, being subjected to legal and medical surveillance to establish their 'true sex' but also attempts were being made to classify and identify different types of perversion (xi–xii). He describes the memoir's style – elegant, affected and allusive – as characteristic of the 'manner of living' of the boarding schools of the era. Barbin's initially ambiguous and increasingly 'abnormal' corporeality is unnoticed in the convent, according to Foucault, and yet simultaneously, s/he is the object of fascination for both pupils and staff, as if Barbin's transgressivity constitutes a powerful erotic difference which provokes desire within the gynocentric universe of the school. Yet Foucault seems to take Barbin at her/his elliptical written word for his idealistic, Nietzschean purposes of evoking a 'happy limbo of non-identity' and 'a world in which grins hung about without the cat' (xiii), as if the pleasurable deeds of chimeric subjectivities are all that should count.

However, as Butler argues, we should resist this romanticisation of Barbin's world prior to her/his 'correct' interpellation within the category of sex (Butler 1990: 98). For within the school, the play of pleasures is performed and negotiated among consenting, material, moral subjectivities who – although they may be ignorant of the spectrum of corporeal morphologies in circulation and, more specifically, of Barbin's intersexual corporeal morphology – repeatedly enact the laws of sex and gender as they condemn Barbin and Sara's lesbian-

ism. Chastised at one moment as a lesbian and, at the next, as having been a Don Juan in drag once s/he assumes her/his masculine status, Barbin can never occupy a space beyond the patriarchal heterosexual economy, which relentlessly shapes its good and bad actors.

Even as the staged singularity of the text positions readers to accept uncritically the hermaphrodite's voice as 'true', to refuse to take Barbin at her/his elliptical word is not necessarily to discredit the hermaphrodite's testimony, for every testimony is incomplete and subject to intersubjective revision across time. Although the autobiographical form promotes fantasies of the self-identical, the errors of Barbin's interpellation as a woman and subsequent interpellation as a man, who is able/Abel to be slain, dramatises the contingency of identity. For, as Butler argues in *Bodies that Matter*:

> One might be tempted to say that identity categories are insufficient because every subject position is the site of converging relations of power that are not univocal. But such a formulation underestimates the radical challenge to the subject that such converging relations imply. For there is no self-identical subject who houses or bears these relations, no site at which such relations converge. This converging and interarticulation is the contemporary fate of the subject. In other words, the subject as a self-identical entity is no more. It is in this sense that the temporary totalization performed by identity categories is a necessary error. (Butler 1993: 229–30)

Barbin discovers through her/his painful corporeal history that there are no peaceful resting places for identity other than in death, when the ambiguous body is annihilated, and even then, the hermaphroditic text remains. Yet the text, even as the intersexuality of its subject is denied, is a metamorphic, teratogenic body, on to which the anxiety-ridden malformations and excrescences of 'the straight mind' are projected, as evidenced by the medical and press statements, the civic records and the fictional literary and filmic reworkings of Barbin's story by Panizza and Féret.[7] The repeated invocation of Barbin's story as the singular story of an hermaphrodite belies the spectrum of human corporeal morphology which exists, and vastly overdetermines Barbin's 'abnormal singularity' against the overdetermined 'normal' sameness of all other bodies. S/he is made to stand for all hermaphroditic bodies. Yet, as Elizabeth Grosz has argued, medical studies indicate that a high percentage of hermaphroditic bodily features occur in the general population, which complicates any easy sexual assignation of bodies and suggests rather that 'sex is

a multilayered psychobiological function in which a number of layers coalesce' (Grosz 1994: 216).

Moreover, Barbin's change in civic status from female to male does not deliver the sexual resolution that s/he anticipated throughout the text, for what is proved to count is not merely the contingent possession of 'true sex', but lifelong possession of 'true sex', according to which the subject must possess a self-same history of his/her sex as well as the appropriate corporeal morphology. Not possessing the history of the sex which s/he assumes, Barbin is perceived as an interloper on two sequential counts: first, as a lesbian who aspires to perform the sexual behaviour of a heterosexual man, and second, as a heterosexual man whose gender history is female and therefore deemed to be at variance with his anatomy. It appears that Barbin attempts to achieve this 'missing' transhistorical self-identity by the reiteration of her/his story to priests, doctors and posterity, although, as noted above, its fragmentary and heterogeneous nature inscribes Barbin ever further within her/his intersexual universe.

In Foucault's commentary on Barbin's case, while uniquely attempting to displace the binary of 'true sex', he constructs a binary of sexual non-identity and monosexuality, and implies that the monosexual environment of the convent is favourable to Barbin's pursuit of sexual non-identity. But, as Butler argues, this misrepresents both Barbin and the women in the convent, for it assumes their corporeal sameness and disregards her/his perception of distinctiveness. It also disavows her/his assumption of sexual agency following her/his sexual encounter with Sara, which is couched in appropriating terms, reminiscent of a Don Juan: 'Henceforth, Sara *belonged to me*!! … *She was mine*!!! What, in the natural order of things, ought to have separated us in the world had united us!!' (51) The sexual agency which is achieved by the consummation of desire will ensure Barbin's nemesis as s/he seeks to consolidate her/his fragile sense of a sexual self by making her/his intersexuality explicit. Yet condemned to transitory, solipsistic pleasures such as these, Barbin's predicament demonstrates – *contra* Foucault's later work – that the taking of pleasure is not what counts in the human subject's bid to achieve sexual agency. The reduction of sexual morphology and sexuality to a surface existence, for which Foucault seems to argue in his commentary on Barbin's life, disregards that sexual agents are always already in movement, assuming intersubjective and transtemporal stances which depend on a certain sedimentation of psycho-corporeal styles.[8]

Like many an autobiographer in pursuit of an impossible temporal self-coincidence, Barbin attempts to achieve an intersubjective and transtemporal sedimented narrative existence through the production of oral and written confessions. For it is rather through the mutual exchange of imaginative pleasure and the assumption and mutual acknowledgement of the material significance of sexual acts that subjects might ethically exist. Eluding the disciplinary gaze of her/his commentators and their nostalgia for sexual and corporeal symmetries, Barbin's intertextual and intersexual testimony performs the fiction of a true, sexed self.

Notes

1 All references to Barbin's autobiography are to the English translation, with an introduction by Michel Foucault (1980).
2 Daston and Park explain that the predominance of male seed (contributed by both mother and father), which would 'naturally' lodge in the right side of the uterus, would produce an 'unambiguously' male child whilst a predominance of female seed (again produced by both parents), 'naturally' lodging in the left side, would produce a 'wholly' female child. Other combinations could produce children of 'an intermediate sexual nature', such as 'effeminate' boys and 'dominant' girls. A perfect balance between male and female seed could result in an hermaphrodite; see Daston and Park (1995: 421).
3 One of the earliest examples of the autobiographical trope of 'the self as book' is in Montaigne's *Essais*, Book II: XVIII, 'Du Démentir'.
4 The singularity of Barbin's life was highlighted by Foucault in his introduction to 'Les Vies parallèlles' collection, in which the text was published in French: 'The Ancients liked to establish parallels between the lives of illustrious men; one heard those exemplary shades speaking across the centuries. Parallels are, I know, designed to meet in infinity. Let us imagine others which diverge infinitely. No meeting point, and nowhere for them to be recorded. They often have no echo but that of their condemnation. We have to grasp them in the force of the movement that separates them; we have to rediscover the instantaneous and startling wake they left when they plunged into an obscurity where "the story is no longer told" and where all "fame" is lost. It would be like an inverted Plutarch; lives that are so parallel that no one can make them meet' (trans. David Macey in Macey 1994: 361–2).
5 Furthermore, it is interesting that the problematic of representing the hermaphroditic body was also a perceived failing of the film version of the text; see the brief review of *Mystère Alexina* in *Cahiers du cinéma*, 374 (1985) 47.
6 The term 'hommo-sexualité' is used by Luce Irigaray as a pun on the Latin term 'homo' for 'man' and the Greek term 'homo' meaning 'same' to designate a sexually indifferent, phallic regime which cannot recognise lesbian desire and collapses it into phallic sameness; see Luce Irigaray (1985: 101–3).
7 I borrow the term 'the straight mind' from Monique Wittig (1992).

8 I refer here to Judith Butler's notion of 'a sedimentation of gender norms' which produce 'prevalent and compelling social fictions' such as 'natural sex' and a 'real woman' (Butler 1990: 140). In the case of Barbin, I emphasise her/his desire for the (impossible) materiality of gender sedimentation more than Butler does in *Gender Trouble*.

References

Butler, J. (1990) *Gender Trouble: Feminism and the Subversion of Identity*, New York and London, Routledge.

—— (1993) *Bodies that Matter: On the Discursive Limits of 'Sex'*, New York and London, Routledge.

Daston, L. and K. Park, (1995) 'The Hermaphrodite and the Orders of Nature: Sexual Ambiguity in Early Modern France', *GLQ*, 1 (4), 419–38.

Foucault, M. (1978) *Herculine Barbin dite Alexina B, présenté par Michel Foucault*, Paris, Gallimard.

—— (1980) *Herculine Barbin, Being the Recently Discovered Memoirs of a Nineteenth-Century French Hermaphrodite*, trans. R. McDougall, New York, Pantheon Books.

—— (1989) *Résumé des cours 1970-1982*, Paris, Julliard.

—— (1990) *The History of Sexuality. Vol. I: An Introduction*, trans. R. Hurley, Harmondsworth, Penguin.

Grosz, E. (1994) *Volatile Bodies: Towards a Corporeal Feminism*, Bloomington and Indianapolis, Indiana University Press.

Irigaray, L. (1985) *Speculum of the Other Woman*, trans. G.C. Gill, Ithaca, Cornell University Press.

Macey, D. (1994) *The Lives of Michel Foucault*, London, Vintage.

Rousseau, J.J. (1953) *The Confessions*, trans. J.M. Cohen, Harmondsworth, Penguin.

Wittig, M. (1992) *The Straight Mind and Other Essays*, Hemel Hempstead, Harvester Wheatsheaf.

6

EMBODYING STRANGERS

SARA AHMED

The AA subway train to Harlem. I clutch my mother's sleeve, her arms full of shopping bags, christmas-heavy. The wet smell of winter clothes, the train's lurching. My mother spots an almost seat, pushes my little snowsuited body down. On one side of me a man reading a paper. On the other, a woman in a fur hat staring at me. Her mouth twitches as she stares and then her gaze drops down, pulling mine with it. Her leather-gloved hand plucks at the line where my new blue snowpants and her sleek fur coat meet. She jerks her coat close to her. I look. I do not see whatever terrible thing she is seeing on the seat between us – probably a roach. But she has communicated her horror to me. It must be something very bad from the way she's looking, so I pull my snowsuit closer to me away from it, too. When I look up the woman is still staring at me, her nose holes and eyes huge. And suddenly I realise there is nothing crawling up the seat between us; it is me she doesn't want her coat to touch. The fur brushes past my face as she stands with a shudder and holds on to a strap in the speeding train. Born and bred a New York City child, I quickly slide over to make room for my mother to sit down. No word has been spoken. I'm afraid to say anything to my mother because I don't know what I have done. I look at the side of my snow pants, secretly. Is there something on them? Something's going on here I do not understand, but I will never forget it. Her eyes. The flared nostrils. The hate. (Lorde 1984: 147–8)

How do strange encounters, encounters in which something that cannot be named is passed between subjects, serve to embody the subject? How do encounters with others whom we recognise as strangers take place at the level of the body?[1] To what extent do such encounters involve, not just reading the stranger's body, but defining the contours or boundaries of the body-at-home, through the very gestures which enable a withdrawal from the stranger's co-presence in a given social space? In the above encounter, recalled as memory, Audre Lorde ends with 'the hate'. It is an encounter in which some-

thing has passed, but something which, as a child, she failed to understand. The sense that something is wrong is communicated, not through words, but through the body of another, 'her nose holes and eyes huge'. What is the woman's body saying? How do we read her body? The woman's bodily gestures express her hate, her fear, her disgust. The strange encounter is played out *on* the body, and is played out *with* the emotions.

The encounter, while ending with 'the hate', also ends with the reconstitution of bodily space. The bodies that come together, that almost touch and co-mingle, slide away from each other, becoming relived in their apartness. The particular bodies which move apart allow the redefinition of social as well as bodily integrity: black bodies are expelled from the white social body despite the threat of further discomfort (the woman now must stand in order to keep her place, that is, in order to keep the black body at a distance). The emotion of 'hate' aligns the particular white body with the bodily form of the community – such an emotion functions to substantiate the threat of invasion and contamination in the dirty bodies of strangers. The gestures which allow the white body to withdraw from the stranger's body hence reduce that body to dirt, to 'matter out of place' (Douglas 1996: 36), such that the stranger becomes recognised *as the body out of place*. Through such strange encounters, bodies are both deformed and reformed; they take form through and against other bodily forms.

Does Audre Lorde's narrative of the encounter involve her self-designation as the body out of place? Certainly, her perception of the cause of the woman's bodily gestures is a misperception that creates an object. The object – the roach – comes to stand for, or stand in for, the cause of 'the hate'. The roach crawls up between them; the roach, as the carrier of dirt, is that which divides the two bodies, forcing them to move apart. Hence, the 'I' of the narrative pulls her snowsuit 'away from it too'. But the 'it' that divides them is not the roach; the narrator comes to realise that 'it is me she doesn't want her coat to touch'. What the woman's clothes must not touch is not a roach that crawls between them, but Audre herself.[2] Audre becomes the 'it' that stands between the possibility of their clothes touching; she becomes the roach – the impossible and phobic object – that threatens to crawl from one to the other: 'I don't know what I have done. I look at the side of my snow pants secretly. Is there something on them?' Here, the stranger's lived embodiment hesitates on the question, 'am I the roach?' or 'am I the dirt which forces me away?'

In this essay, I shall address the role of such strange and 'eye-to-eye' (Lorde 1984) encounters in the formation of bodily and social space. The word 'encounter' suggests a meeting, but a meeting which involves surprise. How does embodiment take shape through encounters with others that surprise 'us', that shift the boundaries of the familiar, of that which is already recognisable or known? By opening with a scene from Audre Lorde's *Sister Outsider*, I have already pointed to the complexity of 'the encounter' as always mediated through a range of different kinds of text or, more precisely, different forms of writing. In *Sister Outsider*, Lorde uses the poetics of remembering to dramatise the operation of racism on her body, in the violence of its particularity. At the same time, we must remind ourselves as readers, that the recalled encounter between herself and an-other is written, and that it functions as an aspect of an argument within a text that shifts between academic, personal and political modes of address. The encounter is hence lived and written, but it fails to be an event, or even a text, that is simply in the present. The encounter is already recalled and relived in the metonymic slide between different encounters: not only do we have the (re)narrativised encounter between the black child and the white woman, but also we have encounters between the narrator's past and present self, between an apparently intimate self and a public life, between the writer and her subject, and between the reader (myself as reader) and the text.

A concern with strange encounters is hence a concern with the dialogical production of different bodies and texts. While Audre Lorde's text allows me to address precisely what is at stake in such strange encounters – to dramatise that there is always *somebody* at stake – it does not provide the only means by which I ask the impossible question, 'what about the stranger's body?' In some sense, the ethics of my own encounter with *Sister Outsider* demands a more responsible reading, a reading which admits of its limits, its partiality and its fragility. I hence do not use the text as an example which simply holds my argument together, as the object of my writing. I move towards and away from her text, only ever sliding across it: my encounter with this text allows me to re-encounter different kinds of body and text. Quite clearly, I am touched by Audre Lorde's story – 'being touched' is a way of understanding how encounters always involve not only a meeting of bodies, but also a meeting between bodies and texts (the face-to-face of intimate readings), in which the subject is moved from her place.

My concern with strange encounters as bodily encounters requires that we first address the question, 'what is the body?' Within feminist theory, 'bodies' certainly have become a privileged focus of attention. There has been an acknowledgement that bodies are not simply given (as 'nature'), that bodies are differentiated, and that subjectivity and identity cannot be separated from specific forms of embodiment (Bordo 1993). However, despite many appeals to the differentiated body, I think there has been less substantive analysis of how 'bodies' come to be lived through being differentiated from other bodies, whereby differences in 'other bodies' already mark 'the body' as such. For example, in Elizabeth Grosz's *Volatile Bodies*, there is little mention of the racialised nature of the multiple and differentiated bodies to which she dedicates her text, except in the following quotation:

> The more or less permanent etching of even the civilized body by discursive systems is perhaps easier to read if the civilized body is decontextualized, stripped of clothing and adornment, behaviorally displayed in its nakedness. The naked European/American/African/Australian body (and clearly even within these categories there is enormous cultural variation) is still marked by its disciplinary history, by its habitual patterns of movement, by the corporeal commitments it has undertaken in day-to-day life. It is in no sense a natural body, for it is as culturally, racially, sexually, possibly even as class distinctive, as it would be if it were clothed. (Grosz 1994: 142)

Here, Grosz introduces 'race' as a signifier of difference ('European/American/African/Asian/Australian') in order to illustrate her point that there is not a natural or indeed real body, that the body is always clothed, that is, always inscribed within particular cultural formations. Race becomes a means by which Grosz illustrates a philosophical shift in thinking about bodies. It appears then (and also disappears) as a *figure* for the differentiated body. In this sense, 'race' is made present only through an act of negation: it is included as a vehicle for the re-presentation of a philosophy of the body rather than as a constitutive and positive term of analysis. This metaphoric reliance on race to signify the differentiated body has quite clear theoretical and political implications. It means that a philosophy of the differentiated body – a philosophy of difference – does not necessarily involve, in practice, a recognition of the function of difference in establishing not only bodily matter, but also *which bodies come to matter*. Such an approach is in danger of fetishising 'the body' itself,

by assuming that it can *contain* the difference within the singularity of a figure.

In order to avoid reading the differentiated body through the figure of race, we need to ask: how do bodies come to be lived precisely through being differentiated from other bodies, whereby the differences in other bodies make a difference to such lived embodiment? Such questions require us to consider how the very materialisation of bodies in time and space involves a process of differentiation. Judith Butler's consideration of 'bodies that matter' defines 'materialisation' as the production of an 'effect of boundary, fixity and surface' (Butler 1993: 9). To examine the function of cultural difference and social antagonism in the constitution of bodily matters is not then simply to read differences on the surface of the body (the body as text), but to account for the very effect of the surface, and to account for how bodies come to take certain shapes over others, and in relation to others.

At one level, psychoanalysis seems to provide us with such a model of embodiment. In Lacanian psychoanalysis, for example, the child's accession into the realm of subjectivity takes place through the process of assuming a body image. In 'The Mirror Stage as Formative of the Function of the I', Lacan postulates that when the child sees itself in the mirror, that self-knowledge is actually a *mé-connaisance*, a mistaking of the image for the thing itself. This act 'rebounds in the case of the child in a series of gestures in which he experiences in play the relation between the movements assumed in the image and the reflected environment – the child's own body, and the persons and thing' (Lacan 1977: 1). The misrecognition provides the child with an 'imaginary anatomy'.

Franz Fanon takes up the Lacanian model of the mirror stage in an interesting footnote in *Black Skin, White Masks*. He suggests that there is a racialised dynamic to the assumption of the body image: 'When one has grasped the mechanism described by Lacan, one can have no further doubt that the real Other for the white man is and will continue to be the black man. And conversely. Only for the white man The Other is perceived on the level of the body image, absolutely as not-self – that is, the unidentifiable, the unassimilable' (Fanon 1972: 114). Fanon is clearly using the Lacanian theory as a general theory of the psychic mechanisms which institute subjectivity, which he then redefines as already racialised. The theory of identification which is articulated by Lacan as a *general* theory of the subject (he writes that

the 'drama' of the mirror stage will 'mark with its rigid structure the subject's entire mental development' (Lacan 1997: 4)) is here immediately differentiated and divided. The relation of the 'I' to the 'not-I' is determined not simply by the psychic processes of misrecognition and projection, but by the racialising of the ego (white) in relation to the materiality of other bodies (black).

Lacan's theory defines both the subject and its other in terms of the relation between the play of the assumed image and 'the reflected environment', which includes the child's own body, 'persons and things' (Lacan 1997: 1). The dialectic of self-othering defined here is abstract: the other is simply that which the mirror presents as beyond the spatial form of the child's body image, which is to say, *any-beyond, to any-body*. Fanon's approach implicitly challenges the Lacanian model in the suggestion that both the embodied subject and the persons and things which are excluded from it are *already* particular and *already* framed and constituted in a broader sociality. When assuming a bodily image, subjects hence also assume the burden of particular bodily others with which that image is already inflected (this is the sense in which the 'drama of the mirror stage' involves historicity). But the assumption of this bodily image, although it constitutes the subject, does not contain it; the assumption of the image does not lead to the securing of the contours of 'the subject'. Rather than simply understanding identification as something that has already taken place in the formation of subjectivity, we can consider how identifications perpetually fail to grasp 'others' in social encounters. That is, subjects assume images which they cannot be or fully inhabit, but the images they assume are already differentiated: subjects and others become differentiated at the very same moment that they are constituted as such. Fanon's reworking of Lacan implies that the self–other dynamic cannot be abstracted, as it is contingent on bodily differences which are themselves inflected by histories of particular bodily others.

An analysis of strange encounters as bodily encounters suggests, then, that the marking out of the boundary lines between bodies, through the assumption of a bodily image, involves social practices and techniques of differentiation. That is, bodies become differentiated not only *from each other* or *from the other*, but also through differentiating *between others*, who have a different function in establishing the permeability of bodily space. Here, there is no generalisable other which serves to establish the illusion of bodily integrity; rather the

body becomes imagined as a (racialised and gendered) particularity, through being related to, and separated from, particular bodily others. Indeed, different bodies come to be lived through the very habits and gestures of marking out bodily space, that is, through the differentiation of 'others' into familiar (assimilable, touchable) and strange (unassimilable, untouchable).

Such a differentiation is registered on the skin, as the bodily matter which produces precisely the 'effect of boundary, fixity and surface' (Butler 1993: 9). The skin functions as a boundary or border, by supposedly holding or containing the subject within a certain contour, keeping the subject inside, and the other outside. But as a border, the skin performs that peculiar destabilising logic, calling into question the exclusion of the other from the subject and risking the subject's falling into – or becoming – the other. Hence, Jean-Luc Nancy describes the skin as an *exposure* to the other, as always passing from one to the other (Nancy 1994: 30). The skin may open out a moment of undecidability, which is at once a rupture or breakage, where the subject risks its interiority, where it meets and leaks into the world at large. Furthermore, if the skin is a border, then it is *a border which feels*. In the work of Jennifer Biddle, for example, the skin, 'as the outer covering of the material body', is where the intensity of emotions such as shame is registered (Biddle 1997: 228). So although the skin appears to be the matter which separates and contains the body, it allows us to consider how the materialisation of bodies involves, not containment, but an affective opening out of bodies to other bodies, in the sense that skin registers how bodies are touched by other bodies.

However, I do not want to suggest that the skin contains a logic which provides us with the means of rearticulating the relation of self and other *in general*. Such an approach would fetishise the skin by assuming that it contains a meaning in and of itself (just as 'the body' can become a fetish if it is read through a figure of difference). Instead, we need to consider how the skin, as the border which feels, functions as a mechanism for social differentiation. Such a differentiation can be understood in terms of economies of touch. Rather than thinking of bodies as always exposed and touchable, we can think about how different ways of touching and not touching allow the reconfiguration of bodily and social space. For example, friendship and familial relations involve the ritualisation of certain forms of touch, while the recognition of another as a stranger might involve a refusal to get too close through touch. Returning to the encounter offered in *Sister Out-*

sider, we can consider how the white woman's refusal to touch the black child does not simply stand for the expulsion of blackness from white social space, but actually reconstitutes social space through the reconstitution of the apartness of the white body. The reconstitution of bodily and social space involves a process of *making the skin crawl*; the threat posed by strange bodies to bodily and social integrity is registered on the skin. But the stranger's body cannot be reified as the untouchable. Although the white woman refuses to touch the black child's clothes, she is still touched by her; her bodily gestures express precisely the horror of being touched. In other words, to withdraw from a relation of physical proximity from bodies recognised as strange is precisely to be touched by those bodies, in such a way that the subject is moved from its place.

Indeed, in the work of Paul Schilder on *The Image and Appearance of the Human Body*, there is a recognition that bodily contours are always shrinking and expanding in the bodily encounter with other bodies (Schilder 1970: 210). In this sense, the permeability of bodily space is produced through the 'connectedness' between bodies (= inter-embodiment): 'A body is necessarily a body amongst other bodies' (Schilder 1970: 281). However, different forms of connection have different effects on that permeability. Bodies that are close by may be taken into the body image, hence expanding the contours of the body. Schilder's work suggests how familiar bodies can be incorporated though a sense of community – *being together as like bodies*: 'We expand the body when we feel friendly and loving. We open our arms, we would like to enclose humanity in them' (Schilder 1970: 210). However, bodies that are further away are less to likely to offer this expanded sense of the body: 'There is no doubt that the far distant body will offer less possibility of interplay' (Schilder 1970: 235). Extending from Schilder's work, we could suggest that further-away bodies – and this sense of distance is irreducible to physical distance – may serve to contract or shrink bodily space, producing discomfort and resistance. Strange bodies may hence be expelled from both bodily and social space – *moving apart as unlike bodies*. Both incorporation and expulsion serve to re-form the contours of the body, suggesting that the skin not only registers familiarity and strangeness, but is touched by both differently, in such a way that the skin becomes a locus of social differentiation. In this sense, the bodily encounter with others who are assimilable (close) and unassimilable (distant) involves the re-forming of both bodily and social space.

How does the bodily process of expulsion produce unassimilable bodies? Kristeva's approach to abjection emphasises the function of expulsion in the constitution of social and bodily space. In *Powers of Horror: An Essay on Abjection*, Kristeva argues that, 'There looms, within abjection, one of those violent, dark revolts of being, directed against a threat that seems to emanate from an exorbitant outside or inside; ejected beyond the scope of the possible, the tolerable, the thinkable' (Kristeva 1982: 1). The abject relates to what is revolting, to what threatens the boundaries of both thought and identity. The abject is expelled – like vomit – and the process of expulsion seems to establish the boundary line of the subject. However, at the same time, the abject holds an uncanny fascination for the subject, demanding its attention, and desire: 'from its place of banishment, the abject does not cease to challenge its master' (Kristeva 1982: 2). As such, the abject both establishes and undermines the border between inside and outside: 'It is as if the skin, a fragile container, no longer guaranteed the integrity of "one's clean self"' (Kristeva 1982: 53).

Noticeably, Kristeva's approach to abjection emphasises the physicality of emotions that threaten to pulverise the subject, and to cross the boundary line. Such physicality is directed towards filth, defilement and pollution, though these are not themselves the abject. Rather, they define the crisis posed by abjection in so far as they pass between inside and outside. The abject is not reducible to a particular object or body: the abject relates precisely to the border which itself becomes the object (Kristeva 1982: 4). In the encounter between the white woman and the black child, when the woman withdraws with horror and disgust at the black body, the border that is threatened by their skin and clothes touching is itself turned into an object: the roach. It is through a complex sliding of signifiers and bodies that the roach becomes the black body, and the black body becomes the border which is hence transformed into an object of abjection. So the narrator can only ask herself whether there is something on her snow pants that has 'caused' the hate.

The relation between the physical emotions of horror and disgust, the matter (out of place) of dirt and pollution, and the production of strange bodies as objects is determined through the 'border': strange bodies threaten to traverse the border that establishes the 'clean body' of the privileged subject. However, we still need to question how some bodies come to be the impossible object that both establishes and confounds the border (we can return, here, to the

stranger's question, 'am I the dirt that forces me to move away?'). What is required is an analysis of how identities are differentiated through the metonymic association of particular bodies with the border that confounds identity (= strange bodies) – including women's bodies, lesbian and gay bodies, black bodies, working-class bodies, disabled bodies and aged bodies.

In *Bodies that Matter*, Judith Butler considers how abjection functions to produce a domain of unthinkable and unliveable bodies. She writes, 'This exclusionary matrix by which subjects are formed thus requires the simultaneous production of a domain of abject beings, those who are not yet "subjects", but who form the constitutive outside to the domain of the subject' (Butler 1993: 3). Such a domain of abject beings inhabit the 'unliveable' and 'uninhabitable' zones of social life. These are at the same time 'densely populated by those who do not enjoy the status of the subject' (Butler 1993: 3). How can zones which are uninhabitable be populated? I would suggest that such zones are inhabited precisely by those bodies which have *failed to materialise in the familiar form* (the 'human body' whose appearance of being unmarked by strangeness is precisely the mark of its privilege). One does not then live *in* an abject body: abject bodies are precisely those bodies that are not inhabited, that are not liveable as such. Through the process of expulsion, particular bodily others becomes strange bodies: bodies that are unliveable in so far as they are already recognisable as bodies out of place.

Here, the marking out of the border which defines the subject – the constitutive outside – is the condition of possibility for the subject, the process through which it can come into being. *This* subject is precisely the subject who determines the formation of home – the space one inhabits as liveable – and whose access to subjectivity is determined through being-at-home – the comfortable and safe domain from which particular bodily others are expelled. The subject who can act and move in the world with ease does so through expelling that which is strange from this zone of the living (although the expulsion always leaves its trace). To account for strange bodies is precisely then to account for the *historical determination of the form of the privileged body or the body-at-home*: the body which comes to matter – which materialises as the familiar – through the recognition of strange bodies as matter out of place. Through the cartographic mapping of other spaces and bodies as strange and uninhabitable, this body becomes home, providing the contours of 'inhabitable' space. In some sense,

the domain of the white masculine subject is established by the equation of his body with home as such: his body transcends itself to become simply where he lives (= the knowable, inhabitable world).

However, the production of unliveable or unassimilable strange bodies involves contingent and overdetermined regimes of difference: in the encounter discussed in this essay, the strange body is the black body, a strange body in relation to the liveable domain of the white female subject. The antagonism between white and black femininities is here determined through a bodily encounter: an encounter which involves the refusal to share social space, to touch each other, a refusal of cohabitation that contains the black body *as body*, and allows the white body to move away, even away from itself. However, other forms of power differentiation intersect in the recognition of bodily 'strangerness': while the white female body can become lived as the body-at-home by the withdrawal from proximity to the strange black body, the white female body becomes uninhabitable and unliveable in relation to the formation of the masculine body. What is required is precisely an analysis of how abjection – the unstable constitution of the domain of the liveable – brings into play multiple forms of social antagonism. The relationship between the processes of expulsion which produce the abject and the marking of, and withdrawal from, particular bodily others as strange bodies is hence contingent rather than necessary: there is a metonymic sliding across different borders, objects and bodies within such strange encounters.

Indeed, strange bodies are precisely those bodies that are temporarily assimilated as the unassimilable within the encounter: they function as the border that defines both the space into which the familiar body – the body which is unmarked by strangeness as its mark of privilege – cannot cross, and the space in which such a body constitutes itself as (at) home. Hence the strange body is constructed through a process of expulsion – a movement between inside and outside which renders that the stranger's body has already touched the surface of the skin which appears to contain the body-at-home. The economy of xenophobia – the production of the stranger's body as an impossible and phobic object – involves not just reading the stranger's body as dirt and filth, but the re-forming of the contours of the body-at-home, through the very affective gestures which enable the withdrawal from the stranger's cohabitation in a given social space. The withdrawal remains registered on the skin, on the border which feels.

Notes

1 As the question suggests, I define the 'stranger' not as some-body that we do not recognise, but as some-body that we recognise *as a stranger*, a form of recognition which relies on a differentiation between the familiar and strange (hence being a stranger easily slides into *being strange*). The process of recognising strangers – those who do not belong in a given social space – involves techniques of differentiation through reading the bodies of others (Do you look as though you belong here? Are you familiar or strange?). The different value given to social spaces suggests that 'being a stranger' is not simply a relativisable condition of the world: some bodies are read as stranger than others precisely because of the restricted 'ownership' of valued spaces.

2 To name the 'I' as Audre is of course a very particular strategy of reading. On the one hand, I am separating the 'I' from the proper name of Audre Lorde. On the other hand, I am assuming a connection between Audre as child (the 'I' as writing effect) and Audre Lorde as adult (the writer). Of course, we do not have access to Audre as child outside the narrating of the story. 'Audre' is hence a signifier. Indeed, the autobiographical imperative can be articulated as the 'writing of the self' through the desire to inhabit the figure of 'the child' and to speak from the child's perspective. The 'I' within such writings hence slides between present and past: the 'I' is the child's only in so far as it must belong to the present; it is the 'I' that the 'I' in the present would have been. The relationship between autobiography, temporality and memory is hence instructive and is played out in the drama of uncertainty about which 'I' is speaking.

References

Biddle, J. (1997) 'Shame', *Australian Feminist Studies*, 2 (6), 222–39.

Bordo, S. (1993) *Unbearable Weight: Feminism, Western Culture and the Body*, Berkeley, University of California Press.

Butler, J. (1993) *Bodies that Matter: On the Discursive Limits of 'Sex'*, London and New York, Routledge.

Douglas, M. (1996) *Purity and Danger: An Analysis of the Concepts of Pollution and Taboo*, London and New York, Routledge.

Fanon, Franz (1972) *Black Skin, White Masks*, London, Paladin.

Grosz, E. (1994) *Volatile Bodies: Towards a Corporeal Feminism*, London and New York, Routledge.

Kristeva, J. (1982) *Powers of Horror: An Essay on Abjection*, Columbia, Columbia University Press.

Lacan, J. (1977) *Écrits: A Selection*, London, Tavistock Publications.

Lorde, A. (1984) *Sister Outsider: Essays and Speeches*, New York, Crossing Press.

Nancy, J.L. (1994) 'Corpus', in Juliet Flower MacCannell and Laura Zakarn (eds), *Thinking Bodies*, Stanford, Stanford University Press.

Schilder, P. (1970) *The Image and Appearance of the Human Body*, New York, International Universities Press.

7

MATERIAL DIFFERENCE AND THE SUPPLEMENTARY BODY

in Alice Walker's *The Color Purple*

CHARMAINE EDDY

Contemporary critical practice has come to be regulated by the standard categories of identity politics. These categories – for the most part subsumed under the triad of race, gender and sexual orientation – situate the representative dimensions of the author and text, as well as the epistemological limitations and inadequacies of the literary critic, in terms of material characteristics and practices. The discourse of identity politics emerged in large part to counteract the false homogeneity and erasure of difference instilled in the post-Cartesian concept of the disembodied epistemological subject. Barbara Johnson has described the gendered discursive effects of this disembodiment as 'the naturalness of female effacement in the subtly male pseudogenderlessness of language' (Johnson 1987: 41), and one need only rephrase Johnson to include the naturalness of 'pseudoracelessness' and heteronormativity to understand the contribution identity politics has made as a response to the legacy of objectivist epistemologies.

By materialising difference, or locating cultural reference points through the body, the discourse of identity politics raises questions about the function and effects of the retention of corporeal markers in our critical practice. As with the search for a distinct female or black female aesthetic (Showalter 1977, 1985; Kolodny 1975, 1985; Smith 1985; McDowell 1985; Collins 1989), the discourse of identity politics, even when overtly anti-essentialist, tacitly accepts the anatomical as the foundation for cultural difference, without questioning the structuring of the anatomical through sex, gender and race relations. Theories of identity politics retain the materiality of the body as an irreducible determinism – in Gayatri Spivak's words, a chromatism or

genitalism (1990: 62) – with gender, race and sexuality related directly to already sexed and raced bodies, understood as prediscursive and prior to culture. To borrow from Judith Butler's critique of the sex/gender distinction in constructivist thinking, the body is thus positioned as 'the natural[,] as that which is "before" intelligibility, in need of the mark, if not the mar, of the social to signify, to be known, to acquire value' (1993: 4–5). As Butler goes on to say, '[t]his misses the point that nature has a history, and not merely a social one' (5). By establishing the body as a ground always already traversed by biological markers, the discourse of identity politics fails to attend to the history of the *choice* of those particular biological markers over others, and to acknowledge the role of our cultural texts in that history. Even when the cultural value of these biological sites is reassessed, the critical task becomes relegated to a rearticulation of a pre-established ground, a retracing of a corporeal topography already charted with fixed material signposts.

By accepting the body's sexuate or racial characteristics – the genitals and chromatic features, for example – as the irreducible proof of one's sex or race, the discourse of identity politics does more than collapse gendered narratives into sexuate characteristics, or racial narratives into racial morphological characteristics. It also equates these characteristics with the materiality of the body, as if they merge in the Imaginary in an uncomplicated, one-to-one relationship with the subject's self-identification. However, the body is not always perceived this distinctly in the representational economy of critical discourse. When I (a white feminist) interpret texts written by black women writers, for example, common practice encourages me to separate gender from race, and to suppress the similarity of our gendered positioning so as not to falsely 'homogenise' racial difference within white feminist parameters (Abel 1993; Johnson 1986; Homans 1994). This bifurcation of gender from race materialises racial differences, but it does so only by threatening to erase sexuate characteristics from the representational frame, and it therefore ensures the partial representation – or misrepresentation – of the body's materiality. A similar misrecognition is at work in the infamous critique of Alice Walker's *The Color Purple* by male African-American literary theorists, who have argued that her political commitment to gender abrogates her responsibility to their race, because the central character's gendered liberation through a discovery of her lesbianism and through writing appears to take place as a consequence of a negative, even racially

clichéd, representation of the black male characters as rapists and abusers.[1] The categories of identity politics cannot be perceived together in these instances, but instead function like reversible figure/ground images (two faces or a wine goblet) or Dr Jekyll and Mr Hyde: you cannot see one when you see the other.

This understanding of the categories of gender and race as separable, distinct economies reveals a gap between the perception and representation of the materiality of the body in our critical practice, and it raises the question as to what we actually *see* when we perform the misidentifications crucial to our self-formations and the role materiality plays in this misperception. Psychoanalysis reminds us that we can never take at face value what is represented in the mirror of the Imaginary. As much as one might concur with Irigaray's critique of the ocularocentrism of Freudian and Lacanian theories – her putting into view that the feminine remains unrepresented and unrepresentable – both Freud and Lacan situate the body as the screen upon which our misidentifications are projected and played out. In Dora's case, Freud situates this misrecognition of the body as symptomatic, with corporeal pain as a semiotic system to be read in terms of displaced psychic signs (Freud 1953). Dora's recollection of an unwanted kiss from Herr K is retained as a corporeal memory of pressure on her upper body and disgust (as a sensation in the mouth). Freud, however, suggests that Dora's corporeal symptoms are misrecognised and displaced. The pressure on her upper body is a misrecognition of the repressed memory of the pressure of Herr K's erect penis, and the psyche, in sending its message through the body, has displaced the bodily sensation to the site of Dora's earliest hysterical symptoms (catarrh, cough, loss of speech). The body of the hysteric thus becomes the tool of communication for the psyche, another form of language for the unconscious beyond slips of the tongue and dreams, with materiality a surface upon which psychic memories are marked as symptomatic residue. In 'The Mirror Stage', Lacan articulates the body as the scene of a utopian misidentification for the infant, who perceives the corporeal image in the mirror as having capabilities beyond his or her own limited motor capacities, but nevertheless assumes that this idealised image is equivalent with the self. Lacan labels this image the 'Ideal-I' (1977: 2), and he describes 'the total form of the body' as 'situat[ing] the agency of the ego, before its social determination, in a fictional direction, which will always remain irreducible for the individual alone' (1977: 2).

What these psychoanalytic articulations of the body tell us, then, is that corporeality is always already '*marked as*' something other in our representational economies. I am introducing the concept of a bodily '*marking as*' here in an attempt to open up a space between the perception and representation of the cultural performativity of the body. While I am not suggesting the possibility of a recoverable 'originary' body prior to its marking, none the less the body is '*marked as*' symptomatic in Freud, or sexed or raced in Walker criticism, and corporeality itself becomes impossible to conceive outside of these representational systems. To think of the body as '*marked as*' is to intervene between the materiality of the body and the materialising of cultural difference, because the '*marking*' of the body '*as*' sexed or raced suggests that something other than corporeality is made visible through this representation, and what is made visible is never represented *as such*. Butler's interrogation of the compulsory order of sex/gender/desire, for example, illustrates that gender relations function as the system of cultural representation in which the body is '*marked as*' an already sexed body due to a particular fetishising of the genitals (1990: 7). By establishing the sexed body as prior to gender, gender produces the genitals as the material, empirical evidence for itself, and this '*posit[ing]* or *signif[ying]* as *prior* ... produces as an *effect* of its own procedure the very body that it nevertheless and simultaneously claims to discover as that which *precedes* its own action' (Butler 1993: 30).

The '*marking*' of the body '*as*' something other ultimately illustrates that corporeality is positioned as supplementary in and through its representations.[2] To say that the body is supplementary to our cultural narratives may appear to say no more than we already know about contemporary normative practices of the feminine, through which, for example, beauty myths and eating disorders replace the flesh itself with an ideal form of the corporeal. However, the logic of the supplement suggests that the odd visibility of the body is not simply replaced by or substituted with an idealised misrepresentation; it also co-exists and merges with that misrepresentation. Derrida has articulated the logic of the supplement as follows:

> [T]he concept of the supplement – which here determines that of the representative image – harbors within itself two significations whose cohabitation is as strange as it is necessary. The supplement adds itself, it is a surplus, a plenitude enriching another plenitude, the *fullest measure* of presence. It cumulates and accumulates presence ...

> But the supplement supplements. It adds only to replace. It intervenes or insinuates itself *in-the-place-of*; if it fills, it is as if one fills a void. If it represents and makes an image, it is by the anterior default of a presence. Compensatory [*suppléant*] and vicarious, the supplement is an adjunct, a subaltern instance which *takes-(the)-place* [*tient-lieu*]. As substitute, it is not simply added to the positivity of a presence, it produces no relief, its place is assigned in the structure by the mark of an emptiness. Somewhere, something can be filled up *of itself*, can accomplish itself, only by allowing itself to be filled through sign and proxy. The sign is always the supplement of the thing itself. (1974: 145)

In this way, the corporeal exists in a supplementary relationship to the cultural narratives of gender and race, as well as to the sexed and raced characteristics presumed to provide material proof for cultural difference. The logic of the supplement exposes the operation of sexed and raced bodily marks as both in 'excess of' or 'added to' corporeality, whereby the corporeal acts to reassure the subject of 'the *fullest measure* of presence' of those bodily marks; and as a substitution of those marks *for* that corporeality, vicariously '*tak[ing]-(the)-place*' of it, compensating for 'the mark of an emptiness' that the body has become.

In the space I have left, I wish to turn to the empty mark of corporeality and the supplementary body by reading representations of Celie, the central character in Alice Walker's *The Color Purple*. Bodies are not easy matters in *The Color Purple*. Celie's body emerges as visible in the discursive representation '*marked as*' sexed and heterosexual. Having no ontological priority to the discursive, paternal prohibition which opens the text and accompanies her rape by her stepfather, Celie's body materialises as the act of violation traces sexual and heterosexual narratives upon her, thus producing the body within a sexualised and gendered economy. As with the representation of the body always *as something else*, the representation of the act of violation which sutures together cultural narratives of gender with the body remains unrepresented as itself and occurs instead first as a discursive prohibition against discourse – '*You better not never tell nobody but God*' (Walker 1982: 3) – and later as a naive retrospective account. This discursive encoding of the act of rape masks the materiality of its effects, while the triply negative (apparently spoken) injunction against 'telling' registers the ambivalence discourse must narrate as it reveals the mechanism whereby the materiality of the body is both represented 'as' something other and erased.

The body is portrayed as a discursive and material enigma in Celie's burgeoning discourse of subjectivity. The naive expressions for the sexual act in Celie's opening letter ('his thing', 'wiggle it around', 'inside me') and her continuing inability to construct an explicable causal or contextual account of the rapes illustrate that the sexual and heterosexual narratives tracing the body, while never separable from the body, also never become 'naturalised' there. Instead, the narratives writing the body manifest themselves materially as a corporeal text which mis-speaks both itself and the history of violence which has made the body visible as heterosexual. In Celie's case, the corporeal text begins to mis-signify a narrative of maternal subjectivity. Celie is raped by the man she believes to be her father, which structures her body in the sexual position of her mother and eventually results in her own pregnancy. As with the heterosexual narrative, the maternal inscription inaugurates certain bodily transformations confirming for Celie her body as a site of meaning which signifies enigmatically according to what is imprinted on it by others : 'Nettie still don't understand. I don't neither. All us notice is I'm all the time sick and fat' (Walker 1982: 12). Though Celie experiences the mis-spoken maternal text as bodily enigma, it never fully merges with the representation of her materiality or with female bodies. Celie is always represented as the 'coming-into-being' of the maternal, or pregnant (Walker 1982: 3); as the 'no-longer-maternal', or bereaved woman whose children have been taken from her (Walker 1982: 4–5); or, in Walker's revisioning of maternity as a relational activity circulating among women (Hite 1989: 271; hooks 1993: 294), as the surrogate maternal, caring for children not her own. Celie's mother is erased from the representative domain, no longer the sexual partner of her husband or a functioning parent when the novel opens, and dead when Celie writes her second letter. As further evidence of the lack of a 'naturalised' maternal female body, Harpo, Celie's stepson, becomes defined in terms of the maternal. Harpo's belly grows larger, until Celie asks him 'When it due?' (Walker 1982: 64), and he later functions in a domestic and nurturing role when rehabilitating his father.

While Celie's 'marking as' the heterosexual and maternal is clearly dislocated from the corporeal, her 'marking as' the subordinate feminine offers an example of the simultaneous instantiation and erasure of the visibility of materiality – its supplementarity through the placing of the mark of sex and gender. Mr ___, Celie's titularly named

husband, beats her, inscribing upon her body a masculinist representative domain in which the body appears as the subordinate feminine. As Celie's body confirms the text of female subordination, its representation moves towards figurative disembodiedness, with her voice silenced, her body transformed into insensate 'wood' (Walker 1982: 22), and her external appearance as 'buried' (Walker 1982: 18). She becomes the Nothing to Mr ___'s plenitude, the negative being in his representational economy. 'You black, you pore, you ugly, you a woman. Goddam, he say, you nothing at all' (Walker 1982: 176).

The act of inscribing the subordinate feminine onto Celie also marks the traces of a circuitous masculine desire which renders the feminine supplementary: replaced by what Irigaray and Eve Kosofsky Sedgwick identify as a homosocial bonding between men (Irigaray 1985: 170–97; Sedgwick 1985), and yet a surplus economy in which the feminine becomes added to itself, figured as lesbian intimacy between Celie and blues singer Shug Avery. Mr ___ has been forced by his father and, later, Celie's stepfather to marry women who substitute for women he has desired. Anna Julia, Mr ___'s first wife, has functioned as a substitute for Shug, the woman his father refused to allow him to marry, just as Celie represents a displacement for Nettie, who was denied to Mr ___ by Celie's stepfather, and ultimately for Shug as well. The dyadic heterosexual relationship between Celie and Mr ___ operates within a triangular structure, in which Mr ___'s thwarted desires are traced out upon the body of the female substitute in an attempt to transform her body into this absent third. When Shug asks Celie 'What he beat you for?', she responds, 'For being me and not you' (Walker 1982: 66). Because this third person has already been rejected as a desired object, beating the surrogate body in an attempt to merge it with the rejected object actually performs an erasure of both, collapsing the apparent heterosexual triangle between one man and two women into the Oedipal rivalry between Mr ___ and his father which is represented as its origin. The surplus effect of this collapse is to position Celie and Shug, not as rivals for Mr ___'s sexual attentions, but as lesbian lovers, expressing overtly an intimacy that Sedgwick has argued remains covered over by the ability of heteronormativity to determine what '*counts* as the sexual' (1985: 15). Although Walker has been criticised for failing to politicise lesbianism as 'threaten[ing] male–female bonding' (hooks 1990: 457), I read Celie's lesbianism as resituating sexual relations in the novel. Displaced through a maternal metaphor, supplemented by

a mirror image of the genitals, and deferred as practice through Shug's new male lover, Celie's lesbianism as rearticulated practice helps to question what constitutes the definition of heterosexual activity in the novel. Celie's desire for Shug is first played out as a mimicry of Shug's costume and actions for her stepfather, and her later sexual encounters with Mr ___ show Celie attempting to imagine Shug's feelings of desire. Though these performances take place within the domain of the heteronormative from the male characters' points of view, Celie's mimicry of Shug usurps the heterosexual site for the articulation of lesbian desire.

The final way in which the text dislocates the body from sexuate characteristics and cultural narratives of gender occurs through a contextual expansion and racial doubling of the framework within which certain scenes are read, ultimately allowing us to question the ontological placing of the critical question of gender itself. As with the confiscating of Sethe's breast milk in Toni Morrison's *Beloved* (1987) – a gendered 'rape' of her maternal body, and at the same time a racial appropriation of and ownership over the (re)production of her labour – the acts of inscription on Celie's body demarcate the body as a site of conflict between often dissenting gendered and racial cultural narratives. In one scene, Celie is called forth by her father's command, and she emerges from the house to be looked 'up and down' (Walker 1982: 12) by Mr ___. This scene appears to confirm her status as a commodity in a patriarchal system of exchange (Walker 1982: 10, 12), object of display to the male gaze. However, the discursive focus on Celie's (negative) potential as breeder (Walker 1982: 10) and her strength as a labourer, as well as the listing of her advantages and detriments as she parades before the potential purchaser, recall the display of the black body as commodity on the auction block during slavery (Bobo 1995: 64). Celie's body thus becomes materialised within contesting representative economies, with Celie experiencing a racialisation of her gendered construction and an engendering of her racial construction. The black male characters, on the other hand, are doomed to a mimetic parody of slavery's doctrine of mastery, domination and ownership, an internalisation of a racialised cultural and historical positioning which they have not questioned. Celie's body, in fact, 'becomes' gendered – as do the bodies of the black male characters – only through the mimicry of this historical racial ritual, which itself inscribes black masculinity and femininity within the parameters of white cultural power. As the feminine becomes rewrit-

ten within racial paradigms, one is forced to query whether the marking of the body as gendered, heterosexual and maternal is, ultimately, 'about' gender.

The later scenes in the novel, often perceived as evidence of a more utopian reading of Celie's subjectivity, confirm the status of materiality in the novel as an uneasy and disruptive site. The 'French Feminist moment', when Celie is encouraged by Shug to examine her clitoris and labia in a mirror, and the representation of her first sexual encounter with Shug, illustrate that the re-visioning of subjectivity remains fixed on the precise bodily and cultural sites – the genitals and maternity – which insist upon the body as already sexed and gendered. Squeak's rape by her white uncle and Sofia's doubling of Celie's submissiveness after she has been incarcerated by the white mayor and his wife illustrate that black women are perceived in terms of the material representative legacy demanded of them by whites. Washing laundry in prison, or on parole as the mayor's maid, Sofia's two options merge into a racialised Same, in which her salvation necessitates succumbing to a strategy of self-erasure to ensure her self-preservation. As Squeak and Sofia illustrate, the representation of the black feminine within a white context ensures the body's supplementarity. Interpreted as the corporeal – the sexual body in Squeak's case and the labouring body in Sofia's – the materiality of the black body none the less becomes supplementary to the cultural narratives of domesticity and desire. The black female body becomes '*marked as*' the figuration of the material, and this representational '*marking as*' masks the acts of violence which racialise the body with the violating cultural texts of sexuality and domesticity that biologise them both.

As my reading of *The Color Purple* indicates, the body is never a secure space for the easy representation of culture. Accepting corporeality as evidence for our cultural narratives erases the distinctions between what should be regarded as diverse cultural sites – ethnicity, nationality, culture and race, for example – through apparently self-evident sexed or chromatic corporeal characteristics. Corporeality comes to operate as the sign of these characteristics, so that we do not question how and why they have become the sites of irreducible cultural difference. Rethinking corporeality helps to interpose a gap between the body and its sexuate and racial characteristics as part of a more complete interrogation of the cultural discourses of gender, race and sexuality, as well as the critical discourses which position bodies of texts and theory according to these cultural discourses. By

questioning the way in which we materialise difference as the foundation for our misrecognitions, we can begin to disrupt the repetition of the appearance of identity that is resolved in the visible limits of the body.

Notes

1 Discussions of the violent black masculinist and heterosexual appropriation of Celie's body and her gendered liberation through lesbianism and writing have been a critical commonplace since its publication. See Christian 1985; Ross 1988; O'Connor 1991; Proudfit 1991; Abbandonato 1993; Babb 1993; Dawson 1993; Gates 1993; Payant 1993; and Davis 1994. For discussions of the ensuing critique of Walker's racial politics, see Harris 1984; Bobo 1989; Christian 1989: esp. 65; McDowell 1989: esp. 88; hooks 1993: esp. 288; and Bobo 1995: 61–90.

2 In the most frequently quoted 'definition' of the trace from *Of Grammatology* (1974), Derrida employs the 'mark' in terms of an empiricist notion of presence: he attempts to 'wrench the concept [of the trace] from the classical scheme, which would derive it from a presence or from an originary nontrace and which would make of it an empirical mark' (1974: 61). However, his discussion of the re-marking of the mark in *Dissemination* (1981) dislocates the notion of the mark from any empirical status by, in Rodolphe Gasché's words, 'embedd[ing it] in a differential system of marks in which it acquires the minimal identity necessary to refer to something other than itself. This identity hinges on its relation to another mark, on its detour through another mark in the very act of self-reference' (1986: 219).

References

Abbandonato, L. (1993) 'Rewriting the Heroine's Story in The Color Purple', in Henry Louis Gates, Jr, and K.A. Appiah (eds), *Alice Walker: Critical Perspectives Past and Present*, New York, Amistad.

Abel, E. (1993) 'Black Writing, White Reading: Race and the Politics of Feminist Interpretation', Critical Inquiry, 19 (3), 470–98.

Babb, V. (1993) 'Women and Words: Articulating the Self in *Their Eyes Were Watching God* and *The Color Purple*', in Lillie P. Howard (ed.), *Alice Walker and Zora Neale Hurston: The Common Bond*, Westport, CT, Greenwood, 83–93.

Bobo, J. (1989) 'Sifting through the Controversy: Reading *The Color Purple*', Callaloo, 12 (2), 332–42.

—— (1995) *Black Women As Cultural Readers*, New York, Columbia University Press.

Butler, J. (1990) *Gender Trouble: Feminism and the Subversion of Identity*, New York and London, Routledge.

—— (1993) *Bodies That Matter: On the Discursive Limits of 'Sex'*, New York and London, Routledge.

Christian, B. (1985) 'Trajectories of Self-Definition: Placing Contemporary Afro-

American Women's Fiction', in Marjorie Pryse and Hortense J. Spillers (eds), *Conjuring: Black Women, Fiction, and Literary Tradition*, Bloomington, Indiana University Press.

—— (1989) 'But What Do We Think We're Doing Anyway: The State of Black Feminist Criticism(s) or My Version of a Little Bit of History', in Cheryl A. Wall (ed.), *Changing Our Own Words: Essays on Criticism, Theory, and Writing by Black Women*, New Brunswick and London, Rutgers.

Collins, P.H. (1989) 'The Social Construction of Black Feminist Thought', *Signs: Journal of Women in Culture and Society*, 14 (4), 745–73.

Davis, T. (1994) 'Alice Walker's Celebration of Self in Southern Generations', in Barbara Christian (ed.), *Alice Walker: 'Everyday Use'*, New Brunswick, Rutgers.

Dawson, E.J. Waters (1993) 'Redemption through Redemption of the Self in *Their Eyes Were Watching God* and *The Color Purple*', in Lillie P. Howard (ed.), *Alice Walker and Zora Neale Hurston: The Common Bond*, Westport, CT, Greenwood.

Derrida, J. (1974) *Of Grammatology*, trans. by Gayatri Chakravorty Spivak, Baltimore and London, Johns Hopkins University Press.

—— (1981) *Dissemination*, trans. by Barbara Johnson, Chicago, University of Chicago Press.

Freud, S. (1953) *The Standard Edition of the Complete Psychological Works of Sigmund Freud*, Vol. VII, trans. by James Strachey, London, Hogarth.

Gasché, R. (1986) *The Tain of the Mirror: Derrida and the Philosophy of Reflection*, Cambridge, Mass., and London, Harvard University Press.

Harris, T. (1984) 'On the Color Purple, Stereotypes, and Silence', *Black American Literature Forum*, 18, 155–61.

Hite, M. (1989) 'Romance, Marginality, Matrilineage: Alice Walker's *The Color Purple* and Zora Neale Hurston's *Their Eyes Were Watching God*', *Novel*, 22 (3), 257–73.

Homans, M. (1994) '"Women of Color" Writers and Feminist Theory', *New Literary History*, 25 (1), 73–94.

hooks, b. (1990) 'Writing the Subject: Reading *The Color Purple*', in H.L. Gates, Jr (ed.), *Reading Black, Reading Feminist: A Critical Anthology*, New York, Meridian.

—— (1993) 'Reading and Resistance: *The Color Purple*', in H.L. Gates Jr. and K.A. Appiah (eds), *Alice Walker: Critical Perspectives Past and Present*, New York, Amistad.

Howard, L.P. (ed.) (1993) *Alice Walker and Zora Neale Hurston: The Common Bond*, Westport, CT, Greenwood.

Irigaray, L. (1985) *This Sex Which Is Not One*, trans. by Catherine Porter, Ithaca, Cornell University Press.

Johnson, B. (1986) 'Thresholds of Difference: Structures of Address in Zora Neale Hurston', in H.L. Gates, Jr (ed.), *'Race,' Writing, and Difference*, Chicago and London, The University of Chicago Press.

—— (1987) 'Gender Theory and the Yale School', in *A World of Difference*, Baltimore and London, Johns Hopkins University Press.

Kolodny, A. (1975) 'Some Notes on Defining a "Feminist Literary Criticism"', *Critical Inquiry*, 2 (1), 75–92.

—— (1985) 'Dancing through the Minefield: Some Observations on the Theory, Practice, and Politics of a Feminist Literary Criticism', in Elaine Showalter

(ed.), *The New Feminist Criticism: Essays on Women, Literature, and Theory*, New York, Pantheon.

Lacan, J. (1977) *Écrits: A Selection*, trans. by Alan Sheridan, New York and London, Norton.

McDowell, D. (1985) 'New Directions for Black Feminist Criticism', in Elaine Showalter (ed.), *The New Feminist Criticism: Essays on Women, Literature, and Theory*, New York, Pantheon.

—— (1989) 'Reading Family Matters', in Cheryl A. Wall (ed.), *Changing Our Own Words: Essays on Criticism, Theory, and Writing by Black Women*, New Brunswick and London, Rutgers.

O'Connor, M. (1991) 'Subject, Voice, and Women in Some Contemporary Black American Women's Writing', in Susan Jaret McKinstry (ed.), *Feminism, Bakhtin, and the Dialogic*, Albany, State University of New York Press.

Payant, K. (1993) 'Female Friendship in Contemporary Bildungsroman', in Joanna Stephens-Mink (ed.), *Communication and Women's Friendships: Parallels and Intersections in Literature and Life*, Bowling Green, Bowling Green University Press.

Proudfit, C. (1991) 'Celie's Search for Identity: A Psychoanalytic Developmental Reading of Alice Walker's *The Color Purple*', *Contemporary Literature*, 32 (1), 12–37.

Ross, D.W. (1988) 'Celie in the Looking Glass: The Desire for Selfhood in *The Color Purple*', *Modern Fiction Studies*, 34 (1), 69–84.

Sedgwick, E. Kosofsky (1985) *Between Men: English Literature and Male Homosocial Desire*, New York, Columbia University Press.

Showalter, E. (1977) *A Literature of Their Own: British Women Novelists From Brontë to Lessing*, Princeton, Princeton University Press.

—— (1985) 'Feminist Criticism in the Wilderness', in Elaine Showalter (ed.), *The New Feminist Criticism: Essays on Women, Literature, and Theory*, New York, Pantheon.

Smith, B. (1985) 'Toward a Black Feminist Criticism', in Elaine Showalter (ed.), *The New Feminist Criticism: Essays on Women, Literature, and Theory*, New York, Pantheon.

Spivak, G. Chakravorty (1990) *The Post-Colonial Critic: Interviews, Strategies, Dialogues*, ed. Sarah Harasym, New York and London, Routledge.

Walker, A. (1982) *The Color Purple*, San Diego, New York, London, Harcourt Brace Jovanovich.

8

THE BODY AND ITS DISCONTENTS

ELISABETH BRONFEN

As Sigmund Freud notes in his discussion of cultural activity, which according to him primarily involves the human subject's attempt to make the earth inhabitable by protecting himself or herself against the violent forces of nature, 'we find that the first acts of civilisation were the use of tools, the gaining of control over fire and the construction of dwellings'. Technologies of civilisation and culture, he suggests, allow the human subject to perfect his or her own organs – spectacles, telescopes and microscopes help to overcome the limits of visibility set by the physical body, cameras and gramophones help to mitigate the imperfections of memory, even while writing helps to preserve 'the voice of an absent person' (1930: 91). Yet it is above all the question of habitation which brings not only corporeality but also the gender of phenomenological dwelling into play. For Freud concludes his list of cultural activities with a reference to the significance of the maternal body for the psychic reality or fantasy life of the subject, suggesting that 'the dwelling-house was a substitute for the mother's womb, the first lodging, for which in all likelihood man still longs, and in which he was safe and felt at ease' (1930: 91). The process of culturation thus involves not only a substitution of the human body by mechanical tools but also, if only implicitly, points to its potential absence, for the technologies of culture can preserve aspects of the body long after its disappearance or its demise, precisely as the articulation of absence. Under the sign of presence, however, the body speaks the rhetoric of the real. As the Austrian performance artist Valie Export (1987) notes, the murky interface between the cultural articulation of an absent human corporeality and the real insistence of bodily presence has proven to be one of the most persistent phantasms of our image repertoire precisely because it demonstrates the vexed role the body plays in western culture. The body is the medium

of both the inescapable real law of mortality and the law of social control. In the Christian icon of 'The Son of God nailed to the Cross', this troubled enmeshment of various psycho-social registers finds its paradigmatic representation. Precisely because the body represents the site over which the human subject experiences its real insertion in the world, a public staging of it readily encourages and sustains the transformation of the real into a tropic function. Literally crucified, Christ gives figural expression to the way all human subjects must subject themselves to the law of the father and the reality principle he stands in for. At the same time, as the soul leaves the martyred corpse it inaugurates imaginary fantasies about salvation and resurrection.

It is, however, significantly over the multi-faceted image of the maternal body that the three psycho-social registers come to be knotted together, which any discussion of the body and its modes of cultural visualisation needs to address. For throughout the life of all mortal beings, the navel signifies a scar that marks the separation of the newborn from the mother's womb, and in so doing, indicates that parturition is the first cut, both real and symbolic, which constitutes the subject as a cultured being. The lost unity with the maternal body can always only be imagined belatedly, and as a nostalgically coloured wish-fulfilment to boot. At the same time, however, it also refers to the fact that the body belongs to a realm which, even while it can only be represented through symbolic language and images, nevertheless also exceeds any system of representation. The body emerges from the matrix of real materiality, upon which those signs and laws of culturation are grafted that engender our image repertoire as well as our symbolic codes. At the same time the body emerges as the vanishing point of visual and narrative figurations of human existence, the unrepresentable alterity of the real which is as inevitable as it is ineffable. Concomitantly, this excess of the body over any refigurations is played through most poignantly when the limit of representation is at stake, namely once the cultured subject is thrown back onto the real materiality of its corporeal existence – notably in moments of traumatic pain or extreme ecstasy, during confrontations with birth-giving or death (see Scarry 1985; Bataille 1957; Bronfen 1992). From this one can surmise not only that the body is the actual double of the real, as Export (1987) argues, but rather that this double is inextricably linked with the images of the self which a given person or a given social group seek to circulate.

Owing to the fact that the boundary between corporeality and

self-representation is such a murky one, the alleged unity between the newborn child and the maternal body has come to be one of our privileged tropes for the possibility of an intact interpersonal relationship of unblemished plenitude, and as such the model for most narcissistically informed images of the self. As Freud insists, lovers, by choosing love objects that promise to help them assuage the sense of lack in existence, actually wish to refind the lost maternal body – 'There are thus good reasons why a child sucking at its mother's breast has become the prototype of every relation of love. The finding of an object is in fact a refinding of it' (1905: 222). At the same time , for Freud, notions of homecoming, involving a sense of recuperating lost wholeness and a sense of being healed from the experience of separation, loss and abandonment, also ultimately have recourse to images revolving around the familiarity of the maternal body – 'whenever a man dreams of a place or a country and says to himself, while he is still dreaming: "this place is familiar to me, I've been here before", we may interpret the place as being his mother's genitals or her body' (1919: 245). In the fantasmatic *mise-en-scène* of our desires, our body comes to represent the only protective dwelling-place of which we can be sure, the only home we always carry around with us. But precisely because we link notions of an intact, integrated and stable self-identity to images of a consistent, invulnerable and omnipotent body, narratives and representations that revolve around the fallibility and fragility of the body often produce anxiety. Ironically, then, although we can never fully see our body and thus fall prey, as Jacques Lacan suggests in his discussion of the mirror phase in psychic development, to a misrecognition of the unified self (Lacan 1977), the body comes to function as one of the most privileged props in our fantasy life. For it serves as the site at which images, signifying such concepts as plenitude, beauty, perfection and integrity, can not only materially take on shape but also, as belated reproductions, come to be cemented and culturally exchanged. In other words, the body, as site of culturation, is in excess of its representation in so far as the ineffable *soma* can invariably only be conceived as *sema*, as a sign, which, though referring to real corporeal materiality, always also signifies more than this phenomenological corporeality. For it articulates both the absence of the real body and its transformation into a cultural value, which the depicted body merely stands in for (be this as a paradigm for integrity and plenitude or as an example for deviation from conventional notions of beauty, goodness and normality). The resilient

aporia, around which representations of the body circulate, consists in the fact that culturally informed notions of the body, its publicly exchanged image, and the depicted object these signs refer to come to mirror each other endlessly. Apodictically put, the body and its tropic transformations mark the fault line between physical materiality, its representations and the cultural code these representations serve, even while they are informed by them.

Given that the separation of the child from the maternal body marks the first and most incisive moment of symbolic castration, the navel, which somatically recollects this corporeal cut, signifies that the subject can come into being as a singular, autonomous individual only in so far as it submits itself to the laws of culture, by accepting this subjection quite literally at its own body. Thus images of the body not only serve as the screen for fantasies of plenitude, integrity and protection; they also function as the medium for formulating and per-petrating cultural prescriptions and forbidding, and as such come to figure as the site at which a given culture can repeatedly renegotiate its privileged collective self-representation as well as its hegemonic values. Accordingly, in the course of rites of initiation, bodies are marked so that the fact of the initiates' belonging to the community can be given a tangible representation, much as executions are often staged as public events precisely so that over the body of the criminal the stability of the cultural values undermined by the offence can once more be solidly affirmed (Girard 1972; Baudrillard 1976). Indeed, as Foucault notes 'For a long time, one of the characteristic privileges of sovereign power was the right to decide life and death' (1978: 135). As the interface between physical materiality and its visual or narrative representation, the body comes to figure as the stake in aesthetic as well as diverse scientific discourses primarily in situations involving the distinction between beauty and monstrosity, between nature and culture, between masculinity and femininity, but also when at stake is a debate about where to draw the line between the living and the dead.

This primacy of the body as object of negotiation and representa-tion, however, also readily calls forth the question whether there is a body outside language or whether our knowledge of the body depends on the highly diverse and differentiated images of it that come to be constructed in accordance with particular social contexts and questions of normalcy relevant at specific historical moments. Is the body always already cultured or does the body pose as the mea-

sure and demarcation point of culture, as the site of truth, authenticity and inevitability? Is the body perhaps such a privileged object of our cultural image repertoire as well as such a pressing category in cultural criticism precisely because it quite literally embodies the fact that the incommensurability between the real and its representations can never fully be resolved? For in the debates on the significance of the body in cultural discourses we invariably find ourselves faced with a philosophical impasse. Does the body exist outside and beyond imaginary and symbolic figurations, independent of these representations, even while it also serves as their ground and vanishing point? Or do diverse cultural discourses in fact produce the body in the course of describing it, constructing it so as to endow their specific intellectual project with authority and legitimation? The point cannot be to arbitrate the debate once and for all in favour of one or the other side. Rather, more fruitful, I suggest, might be an attempt to preserve and explore the difference between the various positions which the body has come to assume in our image repertoire and in our critical discourse, so as continually to ask ourselves why this difference matters.

For, as Roland Barthes (1970) has so poignantly shown in his reading of a novella by Balzac, not to read this difference, and instead to hold onto the belief that the incommensurability between the body and its diverse figurations is resolvable, can have fatal results for those involved in such a hermeneutic task. *Sarrasine* is the story of an artist who does not want to acknowledge that the most beautiful of all women – La Zambinella – is a castrato. After he has been forced to recognise his wilful blindness, he at first strikes at his masterful rendition of this deceptive body with a hammer, and, finding himself unable to destroy his own sculpture, picks up a sword so as to turn his aggression towards the model herself. At this point, however, he is intercepted by the henchmen of the cardinal Cicognara, the protector of the castrato, and is himself stabbed to death. Barthes chooses this particular narrative as an illustration of the dangers inherent in the desire to transform a body into an image, an exchange which seeks not only to cement the notion of clear gender identities, but perhaps more crucially, to screen out a traumatic knowledge of our human implenitude and fragility in favour of a fantasy of bodily perfection. For the body of La Zambinella, allegedly staging immaculate feminine beauty, is not only a deception with regard to gender (in that it attests to the fact that conventional notions of perfect femininity are

nothing other than cultural constructions); the monstrosity inhabiting this corporeal masterpiece at its very core is also a sign of its inevitable symbolic castration. La Zambinella can take on the position of the highly esteemed singer only because her body in fact quite literally commemorates a cut, which is also the precondition for her entry – as a castrato – into the symbolic order that determines her superlative value in the first place.

That the attempt to fix the body of the castrato into a stone image, so as to use it as the medium for the performance of an entirely different fantasy scenario (one aimed at aesthetically celebrating the perfect body of implenitude) should fail, is played through in the frame narrative as well. For like his protagonist, the narrator, who tells Sarrasine's story so as to seduce a beautiful Parisian woman, also fails, albeit with less fatal consequences. The story he narrates deals with sexual castration and murder and with the uncanny proximities of masterpiece and monster, the immaculate feminine and the dismembered masculine body. Yet as the narrator directly discloses the secret of the mysterious figure of La Zambinella, his listener turns away in disgust and horror. She is no longer willing to perform the sexual act once she has discovered the highly ambiguous identity of the strange old man, who appears intermittently in the house of the wealthy de Lanty family, and who, like a figure of death, both horrifies yet also mysteriously fascinates those who see him. For the explanation the narrator offers reintroduces difference. The uncanny figure, she discovers, is not only a castrato, whose song used to delight his peers, and whose beauty inspired painters and sculptors to produce masterpieces even while his deceit brought about the death of his most ardent admirer. He is also a member of a family which is unwilling to acknowledge his alleged monstrosity publicly in Parisian society, so as to keep all reference to the corruption and violent obscenity upon which social power is based a shared secret, which everyone is in on, even while no one will openly admit to it. The fact that the courted woman turns away from the narrator could, of course, be read as a reference to the aporia inhabiting all mediated renditions of the body as a deceptive and duplicitous trace. Because any narration about the direct and totalising designation of a body – whether by virtue of its transformation into a masterful sculpture or its enclosure into a medical category – inevitably also gives voice to the fact that the uncanny figure, which the body takes on in our image repertoire, can never be fully and unequivocally resolved. Not only can the boundary never

be drawn with impunity between feminine beauty as paradigm for a satisfying integrity of the body and masculine castration as paradigm for its terrifying fragmentation, between the masterpiece and the monster, between the body of art and the real material body. At issue also is the question at whose cost such an exchange might take place – the negotiated object, the one negotiating its value, or both.

In Balzac's novella the protagonist Sarrasine recognises that the perfect feminine beauty embodied by La Zambinella bears the difference of castration at its very core. However, the only reason this body came to be conceived as a paradigm for the living masterpiece was because it quite explicitly dissembles superlative beauty. In the same measure as the materiality of the immaculate body came to be emphasised, its opposite was also brought to the fore, namely the fact that this perfection was only made possible by virtue of an incision into the body. At the same time, what becomes equally clear is that the body, which inspires in the artist a fantasy of aesthetic perfection and allows him to realise this masterpiece in stone, can never be detached from its location within a given realm of symbolic codes. Balzac's narration thus warns its readers that any attempt to interpret the body unequivocally can have fatal effects, because such a semantic reduction does not correspond to the fact that corporeal human existence is irrevocably inhabited by an originary difference. To fix the meaning of a given body fatally screens out the undecidability of gender identity, the unsurmountable presence of mortality and mutability in the midst of life, the disintegration at the core of any fantasy of integrating unity. The body insists against such a dissembling denial of its materiality once this is presented as the telos of its visualisation. Like all repressed material it inevitably returns into the realm of aesthetic and scientific research, albeit in a disguised and dislocated manner – as a trace which is neither recuperable nor effacable; as an irritating but also fascinating provocation.

In his writings on the enmeshment of sexuality, knowledge and power in medical, judicial and epistemological discourses, Michel Foucault has not only compellingly illustrated how discourses come quite literally to be inscribed onto concrete bodies, so that these discursive projects can be established as phenomenological truths (Foucault 1963, 1972, 1975). He has also persisted in arguing that the enforcement and acceptance of such discursive formations of power will often have recourse to a disciplinary regime of the body. Certain

judicial practices of punishment call for the hands of a thief to be cut off and the tongue of a perjuror to be nailed to the wall. In a similar vein, well into the nineteenth century, physicians would forcibly penetrate with their fist the vagina of a woman afflicted with an attack of hysteria, so as to re-anchor the allegedly wandering uterus in its proper place. The distinction between what was considered to be normal and what to deviate from the norm – a difference so imperative for the formation and preservation of social codes and laws – continues to be negotiated at the body, namely whenever inadmissible sexual practices are labelled as being 'perverse', when conventionally unacceptable forms of perception are labelled as being signs of 'madness', when actions undermining the social system are labelled as being 'criminal', and when those who do not belong to the ethnic hegemony are labelled as being 'degenerate'. Furthermore, the *double entendre* upon which Foucauldian notions of 'bodies of knowledge' are grounded also consists in the fact that, even while a particular body's meaning is socially constructed and forcibly imposed onto the corporeal substance, a conception of the body as an agentless, deanimated cypher is preserved, namely as the site of pre-linguistic existence, as the material and biological counterpart to the machinations of culture. As Steinberg notes, 'power and knowledge are understood as *embodied* where meaning is constituted in and through disciplinary regimes that produce as well as consume, emborder as well as transgress. Thus the body is reconfigured as both the matrix and matter of culture', as subject and object in the production of experience and meaning (Steinberg 1996: 226). Bodies of knowledge thus come to function as the one value where the boundary between nature and culture, which in the course of modernity has become so disturbingly unstable, can once more be refigured, only to be broken open again, not least of all owing to recent developments in biological experimentation such as genetic manipulation.

In her critical rereading of Foucault, Judith Butler, however, insists that the body, over which the question of normality (and, concomitant with this, the question of truth) is negotiated and confirmed, is itself the product of precisely the discourse for whose legitimation it is constructed (Butler 1990). Bodies, she argues, are performative in the sense that they only appear on the scene of the discursive stage set up to constitute them. Outside such discursive formations they are not perceptible, because their social existence is inextricably tied to the cultural conventions that determine them, because these either

permit or delimit the readability of the body. With all its distinguishing traits – whether these refer to gender, race, sexuality or modes of self-performance – the body is, then, to be thought of neither as a noun nor as a free-floating signifier. Rather, given that it is culturally produced on the basis of disciplinary and regulatory social practices, corporeality instead implies an action which can, however, not be attributed exclusively to the subject, situated before or outside the actions that characterise it. For we cannot conceive of a corporeal identity beyond or before the cultural articulation of the body. Instead, any body becomes legible only by virtue of precisely those articulations which are allegedly posited as the result of its culturation. The belief in a materiality which could be located before or after the law of symbolic castration must itself be thought of as a discursive construct. A universality or essentiality which seeks to think the subject minus its corporeality is as theoretically untenable as the notion of a body devoid of all discursive and cultural delimitations. If, then, both anatomy and culture are the destiny of human existence, cultural criticism concerned with the status of the body in aesthetic and scientific discourses is called upon to think this complexity, that is, that any demarcations – of the body and the identity it bears as well as its geographical and cultural location – are unstable, contingent, caught in a process of constant renegotiation. The desire to discipline the body, so as to engender an unequivocal and transparent system of categorisation, proves to be both defensive and productive.

Indeed, in tandem with the increase in refined strategies of visualising the body, developed since the late eighteenth century, medical investigation has emerged as a displaced mode of self-representation on the part of the scientist. John Berger's claim that, in aesthetic practices since the Renaissance, men act while women use their bodies to appear is equally applicable to other discursive fields in which knowledge is embodied (Berger 1972: 47). As he suggests, 'Men look at women. Women watch themselves being looked at ... The surveyor of woman in herself is male: the surveyed female. Thus she turns herself into an object – and most particularly an object of vision: a sight.' Yet what is most crucial in this exchange is that while 'the "ideal" spectator is always assumed to be male ... the image of the woman is designed to flatter him' (Berger 1972: 64). The many attempts not only to capture the body in an image but to arrest further its contingent and mutable meaning in a disciplinary schema – for which the wax figures and prepared body parts of anatomical museums are as char-

acteristic as the photographs of the insane and the hysteric, produced at the end of the nineteenth century in psychiatric clinics such as the Salpêtrière – reflect the way self-reflexivity is inscribed into the production of knowledge (see Didi-Huberman 1982; Bronfen 1998). While in aesthetic discourse it may primarily be the feminine body which functions as the signifier for the masculine gaze and for masculine creativity, in medical discourses it is the body of the insane or the diseased which comes to represent the physician's gaze (Gilman 1982). Caught in a rhetorical gesture of chatoyancy, these strategies of visualising the body produce a scenario where the materiality of the body and its dematerialisation come to reflect each other, for it is precisely at the substance meant to fix the physical *par excellence* – at the body in all its concrete materiality – that its translation into an image is not only incessantly played through but also becomes endlessly reproducible. That this murky interface between the body and its visual reification can assume a compelling effect outside the clinic and the academy recently became evident in the manner in which the death of Diana Spencer emerged as the most spectacular media event of the year 1997. For ultimately it was our knowledge of her damaged body, disseminated by the press along with an embargo on publication of photographs of her corpse, which called forth a veritable deluge of earlier images of the deceased. Supported by hagiographic renditions of her life, the dead woman came to be transformed into the most beautiful princess in the world, a paradigm of goodness and charity, transfigured into a role model for feminine emancipation, while the public debate over which funeral ceremony was to be performed turned into a violent critique of the behaviour of the royal family. The missing image of the fallible and fragmented body of the princess was replaced with a fantasy scenario revolving around the perfect woman, an image more corresponding to the gaze of the survivors – representing their mourning for their own mutability, their anxiety about the contingencies of their own lives and perhaps their desire for fictions of happiness – than offering a truthful representation of the body that was manifestly the object of these images and narratives, namely the deceased Diana Spencer in her corporeal and historical reality.

In his last Hollywood Film, *Imitation of Life*, Douglas Sirk offers a particularly poignant example of the way that the act of symbolic incision, conceived as marking the insertion of the subject in the field of hegemonic cultural codes, can never neatly be severed from fantasies

of dwelling and belonging, even while it can never rid itself of a trace of real difference. For in this film the question of belonging to a given norm, or deviating from it, is negotiated by virtue of a narrative in the course of which a body that, by virtue of its miscegenist make-up, resists any clear ethnic designation is disciplined until it has become unequivocably legible. And, as in the Balzac story, at stake is the question of life or death. The protagonist Sarah-Jane, daughter of a very dark-skinned black mother and a very light-skinned black father, is able to 'pass', given her undecidable ethnic appearance. Owing to her hybridity, however, she also threatens any cultural fantasies of racial purity as well as the laws of racial segregation explicitly supported in post-World War II American culture. What is so compelling about the disciplining of this miscegenational body, as Sirk discloses in the course of his film, is, however, the fact that it must be clearly and exclusively ascribed to one group (the black American community) and decisively excluded from another group (the white American community) precisely because, owing to its particular corporeality, it quite literally embodies the impossibility of such boundary drawing. Sarah-Jane's mother wants to force her daughter to acknowledge only her black identity; the heroine's white boyfriend, in turn, viciously withdraws from her once he discovers that she is more than the white identity he assumed her to embody. The tragedy literally inscribed on Sarah-Jane's skin is that she belongs to both groups, though at the same time to neither one fully or exclusively. She knows that hers will always be more than one single racial identity and thus recognises that she can do nothing other than accept a subject position which incessantly insists that there will always be more than one normative conception of what an admissible, normal body might be.

In line with the plot constraints imposed by the genre of the melodrama, Sirk's heroine can only solve the undecidable ethnic difference she embodies by utterly disappearing in the course of a different mode of reification. Sarah-Jane leaves her mother and forbids her to take up any further contact with her so that she may work as a nightclub dancer in Las Vegas, with her interracial identity hidden beneath another masquerade, namely that of the white chorus girl. As one of many singing women who all look alike, given that their explicit function is to flatter their male customers, Sarah-Jane is able to surmount the destiny of her anatomy. But the tragic logic of her narrative consists in the fact that she can achieve this liberation only by using her body to perform another destiny, namely that of the gender role

ascribed to women in the American culture of the 1950s. Her reduction to an unequivocal racial designation can only be exchanged with another semantic reduction – namely that of the erotic artificial body, whose agency consists in relinquishing all individuality in favour of reflecting the desires of her clients.

Especially since the late 1960s, artists and cultural theorists have sought to rewrite the fatal logic dictating that the body be the site of disembodiment and disempowerment, by designing aesthetic and critical projects in which the body is reclaimed as a site of agency. Singers such as P.J. Harvey or Sinéad O'Connor explicitly perform their bodies on stage so as to sell their songs about feminine anguish and feminine enjoyment; Madonna continues to astonish her audience with the resilient versatility with which she is able to transform her bodily appearance according to the volatile demands of her audience. The multimedia artist Orlan subjects herself to alleged beauty operations, in the course of which she has her body remodelled under the sign of traditional images of feminine beauty, a project of corporeal dismemberment she proclaims to be an act of self-conscious empowerment. Similarly, Cindy Sherman disguises and distorts her body so as to allow a chatoyant multiple self of the imagination to emerge in her photographs. Such public writing with the body follows Julia Kristeva's interest in a language of the *semiotiké*, a language which reintroduces into significatory practices those pulsations of the body that have been repressed from symbolic language (Kristeva 1984). It implies finding an articulation for the drives and affects that haunt the psychic apparatus, rather than effacing these in the course of shifting from the voice of primary processes to that of symbolic language. To return to the body as a medium of self-expression, to reclaim it against its cultural appropriation, means celebrating a language of flux and contingency, in the course of which the subject keeps changing its shape, taking on a shifting series of at times even contradictory identities and transformations. Reclaiming the body as a site of self-empowerment implies performing the incommensurability between representations of the self and any real, originary and primary core of identity. It involves a language that allows the subject to give voice to its fallibility and fragility along with staging an enjoyment of excess, self-consciously enacting a liberation from the constraint of final, totalising and authoritarian categories.

However, any speaking and writing with the body inevitably

falls back on the inescapability of precisely those cultural codes against which it is pitted. As Judith Butler argues, responding to the constraints posed by cultural constructions of the body, if the gendering of the body is discursively fixed, subversive power can be developed in the rhetorical gesture of parody, where symbolic reification is self-consciously restaged (Butler 1993). In the course of such a reiteration of gender, of which drag queens have become such a resilient example, identities are affirmed, assumed in response to the demands of a particular moment, only to be relinquished when these demands change. In the course of this chatoyant transformation, the body emerges as the site of an open montage of diverse representations of the self, as the site at which different designs of the self converge and diverge again, without fully subjecting themselves to the telos of clear and final closure. Butler's notion of gender trouble as a reiteration of given discursive formations, as a rhetoric of reclaiming the body for creative self-expression, plays through a viable reversal, subversion and dislocation of culturally predetermined modes of corporeal identity. A parodic display of the reification of the body dismantles the inevitable translation of the body into a cultural sign.

Yet even the celebratory gesture of gender trouble leaves us faced with a theoretical impasse, namely the undecidable opposition between, on the one hand, the body as site of cultural appropriation and, on the other, the body as site for agency and authentic self-expression. In our times of virtual and cyber-realities the body may be held up as the last bastion of the real, even while it is presented as the materiality which the new cyber-technologies will finally be able to surmount. It both guarantees the stability of human identity and comes to prove the construction and multiplicity of identities in a posthuman world. Decisively opposed to the notion that our body is to be thought of exclusively as a cultural construction, Susan Bordo argues that even while we cannot get outside historically sedimented discourses and representations, we can also never escape the materiality of the body as that which signifies our finitude, our physical locatedness in history and culture. Insisting on the physical corporeality of human existence is, for her, coterminous with recognising the way we are not only shaped by history and culture but also limited by this locatedness: 'Our materiality (which includes history, race, gender and so forth as well as the biology and evolutionary history of our bodies and our dependence on the natural environment) impinges on us – shapes, constrains and empowers us' (Bordo 1997: 182).

Even though corporeality inevitably implies a limitation of empowerment – given that it points towards the mortality, fallibility and fragility of the physical and thus also addresses the psychic existence of the human subject – it also introduces a moment of subjective agency. The acknowledgement that it is impossible to escape from the body, and with it from locatedness in history, culture and the phenomenology of the world, can also be conceived of as a moment of psychic gain, namely once anatomic and cultural destiny take on the guise of subjective choice. For at stake in our critical debates on the body is always the question of life and death, the question of the limits of representation, of what legitimises political, social and cultural power and what will always recede from these discursive formations. As the traumatic kernel which haunts our cultural existence even while it recedes from any direct representation, this ineffable knowledge irrevocably lies outside any symbolic signification, perceivable and legible only belatedly and only by proxy, in the mode of cultural refigurations. Along these lines Kathy Acker describes her fascination with body-building as an attempt to understand and control the physical materiality of the body in the face of our inescapable and inevitable mortality:

> In our culture, we simultaneously fetishise and disdain the athlete, a worker in the body. For we still live under the sign of Descartes. The sign is also the sign of patriarchy. As long as we continue to regard the body, that which is subject to change, chance, and death, as disgusting and inimical, so long shall we continue to regard our own selves as dangerous others. (Acker 1997: 150)

References

Acker, K. (1997) *Bodies of Work. Essays*, London, Serpent's Tail.

Barthes, R. (1970) *S/Z*, Paris, Gallimard.

Bataille, G. (1957) *L'Érotisme*, Paris, Gallimard.

Baudrillard, J. (1976) *L'Échange symbolique et la mort*, Paris, Gallimard.

Berger, J. (1972) *Ways of Seeing*, Harmondsworth, Penguin.

Bordo, S. (1997) *Twilight Zone: The Hidden Life of Cultural Images from Plato to O.J.*, Berkeley, University of California Press.

Bronfen, E. (1992) *Over Her Dead Body: Death, Femininity and the Aesthetic*, Manchester and New York, Manchester University Press and Routledge.

—— (1998) *The Knotted Subject: Hysteria and its Discontents*, Princeton, Princeton University Press.

Butler, J. (1990) *Gender Trouble: Feminism and the Subversion of Identity*, New York, Routledge.

—— (1993) *Bodies That Matter: On the Discursive Limits of 'Sex'*, New York and London, Routledge.

Didi-Huberman, G. (1982) *L'Invention de l'hystérie. Charcot et l'iconographie de la Salpêtrière*, Paris, Macula.

Export, V. (1987) *Das Reale und sein Double: Der Körper*, Bern, Bentelli Verlag.

Foucault, M. (1963) *Naissance de la Clinique*, Paris, Gallimard.

—— (1972) *Histoire de la folie à l'âge classique*, Paris, Gallimard.

—— (1975) *Surveiller et Punir: Naissance de la prison*, Paris, Gallimard.

—— (1978) *The History of Sexuality Vol. 1: An Introduction*, New York, Vintage.

Freud, S. (1905) *Three Essays on the Theory of Sexuality. Standard Edition* VII, London, Hogarth.

—— (1919) 'The Uncanny'. *Standard Edition* XVII, London, Hogarth.

—— (1930) *Civilisation and its Discontents. Standard Edition* XXI, London, Hogarth.

Gilman, S. (1982) *Seeing the Insane*, New York, Wiley.

Girard, R. (1972) *La Violence et le sacré*, Paris, Grasset.

Kristeva, J. (1984) *Revolution in Poetic Language*, New York, Columbia University Press.

Lacan, J. (1977) *Écrits: A Selection*, New York, Norton.

Laqueur, T. (1990) *Making Sex: Body and Gender from the Greeks to Freud*, Cambridge, Mass., Harvard University Press.

Scarry, E. (1985) *The Body in Pain: The Making and Unmaking of the World*, Oxford and New York, Oxford University Press.

Steinberg, D.L. (1996) 'Cultural Regimes of the Body: An Introduction', *Women. A Cultural Review*, 7 (3), 225–7.

part three

MEMORY AND MOURNING: NARRATIVES OF VIOLATION

9

EIGHTEENTH-CENTURY PROSTITUTION:

feminist debates
and the writing of histories

VIVIEN JONES

In the triad, virgin/mother/whore, which defines femininity within modernity, 'whore' is the category which, through difference, guarantees the respectability of the other two. Perhaps the most significant aspect of that difference is the prostitute's public identity: the prostitute makes visible and commercial, sexual transactions which are hegemonically defined as private and affective. That public identity is nevertheless a silent one. Until very recently, prostitutes have been denied a voice. Eighteenth-century prostitutes are even further marginalised and silenced – by the difference of historical distance.

The prostitute's significance for processes of cultural and gender definition has inevitably meant, however, that within recent histories of gender and sexuality, prostitutes and prostitution have become increasingly popular objects of enquiry, and the prostitute body has been variously and frequently deployed as cultural sign. I have been working for some time on the cultural significances of the enduringly popular seduction narrative in the second half of the eighteenth century. In its tragic or sentimental versions, this story of the unmarried, often lower-class woman who is seduced by an unscrupulous and socially superior man often ends with a fall into prostitution, and the figure of the innocent, penitent and redeemable prostitute emerges in this period as an increasingly powerful cultural myth. What I want to do here is to reflect on some of the ethical issues which have been raised for me in studying – and narrating – prostitution in a historical context.

Let me begin with two rather different versions of the eighteenth-

century prostitute. This is the first:

> in the case of the prostitute, self-sale creates the illusion of an unknow-
> able authenticity by never giving anything away, both in the sense
> of refusing to give free gratification and in the sense of refusing self-
> revelation.
>
> ... She who is able to repeat the action of self-alienation an unlimited
> number of times is she who is constantly there to regenerate, possess, and
> sell a series of provisional, constructed identities. (Gallagher 1994: 17, 24)

This is Catherine Gallagher, in *Nobody's Story*, sophisticating the com-
monly cited identification between prostitution and female author-
ship. She does so by juxtaposing Aphra Behn with the late
seventeeth-century pornographic text *The Whores Rhetorick*, in which,
as the title suggests, the whore's performative tricks are compared
with the persuasive skills of the rhetorician.[1]

Here is my second representation:

> This brings me to that completely wretched, distempered, deserted,
> pitiable Body of whom I mean to speak; whose Sufferings have so often
> made my Heart ach, and whose Preservation I now so ardently wish to
> accomplish.
>
> ... on a search Night, when the Constables have taken up near forty
> Prostitutes, it has appeared on their Examination, that the major Part of
> them have been ... under the Age of Eighteen, many not more than
> Twelve, and those, though so young, half eat up with the foul Distemper.
>
> ... They are young, unprotected, and of the female Sex; therefore
> become the prey of Bawd and Debauchee. (Fielding 1758: 43, 45)

This is John Fielding, half-brother of Henry and reforming Westmin-
ster magistrate, from his pamphlet of 1758, *An Account of the Origin
and Effects of a Police ... To which is added, A PLAN for preserving those
deserted Girls in this Town, who become Prostitutes from Necessity*. Field-
ing's pamphlet is from that mid-century moment when charitable
reformers turned their attention to the question of prostitution, a
movement of disciplinary pity which culminated in the opening of
the Magdalen House for Penitent Prostitutes in 1758.

My immediate concern is with the apparent disjunction between
these two accounts: between prostitute as performance artist and
prostitute as suffering individual, objectified as innocent victim
within a redemption narrative generated by the literature of reform.
At one level both are, simply, narratives, acts of interpretation. At

another, the misery which can be gleaned from even the most sceptical reading of Fielding's account presents a significant challenge to Gallagher's celebration of the prostitute's paradoxical, postmodern selfhood.

Their juxtaposition helps focus important questions of historical responsibility. What might, or ought, the relationships be between the productive discursivity of the sign and issues of exploitation and suffering; between the responsibility to read and interpret the texts of history, and a responsibility to the individuals whose experiences and voices are occluded by those acts of interpretation? Posed in another way, these are ethical and political questions familiar to anthropology, to sociology and – within and across those disciplines – to feminism: 'who is the other woman? How am I naming her? How does she name me? Is this part of the problematic I discuss?' (Spivak 1987: 150). Such questions – asked here by Gayatry Spivak of the relationship with the subaltern in the postcolonial context – are equally pertinent across the historical and categorical differences which separate the late twentieth-century feminist academic from the eighteenth-century prostitute.

What I want to suggest is that a feminist literary or cultural historian's relationship with eighteenth-century prostitution must be explicitly informed by debates on the issue within contemporary feminism. She must take note of, for example, Shannon Bell's recent reminder that:

> What has been occurring in postmodernity – the production of prostitute discourse(s) from the diverse subject positions and stand-points of prostitutes themselves – has altered the discursive domain of prostitution. Ethically, there can no longer be a philosophy of prostitution in which there is an absence of prostitute perspectives and prostitute philosophers. (Bell 1994: 185)

But an immediate difficulty presents itself. 'Prostitute perspectives', in Bell's sense, are hard to come by in the eighteenth century. Eighteenth-century prostitution literature is full of all kinds of first-person narratives, but most of those narratives are fictions, and more often than not they are male-authored. In neither of the texts with which I began, for example, do we hear the voices of the prostitutes concerned: Fielding's documentation of misery, unsurprisingly, speaks on behalf of its objects. In making her case for performative female authorship, Gallagher chooses a prostitute text which may be

in the first person, but which comes from the libertine tradition of male-authored whore narratives (the best known English example of which is of course John Cleland's *Memoirs of a Woman of Pleasure* or *Fanny Hill*).

What I am not advocating, I hope, is any kind of simple-minded presentism: I am not expecting, nor am I interested in forging, one-to-one equivalences between the contemporary and the eighteenth-century contexts. There is, anyway, a danger in assuming that the speaking voice or the first-person account necessarily carries greater authenticity than other kinds of evidence. But we do not have to accept the full phonocentric implications of Shannon Bell's implicit appeal to authenticity in order to recognise the important method-ological challenge which her position politics represents for any his-torical narration of prostitution. What Bell calls 'modernist' feminism fails to make space, she claims, for prostitutes as speaking subjects. It therefore colludes with the production of 'prostitute' as a monolithic category, and consequently with processes of marginalisation. All his-tories are also histories of the present moments in which they are writ-ten. But what I want to explore are the possibilities for a self-conscious double vision which negotiates eighteenth-century evidence in terms of current feminist preoccupations precisely in order to avoid the col-lusions Bell detects.

As Priscilla Alexander, speaking for and from a prostitute perspec-tive, understates it, prostitution has been a 'difficult issue for femi-nists' (Alexander 1988: 184). It seems appropriate at this point, therefore, to rehearse some of the arguments which surround this 'difficult issue'. They are part of those wider debates on the politics of sexuality, and more specifically on pornography and censorship, which have divided feminists since the early 1980s. They are debates associated particularly, at one end of a wide spectrum of opinion, with the work of Andrea Dworkin and Catharine MacKinnon; and they are debates which are of urgent current interest – particularly in the United States, where versions of anti-pornography feminism have been appropriated by the fundamentalist right. Dworkin's etymolog-ical definition of pornography as 'the graphic depiction of the lowest whores' is well known, as is her assertion that 'whores exist only within a framework of male sexual domination. ... The word whore is incomprehensible unless one is immersed in the lexicon of male domination' (Dworkin 1981: 200). From this perspective, prostitution

is the condition of all women who are involved in any way in hetero-sexuality under patriarchy; prostitution defines marriage not by its difference, but by making explicit the coercive sexual-economic con-ditions which underpin both institutions. According to this analysis, prostitutes certainly, but also women in general, are always already collusive with, and/or victims of, a violent and exploitative male desire which is culturally legitimated. In the words of MacKinnon: 'feminism stresses the indistinguishability of prostitution, marriage and sexual harassment' (MacKinnon, quoted in Bell 1994: 80).

In her article 'Should Feminists Oppose Prostitution?', Laurie Shrage carefully establishes the cultural specificity of the Dworkin–MacKinnon position, but concludes that, under present cultural conditions, the answer to the question posed by her title must be 'yes':

> the actions of the prostitute and her clients imply that they accept a set of values and beliefs which assign women to marginal social roles in all our cultural institutions, including marriage and waged employment. ... Though we should not blame the workers in the sex industry for the social degradation they suffer, as theorists and critics of our society, we should question the existence of such businesses and the social principles implicit in our tolerance for them. (Shrage 1989: 347)[2]

Elsewhere in her article Shrage suggests that, under other conditions, the prostitute might 'assume the role not of a sexual subordinate but of a sexual equal or superior' (Shrage 1989: 359).[3] And within obtain-ing power structures, 'we' are discouraged, in the passage just quoted, from 'blaming' sex workers for their own 'degradation'. But the effect of that 'we' is very clearly to put prostitutes and feminists into mutually exclusive categories, where the role of the feminist is to expose the prostitute's false consciousness in selling sex.

Shrage's position is shared by some prostitutes' groups – notably by WHISPER (Women Hurt In Systems of Prostitution Engaged in Revolt), a collective of ex-prostitutes in the United States who define prostitution as sexual exploitation. WHISPER is opposed in the States by COYOTE (Call Off Your Old Tired Ethics), in Britain by the English Collective of Prostitutes, and by those feminists who define prostitu-tion in the first instance not as exploitation but as a legitimate form of work. There is no necessary relationship, according to this contractar-ian argument, between the activity of selling sex and the exploitative conditions under which that sale too often takes place: the prostitute

is assumed to be 'the possessor of property in her own person and is as such capable of selling her labor' (Bell 1994: 77). Supporters of this position do not ignore the abuse of women, or the inequalities of class and race which operate within prostitution. But prostitution is seen as certainly no worse – and for many women considerably better – than other forms of work entered into from economic necessity. It is the criminalisation of prostitution, rather than the activity itself, which makes it degrading and exploitative. This is the distinction which underpins the World Charter for Prostitutes' Rights (1985), which calls for laws which 'decriminalize prostitution and regulate third parties according to standard business codes'.[4] From this point of view, feminists who oppose prostitution, instead of supporting prostitutes' rights, are collusive with a social and legal system which marginalises prostitutes, which subjects them to police brutality, and which makes it almost impossible for them to bring successful charges of rape, domestic violence or sexual harassment.

Theorists on both sides of this exploitation/work argument assume an inevitable connection, either symptomatic or causal, between the status of prostitution and the social and legal status of women generally. Defenders of prostitutes' rights, for example, reverse the Dworkin–MacKinnon position to argue that the effect of decriminalising prostitution must be a general improvement in women's status, since the maltreatment of prostitutes implicitly legitimates a more general misogyny. It is a connection which was made by the nineteenth-century feminist Josephine Butler, during campaigns against the Contagious Diseases Acts: 'you cannot hold us in honour so long as you drag our sisters in the mire. As you are unjust and cruel to them, you will become unjust and cruel to us.'[5] The debate is between the belief that while prostitution exists, it remains impossible for women to have control over their own bodies; and the contention, on the other hand, that women will not have control over their bodies until prostitutes have control over theirs.[6] In both cases, prostitution is understood in terms of the single, sexual category 'woman'.

To identify prostitution as work, as simply selling a service or skill like any other, is to ignore – and therefore, also, potentially to disrupt – our culture's massive overinvestment in sexuality as identity, as well as its disingenuous conflation of sex with 'love'. The question of whether sex has intrinsic properties which make its commodification wrong has been central to feminist debates on the ethics of pros-

titution. For Carole Pateman, for example, the close connection between sex and the self makes prostitution unacceptable:

> Sexuality and the body are ... integrally connected to conceptions of femininity and masculinity, and all these are constitutive of our individuality, our sense of self-identity. (Pateman 1983: 562)

> Womanhood ... is confirmed in sexual activity, and when a prostitute contracts out use of her body she is ... selling herself in a very real sense. Women's selves are involved in prostitution in a different manner from the involvement of the self in other occupations. (Pateman 1988: 207)

Refuting this position in a recent issue of *Ethics*, Debra Satz invokes both the 'diversity' of 'the relationship[s] people have with their sexual capacities' and the difficulty of maintaining that 'only sexual and reproductive capacities are essential to the flourishing self' (Satz 1995: 71, 72). But having begun to break the connection between self and sexuality, and recognising the possibility that there might be circumstances in which prostitution 'could mark a reclaiming of women's sexuality', Satz, like Shrage, falls back to the view that, in current conditions, prostitution is wrong – 'because of its effects on how men perceive women and how women perceive themselves' (Satz 1995: 80, 78). Sceptical of COYOTE's claim that prostitution, properly regulated, can be a site for the empowerment of all women, Satz implicitly perpetuates the subject–object relationship between feminist and sex worker when she suspends ethical judgement, pending detailed ethnographic research into the social effects of what she calls prostitution's '"theater" of inequality' (Satz 1995: 79).

For radical sexual pluralists like Gayle Rubin and Shannon Bell, it is precisely that sense of 'theatre' which challenges the 'tired ethics' of anti-prostitution feminism: it is the performativity of sex work that disturbs the fixed hegemonic categories which condemn 'woman' and 'prostitute' to play fixed roles in a repetitive story of heterosexual, and heterosexist, exploitation. For Rubin, diverse sexualities break open the sex/gender system, one effect of which has been that women in the sex industry 'have been excluded from most production and consumption, and allowed to participate primarily as workers' (Rubin [1984] 1992: 308). Sexual agency – whether in personal relationships, commercial transactions, or pornographic representations – is for Rubin and Bell both strategy and goal. Bell celebrates the emergence of the postmodern prostitute 'simultaneously as a new political subject and as a plural, rather than a unitary subject', but she

also recognises the constraints on agency within the current 'negative reality' (Bell 1994: 99, 136). Taking up a theoretical position reminiscent of Judith Butler's use of drag to expose gender as performance, Bell celebrates prostitute performance art as a deconstructive articulation of that fraught emergent subjectivity: balancing 'the presentation of the prostitute body as an abused body and as an empowered body, refusing any bifurcation' (Bell 1994: 188).[7] And in an academic context, this disruption of categories is enacted in a special issue of the journal *Social Text* which brings together writings by academics and sex workers. Again, the emphasis is on plurality:

> sex workers do not speak with a univocal voice: there is not a single, authoritative narrative of prostitution ... Rather than celebrating an essentialist politics of identity, the essays in this issue throw into relief the difficult politics of alliance. (McClintock 1993: 8)

So how might that 'difficult politics of alliance' be negotiated in a historical context? One of the aims of any feminist account must be to narrate prostitution in ways which simultaneously record and resist reductive, and thus marginalising, categorisations. Those categorisations will include of course the very common representation of the prostitute as always already victim; but they might also include the reverse image, which celebrates prostitutes as independent sexual tradeswomen, or, to borrow Catherine Gallagher's formulation, as postmodern nobodies. Shannon Bell's historical survey of prostitution leaps from the classical *hetaira* to the silenced and specularised prostitute of nineteenth-century reformist and scientific discourses. It is out of this modernist silencing, she claims, that postmodern prostitutes are only now beginning to reclaim subjectivities, and it is incumbent on feminist cultural and literary historians to avoid colluding with that silencing process. One way of doing so might be to challenge Bell's selective historical narrative and her unexamined modern–postmodern binary: to supplement what Bell categorises as 'postmodern' prostitute identities by complicating the received (repressive) versions of prostitute histories.

With this in mind, let me now return to the two eighteenth-century examples with which I began. They represent, of course, very different kinds of prostitute text: Gallagher draws on the libertine tradition; Fielding's pamphlet is from the literature of reform. They thus implicitly give access to very different levels of prostitution and of agency, and to very different working conditions. And, as a result of

those differences, they appear to offer very clear narrative and methodological alternatives: between, on the one hand, the histories of oppression and exploitation which tend to emerge from an exclusive focus on reform texts such as Fielding's; and, on the other, Gallagher's productive discursivity which may or may not empower prostitutes in its refusal to tell a repressive story about femininity.

Nevertheless, in some dominant accounts of eighteenth-century prostitution, these differences have been accommodated within the same narrative: the story of the metamorphosis, around the mid-century, of Gallagher's performative prostitute into Fielding's vulnerable, exploited girls; of how the variousness, and monstrous power, of 'audacious Harlots' at the beginning of the century is reduced and contained by the discovery of the prostitute as a 'fallen Angel'.[8] Randolph Trumbach, for example, argues that this shift is to be understood in terms of changing gender roles and family structures within discourses of equality and individualism, and that the shifting legal and discursive treatment of prostitutes should be read in conjunction with the emergence of the sodomite as other to the new, exclusively heterosexual, man of sensibility: 'new gender roles set the limits of the acceptable by redeeming the prostitute and ostracising the sodomite' (Trumbach 1987: 75).[9] To define the prostitute as recoverable femininity, rather than as a figure dangerously outside gender, is to narrow the categories of both woman and prostitute. At the same time, in saving the individual prostitute, reform texts reify and dehumanise the category of 'prostitution' out of which she escapes: 'Tho' the profession of a prostitute is the most despicable and hateful that imagination can form; yet the individuals are frequently worthy objects of compassion' (*Histories* 1760: I, v). Recent studies which examine prostitution within the discourse of sensibility tend also to reproduce a version of this narrative in their focus on reformist representations of the penitent prostitute.[10]

Told from another angle, this story of containment and silencing traces the splitting off of female authorship from a prostitute identity sometime around the 1730s or 1740s. Thus at the beginning of the century, the fictions of Aphra Behn, Delarivier Manley and Eliza Haywood exploit scandalous rhetorical and performative possibilities no longer possible later under what Janet Todd has called the 'pressure towards respectability' (Todd 1989: 128).

The scandalous memoirist Teresia Constantia Phillips – writer as well as well-known courtesan – is an interestingly symptomatic

figure here. Phillips's ghost-written *Apology for the Conduct of Mrs Teresia Constantia Phillips* appeared in 1748–9. Her text woos a popular audience and threatens former lovers as a way of making money to pay for the labyrinthine law suit, lasting eighteen years, in which she defended herself against her husband's charge of bigamy. Phillips's text, her critical reception at the time, and the labelling of her, together with the other scandalous memoirists of the mid-century, as an example of 'a wanton Muse' (Duncombe [1754] 1990: 173) seem very clearly to mark the impossibility of female writing approximating any longer to the performance art of the prostitute. The *Apology* has clear connections with the earlier 'scandal' writers, but makes much more obvious concessions to a standardised femininity: in her eclectic text, Phillips explicitly resists the role of 'unhappy Sufferer, … [who] bends under every new Oppression' (Phillips 1748–9: 3, 34); nevertheless, her structuring project is to exchange the 'unmusical, harsh-sounding title of whore' (Defoe [1722] 1989: 68) for that of lawful wife. Described thus, Phillips's *Apology* appears to confirm the process of silencing categorisation recorded by Shannon Bell. But this would be equally true of a (perfectly possible) reading emphasising the text's transgressive qualities and celebrating Phillips herself as a proto-feminist figure. Either way, the *Apology* is defined and contained by the responses of 'respectable' opinion, and the binary structures of marginalisation are left intact.[11]

In her introduction to the issue of *Social Text* which I referred to earlier, Anne McClintock reminds us that:

> Demonizing all prostitutes as hapless victims serves only to heighten the climate of violence and hypocrisy under which so many live. … The social depiction of prostitutes as victims and sex slaves not only obscures the myriad contexts and experiences of sex work, but, more hazardously, exacerbates the dangers of assault. (McClintock 1993: 7)

A feminist approach to eighteenth-century prostitution which seeks to recover 'the myriad contexts and experiences' of eighteenth-century sex work might yield other ways of reading Phillips and her *Apology*, and resist the fantasies of assault which haunt representations of passive prostitutes in sentimental fiction and reform texts. I have not forgotten my initial anxiety about the challenge of suffering – in both the past and the present – but central to McClintock's point is that suffering and abuse must themselves be carefully contextualised and discursively understood. We can access something of these

'myriad contexts and experiences' when, for example, prostitutes give court evidence; or, rather differently, are advertised in *Harris's List of Covent Garden Ladies*; and we can glimpse resistance as the inmates of the Magdalen Hospital 'performed' penitence for the crowds attending Sunday Service in the Hospital Chapel, or in the numbers of women listed in the Magdalen records as 'Uneasy under Restraint, and dismissed at their own Desire' (*An Account* 1770: ii).[12] The question is not simply one of how, but also of what to read. What constitutes admissible evidence? And I want to speculate here on what scurrilous and libertine traditions might have to contribute to feminist reconstructions of eighteenth-century prostitution – beyond the performativity celebrated by Gallagher; and beyond simply providing demonstrations of what Carol Houlihan Flynn, analysing Cleland's *Memoirs of a Woman of Pleasure*, has called 'the pains of compliance' (Flynn 1987). So I want to end with two such texts from the mid-century and some brief – and guarded – suggestions as to how they might begin to help diversify prostitute identities.

The first is part of the considerable body of literature produced in response to Constantia Phillips's *Apology*. Its title gives an indication of the kind of text we are dealing with: *A Genuine Copy of the Tryal of Thomas Grimes, Esq. alias Lord S–, For A Barbarous and inhuman Rape, committed on the Body of Miss T. C. P. a young Girl of Thirteen Years of Age On a Special Commission of* Oyer *and* Terminer, *held at the Old Court House, now a Bagnio at* Charing-Cross, *before the Worshipful Mrs. Justice* Broadbottom, *Mrs. Justice* Firebrand, *and Mrs. Baron* Rigglerump. In this spoof trial report, Lord S– (the Earl of Scarborough) is found guilty, by a judge and jury of prostitutes, of raping Constantia Phillips. (Phillips begins her *Apology* by adopting the role of seduced innocent, and blaming her subsequent career on her seduction and rape at the age of thirteen by 'Mr Grimes' – variously identified as the Earl of Chesterfield and the Earl of Scarborough.)[13] The dedication to the *Tryal*, 'To the Chaste, compassionate, and tender hearted Ladies of Great Britain', describes women's ancient right 'of trying such Crimes, as particularly affect the Sex' (*Genuine Copy* [1748]: A2r, A2v). According to the prosecuting justices, Grimes's rape 'affects the sex' by disrupting a sexual economy regulated by internal conventions. He deprives Phillips herself of the opportunity to bring 'her rare Stock of blooming Beauty to Market', but, more generally, he also offends against 'Youth, Innocence and Beauty' in assuming that the privileges of rank gave him the right to 'chea[t] the Trade', employing

'his rascally Valet as his Pimp, without the Consent or Assistance of a licensed Broker. If this should become a Fashion, how many honest industrious good Women, worn out in the Service of the Publick, must turn out on the Parish, or be obliged to Mill-Doll in their Buffs for Stripes and Bread and Water?' (*Genuine Copy* [1748]: 24, 26, 29). Grimes is condemned for participating in 'this Taste for green Girls, this Itch after unripe Maidenheads' which threatens those 'useful Members of Society', the 'Ladies of Pleasure', with starvation – and which is also, of course, in part responsible for the child prostitutes whose plight moved Fielding to advocate reform (*Genuine Copy* [1748]: 27–8). No one here escapes the satirist's attacks – least of all, perhaps, Phillips herself, and certainly not the commercially canny 'Ladies of the Town' and their 'Love-Brokers'. But the knowing ironies, laden with class antagonism, give access to a sexual economy run according to a commercial morality based on agency. In signalling differences within the category 'prostitution' rarely acknowledged within reformist discourse, this decidedly unrespectable text unexpectedly aligns itself with Fielding's attack on the exploitation of the 'wretched … pitiable Body' of deserted girls. Such differences and alliances necessarily qualify and complicate readings of Phillips's *Apology* based solely in the responses of 'respectable' commentators.

My second example is an unexpected variation on the classic sentimental narrative of fallen innocence. It is the story of a posture girl, an erotic performance artist, told in the voice of the girl herself, which is embedded in a mildly pornographic novel of 1749, *The History of the Human Heart*. The posture girl has been performing at a tavern visited by the libertine protagonist of the novel and his friends, and tells her story by way of explaining her refusal also to sell sex. Brought up as a dancer when the death of her parents forced her into the custody of an uncaring aunt, the girl was taught to maintain her virginity as a means to keeping her figure and thus her job. The result is that she makes a clear distinction between a moral self and the performing body:

> though when in that Woman's Service I exposed myself Naked, and in many obscene Pictures in some select Companies, yet being much accustomed to vicious Tricks in my Infancy, they inspired in me no more loose Thoughts, than if I had been reading a Common-Prayer-Book; it was purely mechanical, a Scene in which my Body was only concerned, but in no measure influenced my Morals.
>
> … to get Bread, [I] was obliged to fall into the Tricks which you have

seen, yet still I have preserved my Chastity, and am resolved to do so till I can be settled in some better way of Life.

The Company were mightily pleased with the History the Posture-Girl gave of herself. (*History* 1749: 132–3, 141)

The rakes respect the girl's professional autonomy, and leave her to look for conventional prostitutes.

The posture girl's story reproduces many of the features of sentimental fiction: the importance of maintaining chastity; the fall into increasingly poor circumstances after initial neglect by an immodest and uncaring aunt; and the speaker's manifest capacity for redemption. More interesting, and more urgent, however, are the significant differences between the passive penitent of the classic sentimental seduction narrative and this working-class posture girl. Like *The Tryal of Thomas Grimes*, her vivid account of sex work based on financial necessity allows us to access a sexual economy which does not simply negate female autonomy. The posture girl articulates a split between work and 'self' in which her performance of sexualised femininity is seen as perfectly compatible with her hope of achieving a different feminine identity, defined as a 'better way of life'; indeed, it is a means to that end.

Mediated though it is through this libertine text, the posture girl's resistance to any easy categorisation offers an implicit critique both of glib appropriations of the prostitute as sign of disruptive performativity, and of accounts of eighteenth-century prostitution which use reform discourse to repeat a repressive narrative of victimisation. What I am advocating, then, is the recovery of voices such as that of the posture girl, muffled though they necessarily are by historical distance, genre, even fictionality. Through such acts of self-conscious interpretative recovery – of reconstruction, if necessary – the feminist cultural historian can complicate the received story, and thus contribute something to the 'difficult politics of alliance' central to current prostitution debates.

Notes

1 Published 1683, based on an Italian text. For further discussion of this text, see Turner 1995.
2 See also Chancer 1993: 154–5.
3 See also Primoratz 1993.
4 'World Charter for Prostitutes' Rights', in McClintock 1993: 183–5 (183).
5 In Walkowitz 1982: 81, quoting from Bristow 1977.

6 See Bell 1994: 126.
7 See also Butler 1990.
8 '[A]udacious Harlots': [Defoe] [1726]: 2; 'fallen Angels': [Cleland] 1749: 13.
9 See also Speck 1980; Trumbach 1991, 1998.
10 See, for example, van Sant 1993: 31–7; Ellis 1996: 160–89; Jones 1997.
11 See, for example, Janet Todd, 'Nonconforming Women', in Todd 1989: 128–31.
12 See Denlinger 1997; Lloyd 1996.
13 Lawrence Stone, for example, follows the assumption often made at the time that Grimes was Chesterfield: see Stone 1992: 236–74; Lynda Mia Thompson (1995), however, identifies Grimes as the Earl of Scarborough, an identification supported by *The Tryal of Thomas Grimes*.

References

Alexander, P. (1988) 'Prostitution: A Difficult Issue for Feminists', in Frédérique Delacoste and Priscilla Alexander (eds), *Sex Work: Writings by Women in the Sex Industry*, London, Virago.

An Account of the Rise, Progress, and Present State of the Magdalen Hospital, for the Reception of Penitent Prostitutes. Together with Dr. Dodd's Sermons … (1770), 4th edn, London, J. Knox and H. Parker.

Bell, S. (1994) *Reading, Writing and Rewriting the Prostitute Body*, Bloomington and Indianapolis, Indiana University Press.

Bristow, E. (1977) *Vice and Vigilance: Purity Movements in Britain since 1700*, Dublin, Gill and Macmillan.

Butler, J. (1990) *Gender Trouble: Feminism and the Subversion of Identity*, New York and London, Routledge.

Chancer, L.S. (1993) 'Prostitution, Feminist Theory, and Ambivalence: Notes from the Sociological Underground', in A. McClintock (ed.), *Social Text*, 37, special issue on sex workers.

[Cleland, J.] (1749) *The Case of the Unfortunate Bosavern Penlez*, London, T. Clement.

Defoe, D. ([1722] 1989) *Moll Flanders*, ed. David Blewett, Harmondsworth, Penguin.

—— ([1726]) *Some Considerations upon Streetwalkers. With A Proposal for Lessening the Present Number of Them. In Two Letters to a Member of Parliament*, London, A. Moore.

Denlinger, L. (1997) 'Genteel and Working-Class Whores: The Representation of Prostitutes in *Harris's Lists of Covent Garden Ladies* 1764–1793', paper given at the annual ASECS conference, Nashville, TN, April.

Duncombe, J. ([1754] 1990) *The Feminiad: A Poem*, in Vivien Jones (ed.), *Women in the Eighteenth Century: Constructions of Femininity*, London and New York, Routledge.

Dworkin, A. (1981) *Pornography: Men Possessing Women*, London, Women's Press.

Ellis, M. (1996) *The Politics of Sensibility: Race, Gender and Commerce in the Sentimental Novel*, Cambridge, Cambridge University Press.

Fielding, J. (1758) *An Account of the Origin and Effects of a Police … To which is added, A PLAN for preserving those deserted Girls in this Town, who become Prostitutes from Necessity*, London, A. Millar.

Flynn, C.H. (1987) 'What Fanny Felt: The Pains of Compliance in *Memoirs of a Woman of Pleasure*', *Studies in the Novel*, 19, 284–95.

Gallagher, C. (1994) *Nobody's Story: The Vanishing Acts of Women Writers in the Marketplace 1670–1820*, Oxford, Clarendon Press.

A Genuine Copy of the Tryal of Thomas Grimes, Esq. alias Lord S–, For A Barbarous and inhuman Rape, committed on the Body of Miss T. C. P. a young Girl of Thirteen Years of Age On a Special Commission of Oyer *and* Terminer, *held at the Old Court House, now a Bagnio at* Charing-Cross, *before the Worshipful Mrs. Justice* Broadbottom, *Mrs. Justice* Firebrand, *and Mrs. Baron* Rigglerump ([1748]), London, E. Anderson and E. Pen.

Histories of Some of the Penitents in the Magdalen-House, as Supposed to be related by Themselves (1760), 2 vols, London, John Rivington and J. Dodsley.

The History of the Human Heart: or, the Adventures of a Young Gentleman (1749), London, J. Freeman.

Jones, V. (1997) 'Placing Jemima: Women Writers of the 1790s and the Eighteenth-Century Prostitution Narrative', *Women's Writing*, 4 (2), 201–20.

Lloyd, S. (1996) '"Pleasure's Golden Bait": Prostitution, Poverty and the Magdalen Hospital in Eighteenth-Century London', *History Workshop Journal*, 41, 50–70.

McClintock, A. (ed.) (1993) *Social Text*, 37, special issue on sex workers.

Pateman, C. (1983) 'Defending Prostitution: Charges against Ericsson', *Ethics*, 93, 561–5.

—— (1988) *The Sexual Contract*, Cambridge, Polity Press.

Phillips, T.C. (1748–9) *An Apology for the Conduct of Mrs Teresia Constantia Phillips, More Particularly That Part of it which relates to her Marriage with an eminent Dutch Merchant*, 3 vols, London, printed for the author.

Primoratz, I. (1993) 'What's Wrong with Prostitution?', *Philosophy*, 68, 159–82.

Rubin, G. ([1984] 1992) 'Thinking Sex: Notes for a Radical Theory of the Politics of Sexuality', in Carole S. Vance (ed.), *Pleasure and Danger: Exploring Female Sexuality*, rpt with new intro., London, Pandora.

Satz, D. (1995) 'Markets in Women's Sexual Labour', *Ethics*, 106, 63–85.

Shrage, L. (1989) 'Should Feminists Oppose Prostitution?', *Ethics*, 99, 347–61.

Speck, W.A. (1980) 'The Harlot's Progress in Eighteenth-Century England', *British Journal for Eighteenth-Century Studies*, 3, 127–39.

Spivak, G.C. (1987) *In Other Worlds: Essays in Cultural Politics*, New York and London, Methuen.

Stone, L. (1992) *Uncertain Unions: Marriage in England 1660–1753*, Oxford, Oxford University Press.

Thompson, L.M. (1995), '"I Have a Right to Choose the Weapons: A Pen is Mine": The Weaponry of the Scandalous Memoirists of the Mid-Eighteenth Century', paper given at the Mary Wollstonecraft in Sweden conference, Uddevalla, Sweden; forthcoming in *From Shame to Publick Fame: The Scandalous Memoirists*, Manchester, Manchester University Press.

Todd, J. (1989) *The Sign of Angellica: Women, Writing and Fiction, 1660–1800*, London, Virago.

Trumbach, R. (1987), 'Modern Prostitution and Gender in *Fanny Hill*', in G.S. Rousseau and Roy Porter (eds), *Sexual Underworlds of the Enlightenment*, Manchester, Manchester University Press, 69–85.

—— (1991) 'Sex, Gender, and Sexual Identity in Modern Culture: Male Sodomy

and Female Prostitution in Enlightenment London', *Journal of the History of Sexuality*, 2, 186–203.

—— (1998) *Sex and the Gender Revolution, Volume One: Heterosexuality and the Third Gender in Enlightment London*, Chicago and London, University of Chicago Press.

Turner, J.G. (1995) '*The Whores Rhetorick*: Narrative, Pornography, and the Origins of the Novel', *Studies in Eighteenth-Century Culture*, 24, 297–306.

van Sant, A.J. (1993) *Eighteenth-Century Sensibility and the Novel: The Senses in Social Context*, Cambridge, Cambridge University Press.

Walkowitz, J. (1982) 'Male Vice and Feminist Virtue', *History Workshop Journal*, 13, 79–93.

10

THE STORY
OF DRAUPADI'S DISROBING:
meanings for our times

RAJESWARI SUNDER RAJAN

Among the chief narrative legacies that modern India has inherited in the cultural-religious sphere is the ancient Sanskrit epic of the *Mahabharatha*, with its many variations and revisions to the present day.[1] It is the story of its heroine, Draupadi, and in particular the famous episode of her disrobing, that I subject here to feminist examination and reinterpretation. My interest lies primarily in discovering the resonance of this story in contemporary India and its implications for women. In the latter part of this essay I undertake, consequently, to show how the 'uses of tradition' in postcolonial societies may be understood, drawing upon contemporary social practices and a wide range of modern texts that are connected to the 2,500-year-old story of Draupadi's sexual humiliation.

The resonance of the *Mahabharatha* and its different plots, sub-plots and episodes is evident from the numerous adaptations, commentaries, revisions, dramatisations and retellings it has undergone in Indian cultural history. I do not mean to propose some timeless and unchanging condition of women's oppression in India based upon the wide contemporary currency of the epic's narration of Draupadi's humiliation. On the contrary, it is precisely the potential and the fact of its appropriation by opposite ends of an ideological spectrum – from the patriarchal legitimation of the control of women by inflicting punishment upon them to claims for Draupadi as proto-feminist cultural heroine – that demand our attention and that I shall be outlining in what follows.

The first I see reflected in the ubiquity of the phenomenon of that peculiarly Indian form of male sexual behaviour known as 'eve-

teasing', most prevalent in the larger metropolitan cities, but becoming increasingly an aspect of small-town Indian life; and in its rural counterpart, the practice of women's being stripped and paraded naked in public. In the second part of the essay, I discuss these as actions aimed at the sexual humiliation of women – hence as expressions of misogyny or as methods of social control rather than as a pathology of sexual violence, as such. Following this, I point to both the 'moral' that popular cinema draws from its representations of women in such situations, and to the language of the law's prohibition of the actions. The concluding section of my essay contains reflections upon recent feminist appropriations and critical 'uses' of the figure of Drapaudi.

It will be necessary to recapitulate briefly the Draupadi story and its context in the epic to begin with. The disrobing scene occurs in the second book of the *Mahabharatha*, which narrates the struggle between two clans, the Kauravas and the Pandavas, for the possession of a kingdom. Draupadi is the joint wife of the five Pandava brothers. The Pandavas have successively lost all their possessions, including their kingdom and their own selves, in a gambling match with the Kauravas. They are urged to stake Draupadi in a last throw of the dice. Yudishter, the oldest brother, does so, and loses. Draupadi is sent for to appear at the court, even though, as a Kshatriya woman and a princess, she would not appear in public thus; further, Draupadi is in a menstruating state and hence ritually impure. She refuses to obey, and tells the messinger instead: 'Go and ascertain from the gambler whether he lost himself, or me, first.' She is thereupon forcibly dragged by the hair and brought to the hall by Dhushasana, one of the Kaurava brothers. Again she repeats her question: did Yudishter have a right to stake her if he had already become a slave? Her question is disregarded. Karna, on the Kaurava side, orders her to be stripped since, married to five men, against custom, she may be regarded as a 'whore'. Dhushasana begins to pull off her garments, but miraculously more and more of them appear to clothe her, and he stops, exhausted. The blind old Kaurava king is persuaded to cry a halt to this injustice; and he offers Draupadi three boons to compensate for the insult offered her. With these she frees her husbands. The Pandavas, in response to Draupadi's rage at her humiliation, vow revenge on the Kauravas. After losing at another gambling match, and serving thirteen years in exile, they return to wage war against them. The great Mahabharatha war is fought, however, not to avenge

Draupadi's insult; the 'righteous war', the occasion of the *Bhagavad Gita*, is fought to settle the long-standing struggle between clans for political power. Finally, the Kauravas are defeated and killed, the kingdom is restored to the Pandavas, and Draupadi is avenged.

I wish to draw out several strands of speculation from this: first, to observe that the Draupadi 'scene' is structurally similar to other forms of staged spectacle in its transgression of the 'separate' spheres, that is, in the enactment of a private act (here, the display, disrobing and attempted sexual violation of a woman) in a public space (the king's court or assembly). Woman as the sole and singular object of the public gaze in such scenes may ambivalently be the recipient of both admiration and scorn: neither response is free of the overtones of the other, or of sexual significance. The woman's response to the gaze is also ambivalently divided between pride and shame, an aspect of the simultaneous exhilaration and disgrace/danger that attend what I have elsewhere described as women's exceptional entry into the space of the public (Rajan 1993: 88). As I shall shortly be pointing out, Draupadi too seeks to exploit the public space and public speech that circumstances – however unfavourable – give her access to, with varying degrees of success.

In the *Mahabharatha* episode Draupadi explicitly recalls the only other occasion she had been viewed in public: in the *swayamvara* arena by the assembled kings come to woo her, when she had chosen her future husband, Arjuna, for his feats of prowess. So she laments: 'Alas, only once before, on the occasion of the swayamvara, I was beheld by the assembled kings in the amphitheatres, and never even once beheld afterwards. She whom even the winds and the sun had seen never before is exposed to the gaze of the world. I think these are evil times when the Kurus allow their daughter-in-law to be thus tormented.'[2] Then she had been the cynosure of all eyes. Her appearance – in both senses of the word: her dishevelment as well as her presence in the court – is a very different matter now.

I want to read deeper into her connection of the two exceptional events whose only common point is her presentation to an assembled gaze. I am led to the intuition that what she experiences as trauma is not the shock of the unexpected but the recognition of the familiar. For Draupadi this repetition-with-difference is not merely poignant – it has the quality of nightmare. For in the scenario of nightmare, humiliation follows from stripping or some sense of the loss of the familiar accoutrements of identity, the metaphoric isolation of the naked self,

exacerbated by the stares of a crowd. And in the dream this is attended by paralysis.

Does this dream-state also explain why women experience such fatalism about sexual violation when it happens? If women are socially and culturally conditioned to expect and therefore accept such violation, might it not be that they have always already experienced it? Not in the sense of literal knowledge or of fantasy (the latter based on the covert or unacknowledged desire for it that they are accused of having), but as a 'memory' – from an institutional rather than individual source?[3] This is not to say that women's knowledge of violence is only a subjective experience, but rather to insist that the dynamics of the subjective, here as memory, must enter the space of narration. Draupadi, it is true, is shown to react strongly to her ordeal by speech and action, but the epic narrative mode does not provide access to interiority. So it is through Draupadi's rhetorical evocation of the similar-but-contrasted past that we read her cognitive structuring of the present scene of violation – as the expected and inevitable – and the past scene of triumph – as the ordeal of the public gaze in terms of resemblance.

Both the trauma of publicity and the sanctity of privacy are for women products of the ideology of separate spheres. In the narrative of the *Mahabharatha*, textual scholars say, it is not so much the disrobing as the forced entry into public space that Draupadi returns to later (in her recurrent allusions to the time), which is the source of her shame. Since 'it is the barrier between the public and the private which defines "respectable" and "non-respectable" women', this transgression enforces her new status as slave woman. Even the disruption of her ritual pollution as menstruating woman may be viewed as a trespass into 'the private language of the female body' (Janaky 1992: 1997–9, 1999).

There are two cruxes that are usually recognised as being of special significance in the interpretation of Draupadi's agency: the first, her famous question; and the second, the means of her salvation. Her question: did Yudhishter bet her before or after he lost himself, is never answered, because it is unanswerable. Alf Hiltebeitel, the noted Draupadi scholar, regards it as a *feminist* question since 'it challenges the men to consider … their lordship over and "ownership" of women in contexts of patriarchy' (Hiltebeitel 1994). The philosopher B.K. Matilal describes her question as the sole and 'unique' unanswered dilemma in the epic. But Matilal too notes a displacement:

Draupadi's question is 'more concerned with rights or legality ... than with the morality of the situation'. From his contemporary location he also concedes that it is a 'point [made by] a social rebel, presumably a non-conformist'. 'If Draupadi's questions were properly answered, it would have required a "paradigm shift", in India's social thought' (Matilal 1989: 2–3). In contrast to these comments is the scathing verdict of Iravati Karve, the author of *Yugantar* (*The End of an Epoch*), a major modern version of and commentary on the *Mahabharatha*: 'Draupadi's question was not only foolish; it was terrible' (Karve [1967] 1991: 99).[4]

In a more recent debate on the feminism of Draupadi's question, Draupadi scholar Janaky offers somewhat different arguments to counter Shuddhabrata Sengupta's praise of Draupadi's 'feminist' question on the grounds of a 'universal' womanhood (Janaky 1992).[5] By raising the question of slavery, Janaky argues, Draupadi brings up the class and caste aspects of sexual oppression; and by claiming protection as the 'kulavandhu' of the clan (i.e., on the basis of her kinship relationship), she highlights its political dimension (Janaky 1992: 1999). Draupadi can be recuperated for feminism not by essentialising her predicament as a 'women's issue', but by remaining alert to the 'sexual vulnerability and political subordination of women *within the larger network of intersections of power and ideology at the multiple levels of caste, race and class*' (Janaky 1922: 1999; emphasis added).

How are we to reconcile these different interpretations of Draupadi's question: on the one hand, the easy recuperation of feminist rights talk; on the other, the difficult recognition of the limits of such rights: the universalisation of her predicament as against the specificity of her historical, social, political identity intersecting with the gendered? Draupadi's question, in these feminist contentions, makes no difference to *her* within the frame of the disrobing scene, however it may resonate outside that context.

The second crux of interpretation – which is also a textual crux – relates to the means of her salvation. Draupadi rehearses a range of more or less successful strategies to escape her situation, ranging from physical resistance to recourse to legality, appeals for male protection, curses, threats of revenge, and finally dignified submission coded as moral triumph. Because at the overt level she reacts to her ordeal in such strenuous and resistant ways, she is frequently recuperated as 'feminist' by contemporary scholars and artists. But in the *Mahabharatha*, the prevention of her nakedness is attributed to no

action of hers, but to the operation of cosmic or universal justice. More importantly, she is subjected to the full extent of her humiliation already by being dragged into court, reviled and manhandled: any reading of 'salvation' after such an ordeal can only be ironically intended.

In most popular versions, including the recent television serial of the *Mahabharatha*, Draupadi is saved by the Lord Krishna, who appears in response to her prayers (these are most probably later interpolations, according to critical scholarship).[6] It is, of course, Draupadi's virtue as a chaste wife that produces the miracle. Is this too to be read as a sign of Draupadi's 'agency', her independent assertion of virtuous selfhood? But the tautology of the virtuous woman who is saved because she is worthy to be saved has its inexorable logic: raped women, that is, those are *not* saved, were unworthy. We can admire the feminism of Draupadi's exceptional salvation only at the cost of the misogyny of that logic.

The 'resolution' of the disrobing scene does not, however, consist of this confirmation of Draupadi's virtue, but in what lies beyond and as a consequence of it: the freedom she wins for her husbands by exercising her compensatory boons. When the Kauravas had already won the kingdom of the Pandavas and reduced them to slaves, for them to instigate further the staking and attempt the disrobing of Draupadi is a gratuitous insult that leads to a reversal, their moral defeat. Why then does the gambling match proceed to the self-defeating excess of this event? And yet this question is rarely asked, so logical does it seem as structural climax, and the violation of women of a defeated territory so routinely claimed as the victors' crowning triumph and as a closure to political deals. The Kauravas are seemingly only indulging in playful, high-spirited celebration in calling for the sport of disrobing Draupadi. Nevertheless, there is unease among the Kauravas themselves about the propriety of the act, and the enormity of the transgression of 'dharma', the norms of kingly conduct, finally strikes home.

What I have sought to do in my argument thus far is keep Draupadi's story exorbitant to the narrative movement towards a formal resolution: first by structuring her ordeal as a 'nightmare', or reverie; then by stressing her questioning as futile/improper talk rather than active agency within the situation; finally by calling attention to the narrative excess of the disrobing scene, and to her exclusion from the concerns of political conflict. The *Mahabharatha* will serve as pre-text

for other violations but provide the scenario for few instances of salvation. Draupadi's salvation is not only exceptional; it is also, finally, irrelevant. And, as I argued earlier, it must not blind us to the awareness that the mere withholding of some 'ultimate' outrage (e.g., rape) cannot count as 'salvation'.

Eve-teasing is the male harassment of a woman in public – verbally, physically or both – a form of taunting with varying degrees of seriousness; the eve-teaser may act alone or in a group of like-minded men, while the victim is usually single. Women in the west experience sexual harassment in the form of wolf-whistles, bottom-pinching and similar expressions of male 'admiration' of the stranger woman in a public place. The quaint term 'eve-teasing', in India, carries similar connotations of simultaneous gallantry and 'harmless' male mischief, and has passed into accepted usage (figuring also in the title of the law prohibiting such harassment). Nevertheless, as both social behaviour and phenomenon, it is viewed more seriously in a context where women's chastity and (their) men's honour are major values. There are consequently two contradictions that inform the eve-teasing activity in India (which are highlighted by the *Mahabharatha* episode as well), which mark its difference from sexual harassment as such: one, that even when viewed as wrong in moral and legal terms, it is underpinned by a self-righteous logic of punishment, and consequently carries implicit social sanction; and two, that in spite of its overt and indeed blatant aggression towards the victim, it transparently reveals anxieties about female sexuality, or superior social status, or social mobility, or a combination of these.

Crime statistics reveal interesting facts: a growing increase in the incidence of 'eve-teasing', not attributable entirely to more women reporting the crime than before; a significantly higher incidence in the northern states than in the southern, in Delhi than in other cities; and an equal number of cases in affluent neighbourhoods, colleges and workplaces and in slum areas. Sociologists attribute these phenomena to different causes, such as urban migration, the destruction of a traditional *mohalla* culture, the sudden upward social mobility of certain caste groups, new wealth, and, above all, the pervasive 'culture' of *purdah* (characteristic of the northern belt that had been subjected to Islamic invasions in the past) that secures women's safety only within doors and makes them fair prey in public spaces (see Pande 1995; Goyal 1995, 1997).

Attitudes to gender clash with modernity in particularly conflictual ways. The legitimising logic of 'eve-teasing', as of rape, is based on the confused but genuine belief that 'women [in public places] want it', the skewed semiotics of sex in a rapidly modernising society. One tendency in contemporary analyses is therefore to blame 'modernity' comprehensively for its 'intrusion' on established ways of life, never mind if the latter had/have no place for egalitarianism. The other side of the argument, which I am trying to push here, is that women's rights are an important component of modernity.

An even more vicious expression of misogyny is found in the reports from rural areas of women stripped naked and paraded through the village streets, a 'traditional' punishment meted out by men in village councils to women found guilty of sexual offences such as elopement with a person of a different caste, adultery, illicit liaisons etc.; or of so-called 'witchcraft'. The modern instances of this action, when investigated, invariably turn out to be retaliation by upper-caste landowners upon scheduled caste women with whom they are involved in property disputes, especially when the women are either more vulnerable or more independent than others in their community; or upon the men of the community for similar reasons (Rai 1994). But disputes can arise from a number of larger factors, such as 'inadequate land reforms, ineffective enforcement of Minimum Wages Act, continuance of bonded labour', as the 1979 *Atrocities on Harijans* report points out,[7] and the punishment of women is a familiar form of retaliation.

If, in both eve-teasing and stripping, the intention to humiliate the woman/women derives from misogyny and is, as I surmise, greater than the motive of sexual gratification, the pathology of voyeurism, sadism and domination nevertheless has strong sexual components.[8] The 'meaning' of these actions directed against women is not, however, exhausted by motive (punishment) or practice (ritual); nor can it be confined to an understanding of the pathology of the perpetrators. In almost every instance, the attitude of bystanders is of equal significance: and this, invariably, is one of non-interference, whether out of fear of involvement, or apathy, or even active complicity with the criminals. The law – as represented by the officers of the law – reflects this attitude. It is within this larger frame of reference – that is, in the context of widespread social attitudes – that explanations in terms of 'culture' have resonance.

The Draupadi story, it is needless to say, is not being regarded

here either as the source or as the legitimation of these actions. Rather, it serves as a heuristic, a narrative frame for viewing contemporary events. Mere 'culturalist' explanations ignore the complicated ways in which culture and society function in relation to each other. Cultural resources, I wish to argue, are *selectively* appropriated to mesh with the postcolonial nation-state's requirements. In this case, the entry of women into the spaces of public life, in particular the workplace, is a sign of social change that goes by the ambivalent name of 'modernisation'. Eve-teasing is the new and illegitimate offshoot of the project of the social control of women, a project made urgent by these changes, and is reconciled to as one of the risks that women must run in negotiating public life. Public stripping, by contrast, has 'traditional' sanction for imposing such control but – like present-day sati – it must now function under the sign of disavowal as a consequence of the modern state's refusal to countenance it legally, even as its logic grows more aggressive. Usha Rai chronicles several recent instances of this offence, whilst documenting the caste and property disputes that underlie them, and the politics of cover-up (Rai 1994).

Drawing upon the unfailing impact of the episode of Draupadi's disrobing in producing shock and sexual frisson, popular Indian cinema routinely includes a 'rape' scene in which the villain pulls away the heroine's sari, the point at which the representation of sexual violation generally stops due to censorship restrictions. The popular song-and-dance sequences which feature the hero and his friends serenading the heroine operate, however, according to the more complex sexual semiotics of eve-teasing. The girl is rich, proud, fashionably (i.e., sexily) dressed, and 'westernised'; she is waylaid and surrounded in a public place, college, park or street; the lyrics of the song frequently tease and taunt her with innuendo. There is no condemnation of the antics of the young men, but instead explicit self-righteousness: the girl must be taught a lesson in humility, modesty and subjection. She responds by recognising her 'errors', and falls in love with the hero. Male sexual power effectively levels women's class superiority, a procedure about which the film may rely on widespread acceptance since the traditional gender hierarchy is thereby restored. In the *Mahabharatha*, Draupadi's vulnerability lay in her polyandry; but, as we are told elsewhere in the epic, it is also her habitual pride, haughtiness, mockery and assertiveness that call forth the resentment and wish for revenge of the Kauravas. Since she is

chaste she is saved, but because she is blameworthy she is subjected to the chastening ordeal. We can see how the moral categories of virtue and wrongdoing are displacements of the *ressentiment* produced by social differences, of class, caste, status, across the gender divide.

As in a number of other issues relating to women, the state occupies the moral high ground by passing legislation for the 'protection' of women which overrides traditional practices in favour of democratic and universal human rights; while in terms of executive, judicial and law-enforcement practice it does little effectively to alter the status quo: a contradiction reflected both in the laws themselves and in legal judgements. The Indian Penal Code prohibits and specifies punishment for various forms of sexual harassment: Section 354 ('assault or criminal force to a woman with intent to outrage her modesty'); Section 509 ('word, gesture or act intended to insult the modesty of a woman' or 'to intrude upon the privacy of such woman'); Section 294 (obscene acts or songs). The union territory (now the state) of Delhi also passed special legislation in 1984 targeting eve-teasing, the Delhi Prohibition of Eve-teasing Bill, in which eve-teasing is defined as consisting of the following actions: 'When a man by words either spoken or by signs and or by visible representation or by gesture does any act in a public place, or sings, recites or utters any indecent words or song or ballad in any public place to the annoyance of any woman', he may be arrested. The specificity of the description, the police argue, makes it easier for culprits to be apprehended; besides which the offence has been made recognisable and non-bailable. However, Nandita Haksar, a feminist activist lawyer, describes the bill as 'an eye-wash and a fraud on women'. Sufficient provision for recognising and punishing the offences is already available under the existing penal code, and by fixing punishment at one week of imprisonment, the law only 'trivialised the issue and minimised the offence', she points out (cited in Singh: 1989: 107). Clearly, the ground and rationale for the existing laws are directed less towards ensuring women's rights to freedom of functioning in public than towards preserving an ideal of public morality and civic law and order. Given such a reading, both the blaming of women for being in the wrong place at the wrong time and its offshoots – greater restrictions on their dress, behaviour, movements, as well as the benevolent notion of protection – are inevitable.

A similar situation of legal cognisance and prohibition weakened

by non-enforcement exists in the issue of the humiliation of lower-caste women in public. The Prevention of Atrocities against Scheduled Castes/Scheduled Tribes Act was passed in 1989, and specifically identifies the 'removal of clothes from an SC, ST, parading the person naked, and painting his/her face' as an atrocity. As in the Penal Code, anyone who 'assaults or uses force on a woman with intent to dishonour or outrage her modesty' can also be apprehended under this law. Further, anyone who 'intentionally insults and intimidates with intent to humiliate a member of the SC, ST in public view' is guilty of breaking the law. Stripping can be punished under all three sections. Three national-level commissions set up by the government exist to investigate and recommend action in such cases: the National Commission for SC/ST, the newly set-up National Council for Women (NCW), and the most recent, the National Commission for Human Rights. However, the commissions have limited powers, and, having no authority to enforce punishment, may only direct state governments to do so; and they have limited resources by way of staff, political backing and support for their work. Instances of such atrocities are actually on the rise, marking the limitations of the commissions' existence and functioning (see Rai 1994).

A proposed draft bill for a comprehensive new set of laws on sexual assault and harassment, formulated by the Centre for Feminist Legal Research in New Delhi, therefore proposes that the terminology of Victorian morality – indecency, carnal knowledge, outraging modesty etc. – which codes women's chastity as value, be replaced by one recognising their sexual autonomy and rights to bodily integrity. In addition, it recommends that the criminal prosecution of offenders be supplemented by a substantial civil law dealing with sexual harassment (Khanna and Kapur 1996). In September 1997, the Supreme Court issued guidelines on recognising and punishing sexual harassment of women at the workplace, following the rape of a 'saathin' (voluntary worker), Bhanwari Devi, in Rajasthan. The NCW has also proposed new laws that would bring all sexual violation of women, harassment as well as physical violence including rape, under the broad category of 'sexual assault', so that penetration is not fetishised as the singular or even most serious offence of the many sexual crimes against women.

The examples in the foregoing discussion, of the interventions made by feminist legal activists and the NCW, and the recent example of Rupan Deol Bajaj, a civil servant who won a sexual harassment

action suit against a senior police officer at the end of a much-publicised case, are evidence of successful feminist resistance.[9] But if – on the one hand – it is 'western' feminist initiatives in the arena of legal reform and legal action that, in postcolonial political struggles, are successfully marshalled against the forces of patriarchal cultural 'tradition' – here embodied in the Draupadi story – then, on the other hand, that tradition may *itself* be plausibly interpreted for examples of resistance to patriarchal domination. How productive or progressive this may be as feminist *strategy* is a question to which I shall now turn.

The avenging woman – like and following from the myth of the female goddess – is undeniably, in her energy and anger, an empowering fiction for women; her revenge, in narrative terms, unequivocally establishes the wrong of her violation, and institutes justice in an unjust world; and her representation as a being capable of violence, even of killing, is a rejection of eternal victimisation. Nevertheless, feminism's embrace of feminist *heroines*, and, in particular – in the context of contemporary India's fundamentalist Hindu resurgence – the validation of feminist heroines from the Hindu past, has uneasy political implications, which I have explored at greater length elsewhere (Rajan 1997). Here I shall only want to suggest the following: that like all vigilante action, women's revenge is anarchic in pitting individual revenger against individual perpetrator of crime; that it trivialises the strength of the forces, historical and material, that ground women's oppression; that it reduces female power to a reactive, hence negative, dynamics, that is, that which only acts in the very terms set by the oppressor; and following from these, that it unquestioningly, and questionably as it seems to me, endorses violence as the (intolerable) solution to social evils. It will be easy to see that what is overlooked in this scenario, from the point of view of feminist praxis, say in the women's movement, is a structural understanding of violence; the possibilities of collective protest; solutions within the framework of law, reform and civil society; and a radical interrogation of the *social* responsibility for individual / collective violence against women.

There have been other modern retellings of Draupadi's story that view her more complexly in the light of modern, existential tragedy: Karve's heroine in *Yugantar*, out of joint with her own time; Saoli Mitra's sole protagonist, refusing pliant femininity for difficult intelligence and protest in her dance-drama *Nathabati Anathabat*; Somnath

Hoare's sculptures of the writhing female figure in bronze; Pratibha Ray's grand but pathetic heroine in the prize-winning Oriya novel *Yajnaseni* (1995).[10] In these representations, Draupadi is a 'feminist' to the extent that she questions what happens to her, tragic in that she is doomed to confusion, solitude and ineffectual protest. She is claimed across historical distance, but then surrendered to history.

I shall conclude with a very brief discussion of two stories by Indian women writers that I believe go to the heart of the matter of male sexual humiliation of and violence against women in the form of stripping and eve-teasing. In the first, Mahasveta Devi's 'Draupadi' (1988),[11] Dopdi Mehjen, a Naxalite Santhal tribal woman on the run, is finally apprehended by the police and ordered (by Senanayak, the police chief) to be tortured and gang-raped into giving information about her comrades. There is no question of either salvation or revenge here – yet Dopdi is triumphant. The story ends: 'Draupadi pushes Senanayak with her two mangled breasts,and for the first time Senanayak is afraid to stand before an unarmed *target*, terribly afraid' (196). For Dopdi would not let the policemen wash or clothe her after the night's brutality, for that would be to wipe away its signs. Worse, her nakedness is offered as an affront to their masculinity: '"What is the use of clothes? You can strip me, but how can you clothe me again? Are you a man? ... There isn't a man here that I should be ashamed"' (196). Very simply: Dopdi does not let her nakedness shame her, her torture intimidate her, or her rape diminish her. But this refusal is not to be read as a transcendence of suffering, or even simply as heroism. It is, instead, simultaneously a deliberate refusal of a shared sign system (the meanings assigned to nakedness, and rape: shame, fear, loss), and an ironic deployment of the same semiotics to create disconcerting counter-effects of shame, confusion and terror in the enemy (what is a 'man'?).

The other text that I shall invoke here is 'Teaser', one of a new collection of short stories by Manjula Padmanabhan, in English, titled *Hot Death, Cold Soup* (1996). It is a brilliant monologue crafted in free, indirect speech, of an adolescent boy's gloating plans for and execution of a typical 'eve-teasing' activity, that is, accosting a woman in a crowded bus. However, as in 'Draupadi', a reversal of the envisaged triumphant denouement is in store. The target turns round to confront the hunter: 'The woman reached with her hand and touched him ... She was laughing silently ... looking at the damp patch that had appeared under the waist-band of his jeans, on his shirt. "Silly!"

she was saying. "Silly little boy has wet his pants!"' (94). Male sexuality, that dreaded weapon, is revealed as a very pitiful and vulnerable thing.

Both stories offer debatable conclusions of course. Are acts of sexual violation against women's bodies only *coded* as debasement? Or do they strike at their very identity? Can women unilaterally refuse or alter the meaning of socially defined action? Is male sexual violence defeated simply by its demystification, its (literal) deflation?

What the women do in these stories is not, however, offered in terms of 'correctness', as ideal strategies of resistance/counter-attack, or even as replicable in all or other circumstances. Nevertheless, their reasoning raises fundamental questions for feminism: about identity, language, agency, the body and sexuality, violence and justice. The contradictory mode of resistance that women envisage and enact in such situations – responding to male humiliation as violation, while simultaneously refusing its shame – is dictated by the double aspect of culture, the material/'real' and the ideological, the first to be contended with, the second contested. It is this valence that explains the feminist preoccupation with Draupadi's story in India.

Notes

1 The *Mahabharatha* is a narrative in verse, supposed to have been composed by the sage Vyasa who narrated it to his disciples. An earlier version of it, called *Jaya*, is thought to have existed. This underwent changes and acquired additions over the centuries. The events recounted in the *Mahabharatha* are supposed to have happened about 1000 BC, though the oldest existing text can be dated only to the eighth or ninth century AD.

2 The English translations I have used are those by Nara Simhan and Ray. This passage is Ray's translation (*Mahabharatha* n.d.).

3 I am grateful to You-me Park (Bryn Mawr College) for offering me this phrase and for other suggestions for this discussion.

4 *Yugantar* was first published in Marathi in 1967; the first English translation appeared in 1969.

5 Janaky's article is written as a 'response' to Shuddhabrata Sengupta's article which appeared in *Economic and Political Weekly* in November 1991.

6 The critical edition is published by the Bhandarkar Oriental Research Institute, edited by V.S. Sukhtankar. The *Mahabharatha* exists in many recensions, and the critical edition is based on the oldest manuscripts available.

7 This report was prepared by the Bureau of Police Research and Development, Union Ministry of Home Affairs and suggests that 'in order to constitute atrocity, … it [the offence] should have the background of having been committed to teach a lesson to the Harijans' (cited in Baxi 1994: 137).

8 The misogyny is usually couched in a rhetoric of 'blaming the victim', as I suggest later.

9 For a discussion of the Bajaj case, and especially the political ramifications of the indictment of K.P.S. Gill, Director-General of Punjab Police, see Kannabiran and Kannabiran (1996).

10 *Nathabati Anathabat*, written, directed and enacted by Saoli Mitra, was performed in Bombay and Delhi in December 1991; I draw here on Shuddhabrata Sengupta's review (1991). Somnath Hoare's Draupadi sculptures were exhibited at the Centre for International Modern Art (CIMA) Gallery, in Calcutta, in November 1995; for a review, see Lopamudra Bhattacharya (1995).

11 All quotations are from this translation, and page-numbers are indicated in parentheses in the text.

References

Baxi, U. (1994) *Mambrino's Helmet*, New Delhi, Har-Anand.

Bhattacharya, L. (1995) 'Straight from the Art', *Sunday*, 26 November–2 December.

Devi, M. (1988) 'Draupadi', trans. Gayatri Chakravorty Spivak in *In Other Worlds: Essays in Cultural Politics*, New York and London, Routledge.

Goyal, M. (1995) 'Of Culture, Power and Violence: A Tale of Delhi Streets', *Economic Times*, 8 August.

—— (1997) 'Rape Trends Break Class Barriers', *The Pioneer*, 9 September.

Hiltebeitel, A. (1994) 'Is the Goddess a Feminist? Draupadi's Question', paper presented at the American Academy of Religion Annual Meeting, Chicago, November.

Janaky (1992) 'On the Trail of the *Mahabharatha*', *Economic and Political Weekly*, 12 September, 1997–9.

Kannabiran, K. and V. Kannabiran (1996) 'Gendering Justice', *Economic and Political Weekly*, 17 August, 2223–5.

Karve, I. ([1967] 1991) *Yugantar (The End of an Epoch)*, Hyderabad, Disha.

Khanna, S. and R. Kapur, (1996) *Memorandum on Reform of Laws Relating to Sexual Offences*, New Delhi, Centre for Feminist Legal Research, 27 February.

The Mahabharatha. Vol. II: Sabha Parva and Vana Parva (n.d.) trans. Pratap Chandra Ray, Calcutta, Oriental Publishing.

Matilal, B.K. (1989) 'Moral Dilemmas: Insights from Indian Epics' in Matilal (ed.), *Moral Dilemmas in the 'Mahabharatha'*, New Delhi, IIAS & Motilal Banarsidass.

Narasimhan, C.V. (1965) *The Mahabharatha: An English Version Based on Selected Verses*, New York and London, Columbia University Press.

Padmanabhan, M. (1996) *Hot Death, Cold Soup*, New Delhi, Kali for Women.

Pande, A. (1995) 'Police Gloss Over Eve-Teasing on Campus', *Times of India*, 11 July.

Rai, U. (1994) 'From Draupadi to Shivapati: An Unending Saga', *Indian Express*, 13 February.

Rajan, R.S. (1993) *Real and Imagined Women: Gender, Culture and Postcolonialism*, London and New York, Routledge.

—— (1997) 'Is the Hindu Goddess a Feminist?', mimeographed monograph, Centre for Contemporary Studies, Nehru Memorial Museum and Library, New Delhi, September.

Ray, P. (1995) *Yajnaseni: The Story of Draupadi,* trans. Pradip Bhattacharya , New Delhi, Rupa.

Sengupta, S. (1991) '*Nathabati Anathabat*: An Act of Female Resistance', *Economic Times,* 13 December.

Singh, I.P. (1989) *Women, Law and Social Change in India,* New Delhi, Radiant.

11

BOUNDARIES OF VIOLENCE:
female migratory subjects,
political agency
and postcoloniality

YOU-ME PARK

'Someone very quiet once lived here.' This is the final line of Cathy
Song's book, *Picture Bride* (Song 1983: 85). In this essay, I would like to
conjure those women who crossed oceans to become brides to fulfil
promises that their pictures gave away to unknown men. I am not
interested in merely engaging in a moralistic jeremiad against the
practice of acquiring a wife through mail or catalogues. Rather, I am
committed to exploring the political, economic and cultural implica-
tions of the practice that started at least a century ago and still haunts
us today. What kinds of assumption and desire concerning domestic
comfort, romantic love, women's work and sexuality are being con-
structed and exploited in the venture? Do men and women bring
compatible expectations to the arrangements? How are conflicting
desires and fantasies negotiated when frictions do occur? How does
public discourse in the United States represent those conflicts and
negotiations? What do those representations tell us about interna-
tional power relations?[1]

 In this essay, I shall discuss these issues by looking at a recent
newspaper article regarding a Filipino mail-order bride and an Asian-
American film, *Picture Bride*. By doing so, I wish to honour the mem-
ories of numerous 'some ones very quiet' who 'once lived here', only
to point out that those memories are not mere memories, but are a
present reality that haunts us. We should also ask ourselves why these
memories are repeatedly being constructed as distant past. What

kinds of yearning and desire are implied in our way of remembering these women? What narratives are elided, remoulded and silenced in our act of retelling? Where and how do we articulate these women's labour, desires and hopes?

On 26 May 1996, the *New York Times* reported on 'Mail Order Marriages, Immigrant Dreams and Death: Murder Trial in Washington State Brings Scrutiny to Vigorous Market for Foreign Brides'. I quote from the article:

> Thumbing through a catalogue called *Asian Encounters* a few years ago, Timothy C. Blackwell saw a photograph of a woman who seemed to offer everything he was looking for in a bride. A computer technician from Seattle, he was approaching middle age, but had trouble meeting women. The woman, Susana Remerata, was attractive, young, educated and ready to leave her small town in the Philippines if the right man came along … The two were married three days after they met, following a correspondence. But the marriage lasted barely two weeks. And it all ended one year ago in a courthouse in Seattle where Mrs Blackwell and two friends were shot to death at point-blank range by Mr Blackwell at a divorce proceeding.

The article then proceeds to inform the readers of the booming services of mail-order brides: there are more than a hundred of those services, operating on the internet as well as through mail. These services are quite explicit in soliciting their customers: 'Gorgeous Pacific Women!' and 'Hot Romance!' are among the lines used in advertisements. Filipinos are the largest ethnic group among the mail-order brides. In fact, there are 'nearly 20,000 Filipino women' who leave their country each year in the capacity of fiancées or foreigners. They are particularly attractive to Americans as 'they speak English and are familiar with Western ways and culture'.

Here I would like to draw attention to the following issues: the language of the representation of the murder case; the way the business of ordering brides is presented to the readers; the understanding (or the lack thereof) of the global power structure implied in these languages.

According to the article, Mr Blackwell was outraged as the reality of the marriage 'never came close to expectations' and his wife was 'non-attentive'. In order to understand the significance of the words 'expectations' and 'non-attentive', as used in this context, we need to take into account the cultural stereotypes concerning Asian women that we find in most western countries, and certainly in the USA.

'Native' girls, their eyes wide with innocence and unconditional obe-
dience, suggesting an exotic sexuality (an example of which we find
in the movie *South Pacific*), have been powerful cultural symbols espe-
cially since World War II. What is not as explicit as the assumed inno-
cence and obedience of these Asian women is the cultural expectation
about their ability to perform domestic (or other kinds of) work will-
ingly and well. Whether these expectations were based on real-life
experience of domestic help, which many westerners enjoy in their
household, specifically on the west coast of the USA (such as Seattle
where Susana Remerata was murdered), or on TV series or movies
that represent almost supernaturally strong and competent Asian
domestic workers, or on some Asian countries' state-run advertise-
ments that boast of 'obedient Asian women with nimble fingers',
these beliefs in Asian women as superb domestic beings seem to be
firmly in place. So firmly in place, actually, that the article never stops
to elaborate on the 'expectations' or to explain what Blackwell actu-
ally means by saying his wife was 'non-attentive'. Because we all
know what he means. Or do we?

I would argue that the atmosphere of in-crowd chat in this article
is closely related to and even based on nationalist sentiments. This
becomes clearer when the article reports that Blackwell said that he
felt very responsible 'because I feel like I brought a disease into this
country'.[2] The article, again, goes on without recognising any need to
elaborate on Blackwell's remark. We need to remember that Susana
Remerata was eight months pregnant. It is also worth noting that the
article refers to her as Mrs Blackwell throughout. Even her fate of
having been murdered by her husband does not keep her from being
recognised only through her married name.

I cannot emphasise enough the power and the danger of what we
might call the politics of scarcity in the USA. The discourse of scarcity
presents its argument as follows: as we only have this amount to
share amongst ourselves, any immigrants who will not immediately
contribute to the money-pot in the country with their foreign-born
fortune are intruders at best, or downright robbers. What they bring
in terms of their labour power also gets represented only as a threat
to the scarce jobs in the labour market. As Nancy Fraser (1989) and
others have pointed out, these violent attacks on immigrants, legal
and illegal alike, predictably target female immigrants at the level of
state policy and legislature as well as in the real-life world (following
Habermas's distinction, which Fraser brilliantly critiques from a fem-

inist viewpoint). These xenophobic ideologies and laws specifically assault female immigrants in the way they perpetuate gendered cultural stereotypes and expectations.

In the particular case of Susana Remerata, we can see how the patriarchal adjudication of clean/diseased women colludes with nationalist exclusionary politics of worthy/unworthy immigrants. Furthermore, the condemnation of the unworthy woman (that is, she was inattentive to her husband) who tried to settle in the USA in an illicit way (i.e. she became pregnant) is supported by a medicalised discourse. At least since the Moynihan report during the Reagan era,[3] poor women of colour who try to survive have been portrayed in pathological terms: they are the diseases of the country. Thus Blackwell presents his case as that of ethnic cleansing: the most violent form of nationalist patriarchal discourse of our time.

The article also includes opinions and interpretations of people who are critical of not only the murder but also the practice of mail-order brides itself. Yet some of the feminist arguments against the practice ironically but not surprisingly come in the form of the glorification of masculinity. 'The men who use this sort of service are usually losers', said Judy Myers, a board member of a Seattle organisation, the Asian Pacific Islanders Women and Family Safety Centre. In accusing those men who use the service of being 'losers', that is, of not being 'manly' enough to secure their women without help, this type of argument legitimates and reinforces patriarchal glorification of seductive masculinity rather than critiquing basic assumptions that justify unequal distribution of power in gender relations: being a 'winner' means not having to pay for the woman you get. It goes without saying that the remark also reveals the ways sexual prowess and economic/political power are imagined to be not only related but also interchangeable.

Even more importantly, the critical voices in the article fail to detect the imbalances, in global terms, of politics, economics and culture reflected in and further promoted by the practice. The article points out that 'Filipinos are the largest ethnic group' that participate in the practice and the 'Filipinos are particularly attractive to Americans because they speak English and are familiar with Western ways and culture'. Yet they never mention why these women are fluent in English and 'familiar with Western ways and culture'. By conveniently 'forgetting' and thus silencing the history of US imperialism which subjugated the Philippines as its formal colony in 1897, and by

omitting to mention that the USA has military bases in the Philippines with their usual relaxation and recreation 'facilities' – namely brothels – around them, the language presents the history and rationale of colonialism and neo-imperialism as one of cultural encounters and chancy circumstances.

The catalogue in which Blackwell 'discovered' Susana Remerata was significantly called *Asian Encounters*. The name evokes exotic imagery of adventures 'out there' (akin to the Starship *Enterprise* and *Close Encounters*) at the expense of deliberate forgetting and silencing actual colonial history and neocolonial reality. In this version of history, which we might call 'virtual history', the global community is the site of adventures for lone travellers (predictably white, relatively affluent males). The rest is an open space, just like a computer screen populated by two-dimensional figures, devoid of voice and, most importantly, agency. It is not a coincidence that, in the article, we do not get to hear a single word from actual mail-order brides. Once again, they are circulated, gazed at, represented and – not coincidentally – subjected to violence. It is my argument here that we need to reconceptualise and critique our notions of sexuality and romantic relationships, as well as the institution of marriage, in order to 'remember' and rearticulate history – national and international – from the viewpoint of women. This remembering will have to be performed without yet again containing those women's agency within the framework of patriarchal regulations.

With a view to suggesting ways to achieve this goal, I would like to take a look at the movie *Picture Bride* (Thousand Crane Filmworks 1995), which attempts to 'recuperate' the history of immigration and / of women. The movie is dedicated to 'all the women who made the journey'. It is a conscious attempt to articulate the positioning of women who came to the USA as picture brides. The project of reviving a certain facet of history in which women play a major role, however, does not automatically ensure the empowerment of those women or the restoration of their agency and autonomy. In my discussion of the movie, I will go back to some of the issues I raised in the first part of this essay: expectations and assumptions involved in the picture-bride practice, racial politics, nationalist ideologies and political agency, especially regarding women's sexuality, domesticity, and labour.

Before I start discussing the movie, a short summary of the plot may be helpful. The movie is about a Japanese woman, Riyo, who

arrives in Hawaii as a picture bride in 1918. However, Matsui, Riyo's husband-to-be, had sent Riyo a picture of himself taken twenty years ago. Not surprisingly, Riyo feels betrayed and disillusioned by her marriage and decides to go back to Japan. While she works on the sugarcane field during the day, and does laundry work at night so that she can save up enough money to go back to Japan, she is befriended by Kana, another Japanese picture bride. After Kana and her baby Kei die trapped in a sugar-harvest fire, Riyo tries to flee from the island. Yet after meeting Kana's ghost on the seashore, Riyo accepts her position in her marriage and the community. At the end of the movie, Riyo, now a grandmother, tells the story to her daughter and granddaughter.

Here I would like to focus on three issues: the figure of a ghost, the representation of female labour, and women's political agency. Rather than being three disparate items we can pick out from the movie, these three issues provide us with an opportunity to perform conjunctural analyses regarding women's work and autonomy. The ways women are not recognised as bona-fide workers have a lot to do with the ways women are excluded from the imagined site of political strife. In our cultural imagination, political actions in the public sphere invariably require male actors. The result of this kind of homosocial vision is often costly. Trapped in the dichotomy between public–private, political–personal, and male–female, a woman seems to achieve her autonomous status only after she ceases her bodily existence, because, as a body, she is merely a sexualised domestic being which is, by definition, a dependent minor creature who does not belong in the public sphere.

In this sense, what Derrida calls the 'hauntology' (1994: 10), or the study of ghosts and haunting that resist definite and 'correct' interpretations, becomes significant for minority women's history and culture. Minority women's writings have relied heavily on the figures of ghosts in their critique of social structure that normalises and privileges a certain sector at the expense of making others invisible and silencing them. Toni Morrison's *Beloved*, Maxine Hong Kingston's *Woman Warrior* and Amy Tan's *One Thousand Secret Senses* are just a few prominent examples. We can speculate that, especially for women of colour who are thoroughly and ruthlessly defined as sexualised domestic beings in hegemonic western discourses, being a ghost is the only mode of being that allows them to resist those definitions and explore multiple meanings and alternative modes of existence.

Yet the promise of liberation from restrictive and oppressive patriarchal discourse (and metaphysics, as described by Derrida) that the figure of the ghost offers is, as you can imagine, a double-edged one, as ghosts only gain access to their autonomy and power after they are eliminated from material sites of life and vicissitudes. You observe, interpret and even adjudicate only at the expense of not being able to participate as an actual agent. Thus when women's culture relies on women ghosts to escape patriarchal orders, it also risks the dangers of infinitely deferring women's empowerment.

Then how do we perform a radical critique of phallogocentric rationalism while not sacrificing our commitment to real-life struggles and real-life solutions? I point towards the sphere of articulation where past and future, desires and hopes, memories and possible meaning intersect with each other. Memories can be recuperated and honoured in the ways they create institutional memories[4] that regulate and formulate daily meaning-making. How do we understand the politics of memories in *Picture Bride*? On one hand, grandmother telling the stories of those old days on the sugarcane field seems safely to tuck away the days of hardship and violence, providing a false sense of detachment and history already made. Thus we are 'surprised' to read the story of the mail-order bride murdered in the US in 1995. On the other hand, those memories also legitimate the modern practice of trading brides by awarding a sense of time-honoured aura to it. As Sunder Rajan points out, women subjected to objectification and violence get the sense of having been already there, which can deepen their sense of helplessness and immobilise them. Thus the issue is again that of agency. How do women choose to construct and articulate certain memories in certain ways? And how do women use those memories in order to empower further those same women who have been strengthened through the process of active memory-building?

Picture Bride can be read as a narrative of Riyo's initiation into 'knowing' the ghosts. The night Riyo arrives in Hawaii, she hears strange howling in the wind. Upon Riyo's inquiry, Matsui answers that 'they are the ghosts welcoming you'. When Kana dies with her baby trapped in the harvest fire, she gets to 'know' the ghosts in the wind. It is significant to note that Kana is not only a close friend who taught Riyo how to survive on the sugarcane field, but also the person who shared the only tender moments of caring and laughter in Riyo's life on the island. On various levels, then, the relationship between

these two women occupies the central locus in the narrative, suggest-ing possible modes of building a genuine community where they can work and share their lives in a meaningful way. The movie, however, censors implicit hints at the potential self-sufficiency of women. Kana dies in the most heroic mode available to women, that is, sacrificing herself as she tries to rescue her son. After the encounter with Kana's ghost on the seashore, Riyo supposedly applies her 'knowledge' and memory of Kana to her surroundings and accepts her role in Hawaii. Thus at the end of the movie, Riyo and Matsui dance as a couple, peacefully and properly, now that everything is in order.

Nevertheless, I suggest that we read and recuperate the figure of Kana the ghost in its multiple and possibly disruptive meanings. Here I shall try to read the ways Kana is used in the movie and also offer alternative ways to remember and 'know' Kana. In the first half of the movie, Kana is represented primarily as a superb worker, and a politically conscious one at that. She is 'strong as an ox', to quote Matsui; she works overtime at night to get out of the sugar farm, and she struggles with the cruel overseer, trying to obtain some safety measures for women and their children. She is the one who attempts to resist the overseer's order that women workers move farther away from the site where babies wait for their mothers, unsupervised. Kana is threatened by imminent physical violence, but rescued by the new manager. Thus again the movie regulates and contains the represen-tation of Kana operating in the capacity of a conscious labourer. We also get the sense that there is indeed a feeling of community among women workers who take care of each other and are willing to organ-ise themselves as an entity. When an old woman has saved up enough money to leave for the city (which is everyone's dream on the farm), she leaves her necklace to Kana and tells her to 'take care of the girls'. After Kana's death, Kana appears as a ghost and gives her necklace to Riyo and asks her to take care of the girls. Thus we are left expecting Riyo to mature into a politicised figure who is not only responsible for herself but willing to bear the burden of the community as a worker.

Yet after Kana's death, which I suggest is *the* most important event and the turning point in the movie, the movie co-opts Kana's life and rewrites it according to a fairly predictable patriarchal plot. Kana appears to Riyo on the seashore, significantly dressed in a fem-inine dress rather than the work clothes she always wore when alive, and tells Riyo that she is going back to Japan. Thus Kana escapes the harsh world only to re-enter the patriarchal order as a pretty, femi-

nised figure. The memory of Kana the strong and courageous worker is actively suppressed, as if to say that it was unfortunate that Kana had to be that strong and brave, as that is not the way women should be. Significantly, Riyo and the movie interpret Kana's injunction to 'take care of the girls' in the most traditional patriarchal way: Riyo taking care of Matsui, her husband, rather than becoming an active political figure herself. It is highly suggestive that the movie actively subsumes Riyo's political agency into that of Matsui at the end.

After this point, the movie runs the straight line of putting everything in 'order'. Riyo becomes the loving and loved wife of Matsui and participates in communal singing and dancing, no longer wishing to leave. Interestingly, Riyo's refeminised and privatised subjectivity is affirmed and legitimated through Matsui's masculinity. Riyo begins to love and understand Matsui (thus becoming an ideal woman) while Matsui successfully demonstrates his masculinity through political acts or demonstration of political acumen. We, together with Riyo, witness and learn to admire Matsui's political authority in the community in the scenes where he acts as a peace-maker between Japanese and Filipino workers. Matsui also jumps into the fire in an attempt to save Kana and Kei and becomes the leader of the possible strike in the community. His political competence, moreover, is glibly translated into his benign patriarchal authority in his relationship with Riyo. Ultimately the political strife alluded to in the movie only serves to establish Matsui as a 'benevolent', yet not any less powerful, patriarch. Significantly, what Riyo learns at the end of the movie is that Matsui, who is 'older that Riyo's father was', to quote Riyo, is indeed more than a father to her. Matsui becomes the world to her, but one in which Riyo does not have to negotiate her own political agency.

Thus the movie fails to articulate 'the work of mourning' which can mobilise the grief of losing loved ones into political force. Rather, Kana's death and her ghost become instrumental in containing Riyo's resistance and restoring the patriarchal 'order'. In that sense, *Picture Bride* constructs the memory of women 'who once lived here' in such a way as to leave us 'unprepared' to deal with the 1990s version of picture brides; that is, Susana Remerata, the mail-order bride.

When we try to theorise the issues of comfort women, sex tourism, picture brides, and the circulation and exploitation of third-world female workers in sweatshops (Mitter 1986; Mohanty 1997), and to map out our strategies of praxis based on those theories, there

are questions we should ask. How and where do we locate women's political agency? How do we acknowledge and celebrate women's work in the world where women are being circulated as 'ammunition', 'facilities', 'hands' and 'brides'? By looking at a movie that seeks to recuperate minority women's history, focusing on the representation of women's work and political agency, I hope to have helped to ask those questions, if not to answer them. I conclude this essay with the poem 'Picture Bride' by Cathy Song (1983), remembering that 'simply closing the door' of your father's house and giving yourself to the 'stranger who was her husband' can be as predictably complicated and dangerous in the 1990s as it was in the 1920s:

She was a year younger
than I,
twenty-three when she left Korea.
Did she simply close
the door of her father's house
and walk away? And
was it a long way
through the tailor shops of Pusan
to the wharf where the boat waited to take her to an island
whose name she had
only recently learned,
on whose shore
a man waited,
turning her photograph
to the light when the lanterns
in the camp outside
Waialua Sugar Mill were lit
and the inside of his room
grew luminous
from the wings of moths
migrating out of the cane stalks?
What things did my grandmother
take with her? And when
she arrived to look
into the face of the stranger
who was her husband,
thirteen years older than she,
did she politely untie
the silk bow of her jacket,
her tent-shaped dress
filling with the dry wind

that blew from the surrounding fields
where the men were burning the cane?

Notes

1 Here I follow the lead of Cynthia Enloe whose work of 'making feminist sense
 of international politics' has radically changed the configuration of the disci-
 pline of international relations and politics as well as that of feminism. See
 Enloe 1989 and 1993.
2 As one of my freshman students at George Washington University pointed
 out, Blackwell is here appealing to the anti-immigrant sentiments that are
 rampant in the US at the moment. He has carried out his responsibility as a
 'good citizen' by cleansing the nation of a disease: unworthy immigrants, and
 their children who will be born in the States, become citizens, and take away
 resources from more 'worthy' citizens.
3 In 1965, Daniel Moynihan authored the government report entitled *The Negro
 Family: Case for National Action*. Moynihan argued that the 'real problem' that
 African-American communities face is the matriarchal structure of the
 African-American family rather than racism or lack of opportunities. Accord-
 ing to him, the high crime rate or the mortality rate in African-American com-
 munities should be attributed to the lack of the patriarchal role model rather
 than racism or lack of opportunities.
4 See Chapter 10 in this collection.

References

Derrida, J. (1994) *Spectres of Marx: The State of the Debt, the Work of Mourning, and the
 New International,* London and New York, Routledge.
Enloe, C. (1989) *Bananas, Beaches, and Cases: Making Feminist Sense of International
 Politics,* Berkeley, University of California Press.
—— (1993) *The Morning After: Sexual Politics at the End of the Cole War,* Berkeley,
 University of California Press.
Fraser, N. (1989) *Unruly Practices: Power, Discourse and Gender in Contemporary Social
 Theory,* Minneapolis, University of Minnesota Press.
Mitter, S. (1986) *Common Fate, Common Bond: Women in the Global Economy,* London,
 Pluto.
Mohanty, C. (1997) 'Women Workers and Capitalist Scripts: Ideologies of Domina-
 tion, Common Interests, and the Politics of Solidarity', in Chandra Talpade
 Mohanty and M. Jacqui Alexander (eds), *Feminist Genealogies, Colonial Legacies
 and Democratic Futures,* New York, Routledge.
Song, C. (1983) *Picture Bride,* New Haven, Yale University Press.
Thousand Crane Filmworks (1995) *Picture Bride.*

12

SUBSTANTIATING DISCOURSES OF EMERGENCE:
corporeality, spectrality and postmodern historiography in Toni Morrison's *Beloved*

SUSAN SPEAREY

Thinking of the body as constructed demands a rethinking of the meaning of construction itself. And if certain constructions appear constitutive, that is, have this character of being that 'without which' we could not think at all, we might suggest that bodies only appear, only endure, only live within the productive constraints of certain highly gendered regulatory schemas.

Given this understanding of construction as constitutive constraint, is it still possible to raise the critical question of how such constraints not only produce the domain of intelligible bodies, but produce as well a domain of unthinkable, abject, unlivable bodies? This latter domain is not the opposite of the former, for opposites are, after all, part of intelligibility; the latter is the excluded and illegible domain that haunts the former domain as the spectre of its own impossibility, the very limit of intelligibility, its constitutive outside. How, then, might one alter the very terms that constitute the 'necessary' domain of bodies through rendering unthinkable and unliveable another domain of bodies, those that do not matter in the same way? (Butler 1993: xi)

As soon as one no longer distinguishes spirit from spectre, the former assumes a body, it incarnates itself, as spirit, in the spectre. Or rather, as Marx himself spells it out, the spectre is a paradoxical incorporation, the becoming-body, a certain phenomenal and carnal form of the spirit. It becomes, rather, some 'thing' that remains difficult to name: neither soul nor body, and both one and the other. For it is flesh and phenomenality that give to the spirit its spectral apparition, but which disappear right away in the apparition, in the very coming of the *revenant* or the return of the spectre. (Derrida 1994: 6)

In the process of engaging in very different projects, both Judith Butler and Jacques Derrida speak of a substantive relationship between the corporeal and the spectral, or the present and the not-quite-not-present. Moreover, both seek ethical solutions and method-ological procedures that would enable them to address the spectres which form the constitutive outside of any given construction of real-ity. In their different ways, each registers a marked concern with material conditions while problematising direct oppositions between the material and the immaterial. Butler's pun on the word 'matter' signals the all-too-easy conflation of 'substance' with 'value', indicat-ing, in the first instance, that notions of the material are inevitably limited by the conceptual and ideological frameworks through which materiality is understood, and consequently, that any such overdeter-mining framework will repress and exclude other possible definitions of what matters. Derrida, through his reading of *Hamlet* in *Spectres of Marx*, suggests that ghosts 'summoned by the consciences of those who witness them … figure as casualties of histories in danger of being forgotten';[1] that our duty is to enjoin them; to speak to, with and of them; to mourn them; to acknowledge our debts to them; so as eventually to release ourselves from a history impelled by a cycle of vengeance and retribution. In this instance, the act of summoning the spectre – of invoking the 'paradoxical incorporation' – serves to unsettle notions of presence, thereby forcing the witness to acknowl-edge that which has been excluded or repressed from the here-and-now in the process of rendering the present both comprehensible and habitable.

Toni Morrison's 1987 novel, *Beloved*, is profoundly concerned with attending to the effects of the material conditions of oppression experienced during the period of slavery and its aftermath – often fig-ured in and through the body – and with searching for ways of moving beyond that history, but without forgetting it, and without replicating its methods of advancement or of inscription. The novel confronts the reader with the problem of how to redress the injustices of the past, while raising questions as to what scheme of ethics can be applied, and how one might speak to, with and of the ghosts of an his-torical legacy that is on the one hand very convenient for white Amer-icans to forget, and on the other very traumatic for African-Americans to remember. The eponymous character in the novel is a corporeal spectre who is at once the murdered child of the fugitive, Sethe, and the 'sixty million and more' victims of genocide during the periods of

slavery and Reconstruction, to whom the novel is dedicated. But if Beloved is a revenant, she is also very firmly grounded in the here and now; she returns in the flesh, and is corpulent, insatiable and, before long, pregnant. Morrison's strategy of reifying her spectre in this way raises a number of interesting questions. Why is Beloved's 'becoming body' made *manifest* until its 'exorcism' by the community near the end of the novel, and how, then, are we to read the haunting – its trace – with which we are presented in the coda? What does this device tell us about materiality, and about materialism as a political strategy and a grounds for identity politics? Beloved's function within the community into which she emerges is ambivalent: as the returned ancestor and absented daughter or sister, she is adored; as the avenging angel, she elicits shame and remorse; as the embodiment of the future, she threatens to consume all those who would seek to sustain her. Her character, I will argue, operates at a point of intersection between Butler's and Derrida's respective formulations of the relationship between corporeality and spectrality: she functions *both* as the negation of all that liberal humanism encompasses – as the intelligible repository of all that it denies and represses – *and* as 'the excluded and illegible domain that haunts the former domain as the spectre of its own impossibility, the very limit of intelligibility, its constitutive outside' (Butler 1993: xi). Through her character, Morrison is able to register specific critiques of liberal humanism and the way it has played itself out in the context of American slavery, while at the same time gesturing towards what cannot be said and known within the parameters of the discourses and epistemologies through which it has been supported and sustained. In terms of Derrida's speculations regarding the ethical vicissitudes of relating to the past, Beloved functions as a site at which those caught up in a traumatic present must grapple with the histories which they have repressed, regardless of whether such repressions have been deliberate strategies of survival or whether they have been unconsciously effected. Morrison demonstrates through Beloved's interchanges with the novel's other characters that the project of addressing the past, necessary though it is, is fraught with perils, and does not easily or unequivocally effect justice.

My specific aim in this reading of *Beloved* is to examine and assess the implications of the tropes of corporeality and spectrality for a collective African-American identity, and for a politics which challenges progressivist and individualist historiography without relinquishing

notions of agency. The novel focuses on a community of former slaves that has lived out dislocatedness, unhomeliness, disinheritance and spectrality – all of those conditions detailed in postmodernist critiques that seek to problematise a too-readily accepted liberal humanist notion of the subject. *Beloved* charts the attempts by the members of this community, both individually and collectively, to emerge into 'freedom', into a different form of subjectivity, and into a more enabling relationship with historical process.[2] Morrison places the majority of her characters in positions of disjunction, whether psychic, historical, geographical, political, temporal, familial or communal. All at different times are rendered either literally or metaphorically homeless, thus necessitating the attempt to (re)constitute themselves as subjects, as inhabitants of homes and bodies and narratives and histories, without resorting to the rhetoric and principles of the very humanism that has made possible, for example, schoolteacher's brutally ethnocentric, hypocritical and self-aggrandising claims about what constitutes humanity and human advancement. Significantly, the dislocations with which these characters are faced are not merely a result of the exclusions of dominant ideology and the regimes and institutions by which it is supported. *Beloved* can in no way be construed as a novel about the *victimisation* of African-Americans by dominant white culture – although it certainly never excuses or ignores the atrocities perpetrated by the latter. It is rather a celebration and testimonial to the endurance of the survivors of the African-American community through over 300 years of slavery *in spite of* the relentless discursive and material interventions instigated by those in power. If Beloved's hauntings were to be read simply as apparitions of the dark underside of a humanist narrative which postmodernism seeks to contest, the novel would ultimately reinforce the centrality of that very humanism, regardless of what values might be ascribed to it, and what critiques might be levelled. Morrison instead is able to move beyond *contestation* to the formulation of new strategies for understanding identity, history and agency in more open and less exclusivist terms.

Indeed, the novel requires that we dispense altogether with oppositional readings of history. All of the characters in *Beloved*, regardless of 'race', gender or any other criteria, are implicated in each other's pasts, and all must endeavour to take responsibility for their involvements in the lives of those touched by their own, even though they may not fully understand or even be aware of the con-

nections which link them. Sethe gestures towards the inevitability of such interconnections when she tells Denver that occasionally she bumps into 'thought pictures' which she believes are her own, and later recognises as someone else's 'rememor[ies]' (1987: 36). Morrison makes it clear that as heroic as her characters are, they are not innocent of implication in the histories which they regard with such horror. Sethe's self-accusations are undoubtedly unnecessarily severe, and yet it is just as important for her to remember that she has made the very ink with which schoolteacher records his debasing anatomisations of the black body as it is for Stamp Paid to consider, rethink and act upon his own earlier deed of telling Paul D about Sethe's attempt to murder her children, and for Ella and the rest of the community to confront their collective failure to warn Baby Suggs and Sethe of the approach of the slave catchers. What we are offered, then, is less a politics of blame than a politics of assuming responsibility.

That the novel's Reconstruction-era ex-slaves operate in the first instance from positions of exclusion and disjunction, but nevertheless remain cognisant of their obligations to the past, puts them in an interesting position. On the one hand, in material terms, their circumstances are often rather precarious; they are after all, potential victims of a systematic genocide, and the past comes dangerously close to consuming several of them. On the other, unburdened by the 'privileges' of a humanist inheritance, they find themselves ideally situated individually and collectively to negotiate new ways of orienting themselves and of understanding their relationships and responsibilities to one another, to the past and to the future. It is vitally important, however, that such a gesture does not imply a totalising integration of the present and the not-present since the histories invoked can only ever be partially apprehended. Every legacy, Morrison demonstrates, is multivocal, suggesting manifold readings, outcomes and implications. Sethe and Paul D, for example, engage in an ongoing reconstruction and re-evaluation of their shared past at Sweet Home, one that works less towards a cumulative approximation of truth than towards a mutual understanding that events can be framed differently, and take on a virtually infinite number of significances, depending upon the experiences or memories through which they are filtered or with which they are associated, and upon the stage in the process of 'becoming' that the tellers have reached at a given moment. The narrator tells us, 'Her story was bearable because it was

his as well – to tell, to refine and tell again' (1987: 99). The sharing of the story is of crucial importance. Bodies touch as the tale is told, and share the burden and ease the distress of each act of narration.

By documenting the collective action of the novel's central characters, as well as their revisitations of history, Morrison recuperates for African-Americans an agency in the histories in which they are implicated, while at the same time mapping out an alternative historiographic methodology which forestalls teleological imperatives, contests organicist or integrationalist models of social relationships, and yet retains the possibility for agency and for ethics to be acted upon collectively. She posits neither a pre-lapsarian nor a utopian moment of integration towards which her characters aspire and work, but instead enacts an historical and discursive strategy of emergence in which Beloved, as a figuration of historical spectrality reified according to the terms of liberal humanism, becomes a possessive, imperious, corporeal singularity which is recognised by the African-American community as profoundly threatening to its existence and endurance. Consequently, although she is adored, she is eventually exorcised by them. Morrison demonstrates, in fact, that the possibility of African-Americans being co-opted into a humanist history and epistemology by inserting themselves comfortably into a paradigm that had formerly excluded them is itself a spectre which menacingly haunts that community. Beloved's subsequent proliferation into her multitudinous parts, which are spectral, unhomely and dislocated, renders her 'becoming body' simultaneously present in the form of the runaway pregnant woman, and not present, as suggested by the uncanny hauntings of the coda: the 'footprints [that] come and go', the 'breath of the disremembered and unaccounted for' (1987: 275). Beloved is more than one and not one; she is intelligible and, at the same time, necessarily illegible. The performance of the exorcism is an important manoeuvre on the part of the community, and a crucial turning point in the novel; in her ensuing '(dis)incarnation', Beloved serves as a figuration of Morrison's historical methodology in so far as Beloved refuses – in spite of her persistent demands to be named and claimed – to become static or unitary, or to identify herself according to the terms of any single discourse.

The novel makes clear that the conditions and means through which newly emergent subjectivities come into being and find expression – and the implications of such transitions or transformations – are far from uniform; they differ markedly for Paul D, whose trauma

is bound up with discourses of masculinity and the various humiliating acts of emasculation which he has endured; for Sethe, whose 'race', gender and status as mother all impact profoundly upon the nature of her struggles to claim selfhood; for Denver, who has had no direct experience of slavery, but lives very immediately with its legacy; and even for Amy Denver, the white serving girl whose quest for identity is largely determined by the way she is positioned within the class hierarchy of the South. The novel by no means, however, gestures towards any configuration of individualism or uniqueness as the grounds for coming into being; rather, the focus is perpetually on the space of intersubjectivity, and the manner in which each of these narratives of emergence intersects with and informs the others. Morrison's figures of the corporeal are instructive in this light. Throughout the novel, tropes of the body serve to invoke different configurations of intersubjectivity, and to gesture towards a number of possibilities for disconnection or connection. Without the least hint of sensationalism, Morrison confronts us with graphic images of boiling blood, scarred and branded flesh, and stolen breast milk, and of bodies that have been tortured, lynched, shackled, caged, sexually abused, scalped or dismembered. We are made aware of the economic value attributed to bodies as Paul D overhears the price that he fetches on the slave market (1987: 226–7), and as Sethe realises that her body affords her the only means of paying for the inscription on her daughter's grave stone (1987: 5). We are also alerted to the ways in which bodies are encoded by western epistemology as schoolteacher and his nephews document in detail the ostensible 'animal' and 'human' traits of their slaves – a serviceable foundation for their claims of Enlightenment. Each trope speaks of relationships of power that obtain between the embodied subject of violation and the often disembodied perpetrator(s), but the novel never allows the acts of corporeal brutality to signify the omnipotence of the latter; instead, it works carefully towards tracing the means by which the surviving characters relearn their bodies and subjectivities. If we look, for example, to an excerpt from Baby Suggs' sermon in the Clearing, and the language through which it is articulated, we can see that she is not necessarily calling upon the former slaves to reclaim the one possession that is ineluctably theirs, and which slavery has attempted to break or discipline or expropriate, but rather to reimagine the way in which the body can be conceived of:

'Here,' she said, 'in this here place, we flesh; flesh that weeps, laughs; flesh that dances on bare feet in grass. Love it. Love it hard. Yonder they do not love your flesh. They despise it. They don't love your eyes; they'd just as soon pick em out. No more do they love the skin on your back. Yonder they flay it. And O my people they do not love your hands. Those they only use, tie, bind, chop off and leave empty. Love your hands! Love them. Raise them up and kiss them. Touch others with them, pat them together, stroke them on your face 'cause they don't love that either. *You* got to love it, *you!* And no, they ain't in love with your mouth. Yonder, out there, they will see it broken and break it again. What you say out of it they will not heed. What you scream from it they do not hear. What you put into it to nourish your body they will snatch away and give you leavins instead. No, they don't love your mouth. *You* got to love it.' (1987: 88)

The various metonymic functions of the body, and particularly of the hands – as labour, as agents of change, as vehicles of potential rebellion, as bearers of gifts – and of mouths – as transmitters of words, as conveyors of distress, and as receptacles of nourishment – are suggestive of the multiple ways in which the body can be figured, figures which proliferate ceaselessly, and which are inflected with various discourses of power and of resistance. Moreover, these metonyms suggest neither the limitation of the body to the strictly corporeal or physical, nor its necessary integrity as a given condition or a desired end.

Tropes of corporeality also serve to forge or reconfigure links between subjects, historical moments and locations, and especially between those which seem to have been irrevocably disconnected. Bodily fluids associatively link various characters; Beloved's return is marked by Sethe's waters breaking (1987: 51), and Sethe later recognises in the strange newcomer an incarnation of her murdered child when she associates Beloved's craving for water with the memory of her first reunion with the 'crawling-already? Baby' at 124, when the child had dribbled clear spit over her face (1987: 202). In a similar vein, the experience of bodily sensations often initiates spatio-temporal transitions between narrative frames. For example, as Sethe walks towards the Clearing to commune with the spirit of Baby Suggs after Beloved's arrival, the narrator notes, 'Sethe began to sweat a sweat just like the other one when she woke, mud-caked, on the banks of the Ohio', and the narrative resumes, eighteen years earlier and south of the Ohio river, with the story of Sethe's escape to the North (1987: 90). Bodies also serve as linking devices across barriers of race and

gender: the 'whitegirl' Amy Denver's 'good hands' ease Sethe through Denver's birth; and Paul D's gesture of holding Sethe's breasts is understood as a sharing of the enormous burden of responsibility she has been carrying. Through Paul D's connection with the past in the form of Beloved, his sealed tobacco tin dissolves in a shout of 'red heart' (a productive if dreaded liaison). Morrison's densely textured language, along with her use of metonymic figures, thus serve to remind the reader of the multiple possibilities and interconnections which might be made manifest in any given set of social relationships, political conditions or material circumstances.

Morrison, then, is not merely drawing attention to the material body as the site on which discursive effects are played out, although in the context of slavery, such a reminder is always timely. Nor is she working towards some sort of organicism as a metaphor for both individual and social integration, despite the importance accorded to the responsibilities of each person towards the community and vice versa. Nor is she merely equating the body with selfhood, a concept that is necessarily both provisional and prolific. Denver, the one character not to have experienced slavery directly since she is born during that second Middle Passage across the Ohio River *en route* to the freedom of the North, takes very little interest in the past if it does not concern her directly, and in fact resents the talk of Sweet Home shared by Sethe and Paul D. Yet she ultimately realises she has no self without Beloved, that it is in her connections with this figure of and from the past, and in the stories they create together, that her very selfhood lies. When Beloved turns her attention to Denver, the narrator, shading into Denver's consciousness, notes:

> It was lovely. Not to be stared at, not seen, but being pulled into view by the interested, uncritical eyes of the other. Having her hair examined as a part of her self, not as material or a style. Having her lips, nose, chin caressed as they might be if she were a moss rose a gardener paused to admire. Denver's skin dissolved under that gaze and became soft and bright like the lisle dress that had its arm around her mother's waist. She floated near but outside her own body, feeling vague and intense at the same time. Needing nothing, being what there was. (1987: 118)

Here, selfhood is neither equated with nor contained within the body, its needs, functions or desires. Denver, who is more grounded in 'the present' than any of the novel's other central characters, becomes under Beloved's gaze as ethereal as the ghostly image of lisle dress.

Despite her insistent disinterest in the past, she recognises that without Beloved she has no self but feels 'like an ice cake torn away from the solid surface of the stream, floating on darkness, but thick and crashing against the edges of things around it. Breakable, meltable and cold' (1987: 123). Again, the fragility of a solitary or individually realised selfhood is emphasised. Denver understands her body as a density rather than a substantiality, and comes to realise that she needs that dialogue and connection with Beloved to claim selfhood, to *embody* herself, and to emerge from the green walls of her secret place into a world of social relationships.

Spectral bodies are similarly figured in the novel as excessive and/or partial, as open to many readings, yet never clearly reducible to any one. The containment, integration or isolation of bodies and bodily tropes is always forestalled; no position of locatedness is allowed to remain static; the 'home' against which the unhomely haunting asserts itself as repressed, unfamiliar or defamiliarising memory perpetually shifts and remains elusive. The figures of the headless bride, of the white lisle dress, of the fingers which both caress and strangle Sethe in the Clearing, and of Beloved herself are certainly multiple, but also signal emphatically the significance of their 'missing' components, and alert us to the danger of potential effacement or disembodiment. Beloved, in spite of the plurality of her physical and spectral presence, pulls out a tooth one morning and fears that she will soon disappear:

> Beloved looked at the tooth and thought, This is it. Next would be her arm, her hand, a toe. Pieces of her would drop, maybe one at a time, maybe all at once. Or on one of those mornings before Denver woke and after Sethe left she would fly apart. It is difficult keeping her head on her neck, her legs attached to her hips when she is by herself. Among the things she could not remember was when she first knew that she could wake up any day and find herself in pieces. She had two dreams: exploding and being swallowed. When her tooth came out – an odd fragment, last in the row – she thought it was starting. (1987: 133)

Beloved recognises that the presence and 'integrity' of her body depend entirely upon the continued efforts of those around her to acknowledge her significance as a 'body that matters', and that without that acknowledgement – that confirmed space of intersubjectivity – no effort of her own to express a selfhood or a presence will be registered.

Just as Morrison demonstrates that it is not possible simply to locate identity in a body, so too is it impossible to locate 'home' in any given discourse or geographical topos. In fact, the tropes spill into one another, refusing to be contained. Denver thinks of 124 Bluestone Road as 'a person rather than a structure. A person that wept, sighed, trembled, and fell into fits' (1987: 29). And 124, as the number suggests, is, like Beloved's, a body that is exponentially proliferating, and that contains within it multiple histories and multiple possibilities. It is the family home of the Bodwins, the white abolitionists who represent the idealism and liberalism of Enlightenment philosophy at its most beneficent, and yet who – with no apparent sense of contradiction – expect their black servant Janey to use only the back door, and who keep a change jar in the shape of a caricatured and kneeling Negro, upon the pedestal of which reads the caption 'At yo' Service' (253). But 124 is also a way station, a centre for the community, a womb, a crypt. Not only does the end of the novel effect a disappearance of Beloved, it also circumvents a romantic notion of arrival or homecoming, and closes instead with a scene of haunting which is on the one hand corporeal and almost visceral, and on the other wandering, but which draws the reader's attention out and beyond the reaches of the house itself.

Morrison's novel, while insisting upon the possibility of living and telling a history from a position of homelessness or virtual disinheritance, at the same time opens a space for revisionist notions of an identity which is not contained within the confines of the body, or within the confines of any given time or place or historical narrative, and of agency which is open to multiple possibilities and is capable of producing diverse – if often unanticipated or chance – effects. This is not to say that her characters are able simply to will themselves into freedom by casting off the literal and epistemological shackles of humanism. Intentionality, of course, offers no guarantee of outcome. Sethe, for instance, believes she has behaved profoundly ethically and responsibly in her efforts to save her children from slavery by attempting to take their lives, although her actions alienate the community, instil fear in her surviving children, and break the spirit of Baby Suggs. But Morrison demonstrates that agency is also open to individual and collective revision, reinterpretation and rectification, as evidenced in Sethe's case as well as in the previously cited examples of Stamp Paid's rethinking of his revelation to Paul D, and the community's re-examination of the shunning of Baby Suggs follow-

ing her grand feast. Rememory, then, is not an attempt to re-member (in the sense of *reintegrate*), but to realise or reify as many potential renderings of the past as intelligibility permits. This must be done, however, in such a way as to minimise the pain of recollection, and to share the burden of responsibility.

Beloved as history, as a body, a potentiality, a desire, a terror, a memory, a point of connection, a home and an identity, is continually refigured and resituated by those in the community into which she emerges, and for whom her not-present presence supplements and exceeds and perpetually redefines the material bounds of selfhood and reality. Her legacy as an individual speaks of the dangers to African-Americans of seeking emancipation in a humanist vision of selfhood that manifests itself singularly in and on the body. However, her pregnant multiplicity in both physical and spectral forms presents the reader with a model for a more open historiography which admits of multiple possibilities and mutable realities, and which demands an ongoing negotiation of the present and the not-present as the grounds for ethical action, and as the basis for whatever agency may be enacted in a postmodernist world.

Notes

1 Many thanks to Sam Durrant for his concise and illuminating gloss on *Spectres of Marx* in his (as yet) unpublished paper given in 1996.
2 My use of the term 'emergence' signals an attempt to disengage discussions of feminist – and other – struggles for political and psychic emancipation from discourses which sustain either teleological or recuperative agendas. In this, I follow Donna Haraway's caution, in 'A Manifesto for Cyborgs (1990)', against teleological historical paradigms which posit the beginning and/or the end of history as moments of integration and completeness. Haraway suggests that such 'seductions to organic wholeness through a final appropriation of all the powers of the parts into a higher unity' are the basis for problems common to contemporary feminisms grounded in Marxism, in psychoanalysis, and in movements such as eco-feminism (192). Whether these myths of holism involve pre-Oedipal symbiosis, unalienated labour, innocence of implication in power relationships, or uncorrupted nature, she contends, they variously serve as inadequate grounds for a politics that moves beyond humanist tenets and recognises what are perhaps more complex and less self-interested understandings of agency and historical change. Haraway elaborates, 'An original story in the Western humanist sense depends on the myth of original unity, fullness, bliss and terror, represented by the phallic mother from whom all humans must separate, the task of individual development and of history, the twin potent myths inscribed most powerfully for

us in psychoanalysis and Marxism'(192). Such a move is important, among other reasons, because of the implications of a more complicated notion of history for the subject.

References

Benjamin, W. (1977) 'Trauerspiel und Tragödie', in *The Origin of German Tragic Drama*, trans. John Osborne, London, NLB.

Botting, F. (1996) *Gothic*, London and New York, Routledge.

Butler, J. (1993) *Bodies That Matter: On the Discursive Limits of 'Sex'*, London and New York, Routledge.

Derrida, J. (1994) *Spectres of Marx: The State of the Debt, the Work of Mourning and the New International*, trans. Peggy Kamuf, London and New York, Routledge.

Durrant, S. (1996) '"The Ghost of a Chance": Absent Bodies, Spectral Presences and the Possibility of History', presented at CACLALS, The Learneds, Brock University, St Catharines, Ontario, May.

Haraway, D. (1990) 'A Manifesto for Cyborgs: Science, Technology and Socialist Feminism in the 1980s', in Linda J. Nicholson (ed.), *Feminism/Postmodernism*, London and New York, Routledge.

Lindinski, A. (1994) 'Prophesying Bodies: Calling for a Politics of Collectivity in Toni Morrison's *Beloved*', in Carl Plasa and Betty J. Ring (eds), *The Discourse of Slavery: Aphra Behn to Toni Morrison*, London and New York, Routledge.

Luckhurst, R. (1997) '"Impossible Mourning" in Toni Morrison's *Beloved* and Michèle Roberts' *Daughters of the House*', *Critique: Studies in Contempory Fiction*, 37 (4), 243–60.

Morrison, Toni (1987) *Beloved*, New York, Plume Books.

—— (1992) *Playing in the Dark: Whiteness and the Literary Imagination*, Cambridge, Mass., and London, Harvard University Press.

part four

RE-VIEWING BODIES IN FICTION

13

LITTLE GIRLS AND LARGE WOMEN:
representations of the female body in Elizabeth Bowen's later fiction

CLARE HANSON

Elizabeth Bowen's fate has been typical of that of 'the woman writer'. Her books were both popular and critically acclaimed in their day, but after her death in 1973, her reputation suffered a decline. Her status became that of a 'minor' writer, haunting about the margins of the literary canon, and her later work, in particular, was disparaged. Hermione Lee, for example, had this to say of *The Little Girls* (1964) in her study *Elizabeth Bowen: An Estimation* (1981):

> Such 'meaning' as there is appears in fragmentary and diffused form and is presented in a manner which is without depth or resonance. Not only does the novel record an unlikely and whimsical situation, which is dressed up with awkward attempts at comedy, uneasy ventures into symbolism and contrived literary allusions ... but it also feels dubious and illusive. (Lee 1981: 204)

While this is a fair comment on its own terms, what it none the less suggests is how far terms *have* changed since 1981. It seems that it is only now, in the light of literary theory and the changes which have taken place in our understanding of literary texts, that we have caught up with Bowen and are able to read and understand her experimental later work.

Bowen's fiction is structured repeatedly around an oscillation between the perspective of a young girl and that of an older woman. Her concern with the figure of the girl can be read alongside that of Deleuze and Guattari in *A Thousand Plateaus: Capitalism and Schizophrenia*, and the thought of Deleuze and Guattari, I shall argue, is helpful for unlocking many aspects of Bowen's work. Deleuze and Guattari's understanding of the body as exceeding its assigned (Oedi-

pal) subjectivity and its assigned identity as a functional organism is particularly relevant to Bowen's fiction. For Deleuze and Guattari the 'Body without Organs' (BwO) is the limit towards which all bodies aspire, a body before and in excess of the 'coalescence of its intensities and their sedimentation into meaningful, functional, organised, transcendent totalities' (Grosz 1994: 201). It is the encounters between such 'excessive' bodies which constitute what Deleuze and Guattari call 'becomings'. A becoming occurs through the conjunction of bodies in a state of openness, unconstrained by pre-established ideas of what a given body is or what it is capable of. The example which they give throughout their work (and in *A Thousand Plateaus*), is of the conjunction or 'nuptials' of the wasp and the orchid. The orchid reproduces by incorporating the wasp into its sexual functioning, and the wasp feeds as it fertilises the orchid. There occurs an imaginative suspension of the separable, habitual status of the bodies involved: instead they participate in what John Hughes calls 'a kind of creative symbiosis' (Hughes 1997: 45). A related idea which Deleuze and Guattari develop in *A Thousand Plateaus* is that of the 'haecceity', an arrangement or ensemble of bodies produced by the movement of desire on the plane of immanence. Deleuze and Guattari define a haecceity in this way:

> There is a mode of individuation very different from that of a person, subject, thing or substance. We reserve the name *haecceity* for it. A season, a winter, a summer, an hour, a date have a perfect individuality lacking nothing, even though this individuality is different from that of a thing or a subject. They are haecceities in the sense that they consist entirely of relations of movement and rest between molecules or particles, capacities to affect and be affected. A degree of heat can combine with an intensity of white, as in certain white skies of a hot summer. (Deleuze and Guattari [1980] 1988: 261)

Like Deleuze and Guattari, Bowen explores the potential of the body on the plane of immanence, explores 'excessive' encounters between bodies (as in the instabilities of the dinner-party scene in *A World of Love*), and also focuses intensively on seasons and hours and on their 'perfect individuality' (as in the opening scene of *A World of Love*, in which heterogeneous bodies are brought together to form a new ensemble, connecting rocks, fields, the implied human subject, heat, stillness and light).

As I have suggested, in representing the female body, Bowen

focuses on the little girl and the large, solid (in every sense) woman. For Deleuze and Guattari, the girl is a privileged figure, linked with openness, possibility and 'becoming'. They write that the girl is 'defined by a relation of movement and rest, speed and slowness, by a combination of atoms, an emission of particles: haecceity. She never ceases to roam upon a body without organs. She is an abstract line, or a line of flight' (Deleuze and Guattari [1980] 1988: 276–7). 'The girl' is, of course, a metaphor: 'she' can appear at any stage of life – 'girls do not belong to an age group, sex, order or kingdom: they slip in everywhere, between orders, acts, ages, sexes: they produce n molecular sexes' (Deleuze and Guattari [1980] 1988: 277). None the less, as we shall see, the state of the (actual, historical) girl is more likely to produce that activity and energy which Deleuze and Guattari associate with 'becoming'.

Deleuze and Guattari's use of the term 'molecular' refers to the distinction they make between dispersed libidinal energies ('molecular' energies) and those which strive to aggregate into totalities ('molar' energies). Molar energies attempt to form and stabilise identities through divisions of classes, sexes and races, whereas molecular energies, in the words of Elizabeth Grosz, 'traverse, create a path, destabilise, enable energy seepage within and through these molar unities' (Grosz 1994: 203). Molar energies are linked with 'majoritarian' consciousness, which Deleuze defines as follows:

> The majority does not designate a larger quantity, but in the first place, a standard in relation to which the other quantities, whatever they are, will be said to be smaller. For instance, women and children, Blacks and Indians, and so on, will be minorities in comparison to the standard constituted by any American, or European white-Christian-male-adult-city-dweller of today. (Deleuze, 'Un manifeste de moins', quoted in Braidotti 1991: 115)

Molecular energies, by contrast, are linked with 'minoritarian' consciousness which tends towards the undoing of molar identities and which opens the way for revolutionary transformations.

Returning to *A World of Love*, Deleuze and Guattari's distinction between molar and molecular energies illuminates the marked contrast in this novel between the unassimilable little girl, Maud, who roves restlessly between the other characters, holds to no gender identity, 'knock[s] other people about' and yet has 'a high look of candour', and her mother, Lilia, presented in terms of a sedimented

'molar' femininity, 'woman as defined by her form, endowed with organs and functions and assigned as a subject', as Deleuze and Guattari put it (Deleuze and Guattari [1980] 1988: 275). However, I want to go on to suggest that for the purposes of reading Bowen's fiction, we might wish to reconceive Deleuze and Guattari's 'molar' identities as *Oedipal* identities. In the volume which preceded *A Thousand Plateaus*, that is, *Anti-Oedipus: Capitalism and Schizophrenia* ([1972] 1984), Deleuze and Guattari took issue with the way in which psychoanalysis, as they saw it, functioned as a repressive instrument of the capitalist system, imposing an Oedipal, heterosexual sex / gender identity as the only acceptable sex / gender identity. They argued, too, that while psychoanalysis privileged the subject whose desire was founded on lack, desire in fact does not lack anything: it is rather the *subject* which is missing in desire – the illusion of a fixed subject only comes about through the repressive law of Oedipus. Deleuze and Guattari suggest, accordingly, that we should dismantle the whole cultural edifice of Oedipus, focusing instead on the impersonal but generative and productive force of (positive) desire. Bearing this in mind, I shall argue that the work of Elizabeth Bowen stages an opposition between anti-Oedipal (in Deleuze and Guattari's terms) and Oedipal structures of feeling. Her fiction is founded on a powerful conflict between anti-Oedipal / asocial and Oedipal / social structures and desires, and it is this conflict which I shall go on to explore in her last three novels.

As I have suggested, in *A World of Love* (1955), twelve-year-old Maud is the representative of 'the girl': disorganised and unassimilated, discountenancing all the other characters in the novel. She is linked with unsettling and subversive forces, following the tradition of the subversive woman's being associated with witchcraft. The narrator tells us that Maud has her 'familiar', defined by the *OED* as a 'demon attending and obeying a witch'. She scuffles and spars with this familiar, who is called Gay David and has his own 'small low cave': she also partakes in 'rites' with him. Repeatedly, Maud is connected with hell – for Antonia at one point, for example, she wears 'a select air of having been through hell' (Bowen 1955: 158). Afflicted by hives (an inflammation of the skin), Maud is a tormented and tormenting figure, scornful of her sister's romantic preoccupations yet, as it turns out towards the end of the novel, unhappy because of her father's inability to fulfil his role as patriarch. She is, then, an ambiguous and unsettling figure.

Her twenty-year-old sister, Jane, is further along the Oedipal line: she has 'a face perfectly ready to be a woman's, but not yet so' (Bowen 1955: 11). The novel documents her entry into the Oedipal structure of patriarchy, an entry which is overdetermined because of the complex relationships between the adults in the story. Lilia, Jane's mother, was years ago engaged to Guy, the owner of the small estate, Montefort, where the novel is set. Guy was killed in World War I. His cousin, Antonia (also in love with Guy), feeling the need to 'do something' for Lilia after Guy's death, arranges a marriage between Lilia and her illegitimate cousin Fred. Jane and Maud are the results of this (mis)marriage. The story turns on Jane's discovery of a packet of old letters, *from* Guy, *to* whom is unclear – no name is apparent. Lilia clings to the belief that the letters were to her, a belief in which she is supported by Antonia, although in fact this is not the case. Jane, in this unprecedentedly hot Irish summer, falls in love with the letters, as Antonia remarks – she describes Jane as '[f]alling in love with a love letter' (Bowen 1955: 55). The point Bowen makes is that the letters can seduce *anyone*: the Oedipal/romance script far exceeds any of the individual characters (the name Guy underlines this – the letters are from any man (guy) to any woman). The Oedipal structure of heterosexual romance is stressed: Jane is devoted to her father, and at one point Antonia cries out (in front of Fred) that Jane 'should have been (Guy's) daughter' (Bowen 1955: 117). Jane has, then, fallen in love with her (ideal) father, having repudiated and displaced her mother. Jane's absorption in this Oedipal plot leads directly to the romantic denouement of the novel, whereby Guy is replaced in Jane's affections by a cast-off lover of Lady Latterly, the local chatelâine. Jane is sent to meet him at Shannon airport, and as their eyes meet, 'They no sooner looked but they loved' (Bowen 1955: 224). These are the last words of the novel, ambivalently poised between belief and scepticism. However, the fact that the love is promoted by Vesta Latterly (a belated but certainly not virginal figure) suggests that we should view it with misgiving.

I want indeed to suggest that in this novel, Bowen presents *two* 'worlds of love'. The first, associated with the script of romantic love, is viewed negatively, for it involves a diminishment of possibility, an acceptance of a restricted and restrictive identity. In *A World of Love*, this identity is an Oedipal identity, and there is no representation of an alternative, pre-Oedipal bond between mother and daughter. Indeed, I would argue that in this fiction, the Oedipal is challenged

not by the pre-Oedipal (which would in this respect be an equally restrictive category), but by molecular, anti-Oedipal energies which work through and beyond the characters. Such energies are associated above all with the landscape, and it is this which constitutes the second 'world of love' in Bowen's novel, which could be called a world of desire, in the Deleuzian sense. Repeatedly, the text turns away from the characters *qua* characters, and concerns itself with a mood, an atmosphere, which derives in part from familiar human responses but which moves beyond them in the construction of a new 'assemblage' or haecceity. We might take this passage as an example:

> The chestnut, darkening into summer, canopied them over; over their heads were its expired candles of blossom, brown – dessicated stamens were in the dust. Over everything under the tree lay the dusk of nature. Only the car-tracks spoke of ever again going or coming; all else had part in the majestic pause, into which words were petering out. This was not so much a solution as a dissolution, a thinning-away of the accumulated hardness of many seasons, estrangement, dulledness, shame at the waste and loss. A little redemption, even only a little, of loss was felt. The alteration in feeling, during the minutes in which the two had been here, was an event, though followed by a deep vagueness as to what they should in consequence do or say. (Bowen 1955: 155–6)

This alteration in feeling between Lilia and Fred, involving not a denial of past dissonance but a new communication despite it, is inextricably bound up with the external world – the heat, the stillness, the redemptive dissolution of dusk. And it is noteworthy that in this dissolution Lilia, the 'big' woman who has seemed the exemplar of molar femininity, is de-massified, becomes open, like a girl – confirming the fact that, as Deleuze and Guattari suggest, 'girls do not belong to an age group – they slip in everywhere'.

The Little Girls (1964) explores this idea in detail. The novel is divided into three parts: the first representing the reunion of three sixty-year-old women who were at school together in the years before World War I; the second exploring their relationship in childhood; the third returning to the present day and examining the ways in which they re-establish their friendship. Unsurprisingly, the novel draws a sharp contrast between the 'little girls' and the women they have become, and its radical suggestion is that the bond between the little girls, and their life before they were separated at the age of twelve, is by far the most important element in their lives, the basis to which they must return as they begin to contemplate the end of life. At one point

in the opening section, Dinah remembers the girls – nicknamed Sheikie (Sheila), Dicey (Dinah) and Mumbo (Clare) – playing on a swing:

> Sheikie a firework in daylight. Dicey upside down, hooked on by the knees, slapping not kicking at the earth as it flew under. Mumbo face down, stomach across the seat, flailing all four limbs. Pure from the pleasures of the air, any of them could have shot into Kingdom Come. But they had not.

Most strikingly, she then continues:

> Those were the days before love. These are the days after. Nothing has gone for nothing but the days between. (Bowen [1964] 1966: 60)

What this – heretically – suggests is that love, Oedipalised heterosexuality and the lives which the women have lived under its rule, have all 'gone for nothing', that these things are of far less significance, in the end, than the freedom of movement of the little girls, signified by the game on the swing.

In the first section of the novel, Bowen considers in detail what each woman has become, the impression which she makes. Dinah, who has two sons and five grandchildren, has the habit and force of beauty – 'Her beauty, having been up to now an indeterminate presence about the room, grew formidable and stepped forward' (Bowen [1964] 1966: 63). Clare has become an extremely successful businesswoman who, despite her childhood slenderness, is now a 'massive' and imposing woman – 'A big woman wearing a tight black turban, and on the lapel of her dark suit a striking brooch' (Bowen [1964] 1966: 32). Sheila, in Dinah's opinion, has become more encrusted with the sediment of years of conventional living – she is 'More barnacled over. Far, far more barnacled over than you [Clare] or I are. Wouldn't you say? She's certainly thickly covered with *some* deposit. Thanks to which, she is tremendously "the thing" – almost never not, doesn't one notice?' (Bowen [1964] 1966: 157)

Against these molarised, Oedipalised feminine identities, Bowen sets the lives of the little girls. As Sheila remarks, 'Little girls don't make sense' (Bowen [1964] 1966, 33). Anarchic, rough, kicking and scuffling with each other, they have not acquired the niceties of feminine gender identity. They band together like nomads or wolves, both metaphors used by Deleuze and Guattari in *A Thousand Plateaus* to describe the coming together of bodies in loose groups as lines of energies or force coincide. Deleuze and Guattari use these metaphors

to help us to 'think identity otherwise', in Christine Battersby's words (Battersby 1998: 193). As Battersby points out, Deleuze and Guattari also use the metaphor of music to:

> represent an alternative mode of 'belonging together' that is secured materially, and not just by the 'syntheses' of the imagination. Repeated musical phrases can order the 'chaos' of sensations in ways that do not involve representing identities as closed 'unities' that are 'formed' by the imposition of linear space-time grids onto a material world. (Battersby 1998: 185)

Music, in other words, is made up not of 'things' but of actions and energies constituting a 'becoming' in which 'everything happens at once' (Deleuze and Guattari [1980] 1988: 297).

In a key scene in the central section of *The Little Girls*, Bowen describes a birthday picnic just before the onset of war. The children (rather like Maud in *A World of Love*) are lawless and 'demonic', and at one point, as they are resisting the adults' attempts to force them into organised games, Bowen brings together the motifs of the wolf pack and of music, suggesting the ways in which the children's energies exceed and circumvent any arrangements which the adults wish to impose on them:

> Too late. The children were singing. It was a terrible wolf-like ululation, with a spectre of tune in it. Some, heads back, simply droned aloud to the sky. Any true voice, so far as it ever led, was once more drowned. Singers astray in a verse for a line or two boomed back again into the chorus with the greater vigour. Liked, the song seemed on the whole known. (Bowen [1964] 1966: 134–5)

Still more tellingly, in the same scene, Bowen sets the image of Sheikie dancing against the threat of war. Dicey asks:

> 'Who did kill that Australian duke?'
> Confounded the minute she had spoken, the fool child hung for a minute longer upside down, as she was, in shame. Then she righted herself and got off the breakwater. Had the skies fallen? Every one of the children was staring her way. – No, though, not at her but beyond Mumbo at Sheikie, who was executing a tightrope two-step. This was going on farther up the breakwater, where the structure heightened as it approached the wall. To and fro, backward then forward along the wood-bone, bone-dry, dry-slippery edge of the topmost board jaunted the airily-balanced dancer – going away, returning, turning each turn into a nonchalant pirouette. She danced her music. (Bowen [1964] 1966: 139)

Sheikie's dancing – a talent which defines her existence as a little girl – is a manifestation of bodily flows and energies which precede and resist social organisation. Dancing, she represents a 'line of flight', to borrow Deleuze and Guattari's phrase, which can only be opposed to the organised games like the 'tug of war' proposed by one of the fathers at the picnic, and which can only be opposed, too, to the gathering forces of war.

In this central section of the book, the three girls bury a coffer full of precious objects meant 'for posterity'. Among the items which they discuss burying are a pistol and jewels – classic Freudian symbols of male and female sexuality. It is not too much to suppose that Bowen was aware of this – as Dinah later remarks, apropos of Clare's 'knick-knack' shops, 'everything is a symbol'. Bowen plays with the idea of such interpretation – and of the coffer, then, as the place of repression of the knowledge of adult sexuality. Each of the girls also buries a secret item, later revealed to be in Dicey's case her mother's revolver, in Sheikie's case her sixth toe (both with clear sexual implications), in Mumbo's case the works of Shelley (signalling her poetic and imaginative aspirations).

In the third part of the novel, the three women locate and dig up the box, only to find that it is empty: this precipitates a crisis for Dinah, in particular. After the excavation, she begs Clare to come and live with her, and when Clare refuses, somehow manages to injure her head and retreats to her bed. Dinah's collapse is brought about by the hidden connection between what was buried in the box and her life as an adult woman. What was buried was something which she wanted to repress but which she (and the other girls) also valued, something which they thought of as precious, as a resource. The digging up of the box forces the recognition that adult social/sexual life, both feared and desired by the girls, has been, precisely, 'nothing', an *un*reality. For Dinah, 'Nothing's real any more'. She goes on:

'Nothing's left, out of going on fifty years.'

'Nonsense!'

'*This* has done it,' said Dinah. Can't you see what's happened? This us three. This going back, I mean. This began as a game, *began* as a game. Now – you see? – it's got me!'

'A game's a game,' Sheila averred, glancing down her nose.

'And now,' the unhearing Dinah went on, 'the game's collapsed. We saw there was nothing *there*. So, where am I now?' (Bowen [1964] 1966: 175–6)

This deepens Dinah's sense, expressed in the first section of the book, that the middle years of her life have 'gone for nothing' – but she goes on, in this scene, to remark, 'But *you're* real, Mumbo … You were there before.' (Bowen, [1964] 1966: 176).

Dinah's appeal to Clare to come and live with her is connected with this sense of the *reality* of their early life. Clare resists her request because she doesn't want to fall in love with Dinah, to repeat relationships she has had in adult life. Dinah asks her at one point, 'Mumbo, are you a Lesbian?' and Clare does not deny it. A little later, she reveals that she had loved Dinah's mother, but tells Dinah, the 'enchantress's child', that 'once is enough'. She then leaves the house and Dinah withdraws into her trance, lying in a bed under a canopy having 'the look of a death bed'. She is roused first because Clare sends Sheila to nurse her, finally by Clare herself, who comes in while she is sleeping and thinks about their relationship, now and in the past:

> We were entrusted to one another, in the days which mattered, Clare thought. Entrusted to one another by chance, not choice. Chance, and its agents time and place. Chance is better than choice; it is more lordly. In its carelessness it is more lordly. Chance is God, choice is man. You – she thought, looking at the bed – chanced, not chose, to want us again. (Bowen [1964] 1966: 255)

What Clare sees is that their relationship in 'the days that mattered' was entirely a chance relationship, without calculation or forethought, unmediated by social forms and structures. Chance is better than choice because, in Deleuzian terms, it represents the free play of desire, exceeding the limitations of human subjectivity and of socialised bodily desires. Dinah's renewed need of Clare (and Sheila) can, to a certain extent, set up a relation which reactivates the past. There can be no absolute return to little girlhood, as the last line of the text makes clear, with Dinah acknowledging Clare's adulthood – 'Not Mumbo. Clare. Clare, where have you been?' (Bowen [1964] 1966: 256). But a revived friendship can allow for some interplay between past and present, for some renewed access to the profound freedom of early life.

Eva Trout, Bowen's last heroine, is an inscrutable and powerful figure. When we first meet her, at the age of twenty-four, this is the impression she makes:

> The giantess, by now, was alone also: some way along the edge of the water she had come to a stop – shoulders braced, hands interlocked

behind her, feet in the costly, slovenly lambskin bootees planted apart. Back fell her cap of jaggedly cut hair from her raised profile, showing the still adolescent heaviness of the jawline. (Bowen 1969: 13)

Both massive and childlike, Eva, heiress to an immense fortune, seems to experience her adult female body as a burden from which she seeks to escape. Her backgound is as extraordinary as her appearance. Her father, a wealthy financier, committed suicide, tormented beyond endurance – Eva thinks – by his long-time male lover, now Eva's guardian. Her mother left when she was two months old, only to die almost immediately in a plane crash: Eva has by no means had a conventional family upbringing.

Eva's first love is Elsinore, a fellow pupil at an 'experimental' school to which her father consigns her at the age of fourteen (at which point, we are told, 'Eva was showing no signs of puberty'). Elsinore is delicate, elfin. She walks into a lake, like Ophelia, and then goes into a coma: throughout her illness she is attended, silently, by Eva. The scene is reminiscent of Dinah's trance in *The Little Girls*:

> What made Eva visualise this as a marriage chamber? As its climate intensified, all grew tender. To repose a hand on the blanket covering Elsinore was to know in the palm of the hand a primitive tremor – imagining the beating of that other heart, she had a passionately solicitous sense of this other presence. Nothing forbad love. This deathly yet living stillness, together, of two beings, this unapartness, came to be the requital of all longing. (Bowen 1969: 64)

The references to *Hamlet* underscore the pre-Oedipal and Oedipal possibilities of this situation, and Eva's *resistance* to both positions. She refuses to accept either father- or mother-figures as objects of desire, adhering to the mute reciprocity of her childlike relation to Elsinore.

Eva's next object of love is Iseult Smith, a teacher at the next school she attends. The relation between the two is accidental – Iseult doesn't really know why she takes an interest in this awkward girl – but it brings Iseult Eva's complete devotion. Eva feels that she is a mute and 'submerged' creature, and Iseult's attention seems to hold out the possibility for Eva of speech and connection with others. None the less, the relationship is compromised by Iseult's marriage. When, after she has left the school, Eva goes to stay with her former teacher, she responds to the marriage in an extraordinary way, staging a fake adulterous relationship with the husband, Eric, and even

going to far as to give Iseult the impression that she is pregnant by him. Eva *mimics* heterosexuality, having no great regard for love, as she later confides – 'I had had disagreeable impressions of love' (Bowen 1969: 262).

Eight years later, Eva returns to England with Jeremy, the child she has (illegally) adopted to stand in for the child she is supposed to have had with Eric. Jeremy is a deaf mute, who thus perfectly replicates and mirrors Eva's mute and frustrated existence. The 'inaudible years' of his childhood are spent travelling about America, as Eva and he '[lord] it in a visual universe'. They live in an insulated, solipsistic world – 'Society revolved at a distance from them like a ferris wheel dangling buckets of people' (Bowen 1969: 221). However, the return to England precipitates a break between Eva and Jeremy. Eva re-establishes her friendship with Henry Dancey, the son of a local vicar who had been her confederate when she was twenty-four and he was twelve years old. Their relationship is hardly a conventional heterosexual relationship – it is more like Eva's relationship with Elsinore than anything else, a link that is confirmed by Eva's associating both Elsinore and Henry with a honeymoon in the fantastic castle setting of her first school. The relationship remains in a sense childish – Henry's mother remarks that 'from childhood they have been kindred spirits' and that 'Eva's a child at heart' (Bowen 1969: 249). None the less, the relationship develops to the point where Eva proposes marriage to Henry. Meanwhile Iseult, Eva's old teacher, rouses Jeremy as she had earlier roused Eva, inspiring in him for the first time the desire to use language and make contact with the external world.

Bowen speaks of Eva's return to England as a return to 'face the music', music which once faced 'stirs her'. The suggestion is not only that Eva must face the consequences of her actions, and their effect on others, but that she must enter the world of music, of relationships, of 'becoming'. She enters this world fully only when Henry tells her he will marry her. She has her moment of becoming, of relationship, and speaks with her body, shedding the first tears she has ever shed:

> They were far from alone; down the long, suave car various fellow-occupants were already seated. In here it seemed, after the platform, silent – to be not overheard, the two had to stand close together. As though the train had started and started swaying, they swayed slightly. 'I'm not going to get off,' he said, brushing his lips against her ear. 'I'm not going to get off this train, I mean. Did you really want me to? – did you imagine I would?'

> ... Something took place: a bewildering, brilliant, blurring filling up, swimming and brimming over; then, not a torrent from the eyes but one, two, three, four tears, each hesitating, surprised to be where it was, then wandering down. The speediest splashed on to the diamond brooch. 'Look what is *happening* to me!' exulted Eva. She had no handkerchief, not having expected to require one – she blotted about on her face with a crunched-up glove. 'What a coronation day ... '. (Bowen 1969: 315–16)

Jeremy, however, is still and may always be exiled from such connection: in the final ironic twist of the novel, he shoots Eva dead as she prepares to depart for her wedding journey.

Like Bowen's other late novels, *Eva Trout* presents a heroine who resists the Oedipal plot, and the novel may be said to be anti-Oedipal in this respect, especially in its delineation of the eccentric relationship between Eva and Henry. None the less, the strongest impression which the novel leaves is of Eva's entrapment in a curiously inert body. 'Becoming' in the world of Bowen's last novel seems to be an almost impossible feat, for both female and male characters. An image worth pondering in this respect is that of the trapped bird, which Henry watches as he listens to his father preaching, just before he leaves to join Eva at the end of the novel. The bird might be said to represent both Eva and Henry: Eva is repeatedly compared to a bird, and Henry is, like it, trapped in his father's church:

> A thrush had got into the church. It was adolescent; though full-grown still hardly more than a bloated fledgling. Barely yet fit to fly, it did so with arduousness and terror, hurtling, hoping, despairingly losing height, not knowing where it was to land, if it ever did, or how again to take off, if it ever could ... The thrush, gathering velocity from the distance, catapulted beak-on into the glass of the window above Henry. Like a stone it dropped. Henry fainted, alone in his corner of the vicarage pew. (Bowen 1969: 295–7)

I would suggest, following Deleuze and Guattari, that it is Eva's capital inheritance (her 'horrible money', as Henry calls it, the product *par excellence* of damaging social relations) which petrifies her body, and that it is the church, with its misplaced emphasis on transcendence and its moribund ideas, which petrifies Henry. It is these overwhelming forces which ensure that their intersecting lines of flight, though embarked on with passion, with 'arduousness and terror', will ultimately fail. Bowen does not underestimate here the forces of habit and repression which inhibit the 'becomings' so eloquently

explored by Deleuze and Guattari and so intensely evoked in her fiction.

References

Battersby, C. (1998) *The Phenomenal Woman*, Cambridge, Polity Press.

Bowen, E. (1955) *A World of Love*, London, Jonathan Cape.

—— ([1964] 1966) *The Little Girls*, London, Reprint Society.

—— (1969) *Eva Trout or Changing Scenes*, London, Jonathan Cape.

Braidotti, R. (1991) *Patterns of Dissonance: A Study of Women in Contemporary Philosophy*, Cambridge, Polity Press.

Deleuze, G. and F. Guattari, ([1972] 1984) *Anti-Oedipus: Capitalism and Schizophrenia, Vol. 1*, trans. Robert Hurley, Mark Seem and Helen R. Lane, London, Athlone Press.

—— ([1980] 1988) *A Thousand Plateaus: Capitalism and Schizophrenia, Vol. 2*, trans. Brian Massumi, London, Athlone Press.

Grosz, E. (1994) 'A Thousand Tiny Sexes: Feminism and Rhizomatics', in Constantin V. Boundas and Dorothea Olkowski (eds), *Gilles Deleuze and the Theater of Philosophy*, London, Routledge.

Hughes, J. (1997) *Lines of Flight: Reading Deleuze with Hardy, Gissing, Conrad, Woolf*, Sheffield, Sheffield Academic Press.

Lee, H. (1981) *Elizabeth Bowen: An Estimation*, London, Vision Press.

14

TEXTU(R)AL BRAILLE:
visionary (re)readings of H.D.

RACHEL CONNOR

The label *Imagiste*, first supplied by Ezra Pound in 1912, has long
determined H.D.'s status as the iconic figure of the imagist move-
ment. Maintaining that, physically as well as metaphorically, H.D.
has come to represent 'the exemplar, the veritable Image of Imagism
… the figure in whom Imagism/Modernism recognized itself', Eliza-
beth A. Hirsch has shown that as 'an example of and for her theory'
she has been consistently denied an active role as a theorist of images
by generations of literary critics (Hirsch 1986: 3).[1] The primary pur-
pose of this essay is to reassess H.D.'s contribution to modernism by
examining how theories of the visual in her prose diverge from the
imagist precepts she is said to embody. Her accounts of visionary
experience and her consistent use of metaphors of tactility emphasise
a corporeal realm which operates alongside that of the cerebral, chal-
lenging Ezra Pound's doctrine of the image as an 'intellectual com-
plex' (Pound, [1918] 1960: 4). Given that 'Pound's Image has so often
been taken as paradigmatic for … Modernist poetic[s]' (Hirsch 1986:
3), H.D.'s textual practice can be understood not only as reworking
the epiphanic, visual 'moment' but also as inviting a critical *re*vision
of the modernist aesthetic as a whole.

In order to move beyond the simplistic categorisation of H.D. as
'modernist writer' or 'imagist poet', my essay will situate her writing
within current theoretical debates about corporeality in the construc-
tion of female subjectivity. As well as foregrounding the contempo-
raneity of H.D.'s thinking about gender difference, a consideration of
her writing within discourses of postmodernism highlights the resis-
tance to a singular definition of the notions of 'body' or 'sexuality' in
her texts. Specifically, the reconfiguration of the visual realm in her
work has resonances with the notion of the 'specul(aris)ation' of west-

ern theoretical discourse expounded by the philosopher Luce Iri-
garay.[2] A parallel reading of H.D.'s and Irigaray's work reveals both
writers' deployment of tactility and visionary experience as political
strategies through which to rethink the materiality of women's
bodies. Concepts of 'body' and 'matter' have been questioned, in
recent years, through Judith Butler's critique of feminist theories like
those of Irigaray which ground themselves in 'the sexed specificity of
the female body' (Butler 1993: 28). The notion of gender as an act or
'corporeal style' (Butler 1990: 139) is a useful standpoint from which
to question representations of corporeality and sexual difference in
H.D.'s work (and in that of Irigaray) and I will therefore conclude my
essay by reading her narrative in the light of Butler's theories of
performativity.

My rationale for reading H.D.'s work in conjunction with that of
Irigaray lies primarily in the challenge both women level at the hege-
monic discourse of science which was formative to their intellectual
development. As the granddaughter of a botanist, and the daughter
of a renowned astronomer, H.D.'s early years were shaped by the dis-
cipline of science. Throughout her lifetime she was both fascinated
and repelled by psychoanalysis and, as a bisexual woman living with
a long-term female partner, had an uneasy relationship to the hetero-
sexual norms which it reinforced. Irigaray was famously expelled
from Lacan's *Ecole Freudienne* after the publication of *Speculum of the
Other Woman* (1985a), which was considered to be too critical of psy-
choanalysis. The feminist critique of both these writers focuses pre-
dominantly on the oculocentrism they perceive as central to the
formulation of heterosexual desire within psychoanalytic thinking.

H.D.'s ambivalent relationship to ocular science is best exempli-
fied in her memoir *Tribute to Freud* ([1956] 1985), which recounts her
analysis with Freud in 1933. Focusing on the memories of the psychic
visions she experienced whilst in Corfu with her female partner,
Bryher, in 1920, the text challenges the notion of scopic or scientific
investigation. As Freud's analysand, she feels herself placed 'between
the double lenses of my father's telescope, my grandfather's micro-
scope' (H.D. [1956] 1985: 116). Her horror of this visual scrutiny is
developed still further: 'If I let go (I this one drop, this one ego under
the microscope-telescope of Sigmund Freud) I fear to be dissolved
utterly' (H.D. [1956] 1985: 116). Echoing attempts elsewhere in her fic-
tion to reconcile the contradictory impulses of her mother's 'art' and
the 'science' of her paternal ancestors, this passage suggests her dual

position within and outside the dominant ideology by employing sci-
entific discourse metaphorically within her fictional narrative.[3]
Bonnie Kime Scott has argued that the centrality of science as a
metaphor in modernist writing stems from Pound's definition of the
image, which draws on 'technical metaphors derived from scientific
terminology' (Scott 1995: 97). If we also accept that Pound's use of a
discourse which valorises the male sexual anatomy is 'comparable to
the phallicism of the psychoanalytic theories of Freud and Lacan'
(Scott 1995: 95), then H.D.'s refusal of scopic investigation can be read
as a simultaneous challenge both to modernist aesthetics and to the
phallocentric institution of psychoanalysis.

Rejecting Freud's 'diagnosis' of her Corfu visions as a manifesta-
tion of 'the desire for a union with her mother' (H.D. [1956] 1985: 44),
H.D. provides her own analysis, throughout *Tribute*, of the visions she
calls her 'writing on the wall'. When, at the end of the sequence of
hieroglyphs, she turns away, exhausted, the reading is completed by
her partner: 'Bryher … carries on the vision from where I left off…she
saw what I did not see' (H.D [1956] 1985: 56). The two women, who,
in H.D.'s words, 'for lack of a definite term, we must call psychics or
clairvoyants' (H.D. [1956] 1985: 41), enact a model of spectatorship
which restructures the hierarchical power implicit in the relationship
between observer and viewed object.[4] Their collaborative viewing
and decoding of the images emphasises their proximity and rein-
forces their lesbian desire. As such, their visionary experience chal-
lenges the heterosexual matrix of desire theorised in psychoanalysis,
which depends on the construction of distance between the object and
the viewing subject.[5] This narrative strategy has resonances with Iri-
garay's 'ethical philosophy', which is read by Butler as an attempt to
'reconfigure conventional notions of reciprocity and respect' (Butler
1993: 46).

H.D.'s challenge to the politics of the scopic operates not only
through the reconfiguration of the viewing moment but also through
a focus on the tactile as an alternative site of sensory experience. In
many of her texts, the tactile operates through the portrayal of the
woman artist or writer as sculptor who questions the power relation-
ship implicit in the act of looking. As Scott has previously illustrated,
the notion of the tactile is prevalent in the work of several modernist
women writers, including Virginia Woolf and Rebecca West, where
spinning and weaving operate as metaphors for textual process. The
image of the web, Scott argues, represents a challenge to 'the hard,

exact words called for in much-cited modernist manifestoes such as ... Pound's prescriptions for imagism' (Scott 1995: xvi). It conveys both the importance of collaborative interaction between these modernist women and the struggle of the writing process for the individual woman writer. I would argue further that it articulates a specific textu(r)al method which relies on the direct relationship between textual production and female corporeality.

Rather than reinforcing a binary structure which conflates 'woman' and 'nature', the emphasis on the tactile in H.D.'s texts suggests a more complex attempt to unpick the cultural construction of gender difference. The metaphors of tactility she employs in *Tribute To Freud* draw analogies between her own textual practice and Freud's analytical discourse, thereby blurring the distinction between analyst and analysand, between 'his' science and 'her' art. Describing Freud's thoughts as 'strip[s] ... ripped from the monotonous faded and outworn texture of the language itself', H.D. equates them with the narrative method of her own text (H.D. [1956] 1985: 69). The narrative of *Tribute*, she states, is woven from fragments of psychic material to create her own version of 'Penelope's web', a memoir in which she can 'record the details of my experience and ... write them down ... weave and re-weave the threads, the tapestry on this frame' (H.D. [1956] 1985: 161). The metaphor of weaving as a feminist strategy reappears in Irigaray's *'This Sex Which is Not One'* (1985b), where it represents a resistance both to masculinist discourse and, like H.D.'s expression of tactility, to the regime of the scopic. Irigaray's attempt to recreate 'a morphology of the female sex' (Irigaray [1977] 1990: 82) problematises what she perceives as monolithic, male sexuality by redefining the relationship between corporeality and textuality:

> [She] steps ever so slightly aside from herself with a murmur and an exclamation, a whisper, a sentence left unfinished ... When she returns, it is to set off again from elsewhere. From another point of pleasure ... One would have to listen with another ear, as if hearing *an 'other meaning' always in the process of weaving itself, of embracing itself with words, but also getting rid of words in order not to become fixed, congealed in them* ... What she says ... *touches (upon).* (Irigaray 1985b: 29)

Whilst there are obvious dangers of a collapse into biological essentialism when constructing a feminist politics based on the representation of the body, the subversion of this strategy functions precisely *because* the body has been a site of oppression for women.[6] By

parodying or miming the very masculinist discourse they attempt to undermine, both writers perform the doubleness on which their political strategy and their 'insider–outsider' positionality are founded. Thus, although H.D.'s allusions to weaving appear to suggest a different kind of textual method to that of Freud's scientific logic, her continual use of the metaphor to describe Freud's language and tone of voice implies her reliance on the dominant discourse he represents. Her ambivalent relationship to hegemonic structures is further conveyed in her representation of religion. Whilst she celebrates the sense of community inherited from her strict Moravian upbringing, and recognises its importance to her artistic development, she also signals her resistance to organised religion throughout the narrative of *Tribute*. H.D.'s 'suppressed desire to be a Prophetess ... to found a new religion' (H.D. [1956] 1985: 51) suggests a need to reconstruct Christian ideology, to 'form a new vehicle of expression or a new form of thinking' (H.D. [1956] 1985: 51). This impulse towards 'a new vehicle of expression' is evocative of Irigaray's critique of religious discourse, which I will briefly outline before returning to my discussion of H.D.

Irigaray's representation of religious experience, whilst implicit throughout her writing, is concentrated in the 'La Mystérique' chapter of *Speculum of the Other Woman*, and Philippa Berry has argued convincingly that the whole structure of the text is organised around this central essay (Berry 1994). Irigaray appropriates what she calls 'mystic language or discourse' (Irigaray 1985a: 191) through her depiction of the female mystic as a soul who is 'buried and sealed off in her crypt' (Irigaray 1985a: 195). When read in the context of the rest of Irigaray's work, where light and the sun are equated with the phallocentrism of the scopic, her female mystic becomes a subversive figure who refuses to comply with the androcentric tradition of Christianity. Furthermore, by conveying the ecstasy of the visionary moment through the physicality of the body, Irigaray reverses the binary of body and soul: 'Hidden away, she waits for the rapture to return, the ecstasy, the lightning flash, the penetration of the divine touch' (Irigaray 1985a: 195). This simultaneous reworking of the regime of the scopic and the dominant power structures of Christianity exemplifies what Berry has described as Irigaray's 'new philosophy ... a paradoxical dark vision that can be rooted in matter and the body' (Berry 1994: 242).

In H.D.'s novel *Bid Me To Live* (1960) the female mystic is repre-

sented by the central character, Julia Ashton, a writer and a translator of Greek drama. Through the descriptions of Julia's translations, H.D. is able to explore the sub-text of her own narrative method. Like Irigaray, she evokes visionary experience both through the tactile and the eroticisation of the sacred. A direct relationship is established between body and text, whereby Julia's translated text signifies through the reverberation of the words on the page within the metaphorical body. The physical manifestation of the sacred, the 'inner light', is represented as a 'reality' or truth unknown to the outer eye and perceived through a kind of 'textu(r)al Braille':

> She brooded over each word, as if to hatch it. Then she tried to forget each word, for 'translations' enough existed and she was no scholar. She did not want to 'know' Greek in that sense. She was like one blind, reading the texture of incised letters, rejoicing like one blind who knows an inner light, a reality that the outer eye cannot grasp. (H.D. 1960: 162–3)

Like the description of the 'writing on the wall' in *Tribute*, this constitutes a reversal of the visual process. H.D.'s representation of visionary experience is constructed through a metonymical female body which, like the 'dark vision' of Irigaray's texts, strategically turns inward. The epiphanic moment in the texts of male modernists, such as Joyce and Pound, is therefore redefined in H.D.'s writing through the realignment of the female body against both the phallocentric gaze and a male-dominated literary practice.

These characteristics of textual process in the writing of H.D. and Irigaray underline the close links between vision, gnosis and the body in western metaphysical tradition. Drawing on the work of Heidegger, Berry reminds us that, historically, there has always been a 'scopic bias' in European philosophy 'since the Greek word *theorin*, whence we derive our term theory, actually means to contemplate' (Berry 1994: 231). Both Irigaray and H.D., I would argue, perform a double critique in 'read[ing] religious as well as … [theoretical] discourse *otherwise*' (Berry 1994: 242). The association of a hierarchical model of knowledge with the operation of the scopic is challenged in both these writers, who attempt to 'redirect and reform that "looking" which is implicit in theoretical or philosophical activity' (Berry 1994: 231). The problem with this strategy, as Butler has noted of Irigaray's work, is that it must be read within the same theoretical or phenomenological tradition in which it was written (Butler 1990: 140–1). Irigaray's work, it seems, can only be understood within the terms of its

'strategic aim of maintaining gender within its binary frame' (Butler 1990: 140), a criticism which, by extension, can also be levelled at H.D. I will return to this notion in the conclusion to the essay when I suggest another way of reading 'the body' in H.D.'s writing.

Irigaray, then, appears to serve as a useful point of departure for questioning the construction or destabilisation of identities in H.D.'s work. I would argue that, in a consideration of corporeality in her writing, Butler's theory provides a useful supplement to Irigarayan thinking. Butler's notion of substance as an effect, generated through the inscription of gestures, language and desire on the surface of the body as a means of signification, appears to be a way out of the 'impasse' of materiality in thinking about gender difference:

> Such acts, gestures, enactments … are performative in the sense that the essence or identity that they otherwise purport to express are *fabrications* manufactured and sustained through corporeal signs and other discursive means … This also suggests that if that reality is fabricated as an interior essence, that very interiority is an effect and function of a decidedly public and social discourse. (Butler 1990: 136)

Replacing the substance, or 'beingness' of the body with a *process* which she calls 'corporeal style', Butler appears to rethink the whole notion of corporeality in relation to the question of sexual difference (Butler 1990: 139). Gender becomes an 'act' which appears on the surface of the body and is therefore 'a construction that regularly conceals its genesis' (Butler 1990: 140). In order to place Butler's thinking within the literary framework of H.D.'s texts, I will now conclude with a reading of the novel *Her* (1984), written in 1927.

Her depicts the early career of a young woman writer, Her Gart, whose artistic identity is closely bound up with her emergent bisexuality. Throughout the novel, Her's creative expression is shown to be stifled by her fiancé George, who judges her poetry as 'rotten' and considers her instead as a muse for his own writing: 'You are so damned decorative' (H.D. 1984: 167, 169). Denying her access to her own subjectivity as a writer, George relegates Her's body to the status of blank surface which awaits inscription by another (presumably male) author: 'you are a poem, though your poem's naught' (H.D. 1984: 212).

By the end of the novel Her has endured the betrayal of both her male and female lovers through their sexual involvement with each other. The ensuing emotional breakdown results in a transition from

Her's perception of self-as-text to self-as-author, signalled through H.D.'s allusion to the reconstruction of both: 'Everything had been erased, would be written on presently' (H.D. 1984: 221–2). Compelled to find a 'solid and visible form' (H.D. 1984: 213) through which to rewrite her story, the final pages of the novel describe Her's walk home across a snow-covered field:

> the creator was Her's feet, narrow black crayon against winter whiteness … The meadow lay flat and whiter than the forest. … She trailed feet across a space of immaculate clarity, leaving her wavering hieroglyph as upon white parchment. (H.D. 1984: 223–4)

The metaphor of the imprint in the snow allows H.D. to illustrate how Her's body operates as an instrument of textual process as well as a *tabula rasa* awaiting cultural inscription. Read in the context of Butler's theory of 'corporeal style', this passage of the novel suggests that the body might perform the construction of its own subjectivity. In the example of Her's physical inscription of her own text upon the fields near her family home, H.D. articulates her ultimate challenge to the label of decorative sign or image, which she herself experienced by being seen as the 'image of imagism'.

This positive assertion of female artistic identity, however, is rendered ambiguous later in the text. When Her looks back at her footprints, she perceives that: '[h]er track was uneven and one footprint seemed always to trail unsteadily … The meadow lay like a piece of outspread parchment partially curled under' (H.D. 1984: 224). Despite Her's impulse to inscribe her own subjectivity by covering the field with 'wavering hieroglyphs', the attempt is bounded by cultural limitations. The description of the footprints 'trailing unsteadily' suggests that any refusal of the dominant discourse on Her's part, symbolised by her signification of her body on the blank surface or parchment, can only be temporary. The ending of the novel remains unresolved, with Her returning to find Fayne waiting for her at home, but with no indication as to whether the relationship with Fayne is resumed. In *Her*, H.D. presents us with a character who oscillates between two subject positions, between heterosexual and lesbian desire, within the hegemonic ideology and outside it. This 'doubleness', like Irigaray's strategy of mimesis, may unsettle or trouble the binary positions but, ultimately, leaves both intact.

Butler's notion of the performative posits the idea of gender as 'a strategy for survival within compulsory systems' and, as such, retains

the notion of parody or mime which is the central strategy of Irigaray's theory (Butler 1990: 139). Butler herself acknowledges the open-ended question of materiality when theorising sexual difference, stating that 'it seems radically unclear whether a notion of matter or the materiality of bodies can serve as the uncontested ground of feminist practice' (Butler 1993: 54). In H.D.'s texts the female body operates continually within two contexts and positionalities, performing the categorical 'reverse-mime'. When we are told of the iconic Helen of Troy, in *Helen in Egypt* (1961), H.D.'s final, epic poem, that 'she herself is the writing' (H.D. 1961: 22) she represents, like Her, both textual process, through the performative act of writing herself, *and* textual surface, as the ultimate, historical object of male spectatorship.

Notes

1 In recent years several of H.D.'s critics have begun to address this lack by focusing on the significance of her film criticism and theory and her experience of film editing in the 1920s and 1930s. For accounts of her involvement in film, see Friedberg 1982 and Mandel 1983. For discussions of filmic techniques used in her literary texts and her strategies for redefining the scopic, see Collecott 1986 and Connor 1997.

2 'Specul(aris)ation' is a notion which is central to Irigaray's *Speculum of the Other Woman* (1985a). Sue Vice defines the concept as the suggestion of the close link between 'the economic analysis of hom(m)osexual culture and its prioritization of the visual ... in both Freud's and Lacan's work' (Vice 1996: 179).

3 See Alice Gambrell for a discussion on the significance of 'insider–outsider activity' and its relationship to current feminist debates. Gambrell draws on Teresa de Lauretis's assertion that feminism must be 'at the same time inside and outside the ideology of gender, and conscious of being so ... of that doubled vision' (Gambrell 1997: 14).

4 This is a familiar strategy in H.D.'s fictional prose. In *Her*, for instance, she conveys the sexual desire of the two female characters through the use of mirror imagery. The moment of their meeting is described through the distortion of the visual field by a convex mirror (H.D. 1984: 52).

5 See, for instance, Freud [1905] 1977: 70.

6 The accusations of biological essentialism levelled at Irigaray are, by now, well documented and it is beyond the scope of this essay to refute them here. Sue Vice argues that the apparent essentialism operating in Irigaray's work is, in fact, strategic, 'a ruse to expose philosophy's essentialism, and the maternal-feminine on which it depends' (Vice 1996: 178).

References

Berry, P. (1994) 'The Burning Glass: Paradoxes of Feminist Revelation in *Speculum*', in Carolyn Burke, Naomi Schor and Margaret Whitford (eds), *Engaging With Irigaray: Feminist Philosophy and European Thought*, New York, Columbia University Press.

Butler, J. (1990) *Gender Trouble: Feminism and the Subversion of Identity*, London and New York, Routledge.

—— (1993) *Bodies That Matter: On the Discursive Limits of 'Sex'*, London and New York, Routledge.

Collecott, D. (1986) 'Images at the Crossroads: H.D.'s "Scrapbook"', in Michael King (ed.), *H.D.: Woman and Poet*, Orono, National Poetry Foundation.

Connor, R. (1997) '"Maddening reflections": The Cinematics of H.D.'s *Her*', *Manu-Script*, 2 (1), 17–26.

Friedberg, A. (1982) 'On H.D., Woman, History, Recognition', *Wide Angle: A Film Quarterly of Theory, Criticism and Practice*, 5, 26–31.

Freud, S. ([1905] 1977) 'The Sexual Aberrations', in Angela Richards (ed.), *On Sexuality: Three Essays on Sexuality and Other Works*, London, Penguin.

Gambrell, A. (1997) *Women Intellectuals, Modernism and Difference: Transatlantic Culture 1919–1945*, Cambridge and New York, Cambridge University Press.

H.D. ([1956] 1985) *Tribute To Freud*, rpt, Manchester, Carcanet Press, 1985.

—— (1960) *Bid Me To Live*, New York, Dial Press.

—— (1961) *Helen in Egypt*, New York, New Directions.

—— (1984) *Her*, London, Virago Press.

Hirsch, E.A. (1986) 'New Eyes: H.D., Modernism and the Psychoanalysis of Seeing', *Literature and Psychology*, 32 (3), 1–10.

Irigaray, L. ([1977] 1990) 'Women's Exile', interview with Luce Irigaray, trans. Couze Venn, in Deborah Cameron (ed.), *The Feminist Critique of Language: A Reader*, London and New York, Routledge.

—— (1985a) *Speculum of the Other Woman*, trans. Gillian C. Gill, Ithaca, Cornell University Press.

—— (1985b) *This Sex Which is Not One*, trans. Catherine Porter, Ithaca, Cornell University Press.

Mandel, C. (1983) 'The Redirected Image: Cinematic Dynamics in the Style of H.D.', *Literature/Film Quarterly*, 11, 36–45.

Pound, E. ([1918] 1960) 'A Retrospect', in T.S. Eliot (ed.), *Literary Essays of Ezra Pound*, London, Faber and Faber.

Scott, B.K. (1995) *Refiguring Modernism: The Women of 1928*, Bloomington and Indianapolis, Indiana University Press.

Vice, S. (ed.) (1996) *Psychoanalytic Criticism: A Reader*, Cambridge, Polity Press.

15

DAPHNE DU MAURIER AND GOTHIC SIGNATURES:

Rebecca as vamp(ire)

AVRIL HORNER and SUE ZLOSNIK

Gothic fiction over the last two hundred years has given us characters such as Dracula and Frankenstein's monster who have passed into popular culture and taken on an almost mythic dimension (Day 1985: 3). *Rebecca*, Daphne du Maurier's most famous novel, has given us one such character. This essay will attempt to retrieve Rebecca's textual Gothic ancestry and relate it to a discussion of the destabilising nature of her absent/present body and its status as ghostly yet corporeal trace. In particular, it will explore the significance of signature as bodily trace in relation to the writing identities of both Rebecca and her creator, Daphne du Maurier.

In what is still probably the most memorable representation of *Rebecca* (published in 1938), Hitchcock's film (made in 1940) retains the novel's Gothic emphasis. However, Alison Light's influential reading of the novel has resulted in an argument centred on the class dynamics of the text; this sees the narrator's bourgeois feminine subjectivity as both inflected and threatened by that of a wayward, aristocratic Rebecca who enjoys a freedom of self-expression and lifestyle denied the timid second wife of Maxim de Winter (Light 1984). Whilst providing some invaluable insights, this reading has necessitated a fairly free, and sometimes inaccurate, portrayal of the social class of both Rebecca and her creator.[1] In fact, Rebecca's social class is not entirely clear from the novel. Indeed, Michelle A. Massé, in speculating that Rebecca was married for her money, opens up the possibility that her marriage to Maximilian de Winter combined his aristocratic status with her *nouveau riche* wealth and was thus a marriage of expediency for both parties (as she points out, 'Manderley's splendor is very

recent' (Massé 1992: 181)). Nor is it accurate to describe du Maurier herself as 'aristocratic': her father's title came with a knighthood earned in 1922 and her own title of 'Lady Browning' derived from her marriage to Major 'Boy' Browning. Moreover, such an approach tends to shift du Maurier's novel out of the Gothic paradigm: for example, relating the writing of *Rebecca* to the rise of the love-story during the inter-war period, Light describes the novel as 'a thriller or murder story … as well as a love-story' (Light 1991: 163). A subsidiary effect of such categorisations has been to define Rebecca as a vamp or a *femme fatale*; indeed Light refers to du Maurier as finding 'her scarlet woman irresistible' (Light 1991: 157).

Yet the term *'femme fatale'* is not simply a sign of aristocratic femininity; there are racial and gendered positions embedded in the term which are brought to light when we examine the close but distinct etymological and cultural relationship between the words *'femme fatale'*, 'vamp' and 'vampire'. The first phrase, imported from the French in 1912, according to the *Oxford English Dictionary*, linguistically 'otherises' a particular type of woman as a source of threat. The *femme fatale* has, of course, a long cultural history which goes back to Jezebel, Salome and Cleopatra, but she does not become prominent in art and literature until the late nineteenth century when she emerges, according to Mary Ann Doane, as a response to an industrialised and rapidly changing society in which women were resisting Victorian models of femininity (Doane 1991: 1–2). She is associated, according to Doane, with distinct characteristics. She is never really what she seems to be; her rather morbid sexuality connects her beauty with barrenness, lack of production, death and obliteration; because her power situates the *femme fatale* as evil, she is invariably punished or killed (often by a man); finally, she is often associated with a sexually ambiguous identity, in so far as she is frequently linked with androgyny, bisexuality and/or lesbianism. Rebecca manifests all of these characteristics. She is not what she seems to be: the outward conformity of the sophisticated chatelaine figure, adored by the Cornish community, hides a secret self who behaves differently in London and within the privacy of her boat house. Her beauty is certainly associated with barrenness and death. She is indeed perceived as evil by Maxim and is punished accordingly by him. Finally, her sexual identity is ambiguous; the text makes it clear that she has committed adultery but also hints that she and Mrs Danvers have been lesbian lovers. More broadly, she destabilises current notions of gender: seen

through Mrs Danvers's eyes, Rebecca signifies both femininity and masculinity. On the one hand, the housekeeper emphasises her beauty, sensuality and femininity by endowing her fine clothes with a metonymic significance. On the other hand, she stresses Rebecca's power and masculinity: what she loved in Rebecca, it seems, was her strength, her courage and her 'spirit', which she associates with masculinity: 'She ought to have been a boy, I often told her that' (du Maurier [1938] 1992: 253). At the level of plot, then, Rebecca is presented, it would seem, as a classic *femme fatale* figure.

The discourses of film and literature invariably use the phrase '*femme fatale*' interchangeably with the word 'vamp'.[2] Yet 'vamp' is defined by the OED as a Jezebel figure who is deliberately destructive, whereas the *femme fatale* is often perceived as having '*power despite herself*' (Doane 1991: 2). A few critics, however, do perceive this distinction. Pierre Leprohon, for example, in his book *The Italian Cinema*, suggests that the *femme fatale* and the vamp are quite different, the latter being connected with a conscious desire to destroy: she is, he argues, 'deliberately devastating, the woman who lives off her victims' misfortunes, a kind of vampire'. In contrast, 'the fate of the *femme fatale* is often as dreadful as that of her lovers, and this makes her even more appealing' (cited in Doane 1991: 127). Interestingly, the *OED* suggests that the word 'vamp' (first used in this sense in 1918 and quite distinct from to 'vamp' on a piano, which has a different etymology) does indeed derive from the word 'vampire'. This slippage between the words 'vampire' and 'vamp' is attributed by several critics to a *fin-de-siècle* anxiety concerning the shifting status of women. For example, Bram Dijkstra has noted that '[b]y 1900 the vampire had come to represent woman as the personification of everything negative that linked sex, ownership, and money' (Dijkstra 1986: 351); according to Alexandra Warwick, the changing representation of the female vampire in late nineteenth-century texts reflected a growing anxiety about the 'masculinisation' of women in their transition from angels of the hearth to 'wandering' New Women (Warwick 1995: 202–20).[3] The actual threats embodied in real women, then, resulted in the female vampire being culturally transmuted into the vamp; by the early twentieth century the sinister polyvalency of the former had become translated into the sexual threat of the latter.

The corporeal code of the vamp is, of course, immediately recognisable: invariably her direct gaze emanates from a slender, nubile body; she usually has dark hair, either in abundance or cut very short,

so that it sits like a cap on her head; above all, her presence is strongly erotic. Lulu, in G.W. Pabst's famous 1929 film *Pandora's Box*, played by Louise Brooks, was portrayed in just such a way. Du Maurier's Rebecca, when she *is* made visible in film or television adaptations, is often rendered as the classic vamp.[4] We are not claiming that this is a misrepresentation: du Maurier's famous novel, set in the mid-twenties according to its author (du Maurier [1981] 1993: 10), certainly draws on late nineteenth- and early twentieth-century constructions of the independent and sexually active woman as vamp. Yet the corporeal charisma so important in portrayals of the 'vamp' is communicated in the novel only through traces of Rebecca's body and the things connected with her: her scent, her clothes, the rhododendrons, her signature, her script. In du Maurier's text, it is, paradoxically, the very *absence* of Rebecca that is used to denote so powerfully the *presence* of adult female sexuality. Rebecca, then, is *ghost* as well as vamp. Du Maurier's work is, after all, a Gothic novel, not a *film noir*; the threatening woman is 'otherised' not only through physical difference, but also through the supernatural. Not surprisingly, then, we find du Maurier subtly drawing on the vampiric tradition in her creation of Rebecca and this, we suggest, contributes much to the evocation of the uncanny in the novel. However, we shall argue that the cultural slippages between the terms 'vamp', 'vampire' and '*femme fatale*' are reflected not only in the unstable status of Rebecca's body but also by Maurier's construction of a writing persona which, in flight from the feminine and the corporeal, embraces the masculine and the disembodied.

Like those of the vampiric body, the status and whereabouts of Rebecca's corpse are problematic. When her boat is raised and a body is found in it, doubt is cast upon the identity of the body in the crypt. Rebecca's body – to use Tania Modleski's words – 'becomes the site of a bizarre fort/da game'[5] (Modleski 1988: 49). What Anne Williams describes as 'that intensely Gothic phenomenon, the sight of a worm-eaten corpse' (Williams 1995: 73), is denied the reader: instead, various characters present us with vivid but different narratives of watery disintegration. So Rebecca's corpse is 'absent' for much of the novel yet remains insistently and disturbingly present in the imaginations of these characters – just as her absent body remains insistently 'alive' for the narrator, whose continual association of Rebecca with the blood-red rhododendrons and headily scented azaleas of the Manderley estate evokes a charismatic female sexual presence for both

herself and the reader. Yet the narrator's final thoughts on Rebecca's body link it not with water, but with dust:

> Ashes to ashes. Dust to dust. It seemed to me that Rebecca had no reality any more. She had crumbled away when they had found her on the cabin floor. It was not Rebecca who was lying in the crypt, it was dust. Only dust. (du Maurier [1938] 1992: 334)

Thus Rebecca's 'second' burial (which seeks literally to encrypt her ungovernable force) is associated with the end of Dracula, whose body crumbles to dust at the moment of death: 'It was like a miracle, but before our very eyes, and almost in the drawing of a breath, the whole body crumbled into dust and passed from our sight' (Stoker [1897] 1993: 484). The apparent finality of Rebecca's burial, however, is undercut by an earlier incident in which the narrator thought she had 'finally' destroyed Rebecca's writing (the inscription in the book of poems), only to find it resurfacing again and again at Manderley. The 'dust' that is Rebecca's body is no more final than the 'feathers of dust' of the burned fly-leaf or the ash scattered by the 'salt wind' of the novel's final line. Like the vampire, Rebecca seems able to reconstitute herself endlessly and, like the vampire, her corporeal status is unstable: she is neither visibly a body nor visibly a corpse.

Rebecca is also associated throughout the novel with several characteristics which, according to Ernest Jones, traditionally denote the vampiric body: facial pallor, plentiful hair and voracious sexual appetite (Jones [1991] 1992: 409). And like the vampire, she has to be 'killed' more than once: the plot's excessive, triple killing of Rebecca (she was shot; she had cancer; she drowned) echoes the folk belief that vampires must be 'killed' three times. Although Rebecca lacks the requisite fangs and only metaphorically sucks men dry, she can none the less be placed within Christopher Frayling's second category of vampires, that of the Fatal Woman who, according to Frayling, 'altered the whole direction of the vampire tale' from the mid-nineteenth century onwards: 'sexually aware, and sexually dominant … attractive and repellent at the same time', she is clearly symptomatic of a cultural anxiety concerning adult female sexuality (Frayling [1991] 1992: 68, 71–2). Seen in this light, Rebecca's literary lineage includes Prosper Mérimée's Carmen, Poe's Berenice, Gauthier's Clarimonde and Le Fanu's Countess Carmilla – not forgetting, of course, Charlotte Brontë's Bertha Mason, described in Chapter 25 of *Jane Eyre* as 'the foul German spectre – the Vampyre'. Rebecca may,

then, be read not only as vamp but also as vampire: she is a clear descendant of the female demon lover who transmuted into the female vampire in mid- to late Victorian Gothic texts and into the vamp in twentieth-century cinema.

Like all vampire figures, Rebecca is associated with a transgressive, polymorphous sexuality. She is also, like all vampire figures, a figure of abjection. Recent critics of the Gothic have used Julia Kristeva's *Powers of Horror: An Essay on Abjection* ([1980] 1982) to explore how representations of the abject in certain texts relate to certain discourses and cultural values at a particular historical moment.[6] Kristeva's concept of the abject thereby becomes a concept which enables them to define how shared constructions of 'otherness' are predicated upon shared cultural values at specific times: by this logic, you may know a culture by what it 'throws off' or 'abjects'. But the figure of abjection in a *Gothic* text may, of course, be presented as simultaneously repellent *and* charismatic, thus allowing the reader to indulge in a transgressive redefinition of 'self'. This 'other' is also invariably the focus of more than one cultural anxiety and may therefore act as a vehicle of abjection in several ways. It is not surprising, then, to find that the sexual threat represented by Rebecca as 'vamp' is further inflected by the text's association of her with vampirism and 'Jewishness'. Rebecca was supposedly based on Jan Ricardo who was engaged to Major 'Boy' Browning before his marriage to du Maurier; she was a 'dark-haired, rather exotic young woman, beautiful but highly-strung', according to Margaret Forster (Forster 1993: 91). However, du Maurier's presentation of Maxim's first wife as a dangerous and beautiful dark-haired woman with an Hebraic name might well have been unconsciously influenced by the air of anti-semitisim prevalent in Europe during the 1930s. In this context, it is perhaps worth noting that David Selznick, the producer of Hitchcock's film version of *Rebecca*, is reputed to have had misgivings about the film's title, commenting that it would not do 'unless it was made for the Palestine market' (Shallcross [1991] 1993: 69–70). As both Ken Gelder and Judith Halberstam have noted, the nineteenth-century vampire was often portrayed as having Jewish characteristics – the physical appearance, the often perverse desires and the unrooted, wandering nature of 'the Jew' (as then constructed) all being projected onto the vampire (Gelder 1994: 13–17; Halberstam 1995a: 86–106). Indeed, Judith Halberstam argues that 'the nineteenth-century discourse of anti-Semitism and the myth of the vampire share a kind of Gothic

economy in their ability to condense many monstrous traits into one body' (Halberstam 1995a: 88). Many anxieties are written on the body of Rebecca, including that of the woman author whose social identity is transgressively inflected by her writing identity.

For it is Rebecca's signature and handwriting which constitute the metonymic representation of her body throughout the text, indelibly inscribing her presence. Certainly the semiotic of her script complicates our perception of her function in the novel. On the one hand, her writing – as we see it, for example, in the loving dedication to 'Max' and in the contents of the morning-room desk – is proof of her ability, during her life, to play an allotted role within the realm of 'everyday legality' and to masquerade effectively as a country-house hostess. Rebecca's writing initially appears to tell the tale of an ideal wife, loving towards her husband and the perfect hostess for his elegant country mansion. However, the script itself, which continually irrupts into the text, tells a different story, since it is also associated with a masculine strength and an indelible authority; as such it indicates a wayward, wilful quality that runs counter to Maxim's idea of the good wife. Moreover, it is sharply differentiated from that of the narrator who describes her own handwriting as 'cramped and unformed' (du Maurier [1938] 1992: 93) with all the intimations of immaturity and social inhibition that this suggests. This narrator connects Rebecca's 'curious', 'sloping' or 'slanting' script with a vibrant vitality: 'How alive her writing though, how full of force' (62). Always Rebecca's handwriting suggests supreme confidence and knowledge. In particular, the capital letter 'R', embroidered on the handkerchief the narrator finds in Rebecca's mackintosh and on Rebecca's night-dress case, takes on a runic force which derives from its powerful visual impact and its refusal to be destroyed. In this novel Rebecca surfaces most clearly through her signature, which uncannily inscribes the body's presence despite its absence through death. Above all, it is her autonomous energy, implicit in Rebecca's handwriting, which impresses itself on both the narrator and the reader. Thus, there is a duality in Rebecca's script, which seems to tell one story but which gives the lie to it in the actual appearance of the writing itself. The activity of writing is thereby seen to be implicated in the production of sexual subjectivity.

Yet, despite her accentuated difference from Rebecca, it is the timid and nameless young second wife who has been transformed into the older, wiser narrator of Rebecca's story. She has become

empowered to do this, however, only by modifying her perception of Rebecca as 'other' and assimilating her autonomy. Her initial attempts to exorcise Rebecca's presence, through, for example, burning the fly-leaf in Maxim's book which contains her signature, are doomed to failure. Instead, what we see in the novel is a gradual identification between the narrator and Rebecca, quite literally enacted in the Manderley Ball scene when the narrator's appearance as Maxim's ancestress, Caroline de Winter, seems to raise Rebecca from the dead (even Maxim's sister, sensible Beatrice, says 'You stood there on the stairs, and for one ghastly moment I thought ... ' (225). Indeed, we learn at the beginning of the novel that the (now older) narrator *has* finally acquired the confidence for which she envied Rebecca as a young woman: 'and confidence is a quality I prize, although it has come to me a little late in the day' (13). The conclusion must be that only with Rebecca 'really' dead can she write Rebecca's story, although it is only *through* Rebecca that she can write. Significantly, then, in the final dream of a novel haunted by disturbing dreams the narrator finds herself writing *as* Rebecca:

> I was writing letters in the morning-room. I was sending out invitations. I wrote them all myself with a thick black pen. But when I looked down to see what I had written it was not my small square handwriting at all, it was long, and slanting, with curious pointed strokes. I pushed the cards away from the blotter and hid them. I got up and went to the looking-glass. A face stared back at me that was not my own. It was very pale, very lovely, framed in a cloud of dark hair. The eyes narrowed and smiled. The lips parted. The face in the glass stared back at me and laughed. And I saw then that she was sitting on a chair before the dressing-table in her bedroom and Maxim was brushing her hair. He held her hair in his hands, and as he brushed it he wound it slowly into a thick rope. It twisted like a snake, and he took hold of it with both hands and smiled at Rebecca and put it round his neck.
> 'No', I screamed. 'No. no ... '. (395–6)

Whereas the firing of Manderley reminds us of the burning of Thornfield and of a work which finally eliminates the 'other' woman, this dream perpetuates the psychic disruption which Rebecca signifies. Although the narrator harbours a distrust and fear of Rebecca's sexuality, communicated by the snake image,[7] the dream also reveals her unconscious identification *with* it. For much of the novel she has consciously wished to be the model wife and hostess she believed Rebecca to have been; yet the mirror image of the dream signals a fur-

ther desire for identification with Rebecca's sexual and *textual* charisma.

This is because Rebecca, despite – or because of – her corporeal absence, embodies a dynamic multivalent alterity for the nameless narrator: she is adulteress, lesbian, bisexual, vampire, Jew. The fact that Rebecca's body shows traces of both Jewishness and vampirism indicates the essentially Gothic quality of the novel; for in the Gothic text perverse sexuality, as Judith Halberstam (citing Sander Gilman) notes, is inevitably 'ascribed to the sexuality of the Other' (Halberstam 1995: 68). In assimilating both psychological and corporeal aspects of Rebecca, the narrator implicitly rejects the social categorisations which separate the 'bad' from the 'good' woman. Furthermore, in absorbing the 'disembodied spirit' of Maxim's first wife, the narrator comes to embody aspects of Rebecca's power and self-confidence. Above all, she writes, and with the maturity and adult sexual identity implied by Rebecca's 'bold, slanting hand' rather than with the childish ingenuousness of her former self. Her signature and her text are thus haunted by that of another.

However, that phrase we have just used, 'disembodied spirit', is taken not from the novel, but from letters written by du Maurier in the 1940s. Here we wish to link the issue of Rebecca's signature and corporeal identity *within* the text with that of du Maurier as author *of* the text. As Margaret Forster's biography has revealed, Daphne du Maurier seemed to follow the lifestyle expected of women of her class, yet such conformity hid several unconventional relationships and a complex and conflicted sense of identity (Forster 1993). Furthermore, in spite of living an apparently happy life as wife, mother and successful novelist, du Maurier experienced a great deal of anxiety and ambivalence concerning her identity as a woman writer. For much of the time she felt that part of herself was a 'disembodied spirit', a phrase she uses in two separate letters to Ellen Doubleday, wife of her American publisher, Nelson Doubleday. She uses it first in a letter dated December 1947, which is written in a parodic fairy-tale manner, to describe what we would now call a sense of split subjectivity:

> And then the boy realised he had to grow up and not be a boy any longer, so he turned into a girl, and not an unattractive one at that, and the boy was locked in a box forever. D. du M. wrote her books, and had young men, and later a husband, and children, and a lover, and life was sometimes lovely and sometimes rather sad, but when she found Menabilly and lived in it alone, she opened up the box sometimes and let the phan-

tom, who was neither girl nor boy but disembodied spirit, dance in the evening when there was no one to see. (Forster 1993: 222)

In a letter written to Ellen almost a year later in September 1948, reflecting on her husband's reliance on her money-earning capacity as a best-selling novelist, she uses the phrase in a slightly different way:

> I mean, really, women should not have careers. It's people like me who have careers who really have bitched up the old relationship between men and women. Women ought to be soft and gentle and dependent. Disembodied spirits like myself are all *wrong*. (Forster 1993: 235)

In the first letter, she describes a masculine dimension of her being which, while 'locked' away, undergoes a metamorphosis into the 'disembodied spirit' which is androgynous and suggestive (to her) of a more authentic 'self'. Such a creative spirit, associated as it is in this letter with her life at Menabilly, is intrinsic to her life as a writer. However, the second letter suggests that while acknowledging her career as that of author, she felt ill at ease as a successful *woman* writer in the wider world; this is confirmed by another letter to Ellen Doubleday written in October 1948, in which she confesses to seeing her work as having given her a 'masculine approach to life' (Forster 1993: 232). Later, having become intrigued by the work of Jung and Adler during the winter of 1954, she explains her 'disembodied' self by reference to Jung's vocabulary of duality and identifies her writing persona as having sprung from a repressed 'No. 2' masculine side. In a letter to her seventeen-year-old daughter in the same year she explains, 'When I get madly boyish No. 2 is in charge, and then, after a bit, the situation is reversed … No. 2 can come to the surface and be helpful … he certainly has a lot to do with my writing' (Forster 1993: 276). Thus du Maurier came to perceive her *writing* identity as masculine. While such a 'disembodied spirit' was containable, while it could be put back in the box, it could do no harm; when, however, du Maurier perceived it as taking over – when she referred to *herself* as the 'disembodied spirit' – then she believed it to be socially destructive. Arguably, it was this anxiety concerning the 'Other' contained within the 'self' which gave Jung's work particular resonance for her. Du Maurier's creation of Rebecca as the narrator's transgressive double can also be seen, then, as a manifestation of an anxiety concerning writing, identity and gender.[8]

Interestingly, Forster's biography and Oriel Malet's *Letters from*

Menabilly (1993) provide evidence that in letters to friends du Maurier identified, at different points in her life, with both Rebecca and the narrator. For example, in a letter to Maureen Baker-Munton, written in 1957, du Maurier comments: 'I wrote as the second Mrs. de W. twenty-one years ago, with Rebecca a symbol of Jan. It could also be that ... I – in Moper's dark mind – can be the symbol of Rebecca. The cottage on the beach could be my hut. Rebecca's lovers could be my books' (Forster 1993: 424). In these letters quoted by Forster, the narrator tends to be linked with du Maurier's social, 'feminine' identity and Rebecca with her creative writing persona, that 'No. 2' masculine 'self'. As we have established, this sense of the writing self as masculine 'Other' can be seen in the inscription of Rebecca's 'masculine' energy through 'those curious, sloping letters' that continually surface in du Maurier's most famous novel, a text in which the transgressions of the 'Other' are both written on the body and embodied in the writing process itself. Du Maurier's letters suggest that, as she grew older, she moved towards seeing identity as something multiform and fissured, rather than unitary and coherent. Arguably, the writing process itself provided du Maurier with a way of manipulating such multiplicity and of harnessing the potentially destructive aspect of the 'Other' – as it does for the narrator of *Rebecca*. Rebecca's death within the plot suggests the containment of transgressive desire but her 'disembodied spirit', with all its divergent energies, continues to inform the writing process. We suggest, then, that Rebecca's power to haunt the modern imagination has much to do with her textual and cultural lineage. In creating her, du Maurier drew both on the Gothic tradition and on a broad cultural anxiety concerning the changing status of women in the late nineteenth and early twentieth centuries. For du Maurier, that anxiety was further inflected by the association of the writing woman with a transgressive female identity and this, too, finds expression in her most famous novel. Such anxieties manifest themselves in the way Rebecca's character dissolves some important boundary lines. Neither visibly a body nor visibly a corpse, she upsets the line between life and death; between eros and thanatos; between absence and presence; and between the two stereotypes – that of the asexual virgin-mother and that of the prostitute-vamp – which Andreas Huyssen sees as sustaining 'the myth of the dualistic nature of woman' (Huyssen 1986: 73). Rebecca also disrupts the dividing lines which separate the *femme fatale* from the vamp and the vamp from the female vampire.

This instability of meaning is emphasised by the Gothic nature of Rebecca's body. In addition, the suspended 'R' of her name and the quasi-illegible 'M' in her engagement diary, by constituting a semiotic of fragmentation and incompleteness within the text, indicate metonymically the mysterious uncertainty of her absence/presence. The materiality of Rebecca's signature further signals an anxiety concerning the relation between writing, autonomy and sexual identity. This can be seen as a textual trace of du Maurier's own anxiety about the relation between the 'sexed' body and the cultural construction of authorial identity as 'masculine'. There are, as Elizabeth Grosz has noted:

> ways in which the sexuality and corporeality of the subject leave their traces or marks on the texts produced ... The signature not only signs the text by a mark of authorial propriety, but also signs the subject as the product of writing itself, of textuality. (Grosz 1995: 23)

Just as du Maurier's use of the phrase 'disembodied spirit' in her letters indicates a bodily unease in occupying the authorial position, so Rebecca's uneasy status as both too fleshly (vamp) and too uncanny (vampire) reflects a cultural ambivalence towards the sexually expressive and autonomous woman. Such anxieties are condensed in the way that Rebecca's signature haunts the text; in this sense, writing itself is Gothic.

Notes

1 Even more recent essays on *Rebecca* continue to be heavily infuenced by Light's approach. See, for example, Janet Harbord 1996.
2 See, for example, Linda Ruth Williams's use of the terms as interchangeable (Williams 1993: 53, 56).
3 In this connection, see also Rebecca Stott 1992, especially Chapter 3 on *Dracula*.
4 The Carleton Television adaptation of the novel, shown in January 1997, portrayed Rebecca in this way, for example.
5 Modleski uses this phrase to describe the manner in which representations are played out on the narrator's body, but it is just as appropriate to describe the absence/presence of Rebecca's (dead) body.
6 For example, Gelder 1994 and Halberstam 1995 relate Gothic presentations of the abject to cultural constructions of 'Jewishness' in the late nineteenth and early twentieth centuries, whilst Warwick 1995 explores it in relation to the changing status of women during that period. See also Jerrold E. Hogle (1996) for an example of how textual representations of the abject reflect anxiety concerning changing class structures in early twentieth-century France.

7 The snake image is often associated with female vampires as in, for instance, Tieck's *Wake Not the Dead*, Coleridge's *Christabel*, Baudelaire's *Les Métamorphoses du Vampire* and (obliquely) Keats's *Lamia*.
8 For a fuller exploration of the connection between writing, identity, gender and du Maurier's use of the Gothic genre, see Avril Horner and Sue Zlosnik 1998.

References

Day, W.P. (1985) *In the Circles of Fear and Desire: A Study of Gothic Fantasy*, Chicago and London, University of Chicago Press.

Dijkstra, B. (1986) *Idols of Perversity: Fantasies of Feminine Evil in Fin de Siècle Culture*, New York and Oxford, Oxford University Press.

Doane, M.A. (1991) *Femmes Fatales: Feminism, Film Theory, Psychoanalysis*, New York and London, Routledge.

du Maurier, D. ([1938] 1992) *Rebecca*, London, Arrow.

—— ([1981] 1993) *The Rebecca Notebook and Other Memories*, London, Arrow.

Forster, M. (1993) *Daphne du Maurier*, London, Chatto and Windus.

Frayling, C. ([1991] 1992) *Vampyres: Lord Byron to Count Dracula*, London, Faber and Faber.

Gelder, K. (1994) *Reading the Vampire*, London and New York, Routledge.

Grosz, E. (1995) *Space, Time and Perversion: Essays on the Politics of Bodies*, New York and London, Routledge.

Halberstam, J. (1995) *Skin Shows: Gothic Horror and the Technology of Monsters*, Durham and London, Durham University Press.

Harbord, J. (1996) 'Between Identification and Desire: Rereading *Rebecca*', *Feminist Review*, 53, 95–106.

Hogle, J.E. (1996) 'The Gothic and the "Otherings" of Ascendant Culture: The Original *Phantom of the Opera*', *South Atlantic Quarterly*, 95 (3), 821–46.

Horner, A. and S. Zlosnik (1998) *Daphne du Maurier: Writing, Identity and the Gothic Imagination*, London, Macmillan.

Huyssen, A. (1986) *After the Great Divide: Modernism, Mass Culture, Postmodernism*, Bloomington and Indianapolis, Indiana University Press.

Jones, E. ([1991] 1992) 'On the Vampire', in C. Frayling, *Vampyres: Lord Byron to Count Dracula*, London, Faber and Faber.

Kristeva, J. ([1980] 1982) *Powers of Horror: An Essay on Abjection*, trans. Leon Roudiez, New York, Columbia University Press.

Ledger, S. and S. McCracken, (eds) (1995) *Cultural Politics at the Fin de Siècle*, Cambridge, Cambridge University Press.

Light, A. (1984) '"Returning to Manderley": Romance Fiction, Female Sexuality and Class', *Feminist Review*, 16.

—— (1991) *Forever England: Femininity, Literature and Conservatism Between the Wars*, London and New York, Routledge.

Malet, O. (ed.) (1993) *Daphne du Maurier: Letters from Menabilly*, London, Weidenfeld and Nicolson.

Massé, M.A. (1992) *In the Name of Love: Women, Masochism, and the Gothic*, Ithaca and London, Cornell University Press.

Modleski, T. (1988) *The Women Who Knew too Much: Hitchcock and Feminist Theory*, London and New York, Routledge.

Shallcross, M. ([1991] 1993) *The Private World of Daphne du Maurier*, London, Robson Books.

Stoker, B. ([1897] 1993) *Dracula*, Harmondsworth, Penguin.

Stott, R. (1992) *The Fabrication of the Late Victorian Femme Fatale: The Kiss of Death*, London, Macmillan.

Warwick, A. (1995) 'Vampires and the Empire: Fears and Fictions of the 1890s', in S. Ledger and S. McCracken (eds), *Cultural Politics at the Fin de Siècle*, Cambridge, Cambridge University Press.

Williams, A. (1995) *Art of Darkness: A Poetics of the Gothic*, Chicago and London, University of Chicago Press.

Williams, L.R. (1993) *Sex in the Head: Visions of Femininity and Film in D.H. Lawrence*, Hemel Hempstead, Harvester Wheatsheaf.

part five

SPIRITS, MYSTICS AND TRANSCENDENTS

16

MEMORY, IMAGINATION AND THE (M)OTHER:

an Irigarayan reading of Charlotte Brontë's *Villette*

SUE CHAPLIN

I intend here to employ Irigaray's analysis of materiality and mater-
nality within western discourse to explore how it is that the body
comes to matter in Charlotte Brontë's *Villette*. My reading will be
grounded theoretically first upon Irigaray's account of the way in
which the 'disembodied body' (Butler 1990: 49) of masculine reason
displaces the feminine and comes itself to matter in terms both of
acquiring significance and of substituting itself for matter as the
origin of all possible representation. I shall then engage with two
aspects of Irigaray's later work: first, her development and use of the
concepts of sensible transcendence and wonder, and secondly, her
strategic association of elements and experiences neglected by the
masculine economy and associated with the feminine.

Butler traces the association between materiality and femininity
to etymologies which link matter with the mother (mater) and the
womb (matrix). Irigaray theorises this association in terms of an era-
sure of the maternal/material here and now in favour of 'a beyond, a
future life … a transcendental realm where all ties to the world of sen-
sation have been severed' (Irigaray 1993: 13). It is not simply that fem-
ininity is linked with matter, masculinity with form. The opposition
between matter and form is founded upon an exclusion of the femi-
nine which renders it unintelligible and amounts, for Irigaray, to a
near-pathological denial of the feminine, a symbolic matricide. As an
antidote to this, Irigaray advocates the articulation of the difference
that this symbolic economy has sought to deny – sexual difference.
Women must cease to be used as a 'support for transcendence' (Kris-

teva 1986: 151), in a manner which alienates them from themselves, from the mother and from the divine. Flesh and blood must be injected into the symbolic order so as to shift emphasis from a God who transcends to one who 'lives with us here and now' (Irigaray 1993: 116). Such a shift will generate a *sensible* transcendence capable of embracing the material/maternal and of allowing men and women to contemplate the mystery each represents for the other. Such contemplation of material difference can only be accompanied by a sense of wonder currently reserved for the worship of an immaterial God. As a recognition of the irreducibility of one sex to the other, Irigarayan wonder has the potential to step into the space between flesh and spirit, mediating between the human and the divine:

> Who or what the other is I never know. But the other who is forever unknowable is the one who differs from me sexually. This feeling of surprise, astonishment and wonder in the face of the unknowable ought to be returned to its locus: that of sexual difference ... Into this place came greed, possession, consummation, disgust and so on. But not that wonder which beholds what it sees as if for the first time, never taking hold of the other as its object. (Irigaray 1993: 13)

A true articulation of sexual difference is possible only through the creation of a cultural grammar appropriate to women and it is in this context that Irigaray establishes a strategic nexus between fluidity, fire and femininity. She considers the privileging of solidity within scientific discourse as equivalent to the privileging of the phallic and the visual within philosophical discourse. Fluidity, when it is not altogether neglected, is analysed using inadequate theoretical tools in a manner analogous to the theorisation of woman within a discourse equipped only to speak of masculinity. Irigaray conveys this prioritisation of solidity in terms of the freezing over of the natural world whilst setting against so bleak a scenario depictions of the more positive influences of fire and water. I take her aim to be the creation of a conceptual framework within which privileged solid states are made to melt away under the influence of previously neglected elements, and her next step, the association of these elements with femininity, is in this context a positive one. It enables Irigaray to convey simultaneously the extent of woman's oppression and a sense of her potential once released from patriarchy's icy grip. Water represents not only the threat of drowning but the liberatory potential of that which flows free, or, for Irigaray, of the woman who will not be made 'a female

other of ice' (Irigaray 1991: 54): 'And what is that terror awaiting them in the shadow … That peril of water coming from sky and land? And that horror they feel for the sea when she sheds all masks and refuses to be calm, polite and submissive to the sailors' direction' (Irigaray 1991: 51). And what has the power to melt ice, releasing its fluid potential, but fire? Fire and water are therefore intimately linked to a powerful femininity which is not frozen solid but 'fluid and flaming, multiple and still too numerous for the pleasures of the eye' (Irigaray 1991: 46). Irigaray is not seeking to essentialise the feminine here but to equip women with a set of conceptual tools with which to articulate their own gendered identity. She is not saying that fluidity is a defining feature of femininity any more than solidity can be equated with the essence of man. Rather, she seeks to 'open up a crack' (Irigaray 1992: 191) in the discourse which established these oppositions in the first place. Her way of achieving this is to recover and articulate those aspects of experience denied or denigrated within the masculine economy and strategically to associate them with a feminine other, the 'other of the other' (Irigaray 1985: 169). It is a version of the Irigarayan other woman who, I shall argue, emerges at the heart of *Villette* in three guises; memory, imagination and the (m)other.

Villette explores two alternative modes of vision. There is that represented by Paul Emanuel which is based upon the phallic power of the gaze. It spies, scrutinises and objectifies. Then there is that which is tied to the self-development of Lucy Snowe, which is apparent for the first time as Lucy contemplates the sleeping Paulina at the end of Chapter 3. Lucy moves here from regarding Paulina merely as an entertaining spectacle to empathising with her, and thus Paulina becomes the first recipient within the novel of a non-exploitative female gaze. Henceforth, Lucy is less of a disciple of reason, less of a voyeur. Now, this alternative mode of vision, which is an imaginative, empathetic one, is central to the novel's metaphysical schema. It is upon this that I wish to focus by way of an analysis of a series of episodes whereby what might be termed a sensible transcendence occurs through the operation of female spiritual forces and their collaboration with the novel's female characters. I will begin with the exchange between Lucy and Miss Marchmont that takes place in Chapter 4.

Employed at this stage of her life as companion to an elderly woman, Lucy in fact acts as both mother and daughter to Miss Marchmont. She mothers her in the sense of attending to her physical needs

whilst Miss Marchmont scolds her 'like an irascible mother' (Brontë [1853] 1993: 34). However, Lucy also acts as a spiritual mother, facilitating Miss Marchmont's reunion with Frank by enabling her to reveal the truth about her past. She listens in silence as Miss Marchmont recounts her tale and, through memory, closes the gap between past and present. Memory is personified as a profoundly benign feminine force which take the place of God as the bringer of hope and tranquillity at the moment of death: 'She is just now giving me a deep delight; she is bringing back to my heart in warm and beautiful life, realities and not mere empty ideas' (36). Thanks, then, to memory, and also to Lucy, who takes the place of the priest as mediator between Miss Marchmont and this spiritual force, the lovers' reunion is not postponed to the hereafter according to the will of an 'inscrutable God' (37). Miss Marchmont feels Frank's presence as a physical reality as the past comes to her with full force in the here and now.

It may be objected, however, that Miss Marchmont's death prohibits a positive interpretation of this reunion and even that it demands a pessimistic view of the culmination of Lucy's own story, given the parallels between them. There is, though, one fundamental difference between the fate of Lucy and that of Miss Marchmont. I shall argue that Lucy's narrative ends with a repudiation of bad faith. The same cannot be said of that of Miss Marchmont. She has devoted herself to the service of a man she evidently regards as her superior, and her self-deprecating adoration resembles that of other women in the novel who attempt to freeze themselves into an acceptable feminine role. Such bad faith may explain why ice emerges as the dominant material element throughout this passage. Ice is associated elsewhere in the novel with negative aspects of femininity, with the character Irigaray would term 'the daughter of the father alone' (Irigaray 1991: 101).

I wish to shift emphasis now so as to consolidate my argument as to the significance of female spiritual influence by considering the consequence of its absence. The consequence, I hope to show, is 'dereliction' (Irigaray 1985: 195). For Lucy, the absence of female support occasions spiritual and physical crises, the first of which occurs during her summer-long isolation at Labbassecoeur. Initially, the mothering role Lucy fulfils in relation to the disabled girl prevents her from sinking into absolute despair. Upon the girl's departure, however, Lucy succumbs to a profound sense of alienation akin to the des-

olation associated within the Christian tradition with the alienation of the soul from God. She suffers a dream in which she meets her dead family 'elsewhere, alienated' and which provokes 'an unutterable sense of despair' (Brontë [1853] 1993: 156). In desperation, she turns to the Catholic church, only to acknowledge ultimately that it can be no mother substitute. It is the antithesis of the female spiritual domain which prevails upon the eradication of the chief representative of patriarchal authority, Paul Emanuel. Instead of helping Lucy to progress, it flings her 'headlong down an abyss' (160), for she seeks salvation here according to a belief system which rips apart flesh from spirit, identifying the latter with God and the former with materiality and femininity. She seeks to embrace a theology concerned only with 'the ethical journey of man' (Irigaray 1993: 199), one which postpones confrontation with the divine to an unattainable hereafter. True salvation in this novel depends upon a reconciliation of flesh with spirit and at this moment of crisis it arrives in the form of Lucy's g(o)odmother, Mrs Bretton.

Lucy's reawakening within the Bretton household is characterised by a merging of past and present as memory operates to reveal to Lucy her whereabouts and to renew her association with her first good mother. We are reminded that 'time always flowed smoothly' (Brontë [1853] 1993: 4) for Lucy when with her godmother; it is not 'frozen into blocks, past, present, yet to come' (Irigaray 1992: 90). Mrs Bretton, unlike her son, recognises Lucy, forging links between past and present to which Graham is blind. Moreover, contrary to what Graham imagines, her influence upon Lucy is as rejuvenating as a 'living stream' (Brontë [1853] 1993: 160) and her association with the theme of female salvation is unequivocally affirmed by the philosophical meditations which follow.

Chapter 17 opens with a meditation upon the inward struggle of the individual to thwart passion. It employs the language and imagery of the Christian tradition and contrasts sharply with passages elsewhere which explore the operation of feminine forces. Such forces here are either absent or ineffectual. Memory is denied her power of preserving the past and reviving it in the present, since 'dust kindling to brief, suffering life may meanwhile perish out of memory again and yet again' (175). The name of God is continually invoked, the salvation he offers associated not with a 'living stream' but with a stagnant pool around which 'thousands lie ... weeping and despairing' (175). It is a pathological vision dependent upon the violent sep-

aration of flesh from spirit and it calls to mind Lucy's own vision of the afterlife during her breakdown, namely the dream of her family 'elsewhere, alienated'. This is the desolate 'elsewhere' of the Christian tradition, the contemplation of which leaves Lucy with a 'trembling weakness' (176) which it is for Mrs Bretton to alleviate.

The necessity of leaving Mrs Bretton brings Lucy again to meditate upon the struggle between reason and imagination and the possibility of salvation. Before leaving the Bretton household, Lucy undergoes a dialogue with Reason, personified as a monstrous female who demands self-denial and sacrifice. This is a man-made woman, another 'forewoman of patriarchy' (Millett 1977: 142) and, as Lucy's own attempts to define herself in terms of rationality falter, Reason is deemed a 'hag', as 'vindictive as a devil' (Brontë [1853] 1993: 224). Moreover, she is associated with death, infertility and ice, reinforcing the notion that she is a man's woman in the Irigarayan sense. Instead of flowing free, Reason is frozen solid, 'chill … barren … icy' (224). Against Reason, Lucy sets Imagination, whose appearance at this moment is conceived of almost in terms of a second coming. Hers is a world 'whose day needs no sun to light it' (225). The light of reason is no longer the guarantee of truth nor the male gaze a paradigm for knowledge. Neither is there any glorification of solidity. Her dwelling is without physical boundaries of any kind, 'too wide for walls, too high for dome, whose floors are pure space' (225). Now, Irigaray stresses the need for a feminine conceptualisation of space so as to challenge the rigidification and limitation of the male symbolic economy. Imagination opens up such a space here, emerging as a good mother to replace God the father at this moment of crisis. She creates a safe place for Lucy's occupation and salvation.

The spiritual otherness of imagination as compared to reason interestingly finds its physical equivalent shortly after this meditation in the performance of Vashti. Unlike the Cleopatra painting, to which Lucy makes disparaging reference here, Vashti is not the embodiment of male fantasy but a terrifying female other. She is the fire goddess with the power to release the fluid potential of an otherwise frozen femininity by way of 'a fierce light, not solar – it disclosed power like a deep, swollen winter river' (253). The emphasis upon a 'light not solar' recalls a feminine imagination 'whose day needs no sun to light it'. It is evidence that Vashti stands outside of a male economy which she challenges to the extent almost of burning down its house of culture. Like the Irigarayan other woman, she is at once 'horrible' and

'marvellous' (251). She is the embodiment of imagination in whom female experience and female spirituality unite.

The chain of events which ends with the death of Paul Emanuel begins with a meditation which unites metaphysics with experience in a different fashion. The passage opening Chapter 38 finds Lucy again dwelling upon 'the will of an inscrutable God' (37). Her musings are imbued with an oppressive sense of the power of an unknowable God towards whom the believer must strive in absolute ignorance of his fate, and it is evident that this vision of a God who will have his way 'whether we humble ourselves to resignation or not' (427) is not one which Lucy can sincerely embrace. When she seeks to convey something of his mercy, she can only have recourse to the words of others: 'For staff we have His promise, whose "word is tried, whose way perfect". For present hope, His providence, "who gives the shield of salvation, whose gentleness makes great". For final home, his bosom, who "dwells in the height of heaven"' (427). Lucy appears to be miming faith. Her response to the Christian notion of salvation lacks all of the passionate intensity of her response to the power of imagination. Finally, the passage marries the metaphysical to the real via the figure of Paul Emanuel. His association with an 'inscrutable God' is affirmed as Lucy turns to the scene in the classroom where the pupils await Paul as if awaiting the second coming: 'We were all assembled in class awaiting the lesson of literature. The hour was come. We awaited the master' (427). Ironically, Paul is preparing for the journey which will end in his death and open up the possibility of an alternative to the alienating religion with which Lucy struggles, and fails, to come to terms.

The death of Paul Emanuel may be interpreted as a symbolic act of patricide, removing from the novel its dominant father figure and replacing his authority with feminine influence, both physical and spiritual. In support of this view, I would argue that it is impossible to regard Paul as anything other than an authoritarian figure whose effect upon Lucy is pernicious. Her inclination to speak more kindly of him in the latter half of the novel is, I believe, no more than her attempt to sugar the bitter pill he offers to her. Desperate for companionship, she accepts the advances of a man who rarely ceases to infantilise and objectify her and whom she describes repeatedly as a despot, a tyrant and an autocrat. Her desire for affection as her female companions move away from her encourages her to sacrifice herself to Paul in a manner analogous to her search for his God at moments

of spiritual crisis. She submits herself to his judgemental gaze, begging 'am I pleasant to look at? … do I displease your eyes much?' (471). No longer concerned to 'act to please herself' (138), Lucy teeters on the edge of bad faith.

Kathryn Bond Stockton's Irigarayan reading of *Villette* interprets Paul's disappearance as the 'deferral built into a betrothal to Christ' which leaves Lucy 'focussed on a brink' (Stockton 1994: 105, 107), longing for his return. My own Irigarayan approach places the emphasis elsewhere. Describing the conventional relationship between men and women, Irigaray asserts that 'their wedding is always being put off to a beyond' (Irigaray 1993: 15) as a consequence of the separation of flesh from spirit. Now, in a sense, the wedding of Lucy and Paul is 'put off to a beyond' by Paul's disappearance and the novel may thus appear to endorse that separation between the here and now and the hereafter to which Stockton refers. Yet there is an alternative 'beyond' conceived of in this novel through the operation of memory and imagination. These spiritual mothers enable Lucy to make sense of her life through the telling of her story and ultimately to cherish in memory a vision of Paul dearer to her than the flesh and blood reality of the man ever was: 'I thought I loved him when he went away; I love him more now, in another degree; he is more my own' (Brontë [1853] 1993: 483). There is reason to suppose that, as Lucy makes this assertion, she feels, not bitterness, but contentment. She is an elderly woman whose hair is 'at last, white' (42), suggesting that old age has brought a degree of comfort to her, that perhaps she is no longer tossed from reason to feeling and back again. Lucy succeeds where, to varying degrees, the novel's other women fail. She lives free of the need to ask constantly whether she is pleasing to the Eye/I of man. Furthermore, to recall the episode between Lucy and Miss Marchmont, there is a sense in which the reader takes the place of Lucy at the end of her narrative. Imitating Lucy's silent attention to Miss Marchmont's tale, the reader mediates between Lucy and the forces of memory and imagination and is thus drawn into an economy which finally repudiates the authority of man and his insensible God.

Villette, then, may be said to free the masculine conception of materiality 'from its metaphysical lodgings' (Butler 1990: 30) by offering a vision of a symbolic order central to which is a feminine spirituality rooted in the body. Memory and imagination are spiritual (m)others operating within the physical realm through the facilitation

of alliances between women, the telling of their stories and acts of remembrance which unsettle the opposition between (female) flesh and (male) spirit. There is therefore a sense in which Brontë initiates in *Villette* 'new possibilities, new ways for bodies to matter' (Butler 1990: 30).

References

Brontë, C. ([1853] 1993) *Villette*, London, Everyman.
Butler, J. (1990) *Bodies That Matter: On the Discursive Limits of 'Sex'*, London and New York, Routledge.
Irigaray, L. (1985) *Speculum of the Other Woman*, New York, Columbia University Press.
—— (1991) *Marine Lover*, New York, Columbia University Press.
—— (1992) *Elemental Passions*, London, Athlone Press.
—— (1993) *An Ethics Of Sexual Difference*, London, Athlone Press.
Kristeva, J. (1986) 'Of Chinese Women', in T. Moi (ed.), *The Kristeva Reader*, Oxford, Blackwell.
Millett, K. (1977) *Sexual Politics*, London, Virago.
Stockton, K.B. (1994) *God Between Their Lips: Desire Between Women in Irigaray, Eliot and Brontë*, Stanford, Stanford University Press.

17

THE LESBIAN CHRIST:
body politics in Hélène Cixous's
Le Livre de Promethea

VAL GOUGH

Postmodernism's search for new ways of thinking has involved an unexpectedly religious or spiritual thematics, and in a radical rethinking of otherness, or alterity, postmodernist theorists like Jacques Derrida, Jean Baudrillard, Julia Kristeva and Luce Irigaray have all in their different ways found mystical or spiritual discourses congenial. Such thinkers share a sense of the urgent need to rethink alterity, and to formulate a new discourse of ethics and politics which takes account of the radical deconstruction of the subject, yet remains insistent upon the bodily dimension. This search for a postmodern ethics has led to a fascination with what Nietzsche called 'divine ways of thinking', a form of deconstructive practice with spiritual implications, or what has more recently been termed 'a/theology' (Taylor 1984). The so-called 'French feminist' Hélène Cixous shares this fascination, and as a postmodernist thinker who is first and foremost an experimental writer, Cixous offers us a new and poeticised form of feminist a/theology.

Cixous's continuing literary project (numerous novels and several plays) is always intensely allusive, overdetermined and emphatically intertextual. Allusions to ancient and modern religious discourses of both east and west support Cixous's consistent aim to depict texts and bodies as sacred and redemptive. Thus the Bible, the Egyptian Book of the Dead, Jewish midrashim and medieval Christian mysticism all provide nourishment for Cixous's richly allusive feminist a/theology, a discourse which plunders the imagery of various religious traditions whilst deconstructing the theist principles that, by and large, underlie them. Here, I intend to examine Cixous's

particular rapport with the discourses of medieval Christian mysticism, and more precisely, the way in which Cixous uses the medieval mystic's intensely embodied desire for God as a model for a contemporary form of subversive lesbian desire.

When seen through the postmodern lens of a theorist like Michel de Certeau, medieval mysticism offers examples of 'divine ways of thinking' which resonate suggestively with Cixous's own literary project. The essence of medieval mysticism, says de Certeau, lay not in a body of doctrines (which was the effect of theological interpretations) but in a *style* of practice (both bodily and textual), a *modus loquendi* and *modus agendi*. Specifically, discursive and bodily procedures constructed or presupposed a 'new space, with new mechanisms' (de Certeau 1986: 81). Thus mystic texts inscribed, through a set of procedures, a characteristic attitude to language: an impulse to 'go beyond' via language coupled with a recognition that language can 'say' the absolute only by erasing itself, endlessly. These texts, says de Certeau, 'exhaust themselves in the effort to say it', producing 'endless narrativity' (de Certeau 1986: 82). Such comments resonate suggestively with the writings of Cixous, whose work on the subversive effects of 'style' is infamous, and whose texts, particularly her early fiction, have a tendency to exhaust the reader through textual excess. Further, the mystics' treatment of the divine as an other which 'organises the text [but] is not (t)exterior ... not an (imaginary) object distinguishable from the movement by which it is traced' (de Certeau 1986: 82) correlates with Cixous's work on alterity as an effect of language and an excess of / to language. Just as the mystic seeks, through ascetic practices and contemplation, to clear a space in the soul for God, Cixous speaks of clearing a space for the other. Like the mystic who, says de Certeau, engages in a '"science ... of the things of the other life" – a heterology' (de Certeau 1986: 93), Cixous depicts the encounter with alterity as a process of patient, detailed and respectful observation, as 'a work of indescribable mathematicity' (quoted in Sellers 1988: 121). And just as mystic speech is the speech of the other – the mystic text is the empty place where the divine other speaks – Cixous sees herself as a 'scribe' of alterity, often describing herself as writing automatically or inspired by dreams.

Whilst Cixous never directly appropriates the writings of any medieval mystics, her work – especially her experimental fiction – consistently manifests a fascination with the grammatological potentials of the discourses of medieval mysticism, implicitly viewing

apophatic or 'negative' forms of mysticism – such as that of Meister Eckhart – as a form of deconstruction *avant la lettre*. But as a writer intensely interested in gender difference, Cixous is also drawn to the less abstract, more bodily and affective mysticism of female mystics like St Teresa of Avila. Cixous has explicitly challenged the Lacanian version of corporeal female mystic ecstasy as a *jouissance* 'beyond the phallus' (that is, unspeakable and unknowable), arguing for the possibility of a mystical, feminine, *bodily* knowledge of alterity: 'St Teresa of Avila, that madwoman who knew a lot more than all the men' (Cixous 1986: 99). St Teresa's embodied mysticism is characteristic of a period whose sometimes extravagant attention to flesh and decay was not so much a flight from the body as an immersion in it, according to medieval scholar Caroline Walker Bynum (Walker Bynum 1995: 14–15). For a religion whose central tenet was that the divine had chosen to offer redemption by becoming flesh, the flesh was seen as nothing less than an instrument of salvation. Medieval Christian piety could be characterised by a radical physicality which produced genuinely new somatic events such as stigmata (Walker Bynum 1995: 15). As we shall see, the implications of such an incarnational theology resonate suggestively with Cixous's pledge to produce an embodied, incarnational form of writing: to inscribe the word made flesh and the flesh made word.

Cixous's commitment to 'divine ways' of (re)thinking the body has been infinitely enriched by her encounter with the Brazilian writer Clarice Lispector, whose writing is also suffused with mystical themes and vocabulary. For Cixous, Lispector is the 'Brazilian saint of writing' (Cixous 1991: 36), a writer who attends above all to what Cixous calls the 'mystery' of alterity. Most particularly, Lispector depicts the bodily dimensions of the encounter with an other that is often abject: a beggar, a cockroach. In her writings on Lispector, Cixous has expressed her profound admiration for a writer who conceives of the encounter with alterity as a form of equivalence: 'Clarice's ultimate project is to make the other human subject appear equal to – and this is positive – the cockroach' (Cixous 1988: 30). In Lispector's novel *The Passion According to G.H.*, Lispector depicts a housewife's epiphanic encounter with a cockroach in her kitchen, an encounter which rejects eucharistic bodily assimilation (G.H. tries to eat some of the inner matter of the cockroach, but then vomits) in favour of a form of mystic bodily equivalence. G.H. identifies – body and soul – with the abject other, the cockroach, in a manner that

recalls the medieval mystic's practice in *imitatio Christi* of identifying intensely with the bodily sufferings (the Passion) of Christ on the Cross. In the middle ages, this *imitatio* became, in its extreme forms, a literal experiencing of the same. As Jennifer Ash says, 'The body of the worshipper, the mimic, would be inscribed with the pain and suffering of Christ's dying body: the stigmatised body of the worshipper would be marked in total identification with the body of the Divine Other, would participate in the hol(e)y wounding of (a) grand Passion' (Ash 1990: 92). Lispector's allusions to mystic *imitatio* recur in her short story 'The Imitation of the Rose', which also evokes the mystical text by Thomas à Kempis, *The Imitation of Christ*. The story depicts a housewife's rebellion against domestic responsibilities through bodily identification, to the point of psychosis or mystical ecstasy, with a bunch of roses.

Cixous repeats this motif of mystical bodily identification in one of her fictional tributes to Lispector, *Vivre L'orange* (1989). Here, the semi-autobiographical narrator meditates upon alterity in numerous varied forms – an orange in a fruit bowl, a veiled woman of Iran, a rose – and engages in bodily *imitatio* with them: 'When the telephone rang, I was alive in the moment, I had orange all over, the peaceful light running orange before my windows was my philosophical joy, I was humid, my skin young, sweet, under the ever first rays of the fruit' (Cixous 1989: 20). A concomitant textual equivalence is created through homologies, intricate correspondences between signifiers which come to stand for each other as well as themselves. Thus a rose is literally a rose and also metaphorically a woman writer, a veiled Iranian woman, an Eckhartian mystic rose 'without why', and a generalised form of alterity incarnate.

Yet the problem in *Vivre L'orange* is that Cixous's semi-mystical reconfiguration of the self's relation to alterity gives the impression of being hopelessly utopian, for it seems to exclude power dynamics or hierarchies of any sort. Equivalence seems to connote equality, thus excluding altogether the issue of power from the question of alterity. Despite the narrator's insistence that we remember the horrors generated by the oppressions of the real world even as we meditate upon alterity, the realm of the political *feels* neglected in the novel. What has most textual impact is not the cadavers, the gas-chambers, or even the women of Iran – all of which the novel mentions – but the roses, the oranges, above all the poetic beauty of the language itself. In structuring the self's relation to alterity as a form of mystic *imitatio*, Cixous

is led in *Vivre L'orange* to envisage a rose-tinted utopian realm whose conception evades questions of power altogether. Ultimately, the personal and the political remain separate spheres in the novel, and this makes the political impact of the narrator's meditations upon alterity very limited indeed. However, I would argue that in her later text *Le Livre de Promethea* (1983), Cixous employs the motif of mystic *imitatio* more successfully, in a depiction of lesbian desire which no longer evacuates power from the self–other relation. Power imbalances and the violence they necessarily involve are no longer stripped away in the writing process, as the novel maps out a new territory of subversive, disturbing lesbian bodily desire.

Cixous's attitudes towards lesbianism have not always been congenial to lesbian-feminists. At the Second Sex conference in New York in 1979, Cixous took a stand against the words 'feminism' and 'lesbian', claiming that they had negative connotations of 'phallocentrism' in France, and Monique Wittig cried out 'What France? This is a scandal!' (Wenzel 1981: 268). Hence it is unlikely that Cixous would employ the label 'lesbian' to describe the relationship depicted in *Le Livre de Promethea*. But nevertheless, I would like to claim the novel as a courageous celebration of a subversive, risky form of lesbian desire, in its depiction of an intensely erotic female relationship, whose power dynamics and violent aspects in no way impede the redemptive function of that relationship.

When Promethea says to her lover, H., 'I want to be your slave your queen' (Cixous 1991: 89), this implies that power imbalances, not equality, form the core of this relationship. The emphatically embodied love between H. (who functions as the narrator) and Promethea is conveyed by recalling, in a complex web of allusions, the intensely embodied desire of the medieval female mystic for Christ. Through a series of metaphors, Promethea is depicted as Christ-like, as Parousia or the Second Coming (as well as like Prometheus, of course). She is described by the narrator as 'the astounding Present given me by God' (Cixous 1991: 91), who puts her in 'strange Christian moods'. And by stating that 'I want to write the Imitation of Promethea' (49), the narrator implicitly evokes medieval *imitatio Christi* and its intense corporal identification with the bodily suffering (the Passion) of Christ on the Cross. Violent scenes depicting Promethea and H. engaged in literal/metaphoric mutual wounding recall the self-wounding of those mystics involved in *imitatio* as they 'imitated' or re-experienced Christ's wounds and Christ's bodily pain. H. suffers

literal/metaphorical wounds that function as the means by which body boundaries are troubled and transgressed: 'A need to place my body in front of yours to fend off the spears, a need to wound you, to plunge a blade into your adored belly while shrieking in pain' (66). When Promethea is vaccinated, H. relives in her own body the penetration of Promethea's body by the needle:

> suddenly turned around, the needle, stuck straight into my breast ... I tear it from my breast, there is someone I would like to stab ... there is someone who stabs me in the heart, there is someone I would like to hit, as I groan ... In! I want to come in! I no longer know who is entering who is penetrating who is invaded, my sense of things is torn to shreds. (142–3)

By drawing on the motifs of medieval mysticism, Cixous inoculates her own lesbian bodies with a fever of desire, for as Caroline Walker Bynum has shown, medieval religious piety was often depicted as an intensely embodied desire, a desire that could never be stilled (Walker Bynum 1995: 25). Medieval female mystics such as Hadewijch, Mechtild of Magdeburg, Angela of Foligno and Marguerite of Oingt all spoke of selves (body and soul together) yearning in heaven with a desire that was piqued and delighted into ever greater frenzy by encounter with their lover, God. Angela described Jesus as 'love and inestimable satiety, which, although it satiated, generated at the same time insatiable hunger', so that all her (that is, Angela's own) members were unstrung. Mechtild wrote that she wished to remain in her body forever in order to suffer and yearn forever towards God (Walker Bynum 1995: 26).

St Teresa of Avila described her relationship to God in terms of 'Love's dart that wounds but never kills' (Hurcombe 1987: 134–5), and H.'s reaction to Promethea's vaccination can be seen as a domesticised version of St Teresa's famous vision of the angel with the fiery dart, an intensely erotic experience depicted by Bernini in his notorious statue in Rome. Teresa recorded that she was sometimes given a vision of an angel standing by her, with an arrow in his hand, with which he pierced her inmost parts:

> I saw in his hand a long spear of gold, and at the iron's point there seemed to be a little fire. He appeared to me to be thrusting it at times into my heart and to pierce my very entrails; when he drew it out, he seemed to draw them out also, and to leave me all on fire with a great love of God. The pain was so great that it made me moan; yet so surpassing was the

sweetness of this excessive pain that I could not wish to be rid of i
(Sackville-West 1988: 107)

The image of desire as a fiery arrow recurs again and again in
Cixous's novel. Promethea is described as choosing 'a word from
her quiver' (Cixous 1991: 68) which penetrates H.'s heart and burns
there:

the word fell dead center onto the other's breast, she was smitten, a word
so keen and so charged, which took a long, long time to plunge dead
center through the breast toward the heart and, finally, touched it, finally
found the heart there slowly buried itself, blade into soul ... the fire has
to burn. (Cixous 1991: 69)

Here, the originally heterosexual motif of the mystical 'wound of
love' is employed allusively and reworked to convey a sense of the
redemptive qualities of violent passion with which Cixous imbues
the lesbian bodies in the novel. The allusion functions to make her les-
bian bodies burn with an intensely embodied desire, and by shatter-
ing conventional distinctions between textuality and body (for the
fiery dart is also, crucially, a word), Cixous conveys her fundamental
message that this subversive body experience is indeed somehow
articulable, and hence – *contra* Lacan – emphatically *knowable*.

The female mystic's love for Christ was not always expressed in
heterosexual terms, for if Christ's body in the Middle Ages was con-
structed erotically as the battered and bleeding beloved other, it was
also imaged as a *maternal* body that nurtured and fed. Christ-as-
mother nurtured through the bleeding wound in His side, which
functioned symbolically like a lactating breast, and the bodies of
women mystics – through healing blood and milk, for example – took
on this maternal function in their own *imitatio Christi*. Likewise,
Cixous's lesbian bodies also both suffer and nurture. H. says to
Promethea '"I want to suckle on your soul"' (Cixous 1991: 121), '"I
want to give it to you, the red milk that you are making bubble up in
my breasts"' (123). The exchange of nourishment takes on eucharistic
nuances: 'I can only give you the blood I draw from my blood, and the
flesh I cut from my breast' (123). Both women are described as trans-
formed by desire into 'mothers', a transformation resonating with
associations of Christ's Passion: 'For you, I am turning myself into a
mother painfully and passionately' (142). A welter of images of
mutual consumption and mutual feeding evokes bodily acts such as
oral sex, warns of the danger of psychic devouring through love, and

implies that the transformative nature of this lesbian desire is analogous to the radical transformations of transubstantiation.

Critic Pamela Banting reminds us that when Cixous evokes the female body, it is often the body of the female hysteric, resisting phallocentrism through her hysterical symptoms and gestures (Banting 1992). But in the light of Cixous's mystical imagery, I would argue that the Cixousian body is just as much the body of the female medieval mystic, exceeding all common bodily categories through an intensity of desire for the other. Like St Teresa, Promethea and H. both suffer acute bodily distress, and undergo a paradoxical confusion of exteriority and interiority. Cixous uses allusions to the radically disturbing, disruptive quality of the medieval mystic's encounter with God as a means to convey the violent dislocation of body boundaries and subject positions involved in lesbian desire, making bodily as well as spiritual sense of H.'s claim that 'we go beyond ourselves with love's help' (Cixous 1991: 87).

By depicting a quasi-sadomasochistic lesbian relationship, albeit an intensely metaphoric one, Cixous implicitly enters the ongoing debate about lesbian body politics between lesbian sex radicals and their opponents. In contrast to lesbian-feminists keen to stress the kinship or sameness between women, and who seek a model of lesbian desire uncontaminated by the power hierarchies of conventional heterosexuality, some champions of lesbian sadomasochism have argued that it epitomises 'the most vital components of *all* erotic tension: teasing, titillation, compulsion and denial, control and struggle, pleasure and pain' (Ardill and O'Sullivan 1986: 25). Others have suggested that it 'makes possible the enactment of power fantasies in a safe situation' and symbolises 'sexual outlawry and the dark side of self and forbidden desires' (Wilson 1983: 25). On the other hand, Paulina Palmer makes the point that if lesbian sadomasochistic practices are depicted in an unselfconscious, untheorised context, there is a risk that 'by simply inverting the political, woman-identified view of lesbianism adopted by their predecessors, they perpetuate the phallocentric system of binaries' (Palmer 1993: 25).

For Cixous, doing violence to bodies and to language recalls and indeed unleashes the originary violence of language itself, and it factors back into her a/theology what had been largely lost in *Vivre L'orange*: a Derridean sense of 'the violence of the arche-writing, the violence of difference, of classifications, and of the system of appelations' (Derrida 1974: 110). Her move from *Vivre* to *Livre* involves a

shift from a peaceful, Eckhartian mysticism based on equivalence and equality to a violent, Teresan, bodily desire based on power struggles and difference. By evoking *imitatio Christi*, Cixous also evokes the mystics' warnings against fetishising suffering and self-violence. The way of the mystic, says St Teresa, does not make a technique out of suffering, for it is no use offering God the kind of suffering that can be managed and controlled. Rather, becoming agents of love for God involves difficulties and risks that will inevitably involve suffering, the kind of suffering that is necessarily unlimited and uncontrollable (Williams 1991: 95). Hence by alluding to *imitatio Christi* in her depiction of desiring lesbian bodies, Cixous implies that there is a radical *riskiness* involved in subversive lesbian desire. Such violent, passionate desire involves a radical openness to the other which inevitably involves ethical and ontological risks.

It has to be said, however, that in the last analysis, there remains a problem with Cixous's depiction of lesbian body politics in *Le Livre de Promethea*. For with risk comes the question of responsibility. There is a danger that radical openness can function merely as a futile, even perilous postmodern stance of self-referentiality, and to face the ethical risks of radical openness is also to face the risk of no ethics at all. Indeed, the narrator acknowledges that the intoxication of love distracts her from politics and prevents her from focusing on 'the misery in Salvador' (Cixous 1991: 81). In the end, the political impact of Cixous's vision of reconfigured lesbian desire remains limited, due to its failure to engage with the wider political and social milieu. Promethea and her lover rarely leave their flat, and their subversive, passionate desire is portrayed as a temporary insanity unsustainable in the long term. Body politics and the wider political realm remain insulated from one another. Thus unlike St Teresa, who managed to combine politics and prayer in a 'mixed life' common to many medieval mystics, Cixous's novel fails to reconcile fully what remains as the conflicting demands of the personal and the political.

References

Ardill, S. and S. O'Sullivan (1986) 'Upsetting an Applecart: Difference, Desire and Lesbian Sadomasochism', *Feminist Review*, 23, 31–57.

Ash, J. (1990) 'The Discursive Construction of Christ's Body in the Later Middle Ages: Resistance and Autonomy', in *Feminine, Masculine and Representation*, T. Phreadgold and A. Cranny-Francis (eds), Sydney, Reducto, 75–105.

Banting, P. (1992) 'The Body as Pictogram: Rethinking Hélène Cixous's Écriture

Féminine', *Textual Practice*, 6 (2), 225–46.

Cixous, H. (1983) *Le Livre de Promethea*, Paris, Gallimard.

—— (1986) 'Sorties', H. Cixous and C. Clément, in *The Newly Born Woman*, trans. B. Wing, Minneapolis, University of Minnesota Press.

—— (1988) 'Extreme Fidelity', trans. A. Liddle and S. Sellers, in S. Sellers (ed.), *Writing Differences: Readings from the Seminars of Hélène Cixous*, Milton Keynes, Open University Press.

—— (1989) *Vivre L'orange/To Live the Orange*, bilingual edition, trans. A. Liddle and S. Cornell, Paris, des femmes.

—— (1991) *The Book of Promethea*, trans. B. Wing, Lincoln and London, University of Nebraska Press.

de Certeau, M. (1986) *Heterologies: Discourse on the Other*, trans. B. Massumi, Minneapolis, University of Minnesota Press.

Derrida, J. (1974) *Of Grammatology*, trans. G.C. Spivak, Baltimore and London, Johns Hopkins University Press.

Hurcombe, L. (1987) *Sex and God: Some Varieties of Women's Religious Experience*, London, Routledge.

Palmer, P. (1993) *Contemporary Lesbian Writing: Dreams, Desire, Difference*, Buckingham, Open University Press.

Sackville-West, V. (1988) *The Eagle and the Dove*, London, Cardinal Press.

Sellers, S. (ed.) (1988) *Writing Differences: Readings from the Seminar of Hélène Cixous*, Milton Keynes, Open University Press.

Taylor, M.C. (1984) *Erring: A Postmodern A/Theology*, Chicago and London, University of Chicago Press.

Walker Bynum, C. (1995) *Fragmentation and Redemption: On Gender and the Human Body in Medieval Religion*, New York, Zone Books.

—— (1995) 'Why All the Fuss about the Body? A Medievalist's Perspective', *Critical Inquiry*, 22, 1–33.

Wenzel, H.V. (1981) 'The Text as Body/Politics: An Appreciation of Monique Wittig's Writings in Context', *Feminist Studies*, 7 (2), 260–72.

Williams, R. (1991) *Teresa of Avila*, London, Geoffrey Chapman.

Wilson, E. (1983) 'The Contexts of "Between Pleasure and Danger": The Barnard Conference on Sexuality', *Feminist Review*, 13, 35–41.

18

IMAGINAL BODIES AND FEMININE SPIRITS:

performing gender in Jungian theory and Atwood's *Alias Grace*

SUSAN ROWLAND

Feminist poststructuralism seeks to theorise beyond the binary forms of western traditions in order to liberate the feminine from the position of structural Other to masculinist discourse. In such a textual field, female embodiment can find itself deployed in yet another duality as a site of resistance or as social inscription; essentialist or constructionist in relation to sexuality, identity and culture. It is the contention of this essay that poststructuralist criticism of Jungian theory, deviating by way of Luce Irigaray and Judith Butler, can problematise the essentialist/constructionist binary displayed in conceptions of feminine corporeality. Such a criticism of Jungian ideas needs its own dual approach in order to offer a productive discourse of the female body. First, the concept of the 'imaginal body' will be explored for its poststructuralist implications. Then, the textuality of the Jungian feminine, the 'anima', will be examined for its problematic occult drives and masculinist fantasies condensing around traces of 'feminine spirits' in the writings. Margaret Atwood's novel *Alias Grace* draws upon the powers of postmodern fiction to disturb both cultural and theoretical categories. I will argue that it performs an investigation of bodily dislocation and spectralisation sedimenting around the genesis of Jungian theory. The novel deconstructs binary systems which pinion and (mis)represent the feminine, in particular that of body and psyche in relation to identity.

To provide a context for the specular criticism of Jungian ideas, it

is useful to begin with Irigaray's critique of Lacan's phallus as a theory which incarnates a veiling and inevitable masquerade of the feminine in western culture. To Lacan, the phallus as signifier is productive of both subjectivity and sexual difference through psychic splitting at the moment of entry into language and the symbolic. Irigaray points out that masculinity is in the position of 'having' the phallus, and femininity assigned that of 'being' the phallus for the masculine, in a binary structure which locks femininity into the role of Other to masculine subject formation (Irigaray 1985: 62). Consequently, Irigaray argues that Lacan's Other cannot be the feminine. The subject and its Other are exclusive members of a closed phallocentric signifying economy which operates by exiling the feminine altogether. The feminine is not 'one' (a sex) because it cannot exist within Lacanian binary discourse, and also not 'one' because it is not a monad, not phallic but multiple (Irigaray 1985: 129). Lacan's phallus is yet another masculinist signifier claiming logocentric powers. It veils the feminine and produces it as masquerade. Lacan's Other is a collapsing into the Same.

Butler offers two understandings of the masquerade of Lacan's 'being the phallus' (Butler 1990: 47). On the one hand, femininity as a masquerade may be produced entirely through cultural discourses, may be a construction or a 'performative production of a sexual ontology' (Butler 1990: 47). Conversely, a masquerade may indicate a concept of an essential feminine denied or repressed by the phallic economy. Butler's use of Foucault's critical genealogies of the productive nature of power enables her to argue for gender as performance (the former interpretation) in a feminist poststructuralist understanding of the feminine in relation to embodiment. She specifically rejects the binary nature–culture which posits a pre-cultural sexed body versus a completely cultural gender. To Butler, sexed bodies are culturally produced: all sex and gender is masquerade without any prior ontology of sexed being. It is the task of feminism, she believes, to support ever more overt performances of gender as masquerade in the cause of dispelling the myth of the sexed body as nature. Therein gender freedom may be enacted: '[j]ust as bodily surfaces are enacted as the natural, so these surfaces can become the site of a dissonant and denaturalised performance that reveals the performative status of the natural itself' (Butler 1990: 146).

All the above appears far from Jungian theory's reputation for propagating unhelpful gender stereotypes in the guise of essential

mythical archetypes (Samuels 1985, 1993). While it is true that Jung sometimes wrote as if mental images could be simply inherited in some transcendent form as archetypes, this is not germane to his core theory of the unconscious. What is definitive about the Jungian unconscious is that it is the proactive and creative source of *potentials* for meaning, feeling and value. It is structured (like a language) through archetypes which are the inherited possibilities for image formation, not transmitted contents (Samuels 1985: 23–45). No representation is possible except through archetypal images which are both derived from the structuring potentials of unconscious archetypes and formed through bodily integration into culture. There is no *representation* except through material culture but there can be no *signifying* except by means of a creative input from the unconscious. The Jungian psyche is teleological. Instead of subjectivity occasioned by primary splitting and repression, the unconscious 'gives birth' to consciousness as a method of representing itself and of producing an evolving subjectivity which Jung called 'individuation'. Jung never denied that the Oedipus complex and castration may have relevance in the formation of the ego, but always gave priority to the creative powers of the unconscious. Compensation rather than simple opposition is the key to relations between the ego and unconscious. The unconscious aims to develop the ego into ever greater relationship with archetypal forces. It operates by deconstructing the structural oppositions between ego and the archetypes which can never be fully represented or exhausted by any cluster of archetypal images. Archetypes are unrepresentable in totality: they are androgynous, contain their own opposites and are multiple in their potentialities. Gender is similarly a matter of psychic structural opposition and deconstruction. This brings in the ambiguous Jungian positioning of the body.

Jung never explored whether ego realisation of the body or culture came first: in effect, is the body understood by the ego as prior to culture or only configured through cultural prescriptions? In turn, Jungian theory offers another perspective on these binary alternatives by providing the unconscious as a third, creative term in the equation. For Jung, the body intervenes in the making of meaning but cannot govern it because the radical alterity of the unconscious has priority. So whether the body or culture comes first in the ego's apprehension of itself, the unconscious will counteract or compensate for any perceived bodily or cultural inferiority. The Jungian symbolic consists of the realisation of archetypes through the representation of archetypal

images which are the ontology of the ego. It is the symbolic from which the feminine can never be excluded, because it resides there in the creative androgyny of archetypes which will compensate for any ego fantasies about phallogocentrism.

Jung named the principal archetypes of gender the 'anima' as unconscious femininity in men, the 'animus' as psychic masculinity in women. The Jungian unconscious always structures itself as Other to the ego, so he believed that the principal signifier of Otherness would be found on the model of the Other body. Once the ego has mapped its bodily boundaries (and my metaphor is intentionally suggestive, since mapping is a cultural activity), a compensatory image of bodily Otherness is formed by the creative psyche. Nevertheless, this psychic contra-sexuality is no more fixed than anything else in the Jungian unconscious. Since archetypes are multiple and never containable in a single image nor gender, the anima or animus occasioned by a body image is protean in its potentiality. The unconscious Other can be represented by images of the same gender, or body form, or of animal, tree or dragon etc. The metaphor of heterosexuality in ego-unconscious relations is just that, a *metaphor*. It is not compulsory heterosexuality: the body intervenes in the making of signifying to produce an unconscious Other of another body or gender, but it does not govern the production of psychic Otherness. Similarly, sexuality with an-Other body can be a means to penetrate the unconscious, but there is no productive law in Jungian theory which takes Other body to be 'opposite' gender. Therefore I am arguing that Jungian theory generates an 'imaginal body'. Such an imaginal body is a protean body image in the psyche intimately engaged with the ego's tracing of bodily boundaries, and is autonomously participant in the cultural production of the sexed body. It acts to deconstruct gender binaries and hierarchy due to the compensatory autonomy of the psyche. The creativity of the Jungian unconscious provides a textual position from which to allege that phallogocentrism is a patriarchal fantasy based upon the reification of masculine embodiment. However, this is not to assert that Jungian *theory* entirely escapes phallogocentric fantasy. A critical genealogy may detect such fantasies operating in the theory's occult manufacture of the 'feminine spirit' or anima.

Jung's earliest researches into the autonomy of psychic manifestations occur in his examination of his female medium cousin at a series of seances (Jung 1953: 3–88). He retains the spiritualist model when he describes his evolution of the idea of the independent tele-

ology of the unconscious. His own anima, named Salome, speaks through him as if he were a medium (Jung 1963: 210). Salome acquires her own potent textuality when he generalises from his particular anima as an erotic, unconscious, devious femininity to describe the masculine anima generally. Most unwarranted of all, the male's deceitful anima becomes the assertion of a universal femininity. Women, Jung argues, are more erotic in a connective sense, less analytical and with a 'feminine nature' which could be harmed by exposure to 'masculine' work (Jung 1986: 59). What might construe this cultural slippage as a form of 'anima hysteria' is Jung's far more coherent proposition that male theorists can have nothing objective to say about femininity because their own anima fantasies will inevitably distort (Jung 1954: 198).

It is easy to perceive that the hypnotic power of the anima in Jungian textuality enacts yet another form of femininity as masquerade, a deployment of masculinist fantasy that excludes the feminine from independent representation. We might deepen this criticism by borrowing Irigaray's critique of Lacan, and argue that the anima operates as the Jungian 'phallus' that the masculine 'has' and that the feminine must 'be' for the masculine in a phallogocentric economy predicated upon exclusion of the feminine altogether. Yet in what way does it make sense to describe the anima as a 'phallus'? If Lacan's phallus produces subjectivity and sexual difference, then Jung's anima does the same for the masculine subject in being the primary signifier of the creative unconscious, which is the essential sculptor of subjectivity and sexual identity. The fact that in Jungian theory the anima refers to the *masculine* subject is suggestive in identifying it with the phallic function in Irigaray and Lacan. If we do not deconstruct Jungian theory's fantasies of the anima masquerading as femininity, then the feminist reading of the poststructuralist potential of imaginal bodies will forever be deformed. We can trace a critical genealogy of the anima back into nineteenth-century spiritualism's preponderance of female mediums to detect a gender politics at the genesis of Jungian theory. The feminine position of the medium is appropriated by the masculine subject which displaces the feminine into the realm of the Other as disembodied spirit. The feminine is displaced from medium to anima whose textual hysteria produces a signifying anima economy. Here, the anima acts as phallus in becoming Jung's femininity as masquerade. In Butler's terms, a critical genealogy of the anima unveils Jung's femininity as performance under the conditions

of masquerading as masculinity's Other. A reading of Atwood's novel will further this argument.

Alias Grace's major motifs for textuality are the quilts sewn by women in nineteenth-century Canada. These consist of fabric fragments remade into patterns which both bear the marks of individual imagination and reproduce cultural typology. Similarly, the novel stitches together contradictory historical documents about the alleged murderess, Grace Marks (convicted of collaborating in the killing of her employer, Thomas Kinnear, and his housekeeper–mistress, Nancy Montgomery), by interposing contemporary literature, a fictional first-person narration of Grace and the omniscient account of a fictional doctor treating her, Simon Jordan. The quilt metaphor extends to the logocentric text of the Bible, when Grace learns of significant bits left out of the authorised versions. When she is finally enabled to compose her own quilts, she feels at liberty to alter a biblical pattern because, 'like everything men write down … they got the main story right but some of the details wrong' (Atwood 1996: 459). If the Bible is redefined as a 'theographic metafiction',[1] then *Alias Grace* comfortably inhabits the sub-genre of historiographic metafiction as a work which problematises the writing both of history and of fiction. The historical record of Grace Marks is structured upon that familiar feminine dualism of innocent virgin or murdering whore, concentrated on the depiction of her body and sexuality. Did she seduce James McDermott into becoming the main actor of the crimes, make sexual advances to her lawyer and use the inexperienced Simon Jordan for her own devious erotic ends? Or, instead, is she persecuted by the eroticising masculinist gaze of the law, the church and the medical profession?

It is the achievement of the novel to reveal the binary systems oppressing the feminine as provisions of culture which converge on the representations of female embodiment. History is problematised because it is revealed as fatally contaminated by sexuality and culture: its textuality is saturated with fiction. Fiction is problematised because *Alias Grace* fractures the realist text's claims to portray a coherent *knowable* world and solve issues of representation. More precisely, the metafiction lies not only in the text's refusing to tell us 'the truth' about Grace but in its revelation of its inability to do so. This is not because Grace is an historical figure, unavailable for questioning. Even if the whole novel were pure invention, the solution to the mystery of Grace (and hence in this text to femininity itself, as she is

revealed as a textuality of cultural gender) is shown as radically unknowable in this postmodern feminist work. Or more pertinently, unknowable *as one*, as a single answer, a phallic monad of definition. A crucial binary deconstructed is that of truth–lies. We never know whether Grace is lying when she claims amnesia of crucial events. She suggests that she makes up some of her story to please Simon, but there is no way of telling how much. Was her former madness real or feigned? Grace could be lying (taking the role of female artist) or telling an 'embroidered' truth, or be suffering from amnesia or madness, so finding herself radically unknowable. Yet the novel does more than problematise first-person narration. The erotics of textuality are explored through Simon Jordan, who initially aims to turn Grace into a profitable case study for his psychological career. As a gendered model of an author with 'interests' in the composition of his text, Simon's class, economic and soon sexual frameworks for Grace expose the contingent nature of textuality as embedded in culture. Fiction's claims to 'represent' are compromised by the display of erotic and cultural drives within writing.

Atwood herself linked Jung to her novel in connection with spiritualism, amnesia and suggestions that he was inspired by 'nineteenth century ... opera' (Abley 1996). Simon acts as a prototypical C.G. Jung both in using Jung's early technique of word association and particularly in describing Grace as an 'anima', taking an opera as his source (Atwood 1996: 321). Both Grace and her friend Jeremiah Pontelli (who reappears as Jerome Du Pont, the hypnotist, and Gerald Bridges, the medium) could be described as Jungian trickster figures. The transcultural trickster in Jungian writings occurs as the androgynous archetypal figure of the polymorphous unconscious (Jung 1972: 135–52). What is particularly Jungian about the tricksters of *Alias Grace* is the link to spiritualism, when we remember that Jung 'discovered' his unconscious in the 'tricks' of his medium cousin. Jeremiah's perpetual surname 'Bridges' suggests his persistent role as bridge to the unconscious. It is he, as Jerome Du Pont, who hypnotises Grace in front of Simon and her respectable supporters. Instead of hypnosis uncovering repressed memories, Grace 'produces' a spirit or second personality who claims to have possessed Grace and performed evil deeds in her body. This feminine spirit calls herself Mary Whitney, a woman whom Grace claimed previously to be her dear friend and carnally exploited fellow servant, dying of a botched abortion. The spiritualism scene is a spectacle of the bodily dislocation and

spectralisation of the feminine, effecting the deconstructing of the binaries body–mind, self–Other. Grace's body may have participated in murder but 'worn' by another mind: '"I only borrowed her clothing for a time … [h]er fleshly garment"' (Atwood 1996: 403–4).

However, by this point the reader knows Jerome to be the trickster-liar Jeremiah, who has had time to concoct a fiction with Grace. A guilty Grace may here be the fictional 'author' of Mary for whose independent existence there is no incontrovertible evidence. Or Mary, the feminine spirit, may be the spontaneous production of Grace's Jungian trickster unconscious. Or Grace may be truly spirit-possessed. In Jungian terms we can see the imaginal body inflected in Grace's 'spirit-ualist' evocation of Mary and in Simon's identifying of Grace as his anima. The Jungian unconscious can be contacted through sexuality. Grace's eroticised relations with both Jeremiah and Simon seem to stimulate the production of 'Mary', while Simon dreams of sex with Grace only to find that he has enacted his desires upon the supine body of his landlady. The imaginal body of Grace is not only spectralised by Mary but is carried by the males she is attracted to and displayed in dreams suggestive of her animus (Atwood 1996: 280).

Alias Grace demonstrates the possibilities of the imaginal body by deconstructing binaries (such as body–mind, self–Other, truth–fiction, feminine–masculine), so that embodiment and sexual identity can be figured as constituted through cultural prescriptions yet retain a site for resistance in the alterity of the creative unconscious. The taking apart of these binaries in Grace's spiritualist staging of Mary allows the resulting multiplicity to embody cultural dynamics, such as class and sexuality, which structure such binaries in the first place. Similarly, Simon's identifying of Grace as his anima problematises the binary of self–Other into self–Jungian Other, the bearer of his unconscious feminine Otherness. He realises that he cannot trust his judgement of Grace because he desires both her innocence and her guilt in his excitement at her embodiment (for him) of both conventional femininity and its whorish Other. Sexuality, saturated by cultural formations, is exposed as one author of the binary splitting of the feminine into angel–whore. As anima or collaborator in Simon's psychic construction of his imaginal body, the radical alterity of Grace as signifier of the Jungian Other is maintained to problematise dualism.

Grace is anima as trickster, but why have tricksters of two genders? I would suggest that the double trickster here incarnates the

diverse fates of feminine and masculine embodiment in a specific culture. Jeremiah can shapeshift around the margins of polite society, evading the law. Grace as trickster refuses his marginal path, feeling her only refuge to be marriage to another male who convicts her as his anima, Jamie Walsh. As spurned boy, his testimony at Grace's trial proved her punishment. Grace as trickster deconstructs the boundaries of guilty–innocent in the cause of (re)presenting the cultural myths of the feminine *as* culture, but also portrays the specific perils of female embodiment unable to escape the anima position. Dislocated from the site of the cultural construct angel–whore by the imaginal body, she nevertheless spends much of the text literally and metaphorically imprisoned.

The novel frequently textualises the imaginal body through the use of imagery concerned with clothing and laundry. At crucial points in the story, laundry animates fantasies and dreams as spectral signs both of the absent body and of angels, beings without sexed bodies. Grace describes working with Mary when the washing outside resembles birds or angels rejoicing; inside, the wet clothes seem disembodied ghosts and Mary wears a sheet to frighten Grace by impersonating one (Atwood 1996: 159–60). These images in a happy so-called 'memory' return in ominous guise when Grace claims to dream the laundry as birds, angels or ghostly forms the night before the murders (280–1). Mary's masquerade of a ghost returns to haunt the text when she claims to 'wear' Grace's body in the seance scene.

The body as the clothing of identity, providing a means of cultural inscription, is a metaphor for the imaginal body's clothing or re-presenting of psychic and sexual identity. Clothes can be renewed or exchanged, as Grace significantly wears Mary's and Nancy's clothes just as she claims to wear Mary's identity in her alias, or when 'Mary' claims to wear *her* body. In this way bodily and gendered images of the psychic Other can be worn and exchanged by the creative unconscious.

But what of the phallic anima in this text which situates the genesis of the Jungian anima at the intersection of nineteenth-century discourses such as opera, the gendered fascination with mediumship, and the historical embodiments of eroticism? Jung's spiritualist opening to his *Collected Works* describes the trickery of the female medium as variously signs of unconscious autonomy or romances inspired by repressed sexuality, leaving open the question of whether she was a deliberate fiction-maker or prey to unconscious desire. I would sug-

gest that *Alias Grace* describes a fictional genealogy of the anima. It does so by tracing the dislocation of the feminine from embodied medium to feminine spirit; a spirit that takes the role of Other to masculine subjectivity. This Other as anima is a phallic Other: femininity as cultural veiling in masquerade and phallogocentric fantasy of the Same. Simon dreams of trying to penetrate the body of a maid (he is having no success in 'penetrating' Grace) to find only a series of veils or cloths. *Alias Grace* reveals historical material to be a patchwork subjected to desire and assembled by culturally inscribed patterns of femininity as masquerade. Grace as anima is not only the fantasy of Simon, her lawyer, and Jamie but also the anima of historical record. She is radically unknowable in the truly Jungian sense of the unconscious, but is also deployed by her culture as (phallic) anima as masquerade in her role as a textual screen upon which to project erotic fantasy. The novel both utilises the productive potentials of Jungian theory for feminist representation of female embodiment *and* locates Jungian discourse itself as embodied in the textual inscriptions of culture. *Alias Grace* enables Jungian ideas to be 'quilted' into feminist notions of gender as performance whereby the only prior to cultural encryption in masquerade is the radical alterity of the unconscious, in which no representation or 'natural' sexed being is possible. Of course, Jungian gender as performance is permissible, always providing we diagnose the textual hysteria of the anima wherein masculinist fantasies of gender perform Jungian theory.

Note

1 The phrase 'theographic metafiction' is a coinage of my own modelled on Linda Hutcheon's concept of 'historiographic metafiction' described at length in her *The Politics of Postmodernism: History, Theory, Fiction* (1989).

References

Abley, M. (1996) 'Don't Ask for the Truth: Interview with Margaret Atwood', *Guardian*, G2, 9.

Atwood, M. (1996) *Alias Grace*, London, Bloomsbury.

Butler, J. (1990) *Gender Trouble: Feminism and the Subversion of Identity*, London, Routledge.

Hutcheon, L. (1989) *The Politics of Postmodernism: History, Theory, Fiction*, London and New York, Routledge.

Irigaray, L. (1985) *This Sex Which Is Not One*, trans. Catherine Porter with Carolyn Burke, Ithaca, Cornell University Press.

Jung, C.G. (1953) *The Collected Works of C.G. Jung. Vol. 1: Psychiatric Studies*, eds H. Read, M. Fordham and G. Adler, trans. R.F.C. Hull, London, Routledge and Kegan Paul.

—— (1954) *The Collected Works of C.G. Jung. Vol. 17: The Development of Personality*, eds H. Read, M. Fordham and G. Adler, trans. R.F.C. Hull, London, Routledge and Kegan Paul.

—— (1963) *Memories, Dreams, Reflections*, recorded and ed. Aniela Jaffe, trans. Richard and Clara Winston, London, Collins and Routledge & Kegan Paul.

—— (1972) *Four Archetypes: Mother, Rebirth, Trickster, Spirit*, London, Ark Paperbacks.

—— (1986) *Aspects of the Feminine*, London, Ark Paperbacks.

Samuels, A. (1985) *Jung and the Post-Jungians*, London, Boston and Henley, Routledge and Kegan Paul.

—— (1993) *The Political Psyche*, London and New York, Routledge.

INDEX

255

INDEX

INDEX

INDEX